Durham
Memories

Durham Memories

J. Landt Mawson
Ed. Amanda Stobbs

AMBERLEY

FOR MY PARENTS, JOSEPHINE AND ALAN

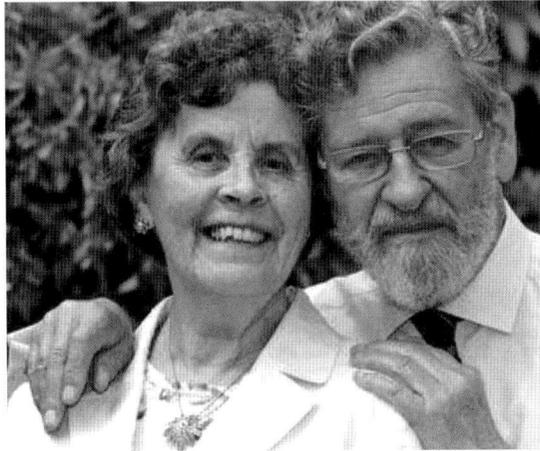

Golden Wedding photo, 19 July 2008, by permission of *The Northern Echo*, Newsquest (North East) Ltd.

Front cover: Durham Cathedral from Prebends Bridge, from a turn-of-the century tinted postcard.

Back cover: 5 Ravensworth Terrace in 1898. Joseph Mawson (standing, rear) with his wife Amalie (seated, left) and their children – middle row: Landt and Flora; front row: Frieda (on Amalie's knee), Anna and Dottie.

First published 2013

Amberley Publishing
The Hill, Stroud
Gloucestershire, GL5 4EP

www.amberleybooks.com

Copyright © J. Landt Mawson & Amanda Stobbs, 2013

The right of J. Landt Mawson & Amanda Stobbs to be identified as the Authors of this work has been asserted in accordance with the Copyrights, Designs and Patents Act 1988.

British Library Cataloguing in Publication Data.
A catalogue record for this book is available from the British Library.

ISBN 978 1 4456 0411 4

Typesetting and Origination by Amberley Publishing.
Printed in Great Britain.

Contents

Acknowledgements

My thanks go to the following people:

My grandfather, the late J. Landt Mawson Esq., for making good use of sleepless nights to write his memoirs in the first place, and for his extensive photo collection documenting his life from childhood onwards.

My parents for their comments and advice, and for access to their photo collections, archives and memorabilia.

Michael Richardson for his interest in, and invaluable help with, this book – and above all for kindly supplying so many photographs from his extensive Gilesgate Photographic Archive. Without him, the book would have remained much less fully illustrated, and purely within my family's archives.

My great aunt, the late Miss Flora Mawson, for giving me all her paintings and sketchbooks.

John Malden of Durham School Archives; Shincliffe Local History Society Archives; and Julian Harrop of Beamish Museum Archives for providing additional photographs.

Mike Hay and family; Muriel Heron; Elsie Shaw and David Williams for providing pictures from their own family collections.

Those friends and neighbours who first suggested that the memoirs might be of interest to people beyond my immediate family and thus planted the seeds for a 'real' book, and who also helped with the proofreading.

Isabelle and Ben Stobbs for being the reason I started this project; Flora Pitt for her interest, though she did not live long enough to see the book completed; and my mother, Jo, for turning eighty and thus giving me a deadline for finishing the original draft.

Foreword

These memoirs were written by my grandfather, J. Landt Mawson, between 1966 and his death a decade later. Apart from a short stint away 'down south' as a private tutor, and time spent away with the army during the First World War, he was born, educated, and lived his whole life in Durham.

On his father's side, Landt came from many generations of Durham residents, but his mother – one of nine surviving children – came from Flensburg, in what is now Germany. Her four sisters and one of her brothers remained in or near Flensburg, but another brother went to Australia and two to America. With the siblings spread over some five countries on three continents, there was great motivation to document family life in words and photographs. Added to this, Landt was a keen amateur photographer from an early age. I have used some of his many photographs to illustrate these memoirs, with pictures from Michael Richardson's collection and Flora Mawson's sketches for the more general Durham shots.

The memoirs give an impression of day-to-day life in Durham during Landt's childhood at the turn of the last century, and include sections on Shincliffe (where he first spent much time visiting his godfather, and later lived all his married life), Saltburn, and Newcastle. The memoirs are not, however, an autobiography. Although, for example, we have documentary and/or photographic evidence of visits made to, and by, the family in Flensburg (and know that at least one sister – Dottie – spent time at school in Flensburg in 1903/4), no mention is made of such events in this book. Landt does not talk about his time at Durham University; nor is mention made of his sisters' education, though we know that Frieda eventually became Head Girl at Durham High School.

My original reason for typing up the handwritten memoirs was to make them more easily accessible for the family, plus a desire to put a few of the photos from Landt's many albums into some sort of context. Later, other people expressed interest and the project blossomed into a full-blown book. The resulting research has provided me with a fascinating journey into the past, which I hope you will enjoy, too.

Amanda Stobbs

Notes

Illustrations

Many of these come from the Stobbs/Mawson family archives, and are not acknowledged.
[MR] denotes those supplied by Michael Richardson,
[SLHS] those from Shincliffe Local History Society.
Illustrations from other sources are individually acknowledged.

Asides

The text is as Landt wrote it, but where I felt there was a need for an explanation to allow the text to be more readily understood, I have added this in italics and within square brackets. Longer explanations and additional information are included separately, either in the photo captions or at the back of the book in the 'Addenda and Corrigenda' section.

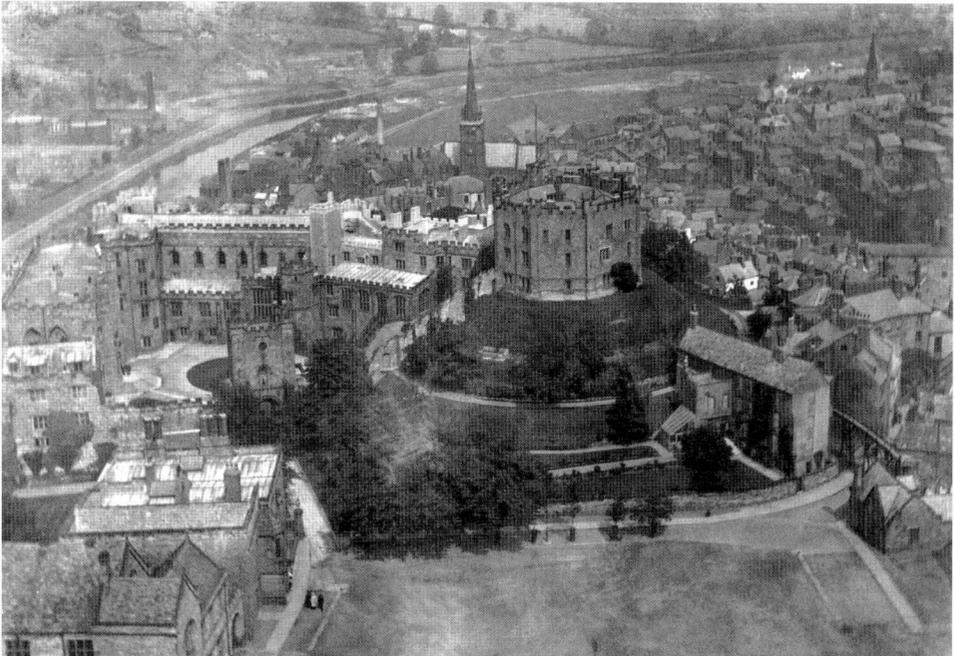

Durham Castle from the cathedral tower, about 1909.

Introduction

I was born on 19 August 1890, and I am now what may, even in these days, be described as an old man – turned seventy-six and beginning to feel it. A sense of frustration when a very active and energetic individual cannot help realising he's slowing up, getting weaker and out of puff; when he finds he cannot do what he did – with the result that more and more time has to be given to rest physically, though somehow the old brain won't lie down, and often sleep becomes difficult, and nights seem long and restless. It is thus that I find myself thinking back and digging up old memories, of people, places and incidents long-since seeming to have been forgotten – but actually in some recording, impressioned part of the old brain stored away, albeit unconsciously (or should I say subconsciously). It is for this reason that I have decided to record some of these memories for my own amusement and occupation, and maybe of interest to those who come after me.

J. L. M., 1966

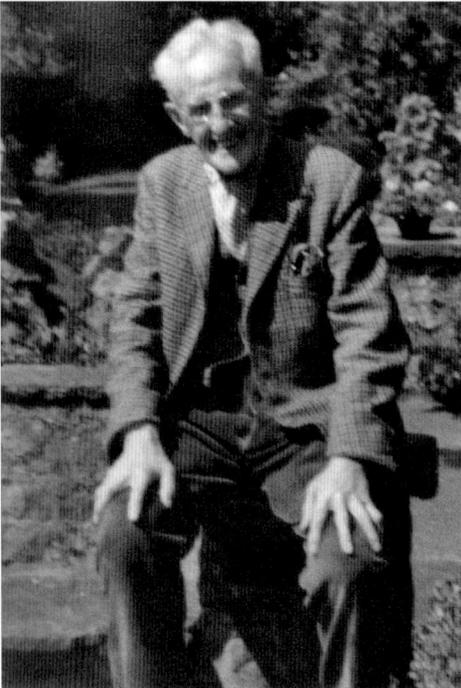

J. Landt Mawson.

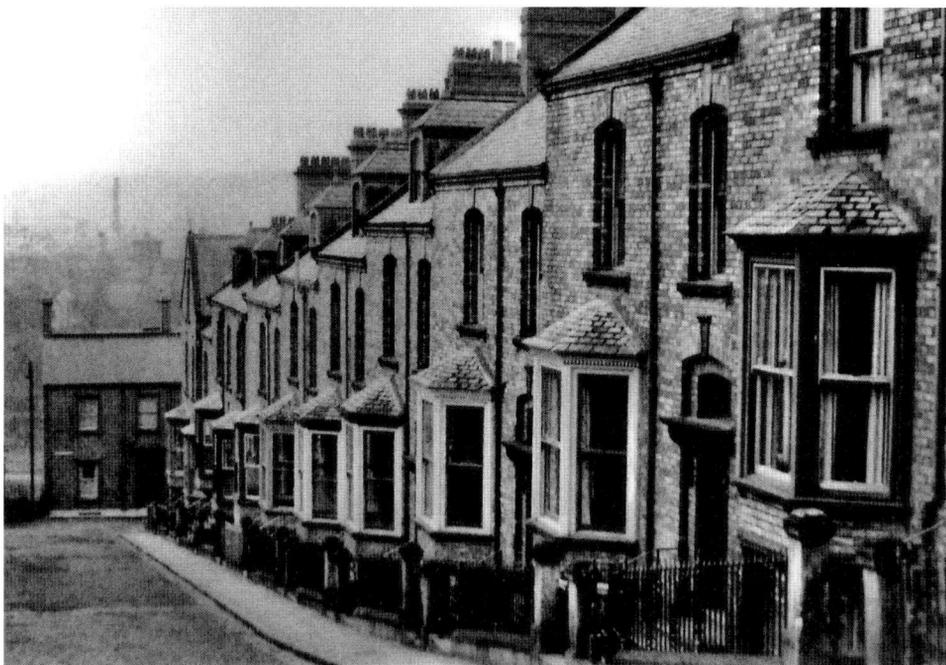

Ravensworth Terrace looking down from Number 10, the family home, to Pelaw Leazes at the bottom – spring 1953. *[MR]*

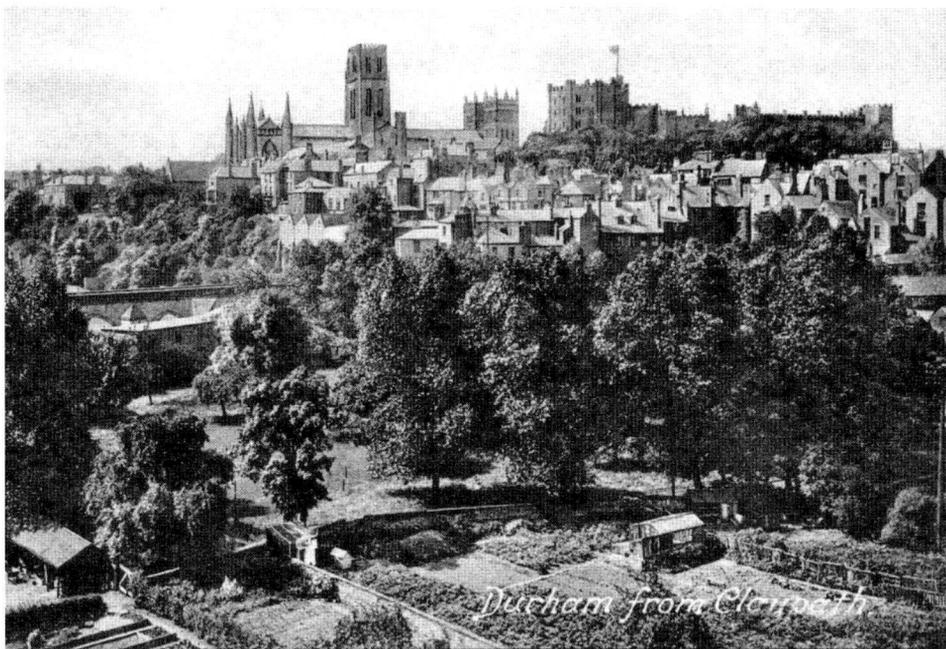

Durham from Claypath, about 1900 – looking over Paradise Gardens (now the Prince Bishops shopping centre) and Brown's Boathouse. *[Postcard]*

I

Family

My father was a solicitor; my grandfather a blacksmith and cartwright, who operated from his home at 123 Gilesgate (near the Duck Pond *[see page 184]*) – behind which he had his smithy and sheds, opening onto the lane adjoining the Barracks.

My mother came from a very old Flensburg family, who had been rope-makers for generations, and were closely associated with the Constantine family *[shipping millionaires]*, who were pretty well brought up there, and even when I knew them spoke with quite a foreign accent.

Both my father and mother were members of large families, and were brought up as honest, God-fearing Christians, and did their best to bring up me and my four sisters in the same religion and tradition. I hope we justified their hopes and efforts!

My father's friend was John Willan, who was then a yeast merchant and operated from a few doors further up Gilesgate. My mother's girlhood friend was Mary Constantine. I mention this because it was through these two childhood friends who married that my father met my mother and married her in 1886 at Flensburg; and to us children, the Willans became, or always were, known as Uncle John and Auntie Mary, with whom we were all closely associated until their deaths.

My first memories of them were that they lived at Shincliffe, in the large house at the bottom of the village now known as the Corner House, and that Uncle John farmed the neighbouring land. Each Christmas Eve, without fail, they sent a package with presents for my sisters and me.

Uncle John was my godfather, and I was christened at St Giles' church, as were all my four sisters. My father was, however, a Methodist, and was 't'harmoniumist' at Gilesgate chapel, and my mother adopted the Methodist faith. We all attended the chapel in Chapel Passage in Old Elvet, where father rented a pew like a sort of pen for cattle. It had seats on two sides, and a door. On the side towards the pulpit (an elevated platform about 8 or 10 feet *[about 3 metres]* square, with deck surrounded by a banister rail on fancy wrought-iron supports, and approached by a long flight of stairs) there was a leaf table with a flap which lifted up to form a shelf, under which were kept our hymn books. Directly opposite the pulpit, at the top of a large gallery which extended along both sides of the chapel, was a wonderful organ, beneath which sat the choir of worshippers. My father was a steward and used to take part in the collection, and afterwards we children sometimes went into the little vestry and watched the money-counting.

After service, it was the custom for people to parade along the racecourse in their Sunday best – how I hated that bit, particularly when I was later fit out in a top hat!

Incidentally, my father was one of those most responsible for the organisation and building of the new chapel in Old Elvet, where it still stands on the site of the first boys' school I attended – from 1898 – run by Mr John Castley, who later transferred to Victoria Terrace. I left that school in 1902 to go to Durham School.

How well I remember the old Durham families, regular attenders and supporters of the chapel. The Willans, Herrings, Chambers, Collinsons, Myers, Dawsons, Listers, Charltons and the rest.

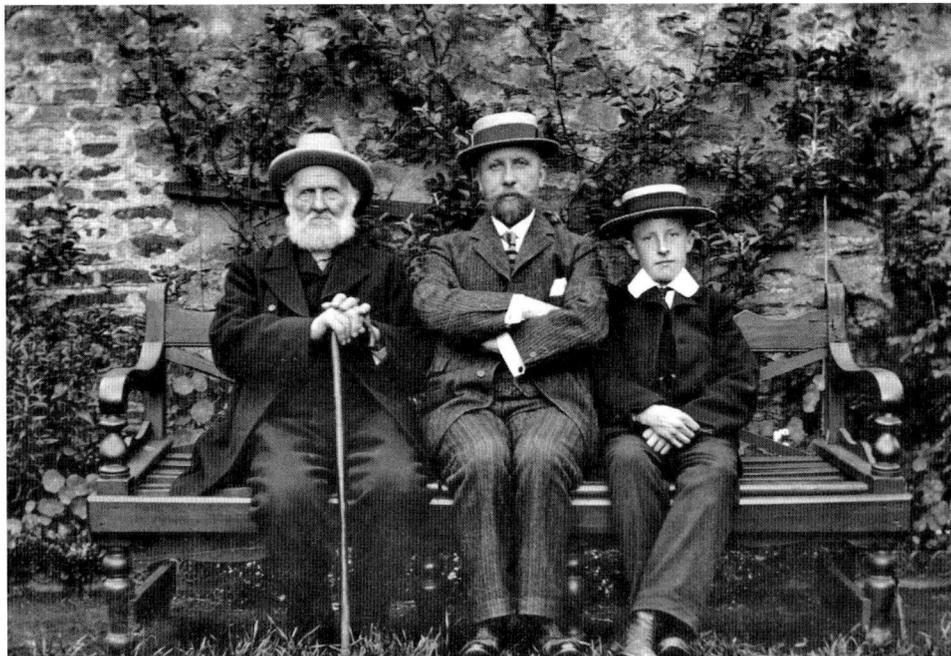

Father, son and grandson – Michael, Joseph and Landt Mawson, around 1903.

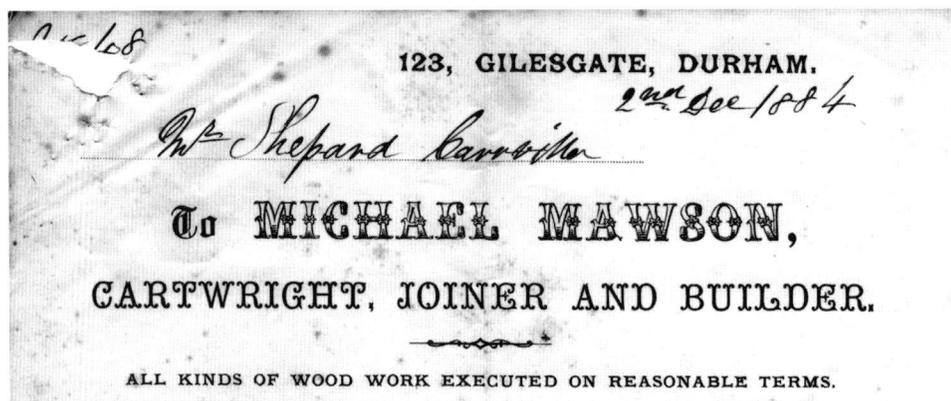

Letterhead from Michael Mawson's business, 1884.

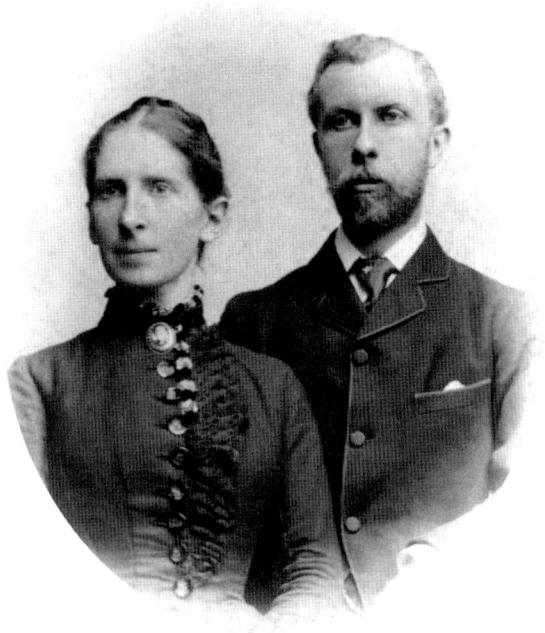

Landt's parents Amalie and Joseph
Mawson, wedding photograph, 1886.

Robert Constantine, John Willan and
(front) Landt's cousin Hans Lemmel,
about 1913.

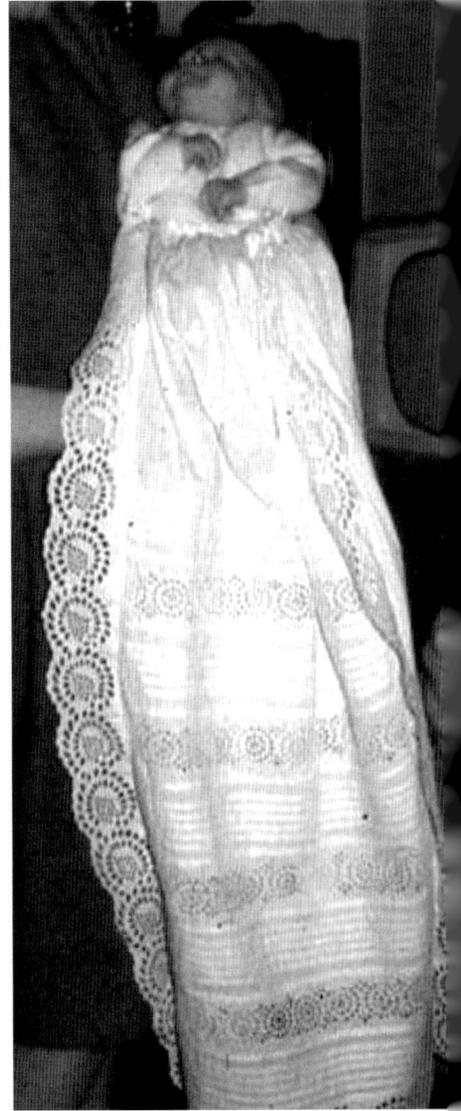

Above left: Amalie Landt (seated) and friend, 1870s.

Above right: The family christening robe (photographed in 1963) worn by at least four generations of the family.

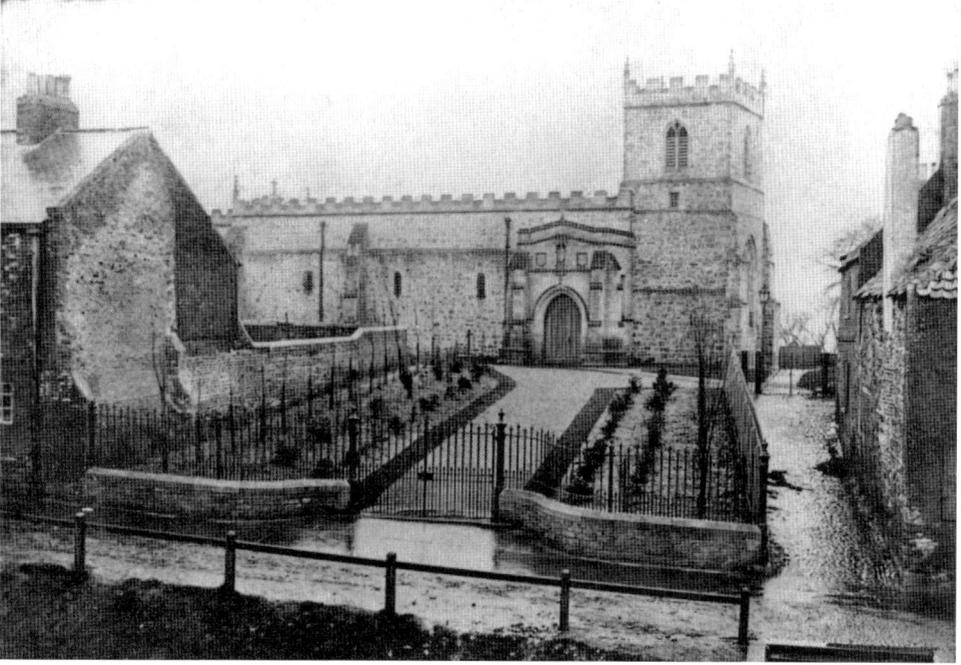

Above: St Giles' church, 1900s. At least four generations of Landt's forebears are buried at St Giles and two generations were baptised there.

Right: The Norman font at St Giles', 1900s. *[MR]*

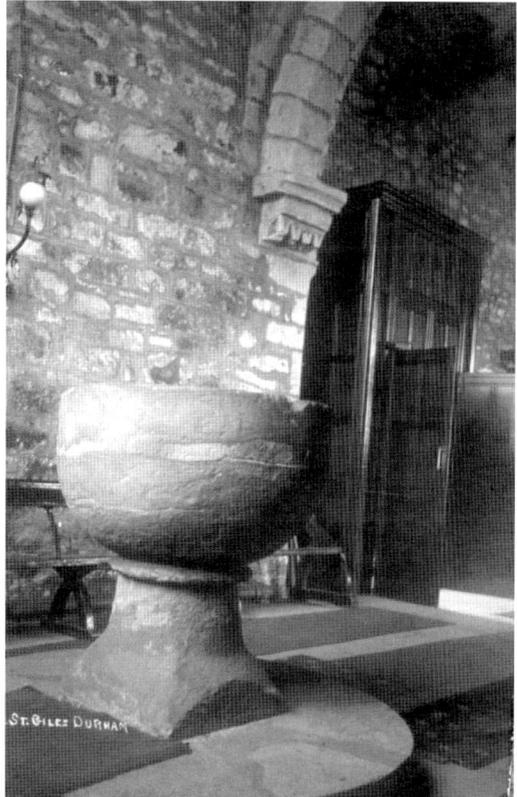

Looking down Chapel Passage
towards the chapel, about 1903.

The Revd Grimshaw Yates in the
pulpit at Elvet Methodist chapel in
Chapel Passage, 1900s. *[MR]*

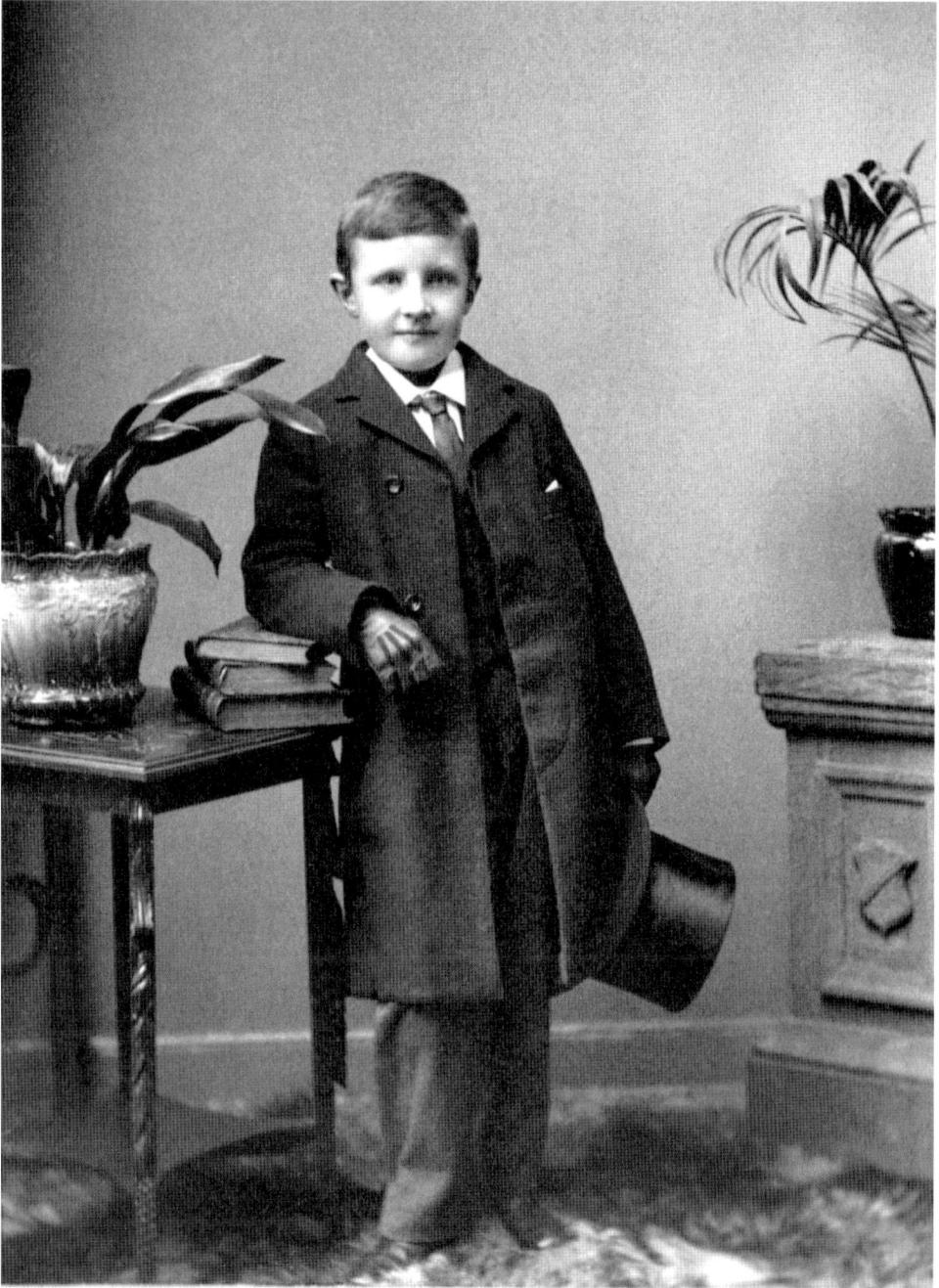

Landt and his top hat, about 1900. 'How we had to pose for these early photos – all time-exposures. Great big cameras with mahogany legs, black head-cloths and lens hoods, all mounted on castors.

'What fun this one was! Whenever the photographer ducked behind his black head-cloth or behind the camera when taking the lens hood off to expose the plate, I laughed – had to go back several times to try again.'

2

Neighbours

My sisters and I were all born at No. 5 Ravensworth Terrace, between 1888 and 1897. Marshall – the town clerk – lived at No. 1, and at No. 2 was Miss Notman's 'school for girls and little boys' at which we attended; at first only on a Friday afternoon for me till I was five, then the whole time. My main memories of that were Miss Lumsdon's dancing class – a buxom body in a Victorian long, black skirt which she lifted a very little (but discreetly) to let me see the position of the feet for the waltz, polka and such. Then it was discovered that I had a 'voice', so often on Sunday evenings I was invited to No. 2 to sing hymns with the girl boarders, and always had to sing one verse solo to my embarrassment, to be presented with a chocolate for it. At Miss Notman's we learned our lessons in such a way that we remembered them for the rest of our lives – we did physical jerks, the while rhythmically chanting our countries, capitals and rivers; alternatively, countries and all the main towns in those countries. From Miss Notman's I proceeded to Mr Castley's at the age of eight – of which more later!

No. 3 was occupied by Mr Arthur Pattison (later Alderman), who was the founder – or nearly – of M. Pattison and Company, upholsterers and cabinet makers, and whose successors still *[1966]* carry on his business under his name on Elvet Bridge. As a hobby he kept pigeons, and used to carry me down from No. 5, via Tinkler's Lane, to see them. He was a portly man, with a face that seemed somehow to look rather pigeon-like, particularly his 'beak'.

In No. 4 lived Bell *[see page 184]*, and in No. 6, Harry Brown (a retired schoolmaster) and his daughter, Miss Lizzie. She was a peeky, dainty little thing who used to lend us books to read; and later when she had to have her big toe cut off, she invited me to go and see it – but I funked it!

Then up the street was Crozier, Mirfields, Dr Vann, Mohuns, and Veitches; and at the top of the hill, Morgans – Freddy Morgan and I being 'buddies', mad on tin soldiers. What battles we had across the landing – one headquarters in the bathroom, the other in a bedroom. Real clever soldiers – shilling a box of twelve at Miss Brewster's in Sadler Street. The shop was run by two little old ladies – typical Victorians.

Talking about tin soldiers, I won two boxes thro' being 'brave' when I had teeth out – at Mr Inman's in Elvet.

What sticks in my recollection of Freddy is the occasion when we were taken for a walk by our mother's help and we both ran helter skelter down the lane to the old wooden Baths Bridge – too fast. Freddy turned left along the waterside. I unfortunately tried to take the bridge steps two at a time. I missed, split my head open and passed

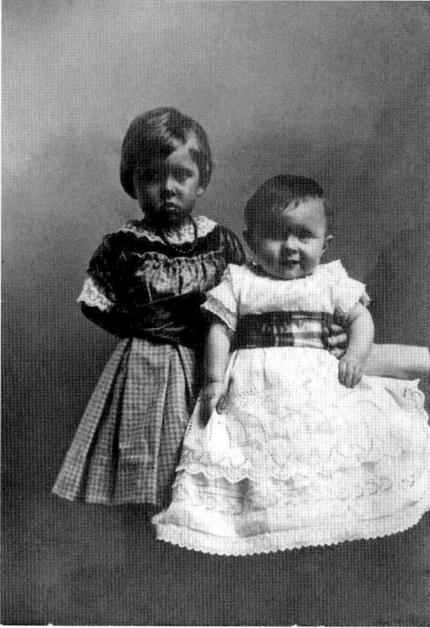

Above left: Flora and Landt, 1891.

Above right: Advert for Miss Notman's school, early 1900s. *[MR]*

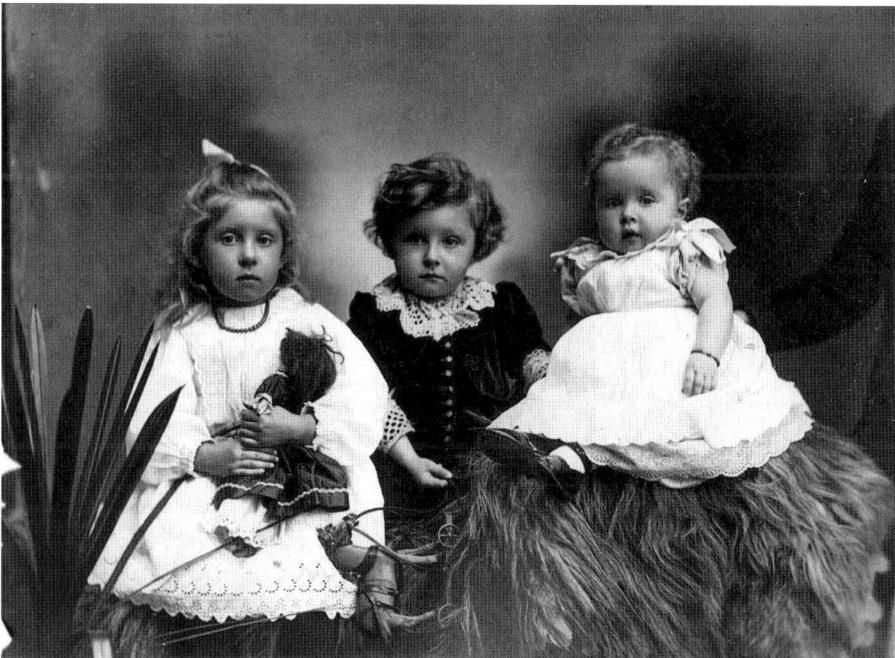

Flora, Landt and Dottie, 1893. (Landt's 'Little Lord Fauntleroy'-style velvet jacket and waistcoat are a deep blue.)

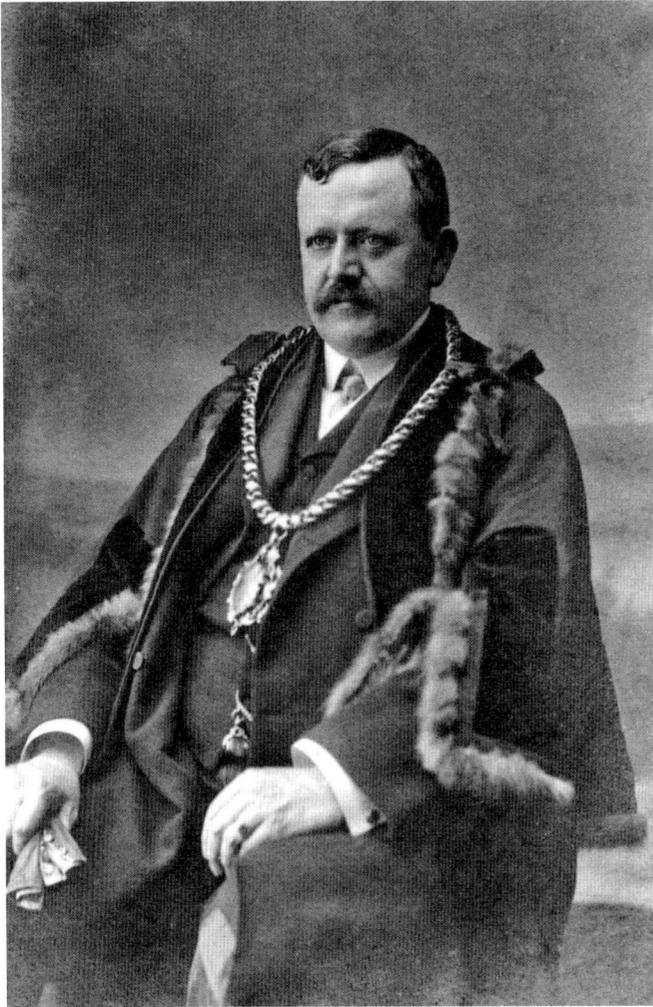

Arthur Pattison, about
1906. (He was Mayor of
Durham three times – in
1905, 1906 and 1917.)
[MR]

out. I was carried straight up the vennel *[alleyway]* to Dr Jepson's *[in Old Elvet]*, where I came to and was patched up. I still have the scar.

I wonder how many people remember the old wooden Baths Bridge, a graceful curve?

Another incident occurs to me about this time – 1898 – when Anna had a birthday. We'd been to Miss Brewster's to get her a ball – twopence – and on the way home playing with the ball, it bounced over the kerb between Brown's boathouse and Elvet Bridge and ended up in the river. I tried to recover it and fell in – January, in a new overcoat! – but was fished out pretty quickly by a printer from Procter's in the Market Place. (My father sent him a gold sovereign, and I have his letter in reply still, dated 26 January 1898.) When fished out, I remember disregarding nurse, sisters and so on, and making for home hell for leather, where Mother stripped me and smacked my backside; and I remember it was while I was still in my wet combinations – it stung!

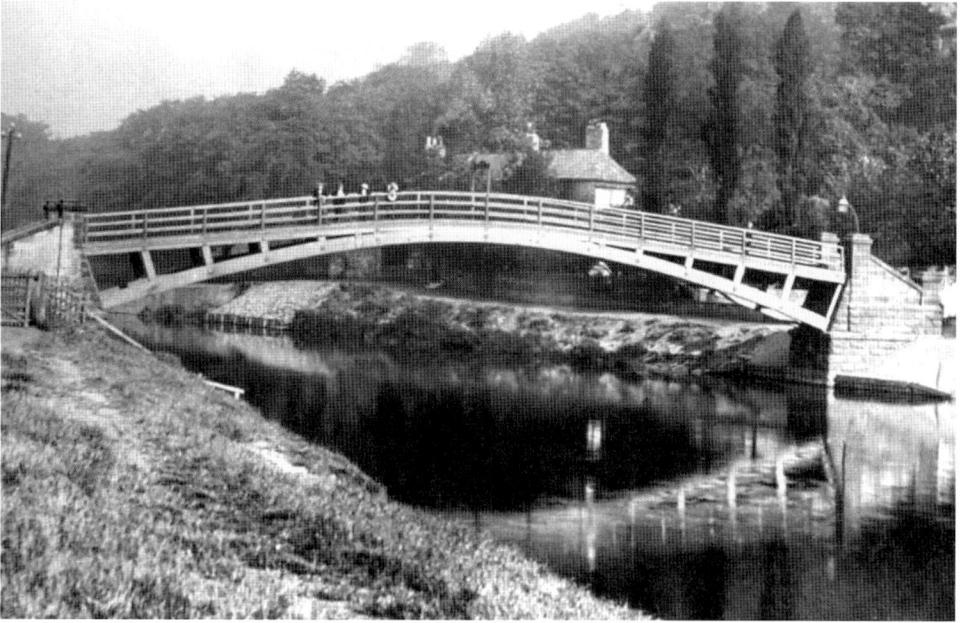

The original wooden 'Baths Bridge' of 1855–95, photographed in the late 1870s. (Ravensworth Terrace is just out of sight to the right.) *[MR]*

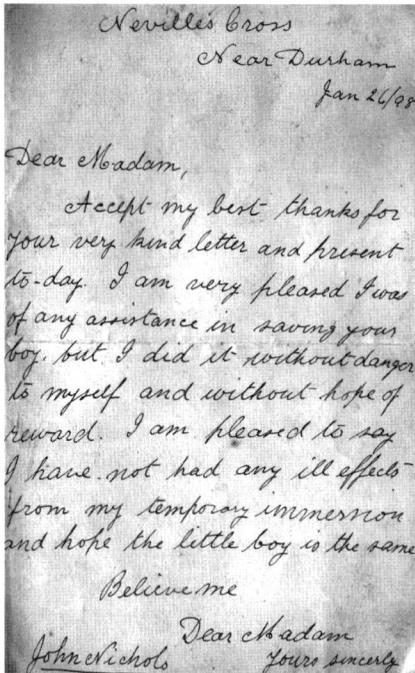

The letter sent by Landt's rescuer, John Nichols.

Mrs Mirfield, late 1900s.

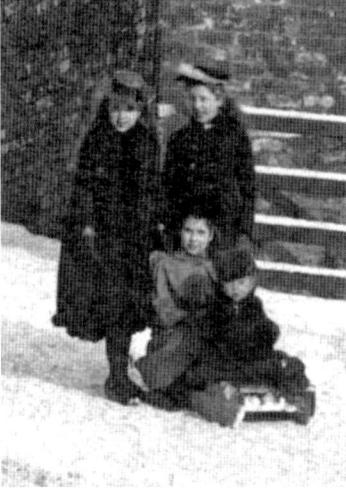

Left: 'Flora *[Mawson – standing, right]* with Maud, Una and Ethel' *[Mirfield]*, early 1900s.

Above: 'Arthur *[Mirfield]*; Mohun; Bainbridges', early 1900s.

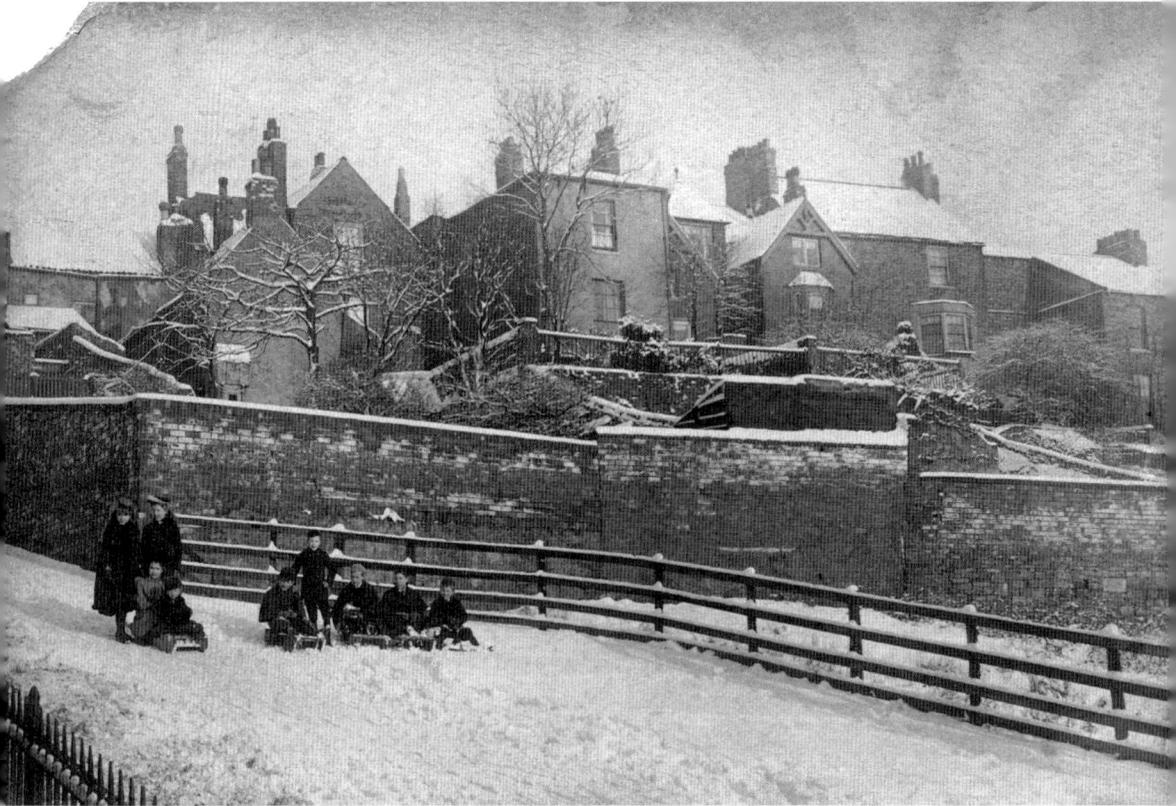

Sledding down Ravensworth Terrace, around 1900 (the houses at the top are at the Chains, lower Gilesgate).

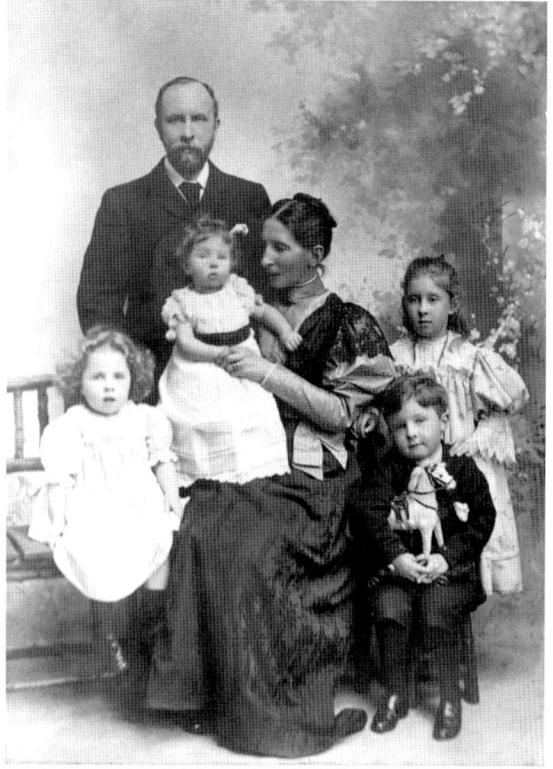

Right: Joseph and Amalie with Dottie, Anna, Landt and Flora, 1896.

Below: Landt (standing, centre back), Joseph and Amalie (the seated couple immediately to the right of Landt), Anna and Frieda Mawson (the two girls, centre front) with the Mirfields (the elderly couble seated, back left), Dixons (the young couple and small child seated, right) and others, about 1903.

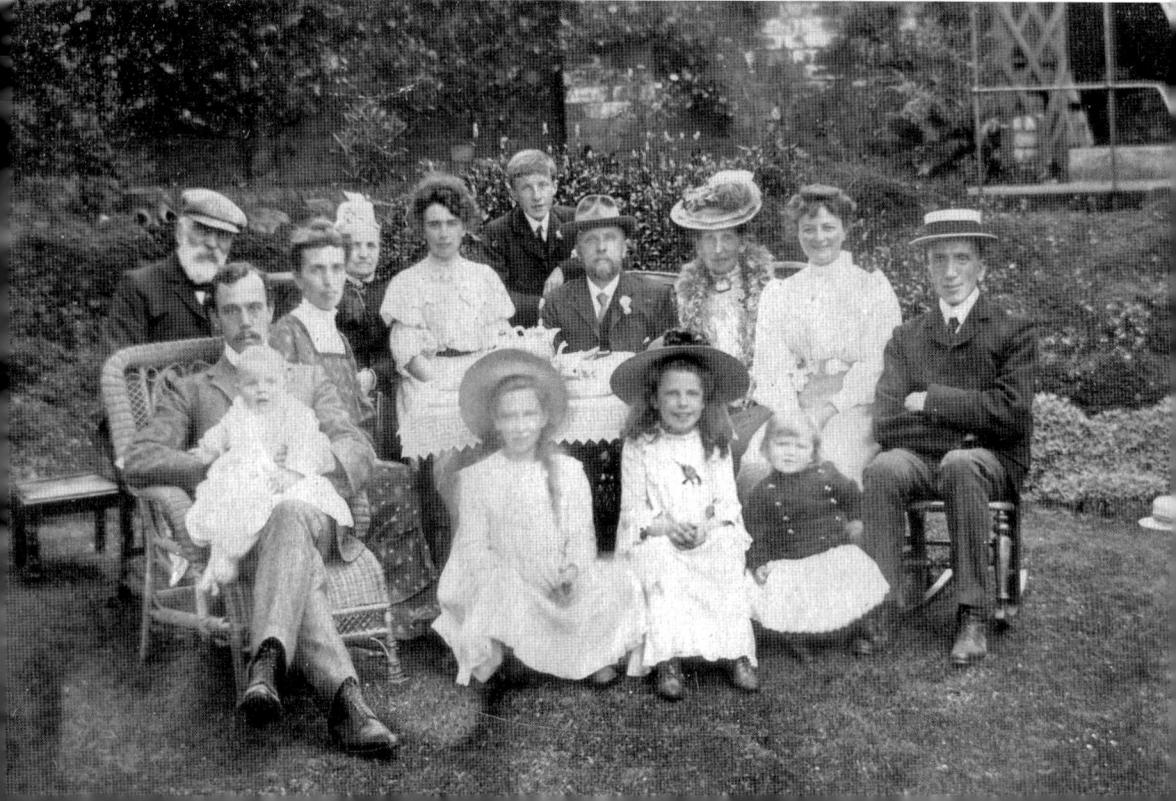

3

Around the City Centre

Who now remembers the river at Elvet Bridge when Sanger's Circus came to the Hollow Drift and brought the elephants to roll in the river opposite Brown's boathouse, and squirt water all over? Or the impressive circus parade through the town: fine horses, carriages, elephants, camels and caged lions and tigers?

Saturday was market day, and we used to go with Mother to the covered markets, where people from the country brought their produce for sale.

On Saturdays the pitmen, farmers and cheap jacks flocked into the town. No motors then, just horses, carts, wagons, tubby traps and the like. The horses were stabled down passages off Claypath, or up the slope of the Rose and Crown Hotel (an alleyway which led to stables behind) where now *[1966]* is Woolworths *[which closed down in 2009, and is currently occupied by Tesco]*. Carts and traps were parked in Claypath, Elvet and elsewhere – two-wheelers with their shafts sticking up in the air, hard up under their neighbour.

Many pitmen kept a pony and trap as a sideline, and made pocket money by standing in rows at the hospital gate, top of Gilesgate and elsewhere; they ran people to, say, Meadowfield for threepence, plying for hire as it were. England was free then – no licence needed.

The old Pant *[well-head]* was there in the Market Place, with Neptune at the top and the drinking trough at the side towards Silver Street. Neptune is now *[1966]* in Wharton Park, looking over the city. *[He was returned to the Market Place in 1991.]*

Cheap jacks shouted their wares, standing on carts or throwing cheap jewellery out among the people to attract a crowd. You could have a tooth extracted, sitting on a wagon, by a real 'butcher' – how the poor victims stuck it, I know not. They truly had 'guts'! And the crowd revelled in it!

Then the drunks! Almost every Saturday there was a 'scene' when some drunk got violent and had to be physically 'controlled' by lusty bobbies *[policemen]*, who commandeered a handcart from the Rose and Crown, and forcibly removed the offender to the cells at the little police station at the bottom of Claypath – which is now the Council Rate Office! Yet somehow everybody seemed to enjoy themselves – and at the end of the day, happy, tired and many half tight, they went home to the outlying pit villages on foot or by tubby trap, singing lustily to the accompaniment of mouth organs. Some too went by train. Yes – in those days you could go by train to Croxdale, Brandon, Crook, Willington, Witton Gilbert *[pronounced 'Jill-but']*, Lanchester, Leamside, Murton and where else.

Elvet Station was just new when I was a small boy in the 1890s, and our parents used to take us by train from there to Ryhope (change at Murton) for a day at the seaside – and we used to bring back our toy barrow, filled with sand, in the luggage van. One day, Flora wasn't looking where she was going, and wheeled the barrow off the platform! Tragedy! And we used to see Father off from Elvet Station when he went to tax meetings at Sunderland on the 9.15 a.m.

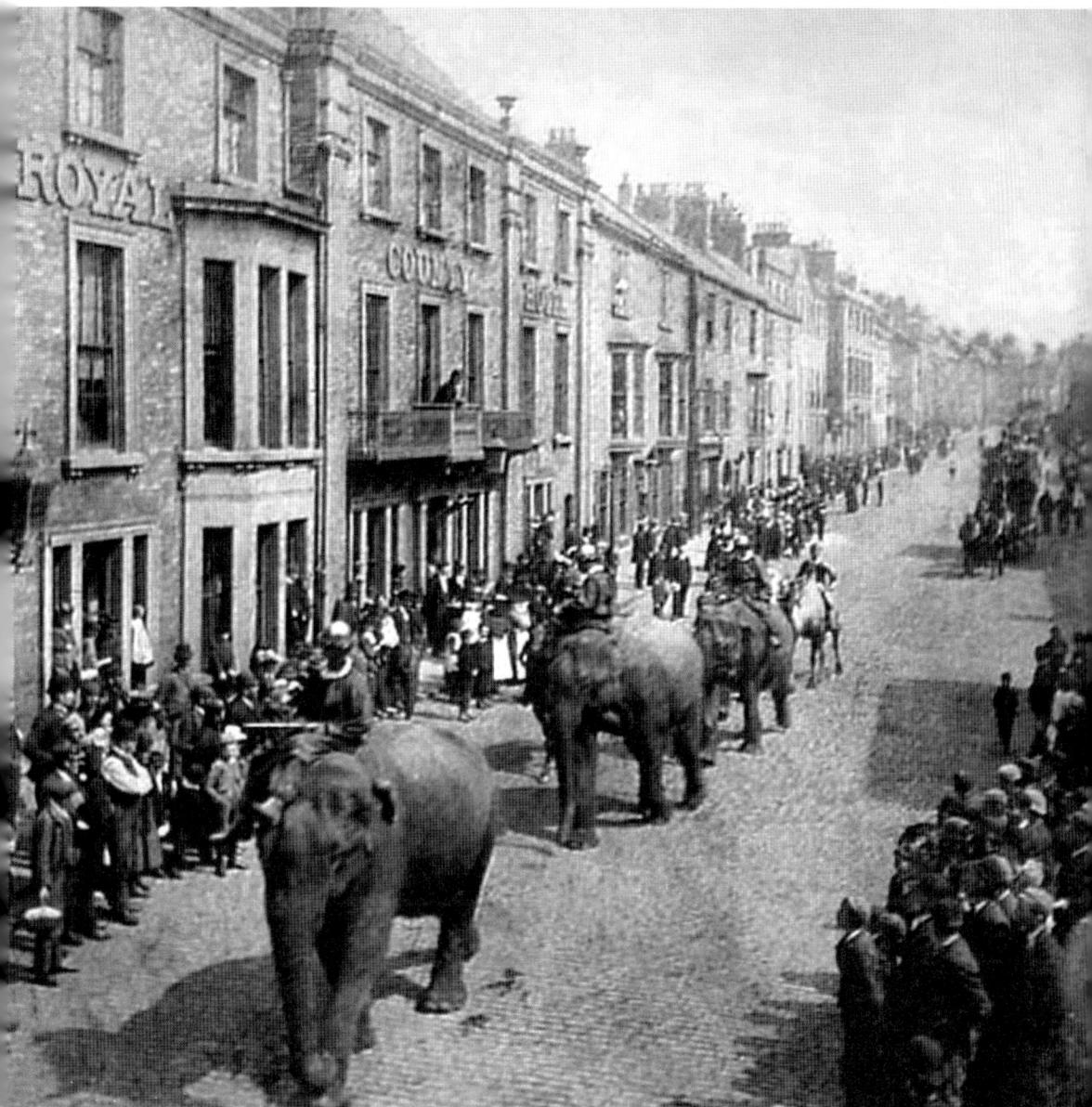

Sanger's Circus: three elephants and a camel parading through Old Elvet, about 1896. *[MR]*

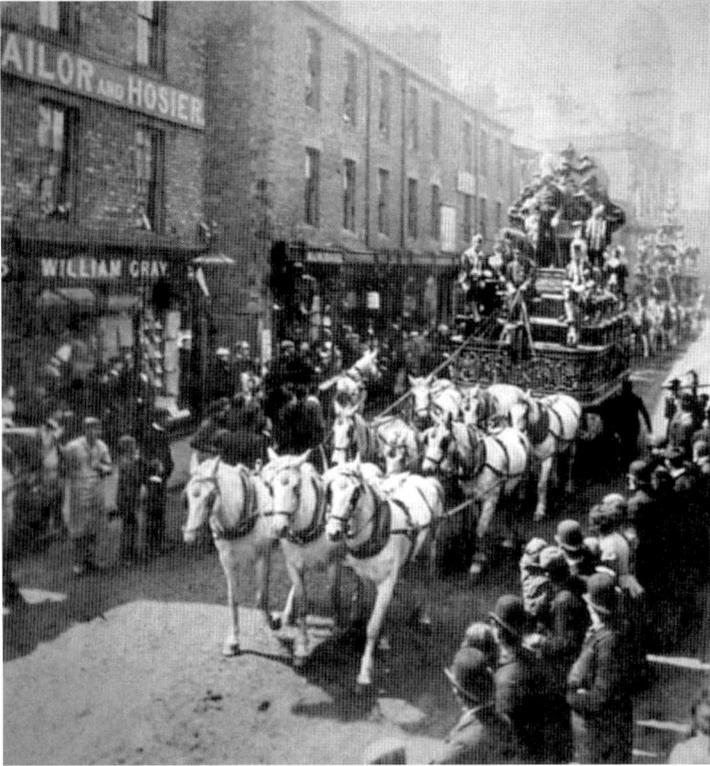

One of the decorated floats parading down North Road, about 1896. [MR]

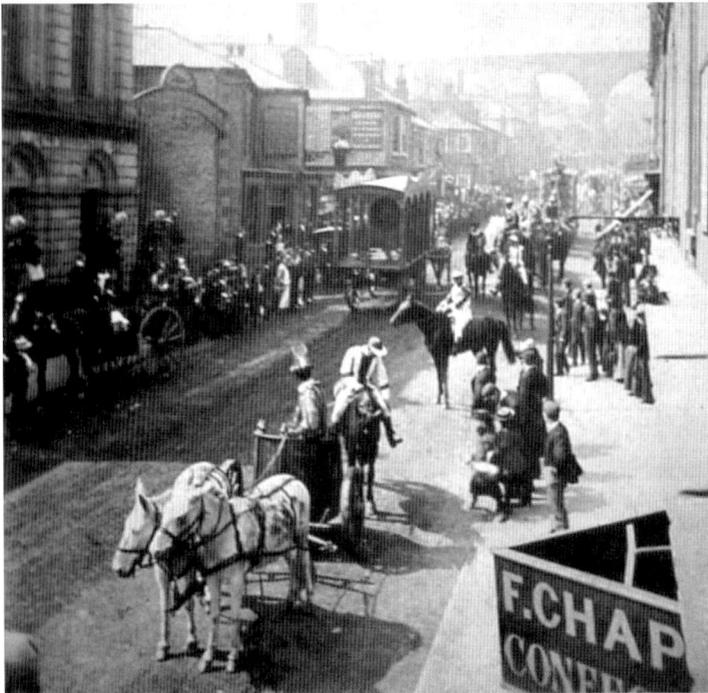

Parading down North Road, about 1896 (the lions' cage can be seen, centre). [MR]

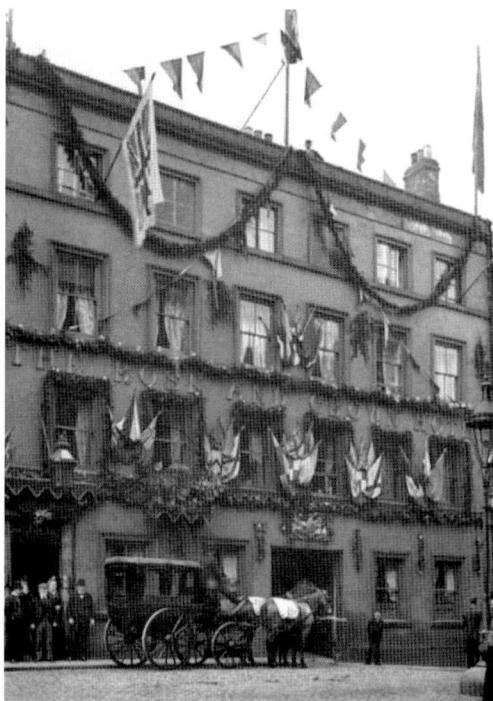

The Rose & Crown at the top of Silver Street, decorated for Queen Victoria's Diamond Jubilee, 1897. There is someone looking over the roof, just to the right of these small chimney pots and the central flag-pole. *[MR]*

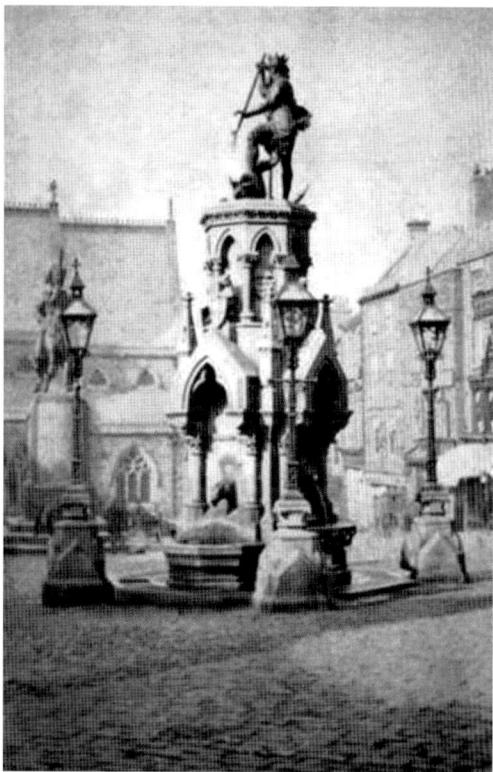

Neptune atop the second Pant (of 1863–1902), 1870s. *[MR]*

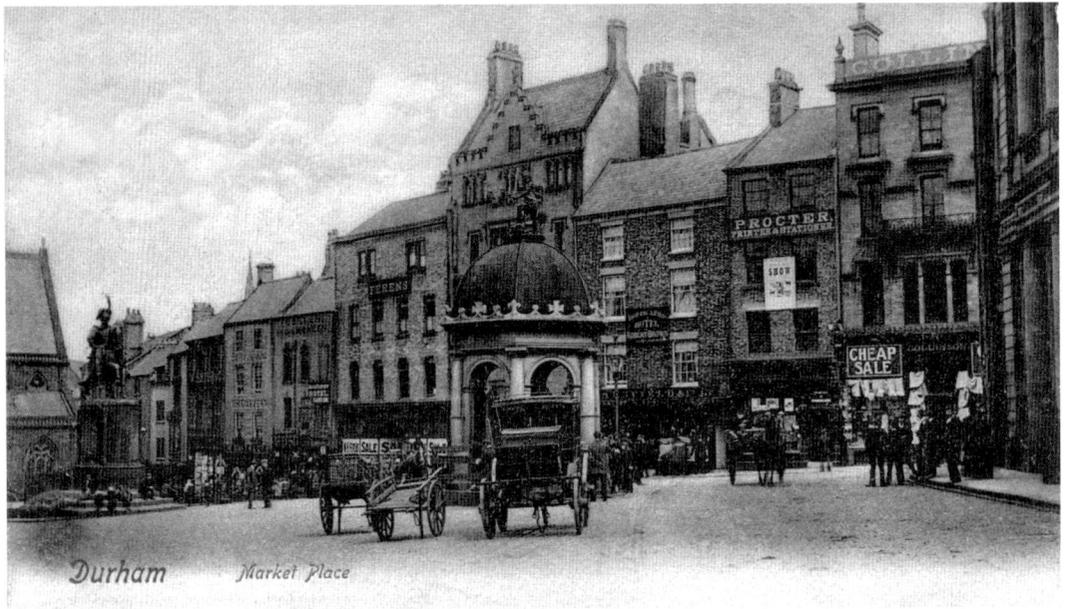

Durham Market Place (and the third Pant), 1903. Situated just left of centre is the Hat and Feather Hotel, Procter: Printer & Stationer is located two buildings right of centre and Collinson's is next door to the right. *[Postcard]*

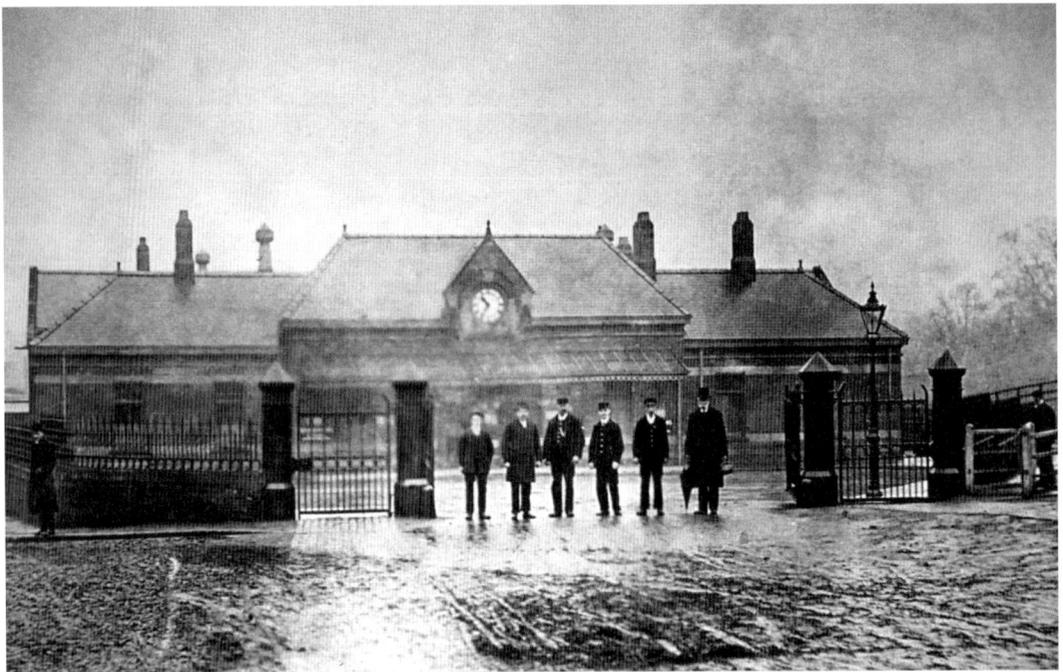

Elvet Station (opened in 1893), 1900s. *[MR]*

4

Gilesgate and Elvet

Christmas in those days had a much more Christian and religious significance. Chapel Service as well as a time for good will, but particularly a time for family reunion. Father might be regarded as the head of the Mawson family, and on Christmas Eve, Grandpa, aunts, uncles and cousins assembled at our house for a Christmas dinner. We had maids in those days to help. The dining room had drugget *[a coarse fabric for protecting the floor]* spread over the carpet, and a huge Christmas tree in the bay window.

After the meal, we all came to the dining room, including the maid servants, and the dining table was laden with presents for everybody, which were carefully handed out. Then the tree had all the candles lit, and we marched round it hand in hand, singing Christmas carols – 'Good King Wenceslas', 'While Shepherds Watched', and the rest. Meantime Grandpa, who was too feeble to take part, sat in an easy chair smoking his pipe – a fine, handsome man.

Talking of pipes reminds me of Father's old friend Mr Mirfield (who, incidentally, put up the first telephones in Australia, and lost an eye in the process), another fine old character, who lived a few doors away and often came for a chat. On such occasions, father used to give us twopence, and sister Dottie and I had to go to a little shop a short way up Gilesgate, where the owner made clay pipes. There we bought four 'churchwarden' pipes with the foot-long *[30 cm]* stems, which Father and Mr Mirfield smoked, and Dottie and I got one each to blow bubbles with. Pipes – a halfpenny apiece!

When I was seven, our family had grown too big for No. 5 and we moved up to No. 10 Ravensworth Terrace – the large, double-fronted house at the top of the row, but only about two thirds of the way up the hill on a gradient of one in three.

It was also about this time that I was sent to Mr Castley's Preparatory School for Boys *[called the Bailey School, because it began in the Bailey]* – in Old Elvet, where now stands the Wesleyan chapel. Mr Castley was a big, fine man, with thinning red hair – a good master and disciplinarian who didn't hesitate to use the cane as and when fairly required. He had a high desk and if we were a bit dense or slow in the uptake, the procedure was to bring us out to stand beside him at his desk, the while he drummed into us our knowledge, interspersing his comments with repeated flicks with the cane on the calves of our legs. More serious offences were followed by, 'Hold your hand out!' and you got two or maybe three.

We played football at the Hollow Drift below Parson's Field with Mr Castley instructing us and joining in the game. Mrs Castley also helped in the school, and taught Latin. Don't I remember how I was kept in from football and learned things by heart: '*Currus* – a chariot; *ictus* – a blow; *portus* – a harbour' and all that; '*adventus* – an approach'. How it stuck once I got it in – and how useful I have found my Latin and Greek ever since – from which so many words in the English language are derived.

At what we called lunchtime – glass of milk and a biscuit – we played in the school garden, where there was an asphalt tennis court: marbles, top-spinning, hoop-bowling – bigger boys had iron hoops. Tip cat marbles from Fenny's toy shop in Sadler Street *[see page 184]*. 'Pop alleys' *[marbles]* which my friend Joe Wood and I used to gather from the broken bottles of his father's mineral water works near my auntie's home in Gilesgate. You don't see bottles like that now. They had two sides of the neck pushed in to stop the pop alleys falling into the bottle, and when filled, the pop alley by some mysterious process was sucked up against a rubber washer to make a perfectly air-tight seal just inside the mouth of the bottle.

In those days, nearly all Durham streets were paved with the old round cobblestones, and hills like Claypath, Gilesgate, Crossgate and others had smooth stone slabs laid like railway lines for the cart wheels to travel, whilst the horses dug their toes on the cobbles, between the 'lines', to get a grip.

The goods station at Gilesgate used horses (beautiful beasts, whose drivers loved them and kept them in lovely condition) and rolleys *[flat carts with four wheels]*. For heavy loads, several chain horses were regularly kept standing at the foot of hills – in Claypath they waited outside the Gas Office, which still (in 1966) occupies the site it did then *[slightly up from Millennium Square]*. *['Chain horses' were attached by chains in front of the horse(s) in the shafts to help pull heavy loads up steep hills. Or they were chained behind the cart to act as extra brakes for loads going downhill.]* Sometimes I came back from school through the town, and as I knew the rolley drivers, I was allowed to jump on beside the driver and ride up Claypath. I was particularly fond of one old driver – a rugged man with a small beard and curly side-whiskers – a loveable character; and how he loved his beautiful black animal: its coat shone like silk, but its tail was nothing to boast of. And how the old man loved to tell me,

'He's a poor old fellow – so poor he hasn't a rag to cover his arse!'

The harness too was kept spotless, and the brasses about it shone like glass. Like train drivers, those men took a pride in their work and transport. At the railway stations, engines were kept spotless – the moment a train stopped at a station, either driver or fireman was out on his engine polishing – and believe me, there was something to polish – mostly brass.

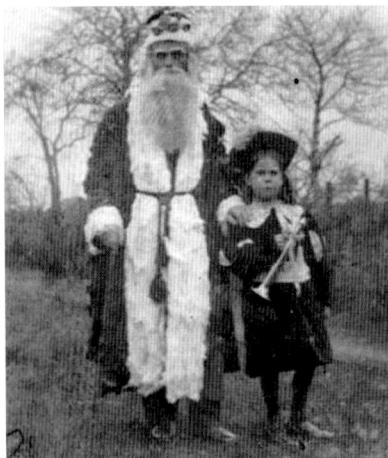

Frieda Mawson with 'Father Christmas', around 1903.

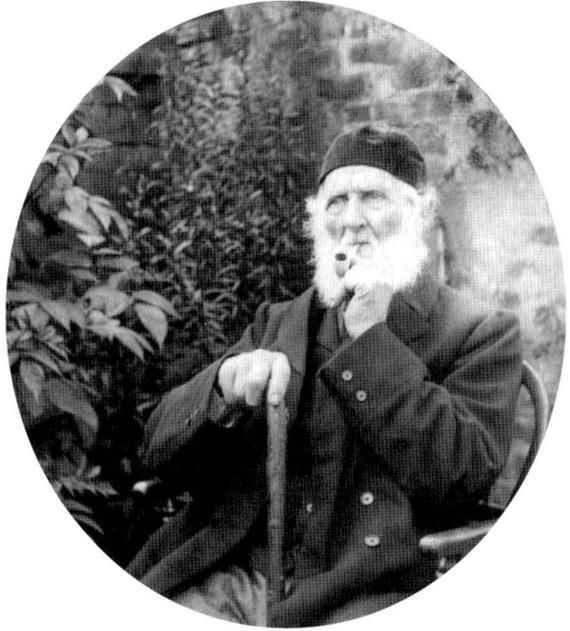

Grandpa (Michael) Mawson with
his clay pipe, about 1908.

A Durham man with a
churchwarden pipe, 1860s (photo
taken by J. Kirkley of Paradise
Gardens). *[MR]*

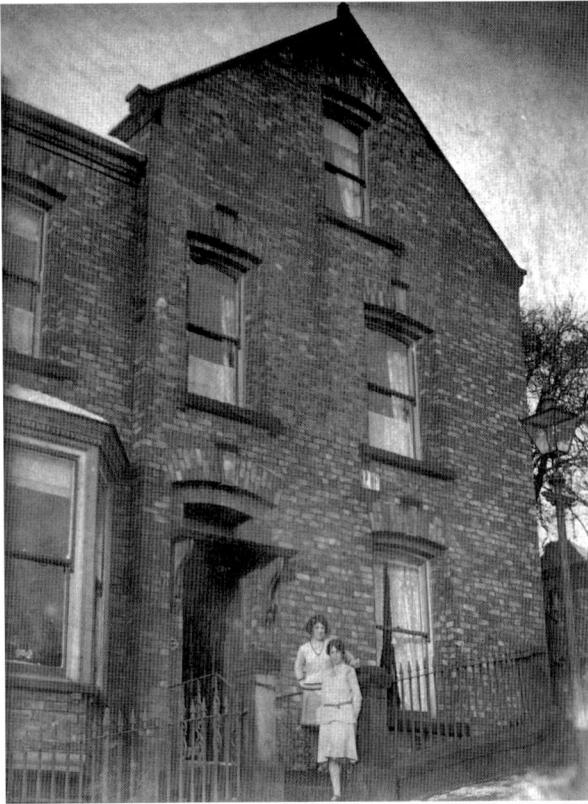

Left: Dottie and Anna Mawson outside No. 10 Ravensworth Terrace, 1929.

Below: 'Car ran into Doctor Vann's house' (9 Ravensworth Terrace), July 1925.

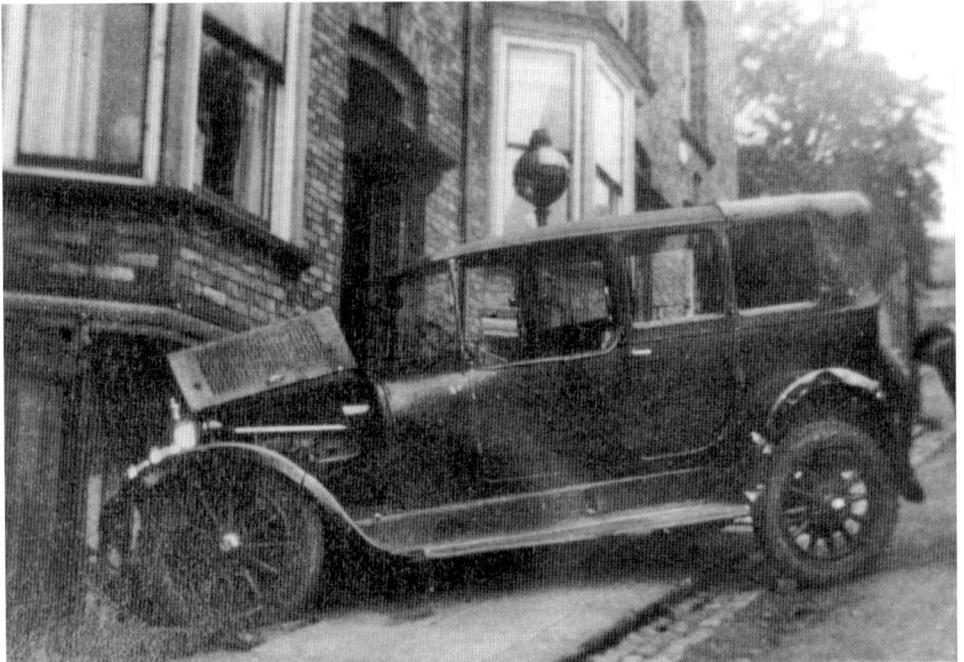

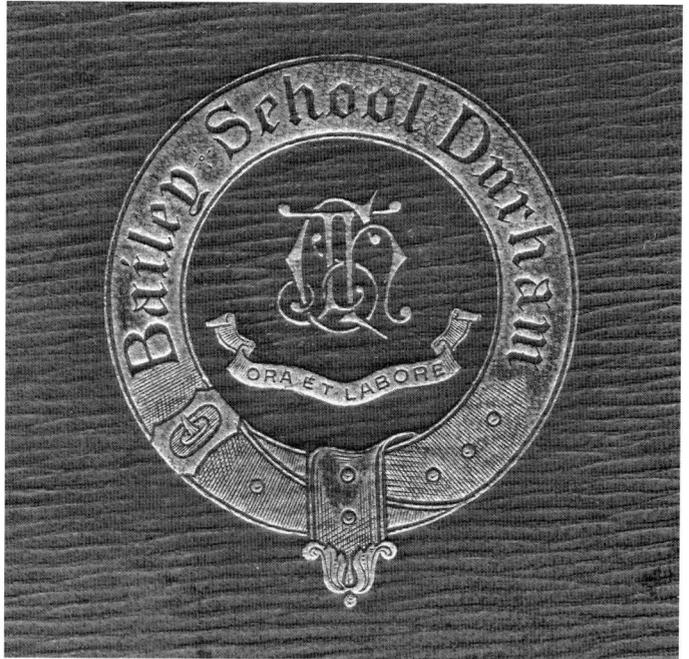

Right: The Bailey School Emblem (including Mr Castley's monogram, and the motto '*Ora et Labore*' – 'Pray and Work').

Below: Castley's 'Bailey School XI' at 9 Old Elvet, Durham. Photograph taken in 1901 by Mr J. H. Castley, headmaster. Back row, from left: H. Holiday, Percy Manners, Lindsey Ogg, Bill Taylor, Kelso, L. Mawson; front row, from left: N. Slack, Joe Wood, Reggie Moyes, 'Fatty' Burton, N. Stokoe.

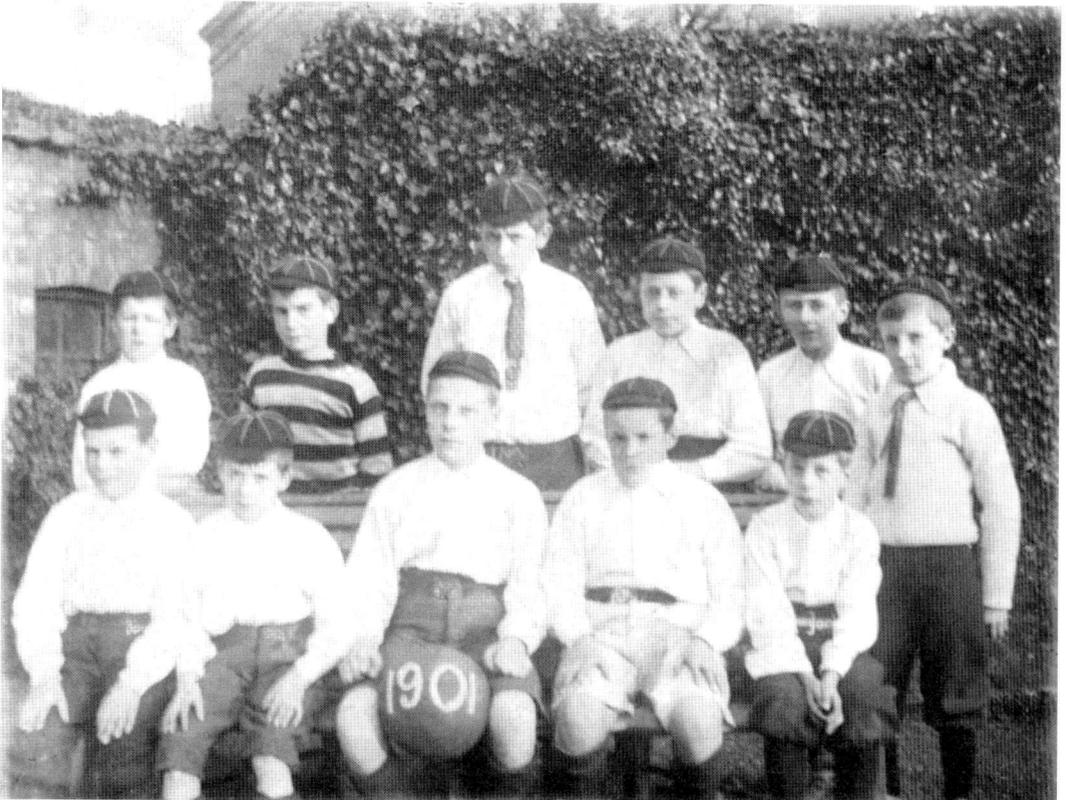

From a letter to a local paper, written in February 1967:

Sir,

[...] I well remember three of the old 'Pop' factories:

1. **Wood and Watson,** who still carry on where they were over 70 years ago to my knowledge. I have reason to remember them particularly, because the late J.W. Wood and I as boys used to scratch about among the thrown-out breakages (tipped just across the lane, opposite the gate to the old St. Giles' cemetery), and picked out the glass pop alleys. I still have a few, as well as my old prize iron 'Penker.' We also had coloured glass and 'blood' allies and even boiled cod's eyes!

2. **Staffords.** At the North end of Chapel Passage, Elvet, opposite the vestry door of the old chapel.

3. **Forsters,** or **Jessop and Forster,** whose factory was at Langley Bridge, Langley Moor.

And there was **Joseph Johnson,** whose brewery was in New Elvet, on the site of the university's new Arts Block.

A good bottle of 'pop' in those days cost a penny, and you got a whopper for 'tuppence.'

Pop waggons were horse-drawn, and Woods' stables above the factory were approached by a ramp up which the horses clattered.

Yours etc.,
J. LANDT MAWSON
Shincliffe

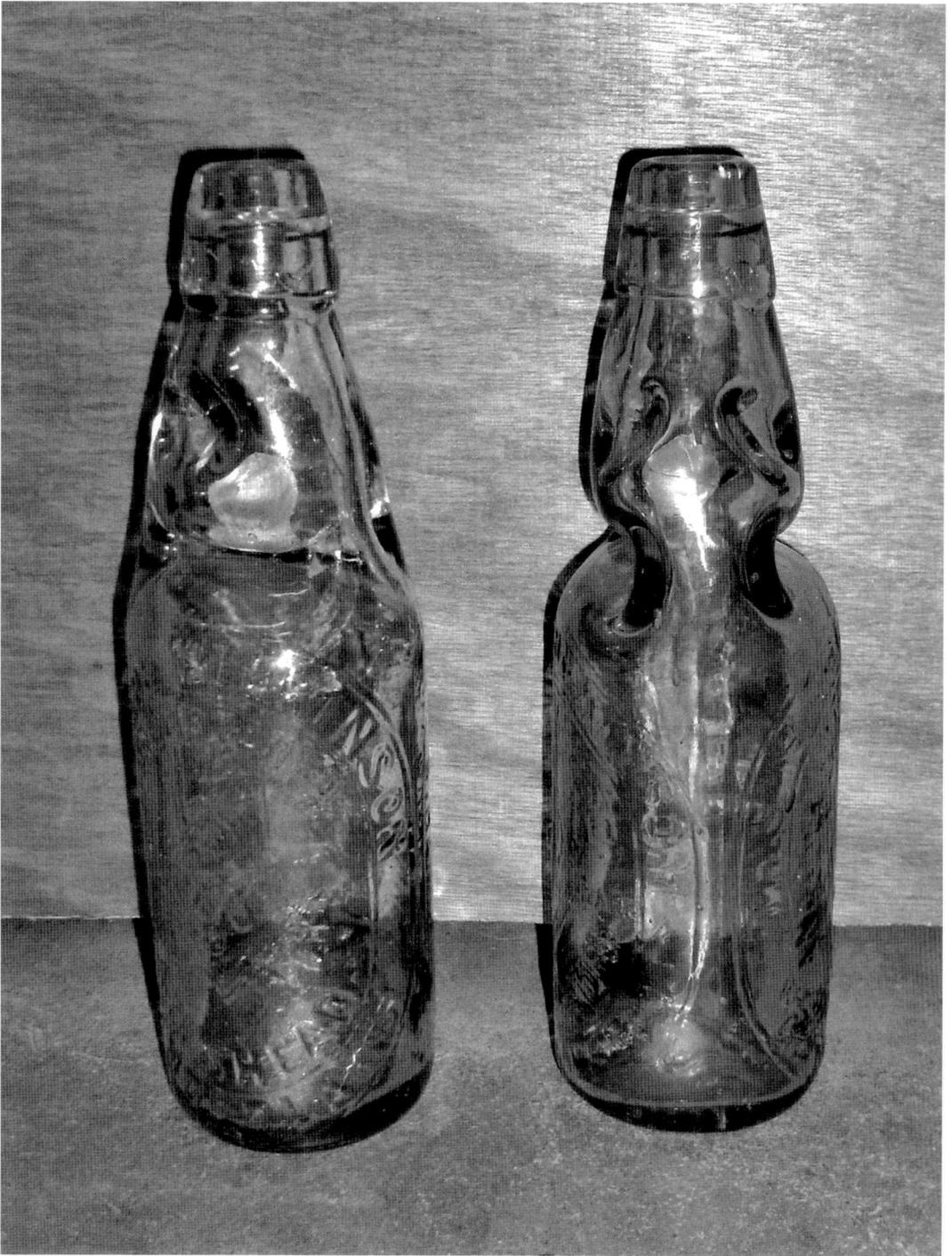

Old bottles with pinched necks and pop alleys *[marbles]*.

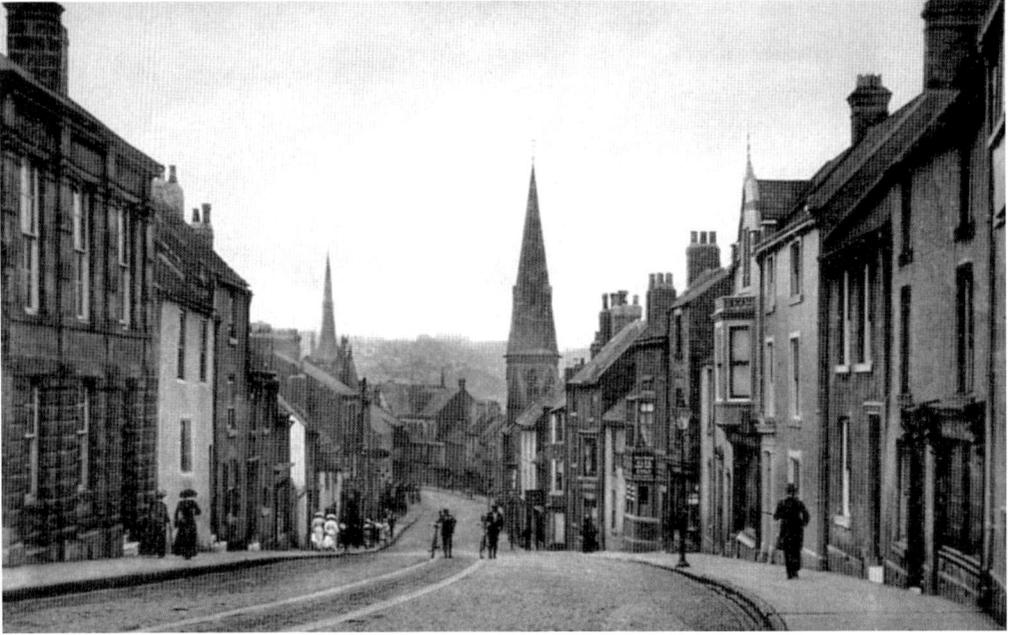

Looking down Claypath, about 1904 – rounded cobblestones for the horses, and smooth stone slabs for the cart wheels. *[MR]*

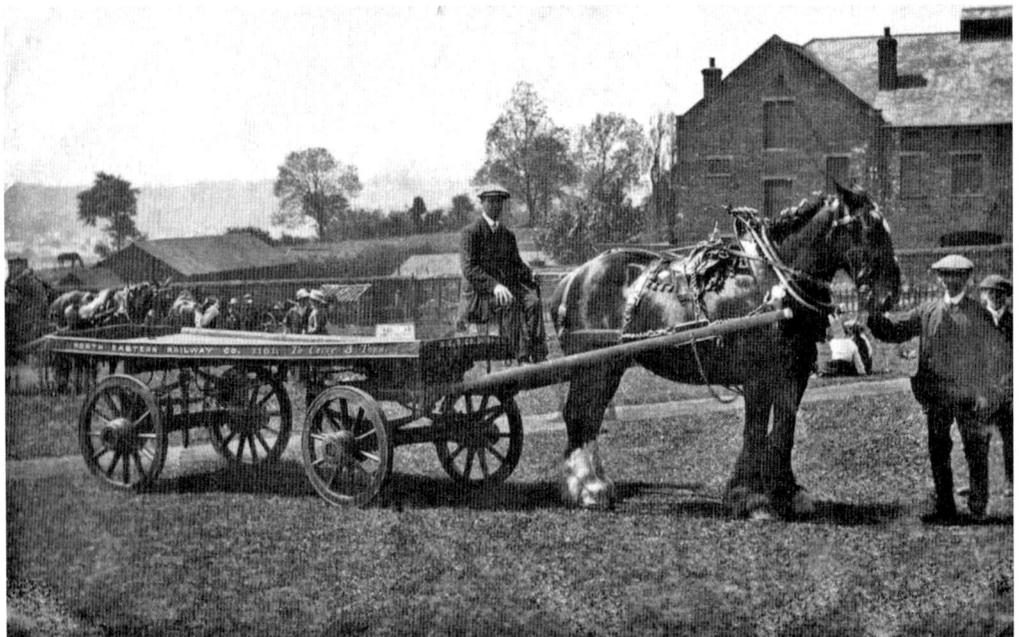

A rolley, about 1910. (The picture shows Robert William Hall of Gilesgate, an employee of the North Eastern Railway Company – and entrant in the Durham City Horse Parade – in the Barracks field, with Wood and Watson's Pop Factory behind.) *[MR]*

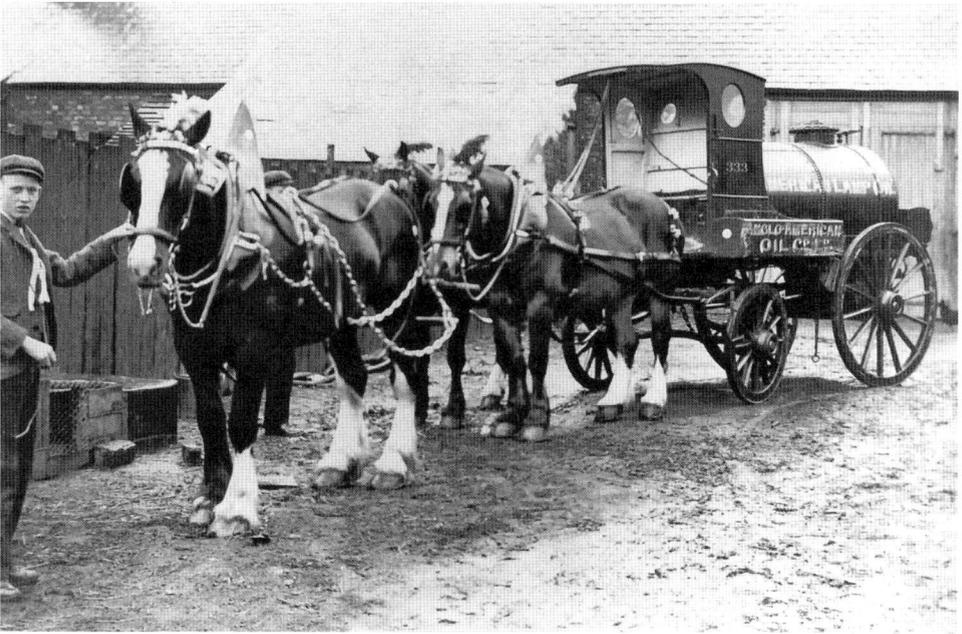

A chain horse at work, 1900s. (The picture shows Mr J. W. Blackburn in about 1892, with a cart specially designed to transport Anglo-American lamp oil.) *[MR]*

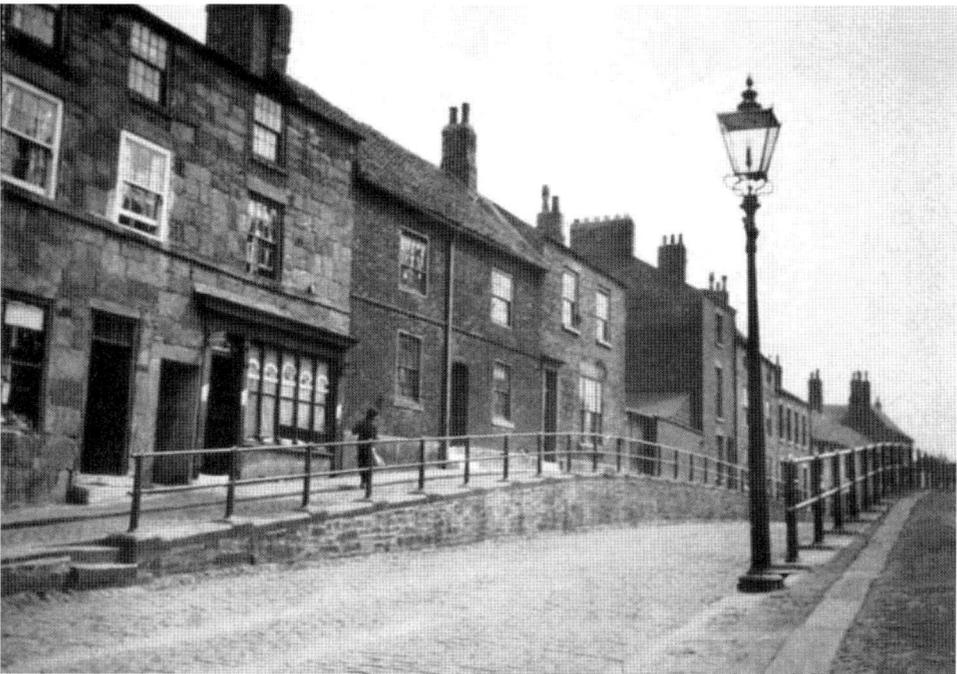

The Chains, Gilesgate, 1900s (near the junction with the top of Ravensworth Terrace). *[MR]*

5

Shops and Businesses

I still seem to be in the 1890s, so let's try and dig up some more bits of Durham about then …

From a letter to a local paper, written in July 1970:

Sir,

As one who remembers the tea-pot in *[…]* position at 30 Gilesgate, as shown in last week's Durham Advertiser, I have naturally been interested in its subsequent peregrinations.

[…] up to 1906 the little shop was in my time run by two little white-haired old ladies – Miss White and Mrs Vasey – who described themselves as tea-merchants and grocers, and also ran the Post Office.

Glentons took over in 1906 and were there until 1912 when they moved with the Post Office to 241 Gilesgate (on the Chains) which belonged to my mother, and before that was the girls' school of the Misses Taylor.

The association of the tea-pot was probably in some way connected with the fact that the two old ladies were among the early tea-merchants *[…]*.

Yours etc.,

J. LANDT MAWSON
Shincliffe

(30 Gilesgate stood opposite the northern entrance to Bede College, near the Drill Hall; it is now the site of the Gilesgate Roundabout.)

A subsequent reply in the Advertiser noted that Alderman Mrs E. Blyth had an old print, dated 1832, showing the teapot above White's tea merchants and grocers in Durham Market Place, next to the Market Tavern.

After Glenton's moved, the teapot remained above the shop at 30 Gilesgate (then run by Salkelds), until the property was demolished in the late 1940s. The tea-pot was saved, and moved to Fowler's the grocers in Claypath from the mid-1950s until that property too was demolished (in the early 1960s, for the new Leazes Road), when the teapot was moved to Saddler Street, above what used to be the House of Andrews bookshop, where it still is today.

The old 'Teapot' was just above 'the Chains' in Gilesgate, and run by two white-haired little old sisters, Miss White and Mrs Vasey, as the post office.

Further along were Jimmy Wall and his wife, who made toffee in flat tea trays and smashed it up with a little hammer. Jimmy – a cheerful little soul, always whistling; his wife a tall, lanky individual with grey-black hair held in a thick black net at the back of her head – always pleased to see us with our pennies, which we often got from Mr Moody the butcher opposite, where we got our meat. Mr Moody looked fearsome – a big man with ruddy countenance – stubbly red beard and side-whiskers, topped by a big felt square topper; the usual butcher's blue apron held on by a thick leather belt from which his steel *[for sharpening knives]* was suspended from his extensive middle. He cut up his meat on a huge lump of tree trunk, which formed his chopping block. Well I remember when Dottie and I went with the order, 'Will you please send Mother a nice piece of sirloin with undercut, about six or seven pounds' *[about 2½ kg to 3 kg]*. We got a kind word and often a penny each *[less than ½p]*.

Then there was Fowler's in Claypath, and Walter Wilson's in Sadler Street opposite the old Magdalene Steps. Both always kept a big wooden box full of mixed sweets, and when we went shopping with Mother we almost always were presented with a big bag full. To buy would be, as near as I can remember, either 2 or 4 ounces *[50–100 g]* for a penny; and a bigger bar of cream chocolate than you get now for sixpence *[2½p]* cost a penny in those days – you could suck boiled sweets for a whole afternoon for a penny. Bread was three-ha'pence *[one and a half old pennies]* a loaf – one dozen boxes of matches three-ha'pence – four bundles of sticks a penny, chopped by inmates of the workhouse in Crossgate, and delivered by the old men with a handcart – two

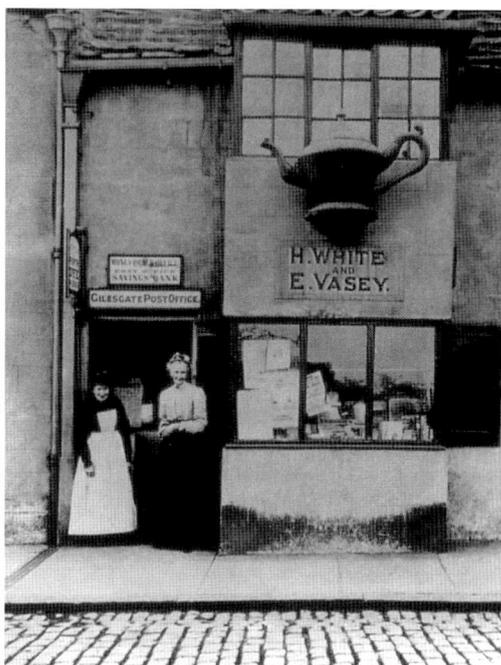

Miss H. White and Mrs Emma Vasey outside their shop, Gilesgate post office, 1892. *[MR]*

pulling, two pushing. We used to get these little necessaries at Mrs Foley's – a little shop opposite the top of Tinkler's Lane. Mrs Foley ran the shop – a typical general dealers, which sold almost everything. The counter had a zinc top, and how I used to love to fool Mrs Foley by pretending my penny was in the forward hand whilst I really made it slap on the counter with the other. Old Man Foley had a little cubbyhole just inside the shop door (which rang a big bell when you opened it) – his little window saw who came in. His job was a saddler, and he spent his time making and repairing harnesses for the pit ponies. A craftsman – who ended up in Sedgefield *[mental hospital]* having been picked up running about Pelaw Wood stark naked.

In Claypath too was the old Mechanics' Institute, just below Leazes Place – a sort of reading-room and library where we used to borrow books for my father. In charge was a typical old Victorian lady, I think called Mrs Blyth, who operated from behind a sort of wire-mesh grill. Nearly opposite was Ramsbottom's pork shop, run by another old lady, who limped along with a gammy hip. And when tradesmen's cycles came in and advertisements were painted on a flat sheet in the frame, she caused much amusement by painting 'Ramsbottoms for pies'!

At the foot of Claypath was the Blue Coat School – to which my father went, till at the age of fourteen he was recommended by the Headmaster, Mr Fish, as office boy to Mr John Ward, solicitor. (When she died, Mr Fish's widow left me some ornaments and an old photograph of St Nicholas' church in the Market Place, taken sometime before 1857. It was in an old 'putty' frame when it fell down and got broken, but I still have the photograph.) *[See page 178]*

Further down was Howey's paper shop. Typical Victorian – personal service, and papers delivered with regularity by himself. A little fellow in a huge bowler hat, who always half-ran, and seemed to be doing so to save himself from falling flat on his face. We children used to buy papers like *Chips* and *Comic Cuts* and follow the exploits in them of Weary Willy and Tired Tim. Most papers then cost a ha'penny.

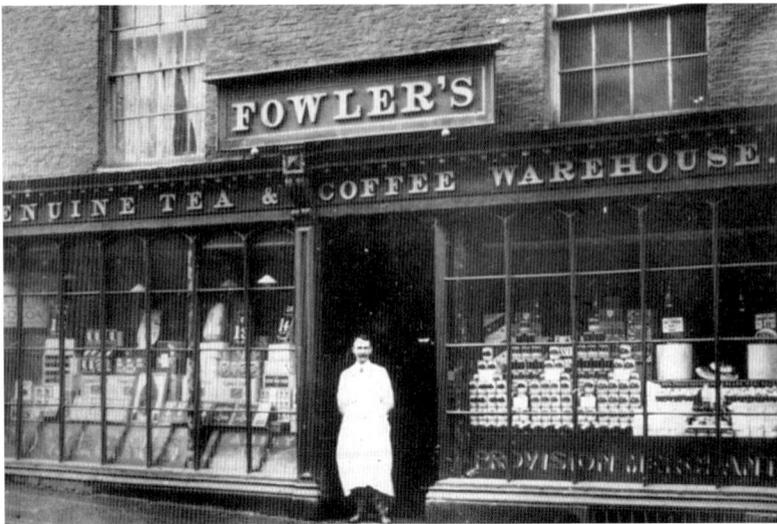

Fowler's shop at 99 Claypath, 1900s. *[MR]*

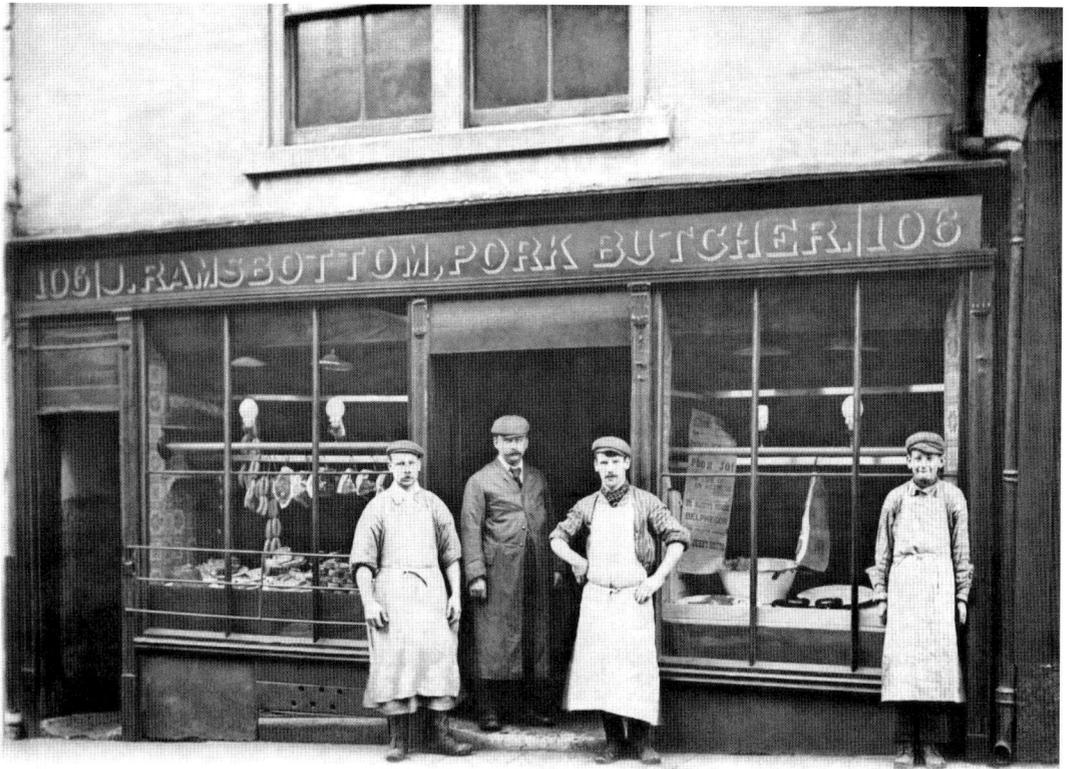

Ramsbottom's pork butcher's at 106 Claypath, 1900s. *[MR]*

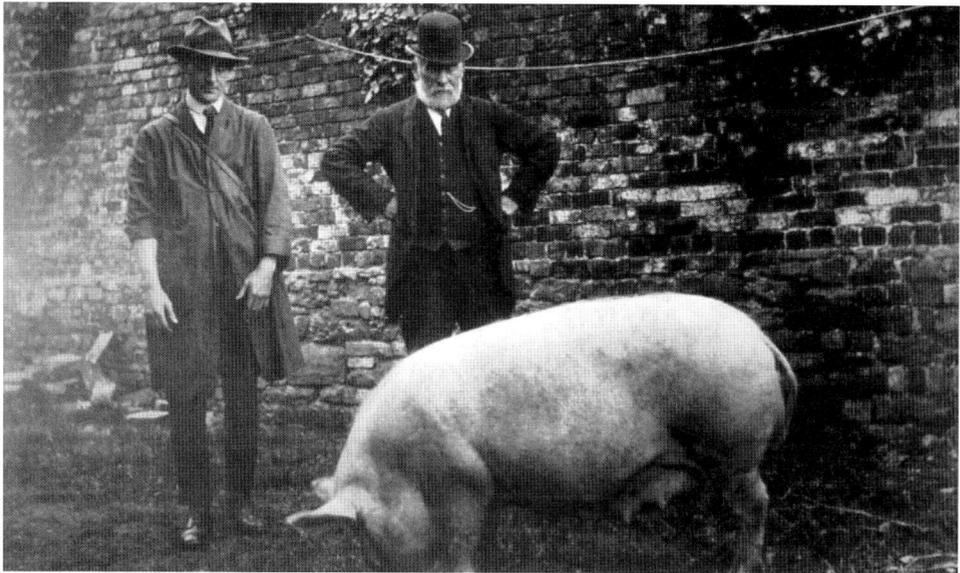

Mr John Moody (right) and son Alfred, around 1920. *[MR]*

Next to that was Willan and Smith's wholesale paper merchant's. Mr Smith lived at Pelaw House, the large house at the end of a long drive off Sherburn Road, just past where it forked off the Sunderland Road. A beautiful old house facing almost south, and with extensive views over Shincliffe and beyond. *[See page 186]* Mr Smith was a great friend of my father, with whom he used to go fishing up Weardale, and they used to write poems, which were published in a little book, with illustrations – mostly in pen and ink – drawn by Rosa, Mr Smith's daughter. My father used to call on Mr Smith in Claypath on his way home from the office, and bring him in for tea and a chat.

Mr Smith often brought books like *The Last of the Mohicans*, *Robinson Crusoe* and such, which were presents for us children.

His shop seemed always to be full of huge packing cases, and it was from this source that later I used to be supplied for building my rabbit hutches. He used to lend us a small iron-wheeled hand-barrow to bring them home. One beauty sticks out in my memory – 5 feet 6 by 4 feet square *[165 cm by 120 cm]*. What a job getting it pulled up Claypath over the cobbles! My friend (was it Alan Collinson or Walter Vann – I forget) and I managed to get it down to the lane door in Tinkler's Lane *[a narrow footpath]* – rougher going than Claypath, with sets *[cobbles]* all shapes to negotiate and a steep corner; alas the crate was too big to get through the door, so we had to rig up posts against the lane wall about 7 or 8 feet high *[about 2 m–2½ m]*, and rope the crate, carry the rope over the wall, and gradually inch the crate up over the wall – both of us on the rope, then one into the lane to push up the crate. We won at last, and I had the finest hutch any boy could wish for! What fun and satisfaction it was, hammering, sawing, planing and the rest to make doors fit, but the masterpiece was a little corridor from the big hutch to another hutch on the same level but set at right-angles to it; sloping roof and a little trap-door so that the buck could be separated from the doe at will, or both could be given the extensive run of the two hutches. We hammered and thumped and got great satisfaction in gloating over the results of our handiwork, which occupied all our spare time till the job was done. We hammered even one Sunday afternoon, which brought my father out; and I never forgot what he said – sternly and firmly, I wouldn't say angrily:

'My boy, stop that noise. Whatever may be your ideas of how Sunday should be observed, remember that most other people have different ideas, and expect peace and quiet!' or very nearly that. But its effect impressed me for life, particularly when I got more familiar with the Latin phrase, '*Sic utere tuo ut alienum non laedas*', which translated means, 'So exercise your rights and privileges that you don't offend the rights and privileges of others.'

And so back to some old Durham. When I was at Castley's, Old Elvet was all cobblestones, with a sort of centre roadway, and cobbles on a slope up to the footpath – something like Bedale or Yarm is to this day. Each year – or was it twice a year? – came to Elvet the horse fair. Hawkers, gipsies, farmers and the rest. What a clatter – horses being shown off by their owners, running up and down the street led by a rope halter – carts, iron tyres rattling over the stones – people shouting their wares. On the side slopes were spread harnesses, saddlery, horse rugs, carriage rugs, and all that went for horses and their accessories – beautiful animals and many unbroken and semi-wild. Occasionally one got away and an exciting chase followed. Here too were 'The Hirings' where farmers engaged new hinds *[farm labourers]*.

WEAR FISHERY DISTRICT.

Salmon Fishery Acts, 1861 to 1876.— Fresh Water Fisheries Act, 1878.

No. 1282 LICENSE

THIS IS TO CERTIFY THAT *Joseph Mawson*

of *Gilesgate Durham*

in the County of *Durham*

having paid the Sum of One Shilling to *Thomas Steel*

Distributor at *Durham City*

is hereby licensed to fish for Trout and Char in the Wear Fishery District during the open Season.

This License will expire on the 2nd October, 1885.

Dated the *9th* day of *May* 1885.

By Order of the Board, *Thomas Steel* Distributor.

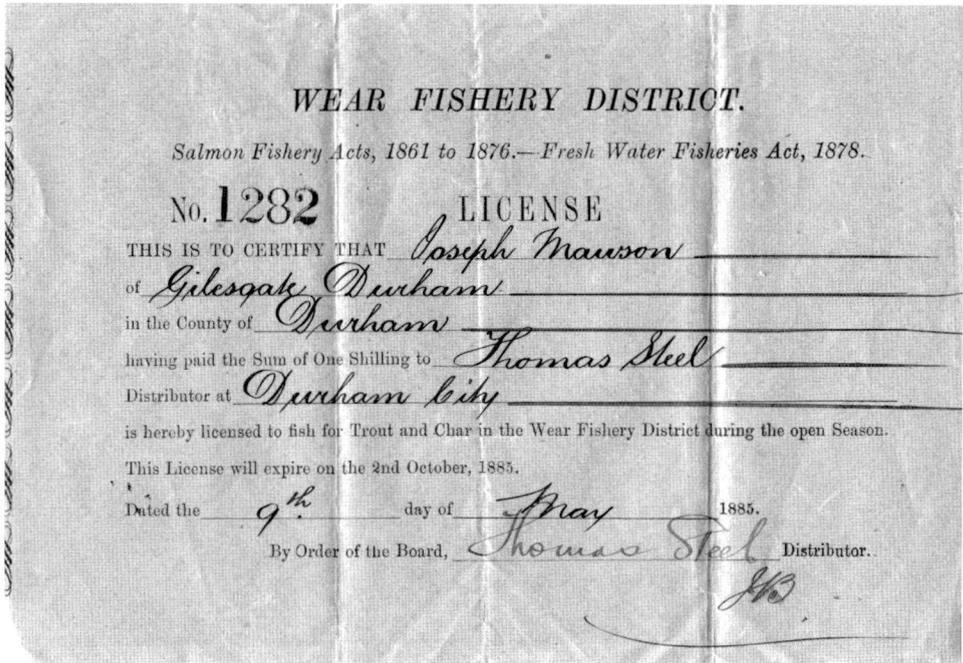

Above: A fishing permit from 1885.

Right: A few of Joseph Mawson's fishing lines.

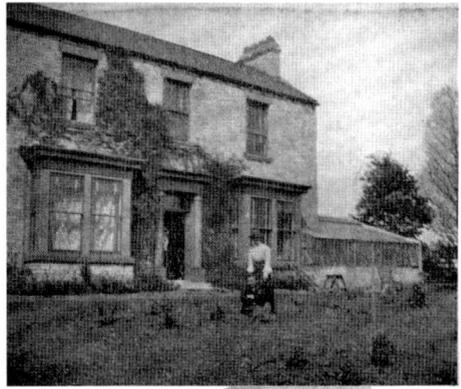

Piscatorial Epistle.

On Thursday, February 15th, 1900, the writer, whilst in the higher part of Weardale, was caught in the terrible blizzard that raged on that day, and rendered unable to attend to business for several weeks, during which time he received the following epistle from Mr. JOSEPH MAWSON, of Durham.

21st March, 1900.

This lofty flight of my Pegasus I dedicate to the immortal honour of my dear friend Smith (in his illness) in memory of many happy fishing excursions.

I PUT aside my pen and book,
 And dosed off in a pleasing dream ;
I stood me by a babbling brook
 (Some poets say "a rippling stream").

With rod, and line, and creel, and fly,
 Out of the limpid, wat'ry maze,
I hoped at each successive try,
 The bonny speckled trout to raise.

But all in vain my fly was cast,
 Nor trout, nor grayling cared to rise,
And thoughts of chair, and pipe, at last
 Crept o'er my mind. When lo ! surprise !

37

Songs
of Moor
and Stream

W. Herbert Smith.

Top left: Mr Smith, about 1900.

Below left: Part of Joseph Mawson's poem.

Top right: Pelaw House.

Centre right: The book, 1901.

Below right: Rosa Smith, 1902.

GILESGATE, DURHAM.

TO BE

SOLD BY AUCTION

At the House of Mr. ROBERT ELLIOTT, "Durham Ox Inn," 39, Gilesgate, Durham,

On WEDNESDAY, 20th Oct., 1886,

At 7 o'clock in the Evening (*subject to the Conditions to be then read*).

MR. THOMAS SARSFIELD,

AUCTIONEER.

LOT 1.---ALL THAT FREEHOLD

HOUSE AND SHOP

situate in Gilesgate, at the corner of Magdalene Street, numbered 27, Magdalene Street, occupied by Mr. E. HESLOP, Tailor, at a yearly rental of £14, and containing Shop and Kitchen on the ground floor, and 3 rooms above, with Yard and conveniences.

Bought October 23rd 1886 for £183.

LOT 2.---ALL THAT

FREEHOLD HOUSE

situate and being No. 94D., Gilesgate, occupied by Miss PORTER, at a yearly rental of £7 5s. 0d. (including water rate), and containing 2 rooms, with Yard and conveniences.

The Tenants will allow the Premises to be viewed, and further particulars may be obtained of the AUCTIONEER, TENTER TERRACE, DURHAM; or of

JOSEPH MAWSON,

5th OCTOBER, 1886. ## SOLICITOR, DURHAM.

WILLAN AND SMITH, PRINTERS, CLAYPATH, DURHAM.

Property auction poster printed by Willan & Smith. (A pencilled note adds that Lot 1 was bought on 23 October 1886 for £180.)

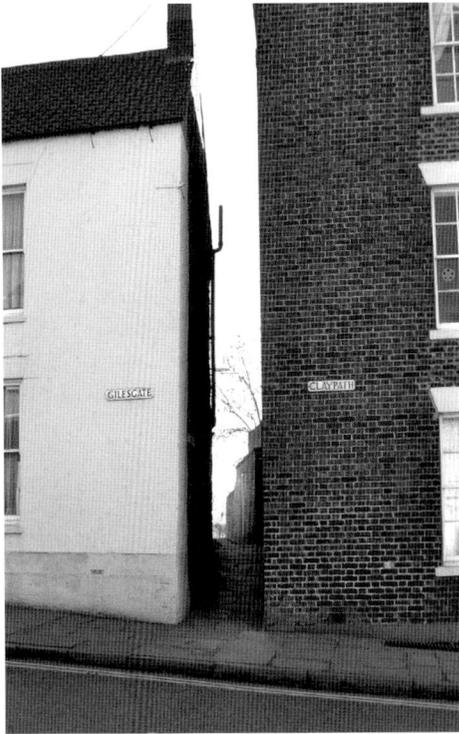

Left: The narrow entrance to Tinkler's Lane footpath – at the boundary between Gilesgate (uphill to the left) and Claypath (downhill to the right).

Below: Landt's rabbit hutches, early 1900s.

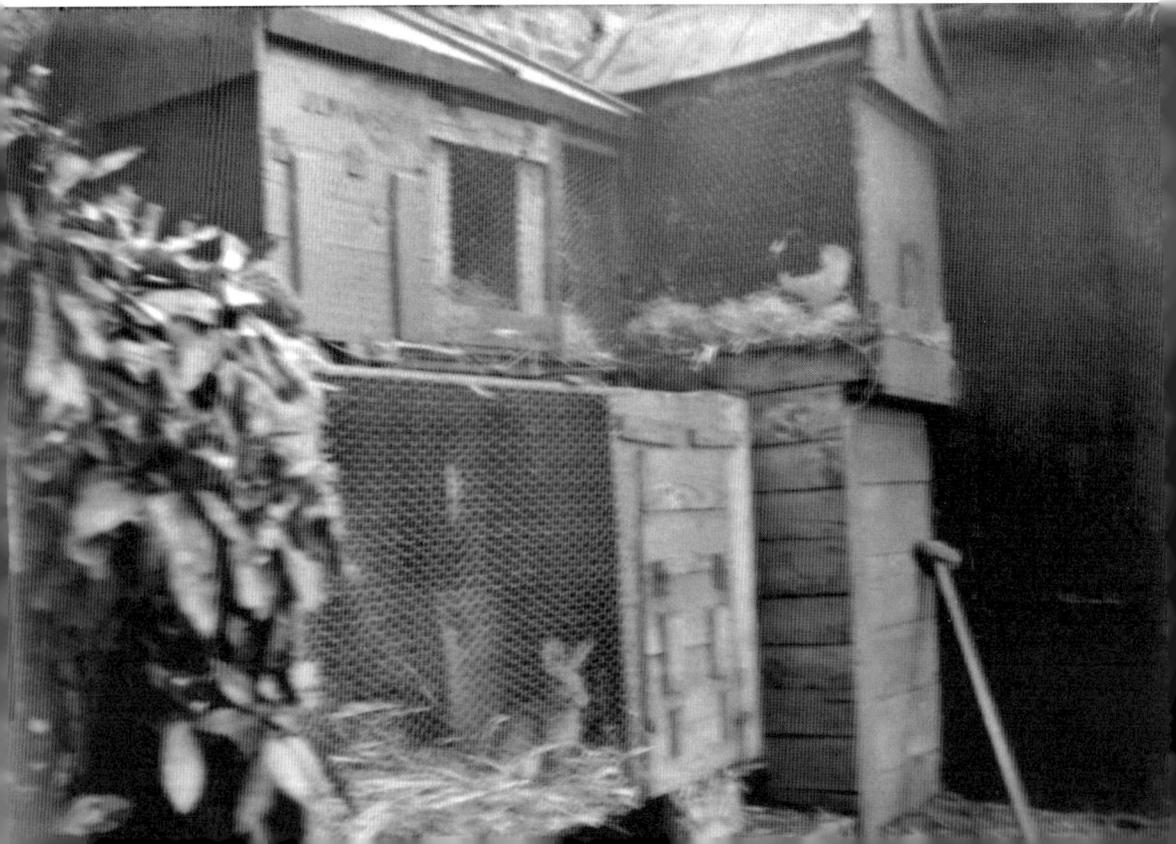

And here also came the judges on their way to Assizes: a real showpiece, with outriders on horses in old livery and uniform. Then a magnificent coach with a driver on an ornate box, all decked round with tassels. The driver in powdered wig and three-cornered hat. Wonderful horses – I think four of them. The coach was 'slung' between the wheels, and swayed. On a platform at the rear of the coach body stood two footmen, trumpeters and all that – all in the old traditional livery, powdered wigs and what-have-you, too. A truly impressive and dignified evidence of the majesty of the Law.

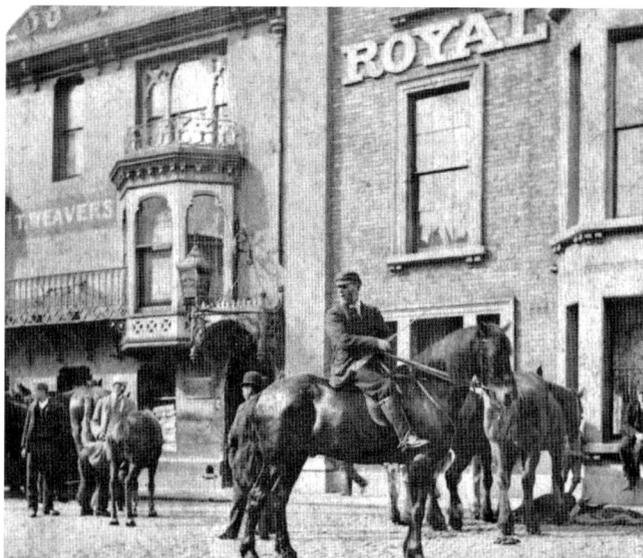

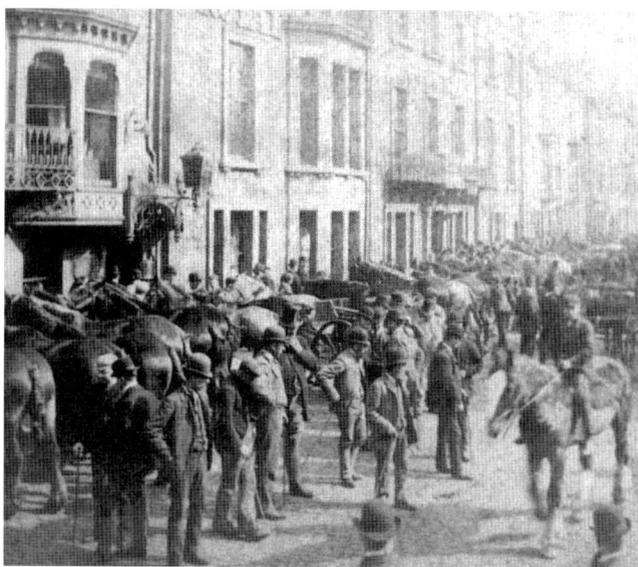

Annual Horse Fair, Old Elvet, outside the Waterloo and County Hotels, 1890s. [MR]

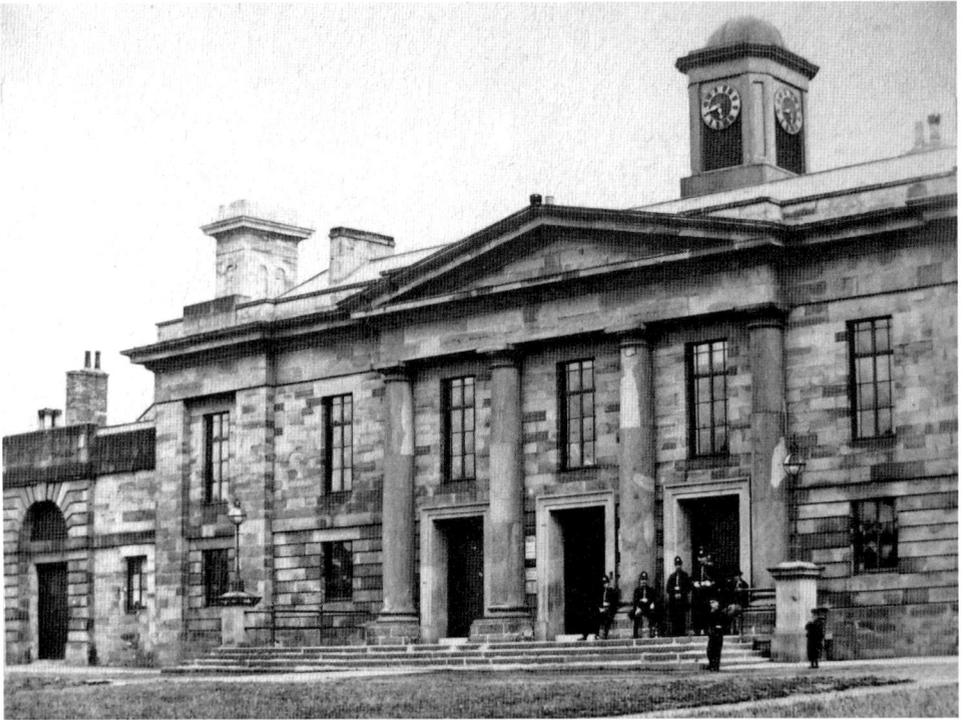

The Assize Courts, Old Elvet, 1890s. *[MR]*

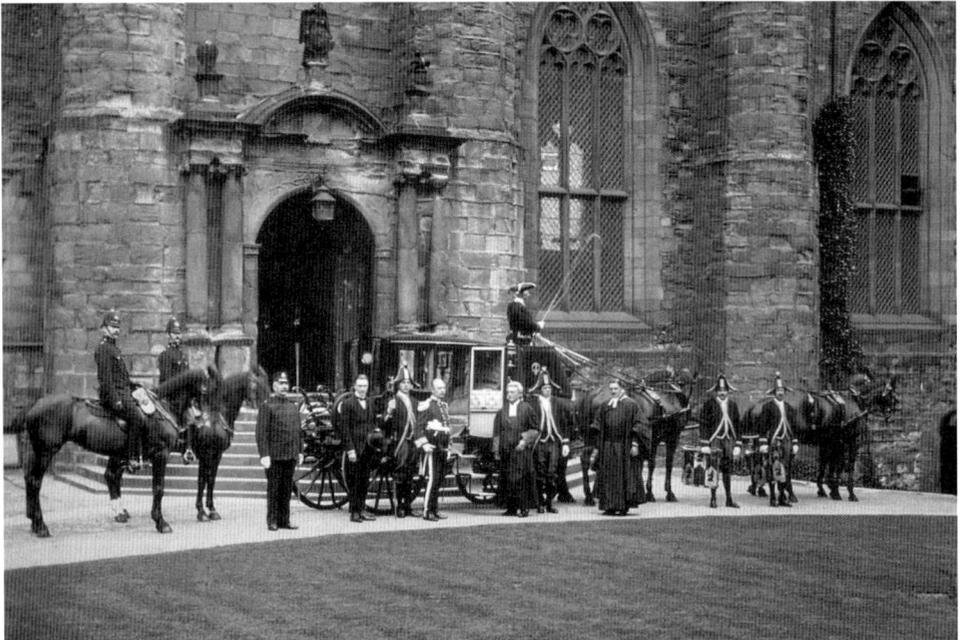

The Assize Judges' coach outside the castle, around 1900. *[MR]*

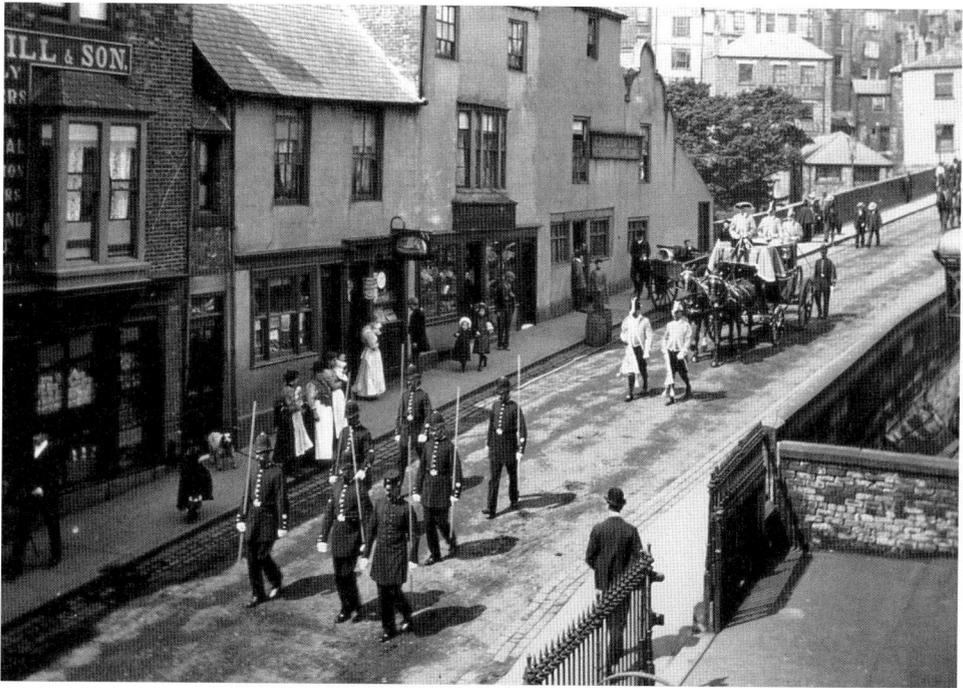

The Assize Judges crossing Elvet Bridge, about 1901. (The policemen are: front row: PCs Scott and Anderson and Inspector Harnby; second row: PCs Lay and Fowler; third row: Sgt Thompson and PC Roberts; behind the coach: PC Atkinson.) *[MR]*

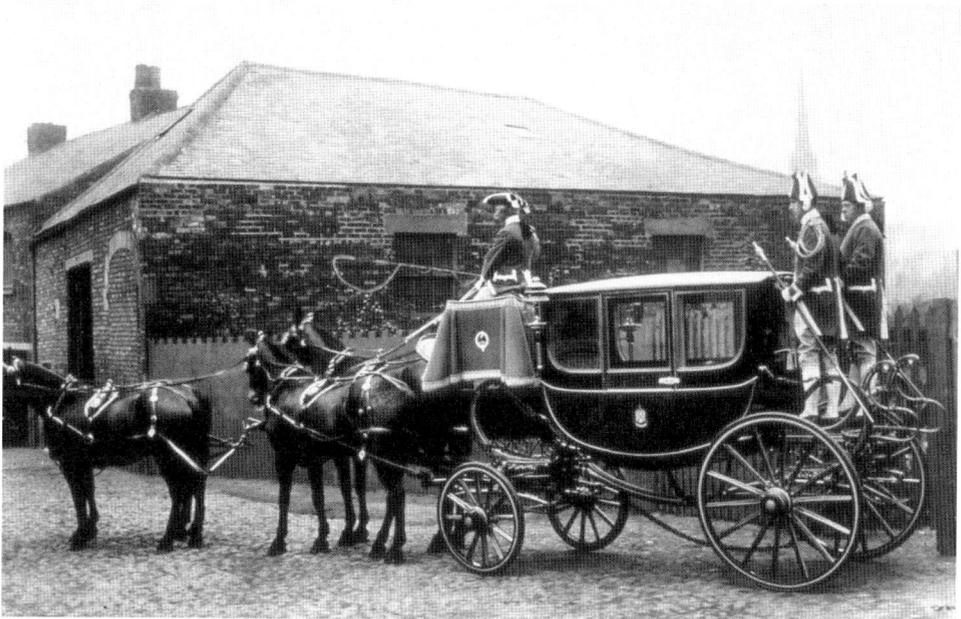

The Judges' coach (behind the County Hotel), 1900s. *[MR]*

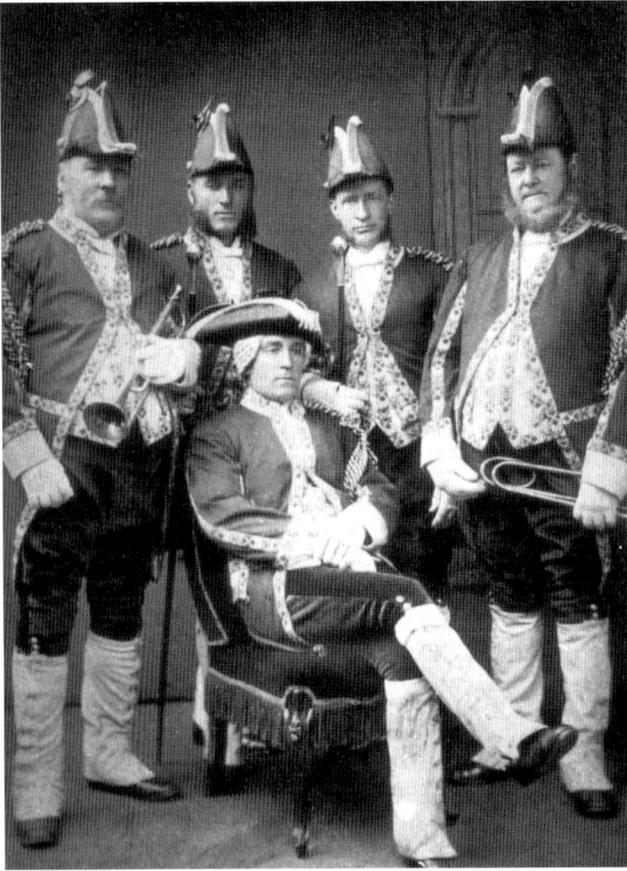

Left: The Assize Judges' entourage, 1883. *[MR]*

Below: The Rose & Crown's horse bus, 1897. *[MR]*

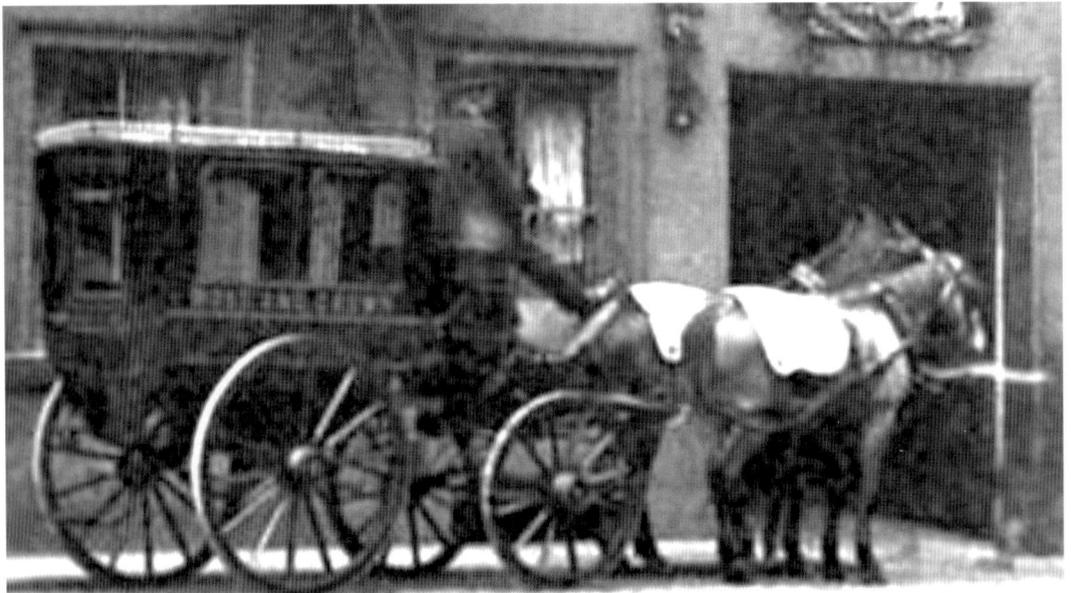

Motorcars just 'were not' in those days. Practically all horse transport. There were livery stables behind the County Hotel, providing four-wheeled cabs drawn by a pair of horses – it had to be a pair because of the hills – the coachman sitting on a box forward.

The County Hotel and the Three Tuns and the Rose & Crown – all had their own horse buses, which met the trains regularly. The County Hotel stables were behind the hotel, and the blacksmith's shop was opposite, in Elvet Waterside. Brook's livery stables near the Tuns coped there.

The Rose & Crown stables were up a long, steep passage adjoining the hotel. Barrowboys, too, met trains and brought commercial travellers' samples to the hotels, usually in big black leather trunks – rectangular, and brass-riveted. These barrows were frequently commandeered by the police to take drunks to the police cells at the foot of Claypath, where was the police station.

Durham City had its own little police force, and a separate Commission of the Peace – alas now absorbed in the county. How well I remember the little police station – a high counter with a large bobby behind it; and facing that, a hard seat for visitors; the old black fireplace, always with a roaring fire; and above that hung steel handcuffs – highly polished – batons and the rest. (How welcome was this little haven to me in the '14/'18 War when I landed home unexpectedly on leave at some unearthly morning hour, and waited and chatted with the duty officer till I thought the folks at home might have got out of bed!)

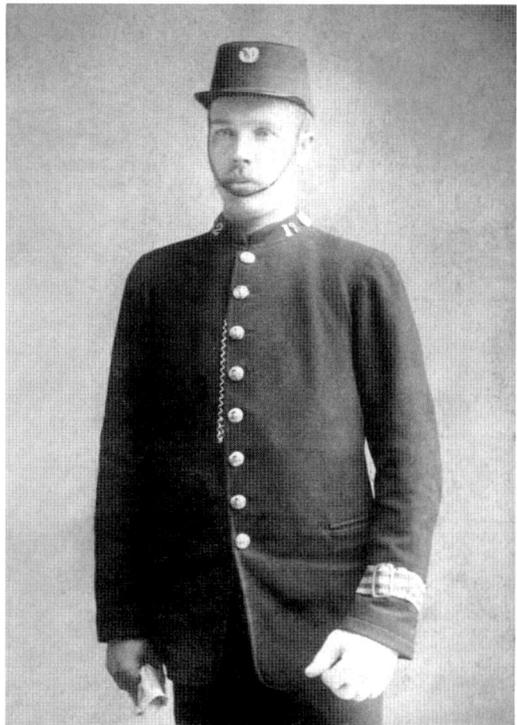

PC William Wheatley of 2 Tenter Terrace – policeman in Durham 1887–92. [MR]

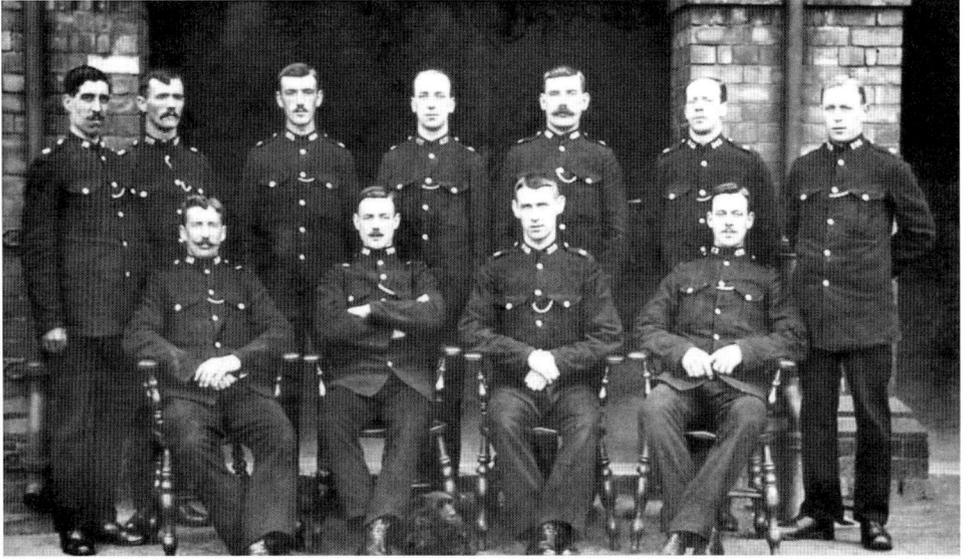

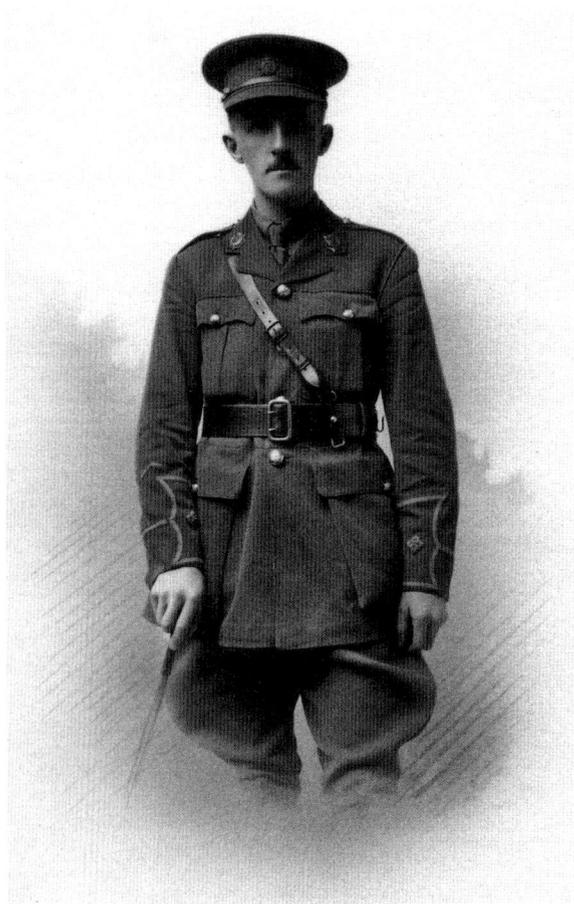

Above: Durham policemen at the rear of the old station in Court Lane, 1910. Back row, left to right: Robert Forder, William Troughton, Alfred Wiper, William Stephen, George Spratt, James Flynn, George Scaife; front row, left to right: John Duff, William Hayes, John Fenwick, Joseph Alder. *[MR]*

Left: Landt, about 1918. He served in the Army Service Corps as a despatch rider and heavy lorry driver; 2nd-Lt M/320617 Mawson.

Shincliffe

I'm afraid my thoughts jump about at random in recording these old memories. I'm back at Shincliffe now, my earliest memories of it being when Mother wheeled us children out to see the Crowthers, Willans, old Mrs Russell and Miss Hodgeson and others. The pram was a four-wheeler – two huge wheels and two not quite so big; a body like a bath, with a foot-well in the middle – and a hood. First snag: Baths Bridge steps. Then plain sailing along Parsons Field, Hollow Drift to Maiden Castle Wood stile. If a maid wasn't with us, Mother had to wait for a pitman or somebody to help her over with the pram. Then to Shincliffe – truly a rural farming community then.

I seem to remember Shincliffe Station – I think at that time (1893) a terminus, as I don't remember the bridge over the road. What I do seem to remember is the station, high up on the left side of the road – the wooden paled fence with a guard waving a green flag and setting a train away. At that time there was only a narrow lane cutting where now is the bypass, with a small brick bridge over it for the railway. We used to shout underneath it – hoping for an echo – and I remember it was always dripping water on the underside. The embankment partly exists to this day on both sides of the bypass. And the the Railway Tavern pub is still there, too *[extended and converted into flats in 1991, and re-named 'Bishop's Court']*. The line went to Sherburn House, past the old brick works, and joined the Elvet line, which was only opened in my early childhood; then carried on to Pittington, Murton, and Sunderland.

The old Sherburn brickworks (where now is the council rubbish dump) *[today the bridge over the A1 motorway]* were interesting to us children – watching the men there who used to give us lumps of clay with which we made little ovens, and burned touchwood in them; simple little pleasures – like hollowing out a turnip and making holes for eyes, nose and mouth, and putting a candle inside.

The footpath from Old Durham came under the railway and then up to the little beck *[stream]* – the old River Pitting – below Sherburn House, after going through the tunnel under the Shincliffe line. There were two tunnels – one a footpath, the other alongside for the beck. We took our boots and socks off and paddled through this as a stunt.

We must have walked miles in those days, enjoying the countryside and occupying our spare time without offending anybody, and at no cost except shoe leather and occasional torn clothes.

What fun we used to have going down Kepier, past the old hospital. And in the ponds on the way to the wood were tadpoles, frogs and all the rest. You could amuse yourself there for hours.

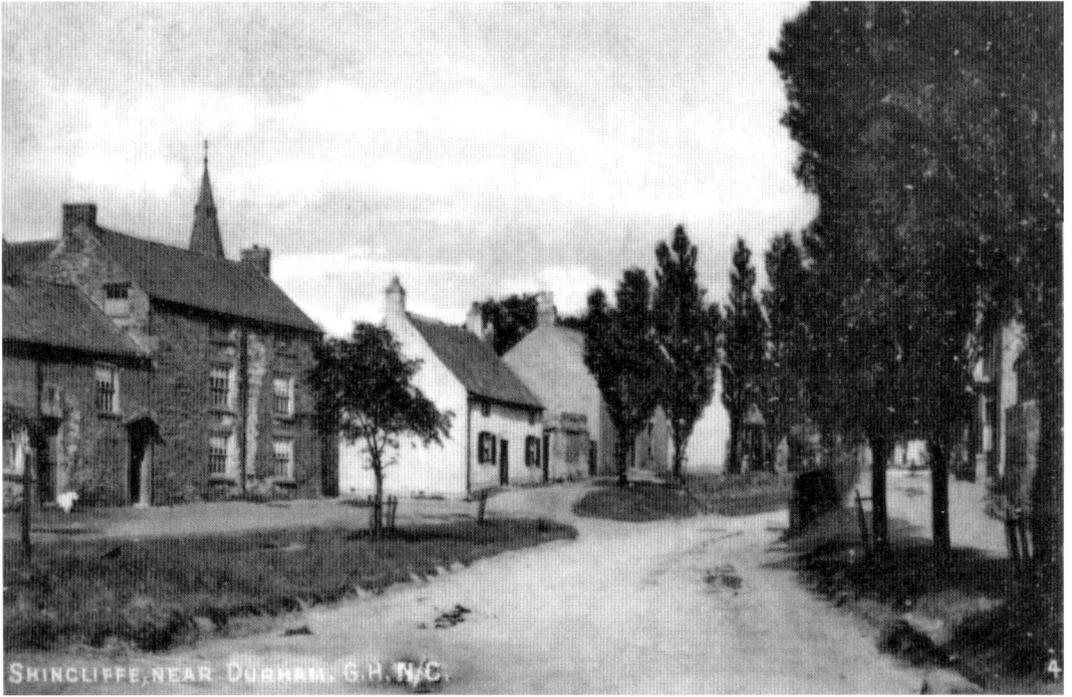

Shincliffe Village Green and High Street, about 1912. *[SLHS]*

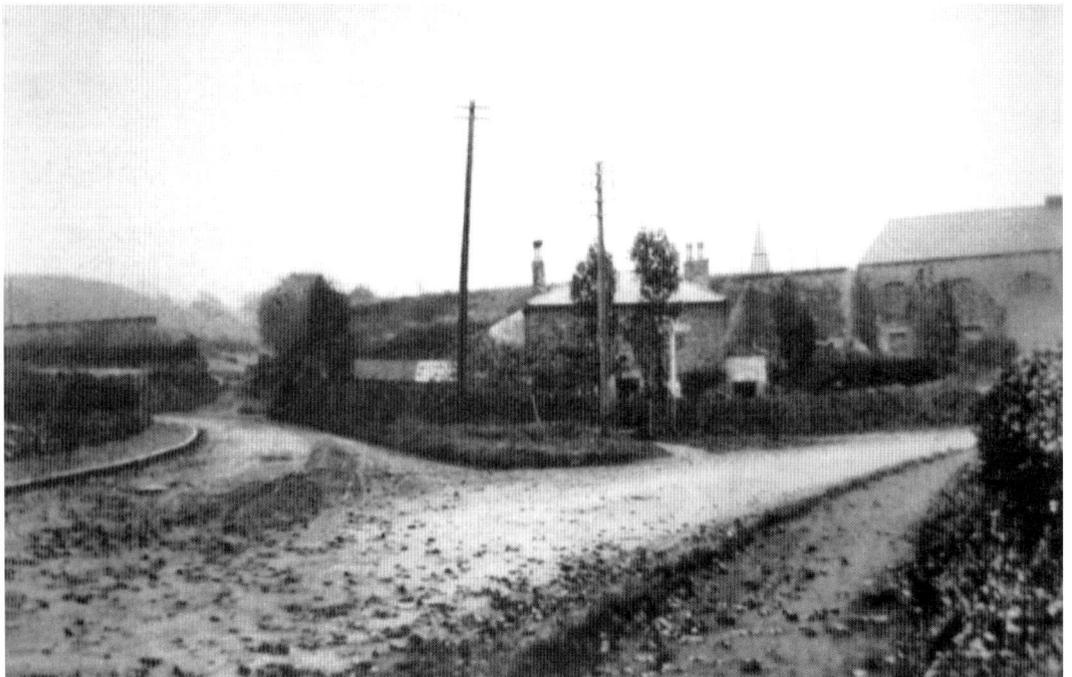

Shincliffe Station seen from the end of Shincliffe Bridge, about 1905. *[MR]*

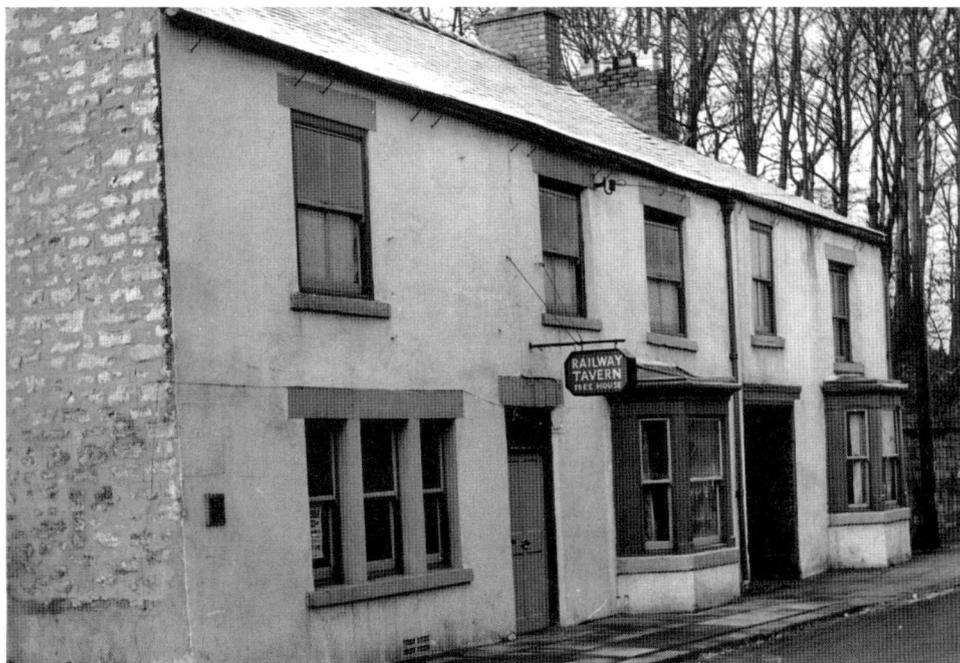

Above: The Railway Tavern
(photographed in the 1960s).
[SLHS]

Right: Kepier Wood, summer
1908.

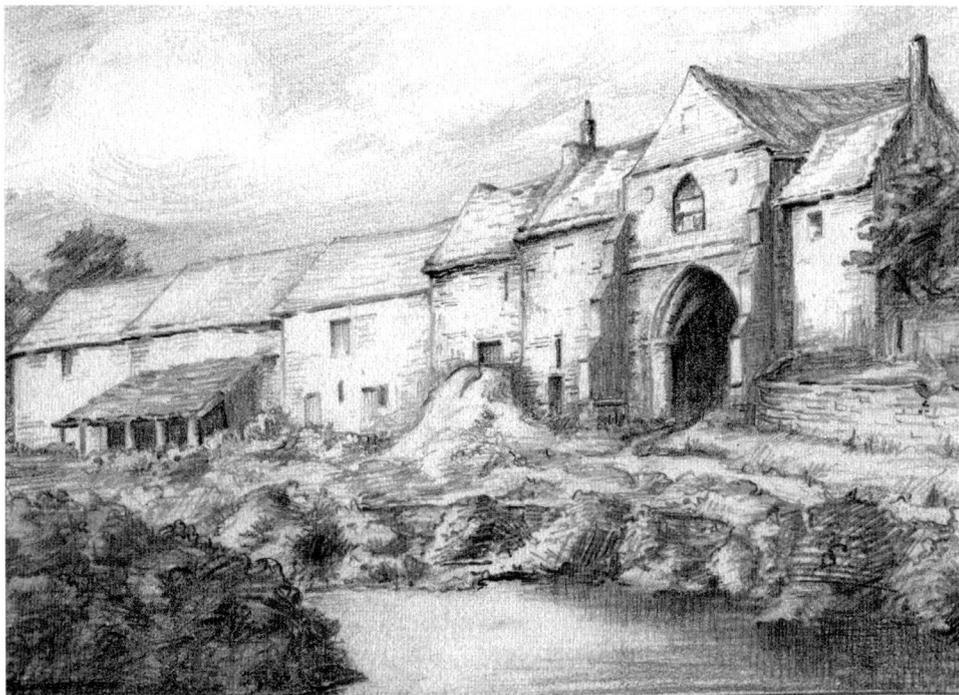

Kepier, 1916 – drawing by Flora Mawson.

But let us stay a little longer at Shincliffe as it was in the good old days. Where the village bypass is now was a delightful track (known as Back Lane) for farm vehicles only, between high banks covered with wild flowers, and lovely trees – almost touching each other overhead across the track. At the top, before it rejoined the village road, was a step made by a kerb across the path; and halfway up the track, steep steps led up to the churchyard and into the village – which was lit by oil lamps in those days; then years later a little gas – dim, poor stuff – and electricity didn't come to Shincliffe until well into the 1930s – just in time for the blackout during the Second World War!

Shincliffe before my time had a colliery – so had Houghall *[pronounced 'Hoffle']* – and the old waggonway from Shincliffe Station to Houghall still exists.

At the bottom of the village were four rows of pit cottages on the site now occupied by Wood View and Robson Terrace.

I think the pit closed in about 1886, and the cottages were bought by Charlton Robson, for whom my father acted as solicitor. Wood View was built in the very early nineties, and some of the stone from the old cottages was worked into the gables. Some of the kitchens with set pots etc were still visible as part of Wood View in the 1920s. Robson built the houses in pairs. He lived in No. 1 (now No. 7) himself. He ran out of stone when he got to the third pair of houses, as is evidenced yet by the fact that the gables at the northern end of the row have no stone, and are brick built. (Having built six houses, the end house – next to the road – was not built till several years after the others, by another builder and architect, Plummer and Burrell.) All had earth privies

Shincliffe Back Lane and church steps, about 1930. *[SLHS]*

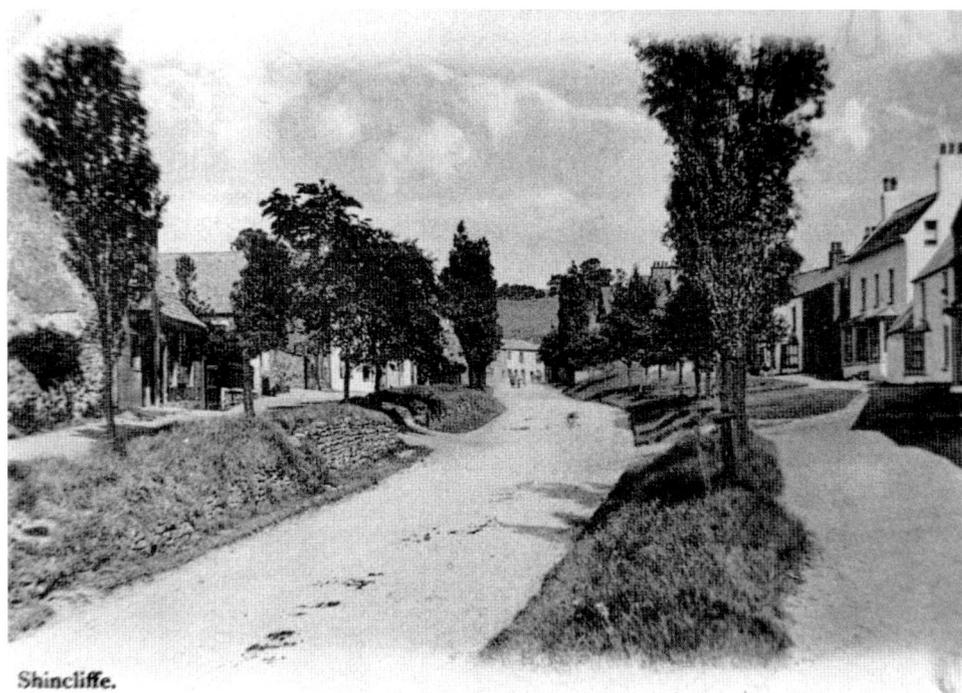

Shincliffe.

Looking up Shincliffe High Street, about 1910. *[SLHS]*

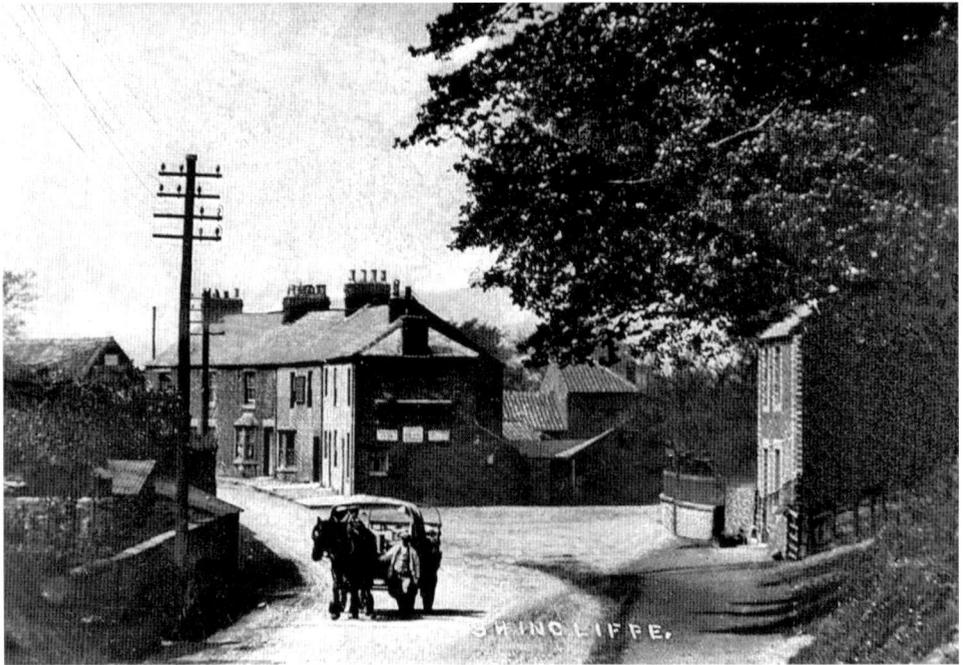

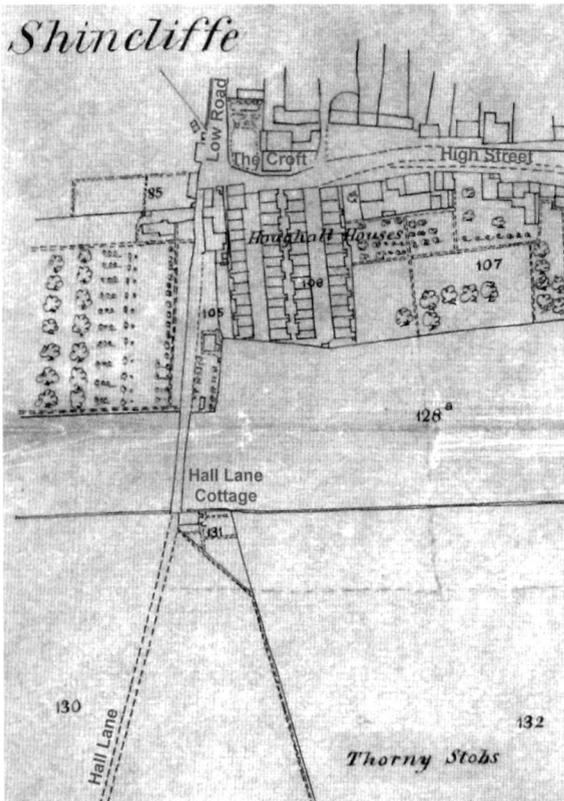

Shincliffe

Above: 'Top' end of Shincliffe, 1920s. (High Street is to the left, Back Lane to the right.) *[SLHS]*

Left: Detail from an old map of Shincliffe (1870s or earlier) showing 'Houghall Houses' pit cottages – four rows of fourteen cottages each – on the site of what is now Wood View and Robson Terrace. (Dotted lines showing some modern field boundaries have been added later in pencil. Typed names have been added digitally for the sake of clarity.)

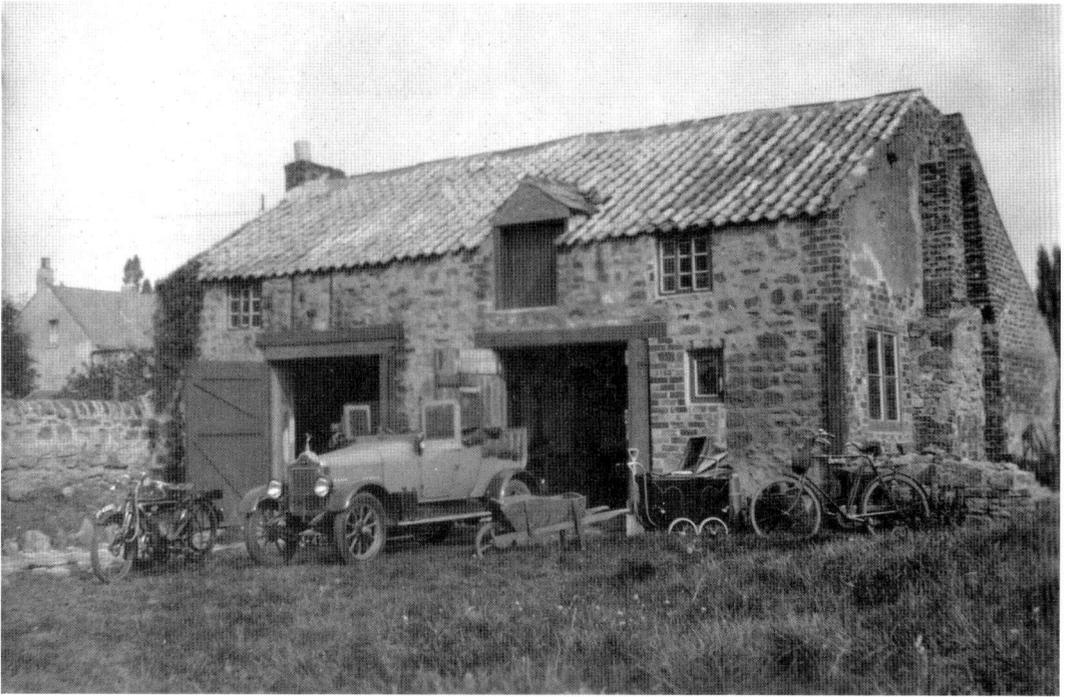

The garages at 7 Wood View in 1925 – last remnants of the Pit Cottages known as 'Houghall Houses'. (A motorcycle, car, wooden wheelbarrow, pram and bicycle are ramped in front of the building.)

Stone in the Gable Ends of Wood View.

and ash pits in what are now mainly coal sheds, etc. Robson, as will be appreciated, built Robson Terrace. I think all this would be about the first effort to make Shincliffe partly residential as opposed to a farming community.

There were no motor tractors or farm machinery in those days – it was all horses – beautifully groomed, and working long hours in all weathers. What the present generation misses! A pair or beautiful horses up and down a field all day ploughing, with birds following the plough for anything that turned up. Haymaking. Picturesque hinds with hayforks, making the ricks and later stacking – and expert thatchers. Corn stooks and all the rest. Hard – but healthy work; and what a cheery, happy crew they always were.

Uncle John always kept good horse-flesh, and at The Croft (as The Corner House was known then) always insisted on sleeping at the back of the rambling old house, because he loved his horses and liked to hear them stamping next to his bedroom (which adjoined the stables), or the halter rope pulling through the wood block; and he could hear if a horse got loose.

I remember him coming in for dinner one day, very pleased with himself.

'Did a good deal today, Landt – sold a pair of horses to Johnson's Brewery' (then in Elvet, opposite the Three Tuns Hotel) 'for exactly twice what I paid for them – and had two years' work out of them besides!' Breweries then, as ever, always went in for good heavy dray horses – lovely, powerful beasts.

Uncle John also kept two riding or trap horses. One quiet one to take Auntie Mary in the rubber-tyred trap and occasionally help out on the farm; the other a bit mettlesome, for Uncle John to ride (he was a major in the old Durham Volunteers) and to use in his large wheeled dog cart *[a two-wheeled trap, with space at the back for transporting gun-dogs]*, which had no rails to the seats – the driver sitting several inches higher than the groom or passenger.

I count to being no horseman, though Uncle John tried to make me one, as the two following incidents will show – amusing now, but not at the time!

The quiet horse was 'Daisy', and the mettlesome one, 'Sammy'. One evening, Uncle John put me on Daisy, and he on Sammy, we went up to near Cassop, where there was a wide grass verge, and the roads were there pretty hard (no tarmac in those days). All went well till he put me on the grass verge to try a gallop – not too bad one way, but coming back, I found difficulty in steering the brute and avoiding a line of telegraph poles – actually might have broken a leg when we did touch one. Trouble was, Daisy wouldn't 'whoa' when we got to the end of the grass verge, and we went on galloping for quite a bit along the hard road before I got her stopped. Up came Uncle John – a big, heavy man, in full riding kit, face red as a tomato and white moustache twitching – and boy, oh boy did I drop in for it!

Another incident occurred when we'd gone for a ride in the high dog cart with Sammy in the shafts. Uncle John took the high seat and we went up the South Road. About Bow School, he'd have me take the high seat and try driving. I tried to dodge it, but he insisted. A good trot up past South End, and just after that – either incidentally or deliberately – Uncle John drew my attention to something at the farm in the left, opposite Oswald House *[see page 186]*. Sammy apparently realised my inattention and

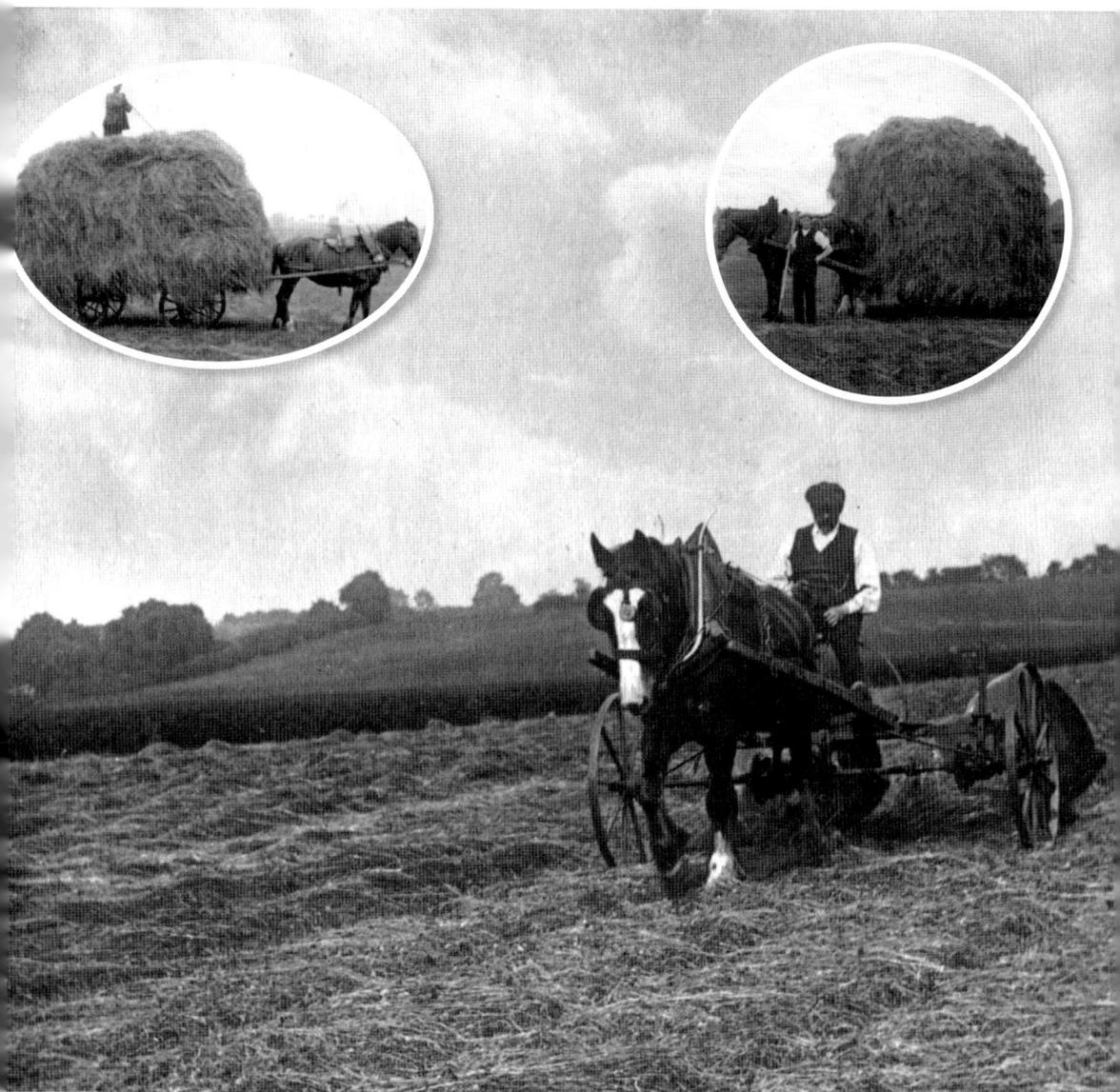

Horses at work on John Willan's farm, about 1907. (The current 'Croft' now stands on the skyline, hidden behind more recent woodland.)

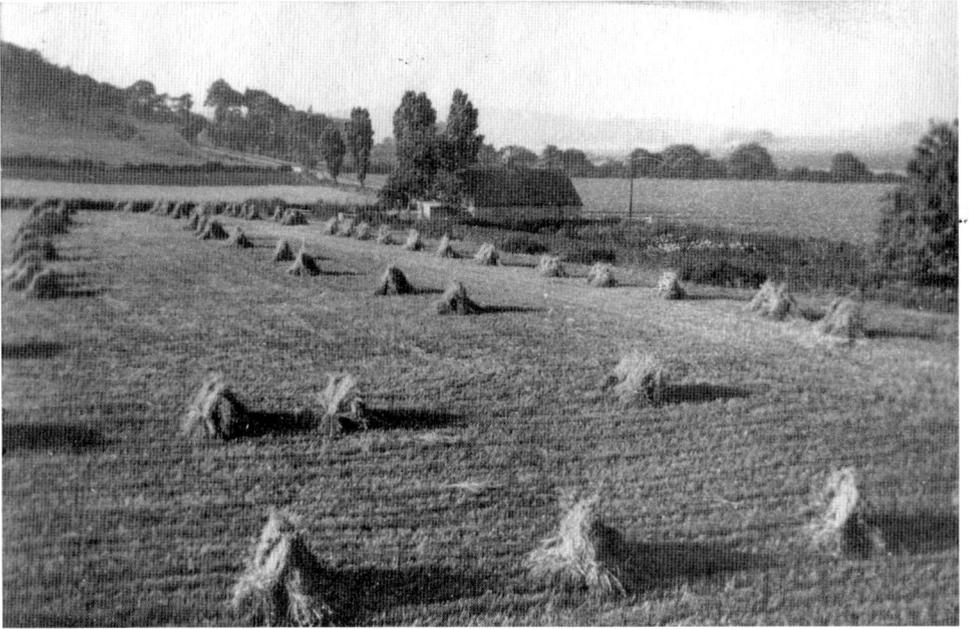

Corn stooks in the field, about 1925 – looking towards Shincliffe Wood (taken 'from the study window' – upstairs – at 7 Wood View).

A haystack to the left of Hall Lane Cottage *[now called 'Old England']*, 1939 (from an early colour slide).

Shincliffe Croft, about 1905. The side of the house and farm buildings seen from the Village Green.

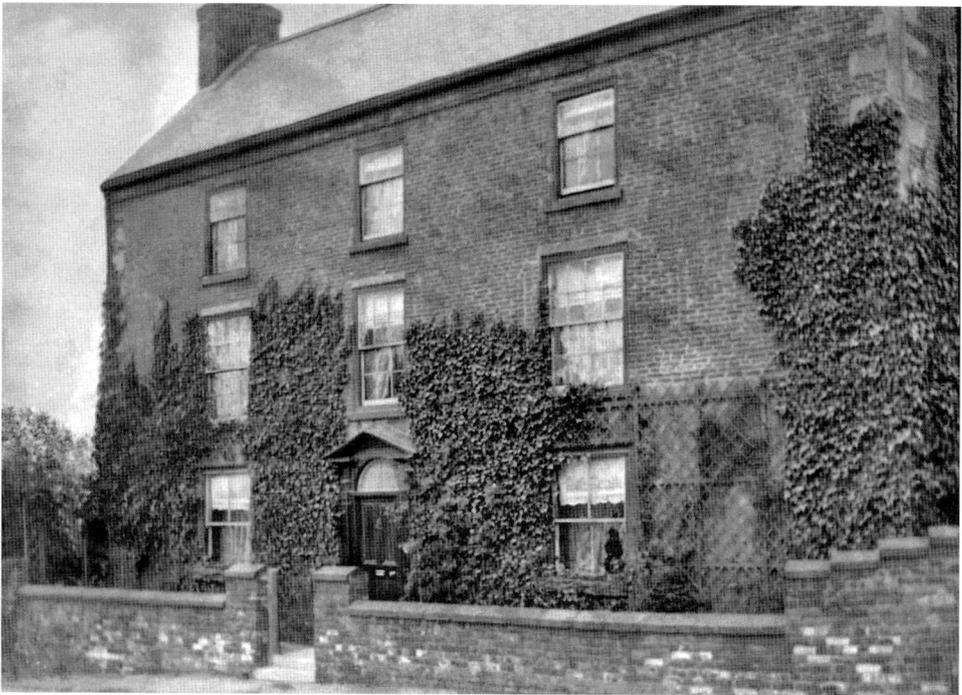

The front of the house seen from the end of Wood View/Robson Terrace.

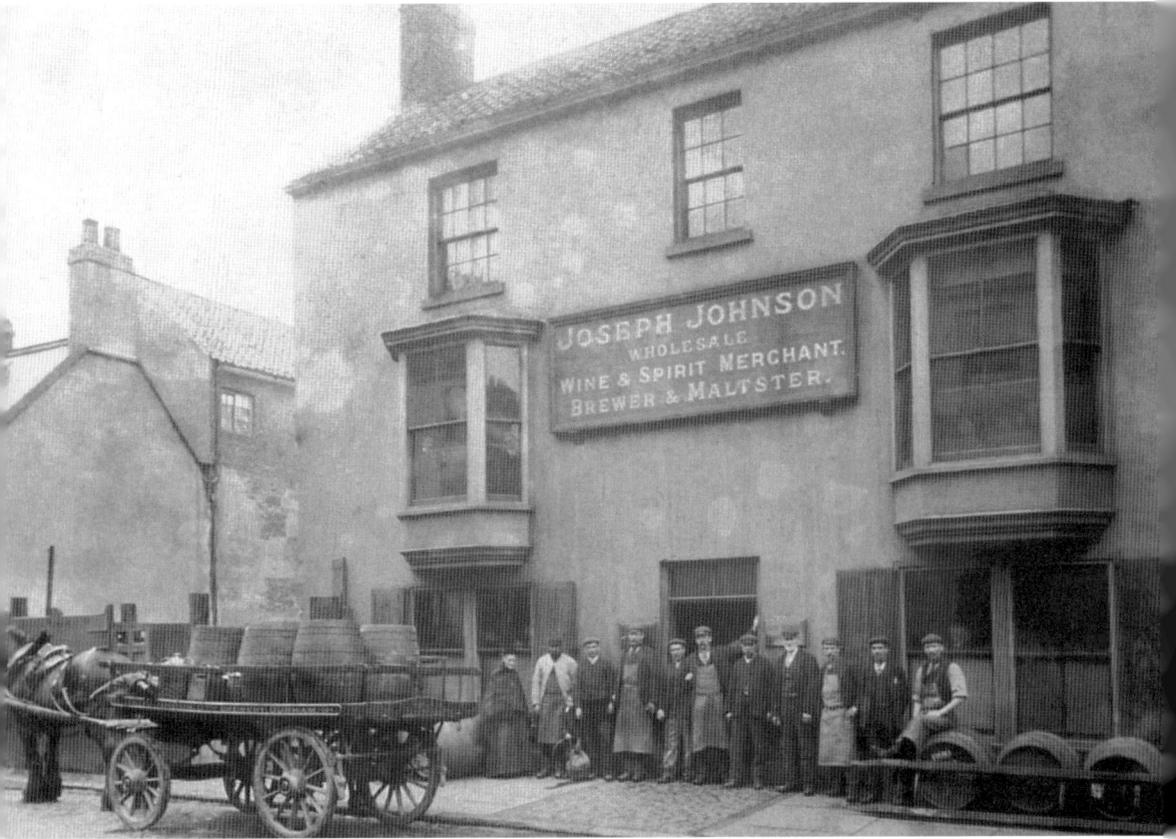

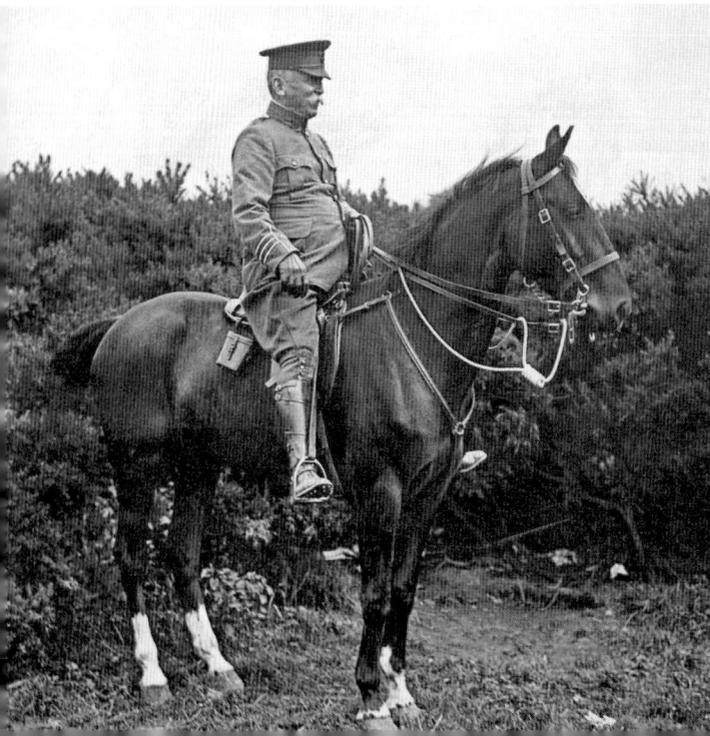

Above: A dray and barrels outside Johnson's Brewery, New Elvet, 1890s. *[MR]*

Left: 'Uncle John Willan, 17 August 1912'. (Major J. Willan, JP, 8th Battalion Durham Light Infantry.)

Above and below: John Willan and his granddaughter, Grace Vanderpump, riding along Hall Lane, Shincliffe, May 1915.

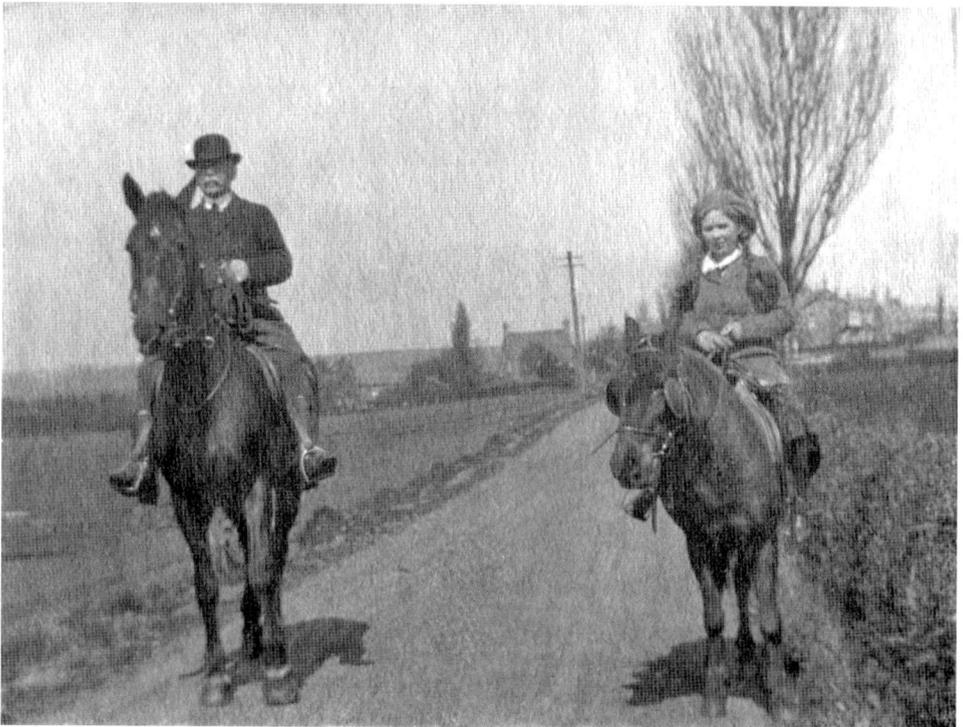

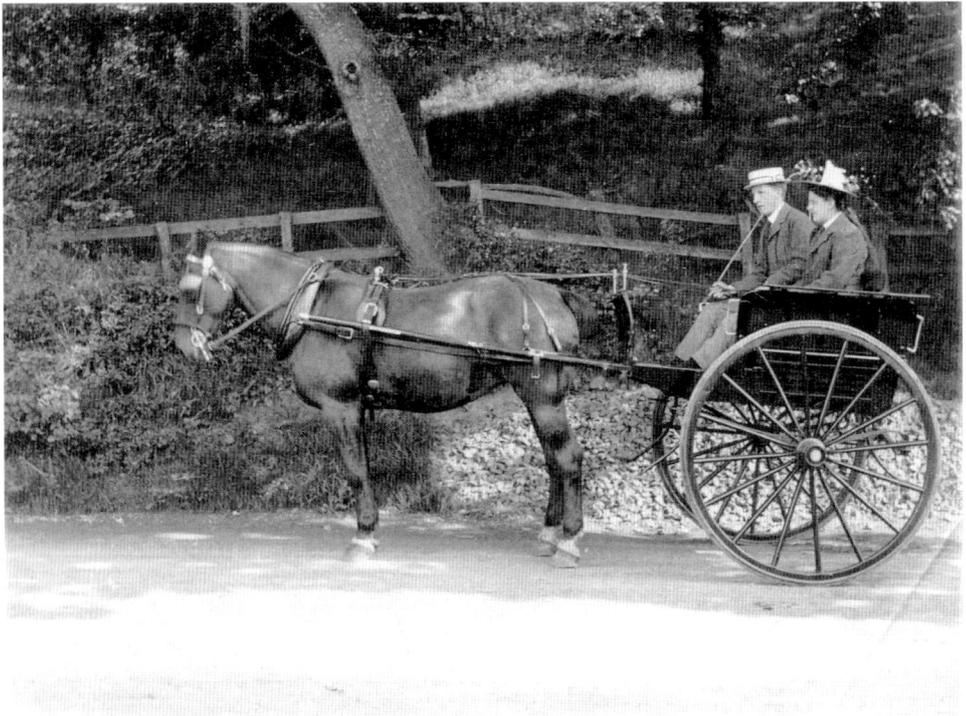

Landt driving, 1900s.

suddenly, without any warning, he shot off to the right into the lane below Oswald House – bumping the offside wheel over the grass verge and nearly turning us over. Did I catch it yet again! But Uncle John took over after that, and I could only say I didn't want to drive but he made me.

Sammy must have been a particularly wild animal, because although he was reasonably manageable in shafts, he refused to have anyone on his back. A real 'bucking bronco', albeit a beautiful creature. One evening, Uncle John and his foreman, Anderson – a big, heavy man of similar build – tried to take Sammy in hand and make or break him. Yard gates were closed, and they both mounted him in turn. His vitality was amazing, and how these big men managed to stick on his back when he upended and nearly came over backwards, or arched his back and landed on all four feet with a jolt, I wondered. But Sammy won, and Uncle John decided to get rid of him. Sold him to McLaren at Offerton Farm near Sunderland – also a major at the Volunteers.

Next year, to Uncle John's surprise, McLaren turned up at Summer Camp riding Sammy, a reasonable, disciplined horse; and when Uncle John asked him how he'd tamed him, he told him,

'Ran him in a Milk Float for a bit with some clattering cans behind him – meant putting Sandy, a man, on the rounds specially to take care of Sammy, but it worked!'

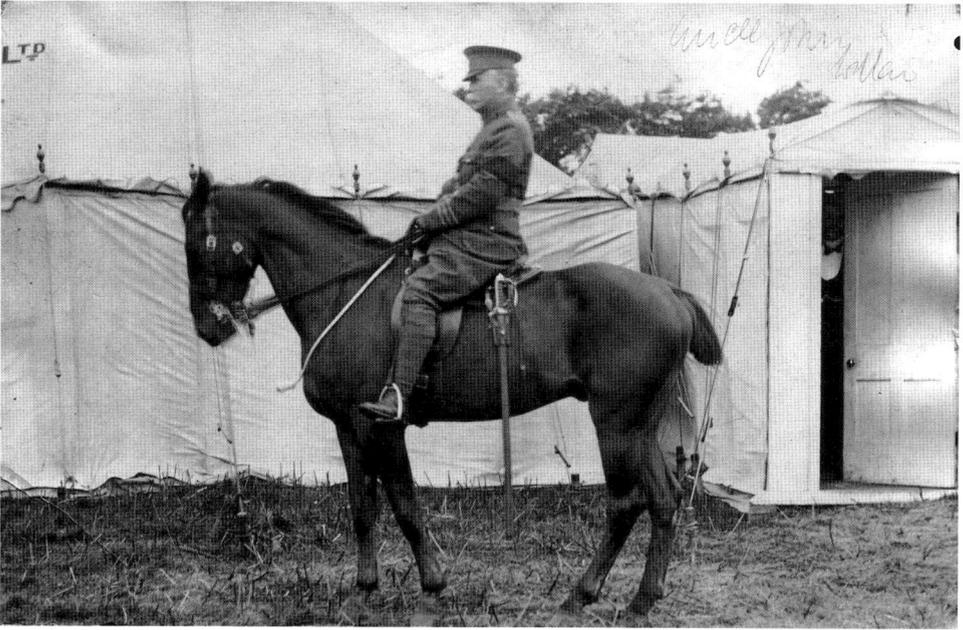

Major John Willan at Summer Camp, about 1912.

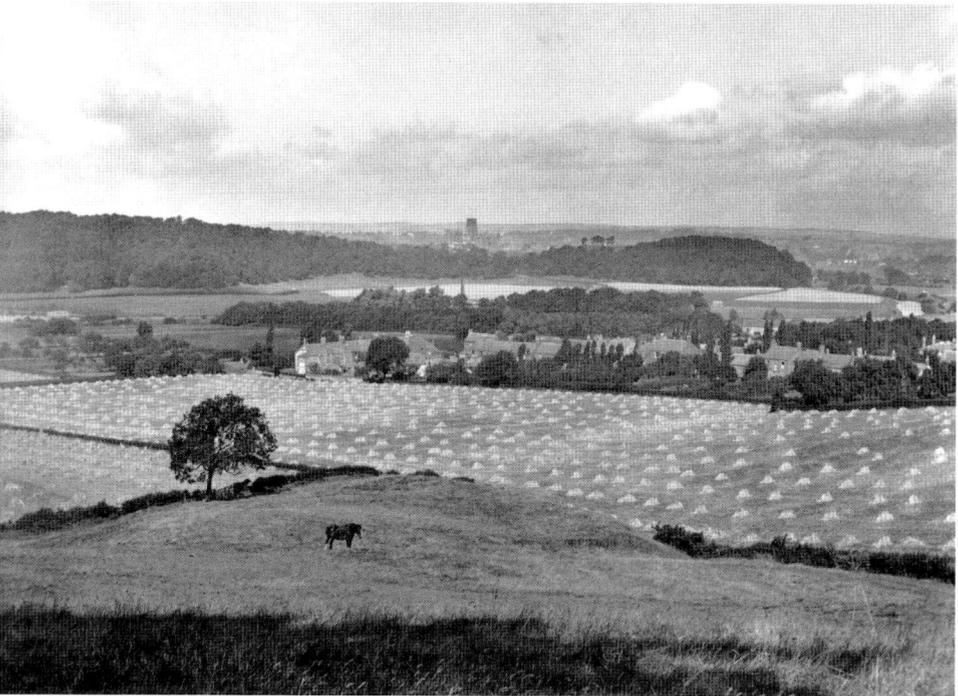

Shincliffe, from the woods, looking towards Durham, about 1925. (The cathedral is visible on the horizon, centre; and to its right, just to the left of Maiden Castle Wood, are the trees on Nine Tree Hill.)

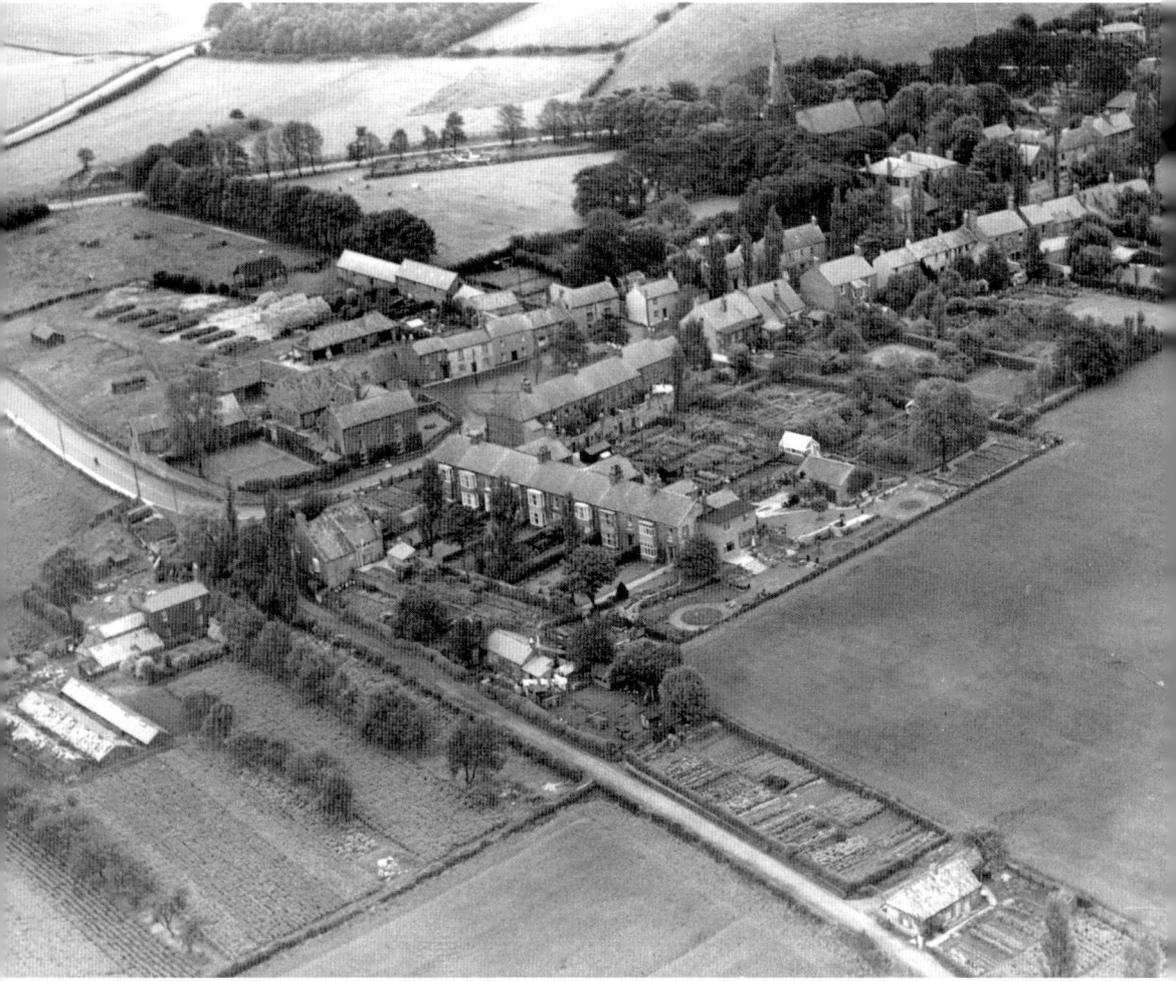

Aerial view of Shincliffe in 1938. (The railway had gone, and the bypass had been built, but otherwise little had changed since the 1890s.) *[Photograph by Roland Park, Newcastle]*

Durham School

And now I seem to have got to the stage where I was sent to Durham School: 1902–8; at first as a boarder. As Caffinites was full, I went to the Grove overflow house managed by R. H. J. Poole. I started off in Second Form – Master: Burbidge. Nothing very exciting here, but soon got into the Caffinites – House Master: H. W. McKenzie – a severe, stern character with *pince-nez*, gown and mortar board. Junior House Master J. H. 'Jock' Beith – later known as 'Ian Hay', the author of novels and *The First Hundred Thousand* of the '14–'18 War, and other famous books and plays – several of which had characters clearly recognisable as some of his pupils, including myself.

I was soon promoted to Form III, of which he was Master. A likeable and popular master, clearly fond of schoolboys. For instance, in the Caffinites before lights went out, he went round all dormitories and had a cheery word for us all. But Sunday was his day. Then, between tea and prep, there was a standing invitation to the under fifteens to go to his study, where we sat in a circle round the fire and he lounged in an easy chair with his feet on the mantelpiece and read us W. W. Jacobs stories. On his sideboard were his cups and trophies, many pewter mugs with glass bottoms, narrow at the top and wider at the base. The end boy had to keep a trophy topped up with chocolate cubes from a biscuit tin, and periodically pass it round among us, and you could grab as many as you could get. But subtly enough, if you grabbed too many you couldn't get your hand out of the tankard, and had to drop the excess back again!

Another incident, at the school baths, which were open air – full of leaves, dead crows and the like, but very popular. To get into the school boats, you had to pass a test. You made an appointment with 'Jock' Beith to try. When I tried, it was twice round the school baths, or two and a half times round the City baths, with rowing clothes on, and shoes. When all set, I dived in – and being a bit of a waterbaby did the twice round quite easily. But when I reached the steps to come out, there was Jock squatting on his hunkers, wagging his finger at me, saying,

'Go back to the other end – you dived in.'

Just like him, but fair enough.

He was a tough lad, too – and didn't we know it when he set the steeplechase course for the sports. Red ribbon on the right, blue on the left at a 6-foot-high *[2-metre]* thorn hedge, probably 6 feet thick, too, and you had to get through it somehow. Came in after this cross country jaunt, our clothes torn to bits and nearly all ripped off – almost naked – and bloody and bleeding from crashing through the thorn hedge – but proud of our goriness! I won that *[the Junior Steeplechase]* in 1906 – with ease. I knew I was

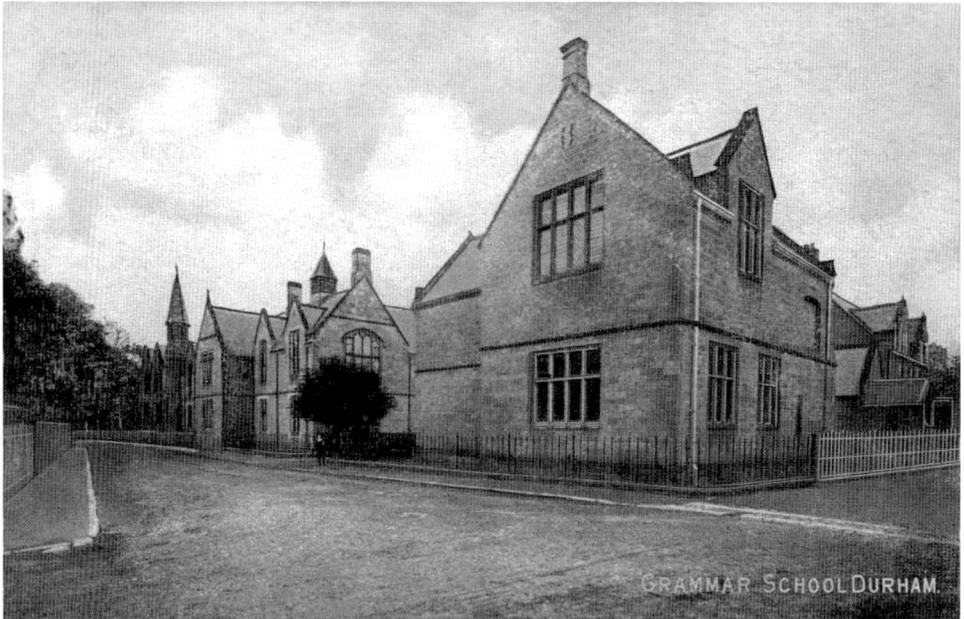

Durham School (corner block), early 1900s. (Dating back many hundreds of years, and re-founded by Henry VIII after the dissolution of the monastery in 1541, Durham School was still often known by its ancient name 'the Grammar School' until the mid-twentieth century. It moved from Palace Green to its present site in Quarry Heads Lane in 1844.) *[Postcard]*

Dottie Mawson's *pince-nez* glasses (small spectacles worn clipped to the nose rather than hooked round the ears).

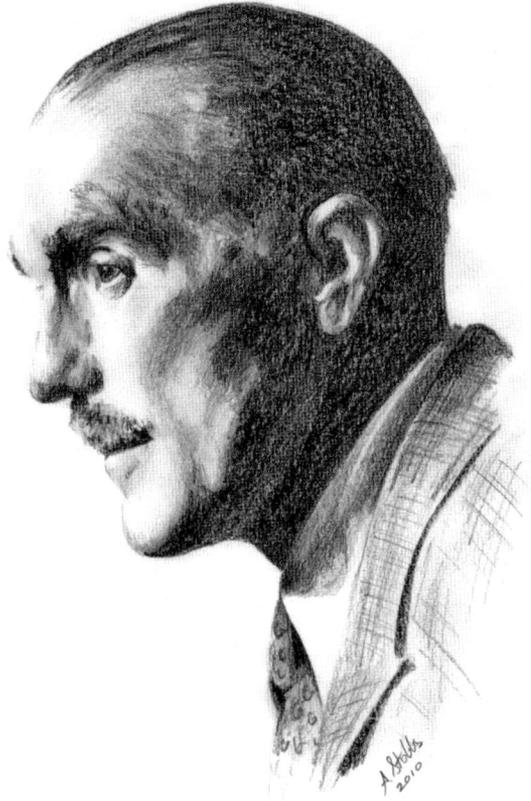

John Hay Beith (1876–1952)
pictured in the 1930s –
drawing by Amanda Stobbs,
2010 (from a photograph).

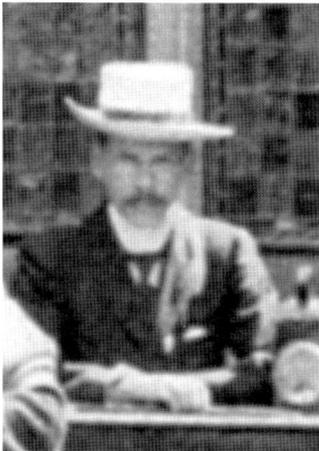

From left to right, Messrs Burbidge, Budworth and Poole. *[Durham School Archives]*

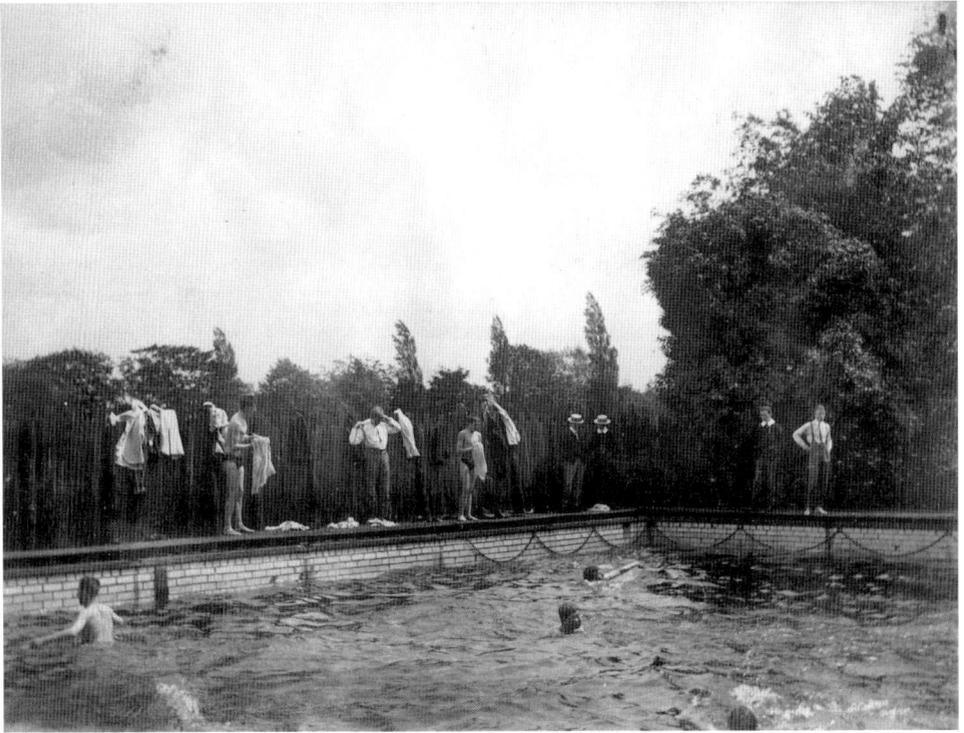

Above and below: Durham School swimming baths, around 1905.

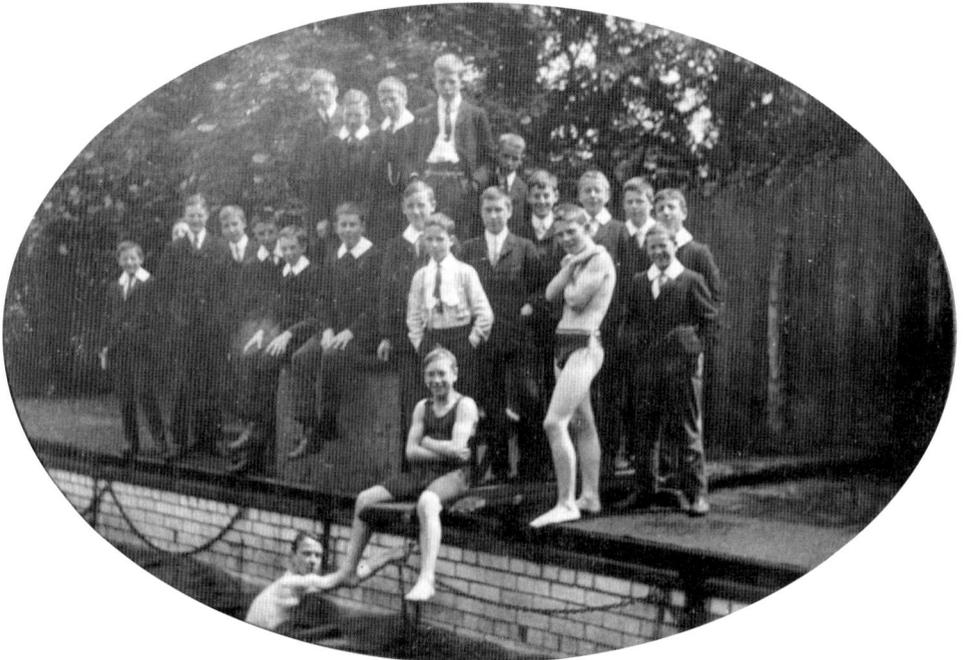

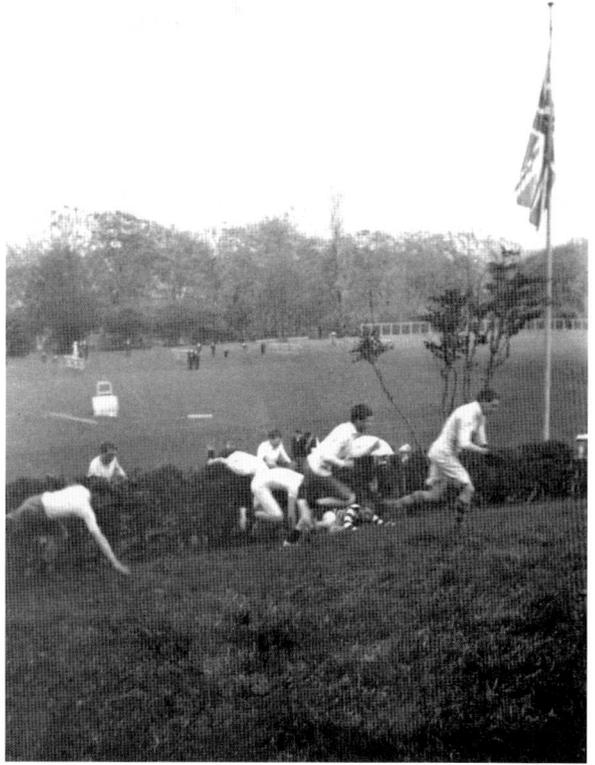

Right: The steeplechase, Durham School, early 1900s.

Below: The steeplechase crossing the thorn hedge, about 1920. *[Durham School Archives]*

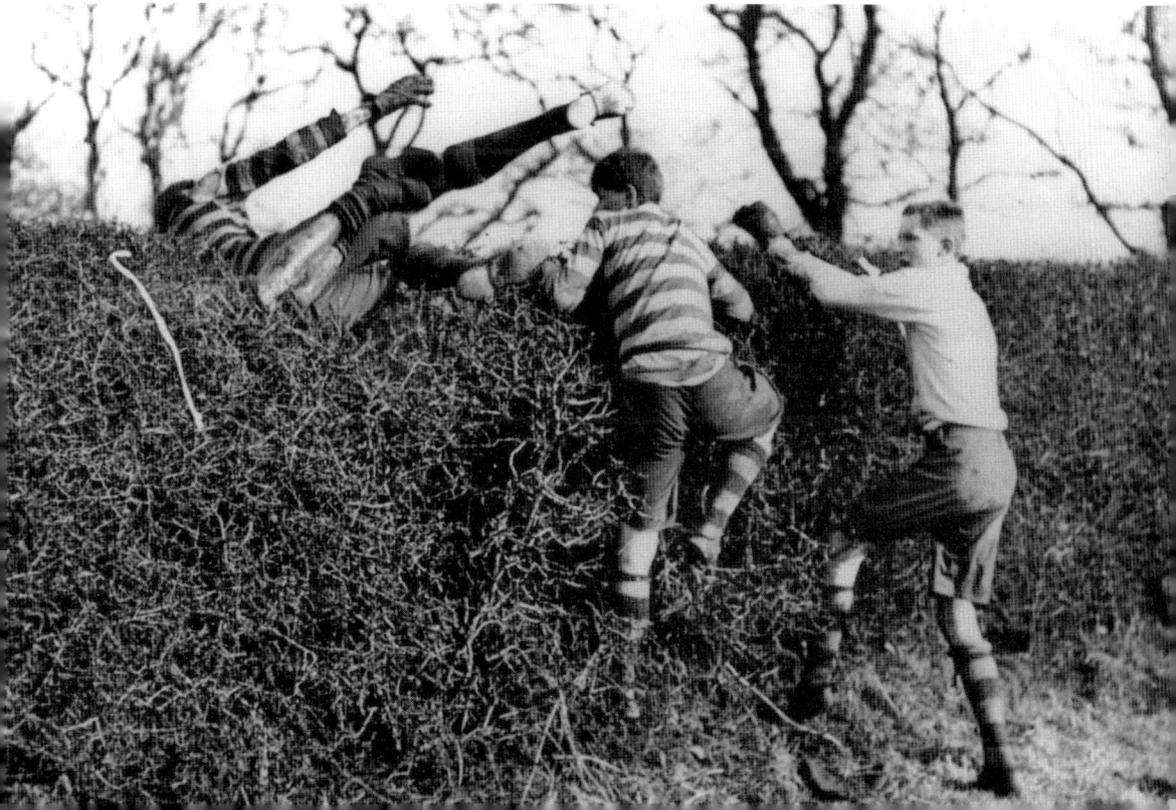

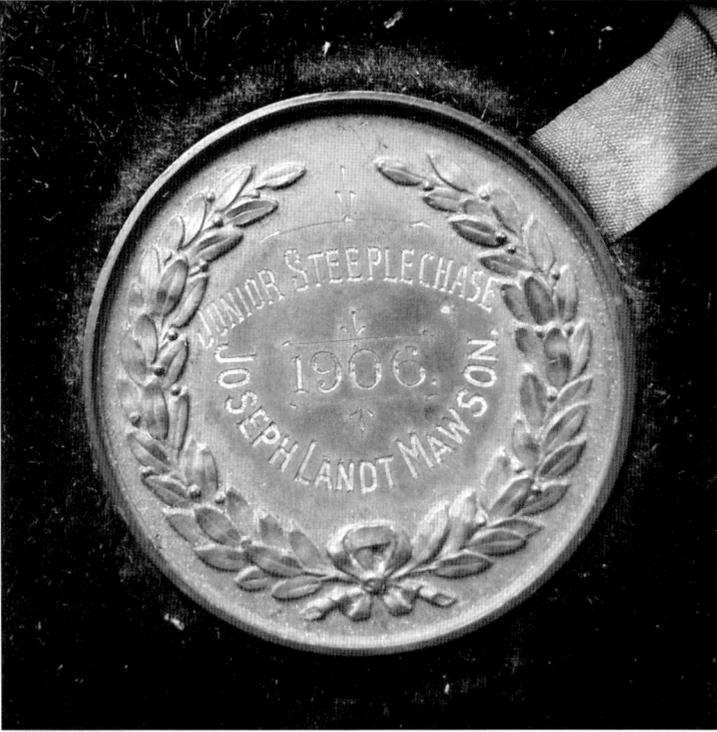

Above and below: Front and reverse of the medal Landt won for the 1906 Junior Steeplechase (enlarged) in its original green-velvet-lined box.

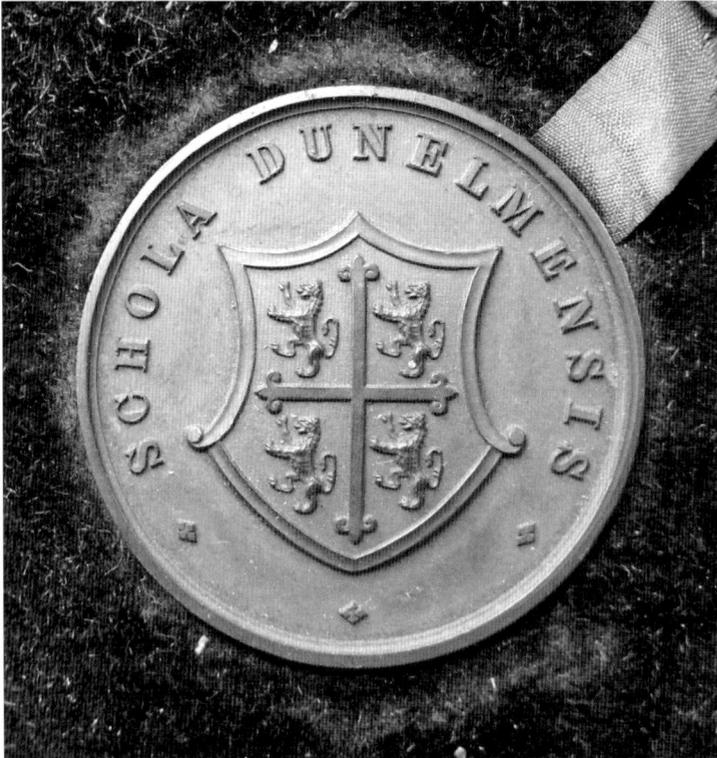

favourite, because I'd beaten all my rivals not long before in the house run. I never could 'sprint', but cross country I could go on almost indefinitely.

I was never a scholar, and the only prizes I ever won at school weren't for work, but for sports; the steeplechase; and one for photography! And the only praise I ever got was from the science master on 'magnetism and electricity' when I was the only boy who knew the answer to a question, and he said,

'Mawson, I believe you're the only competent boy in the class!'

Somehow, lots of incidents come up in my memories of school. Poole was a great character – tough, and swore like a trooper – you felt he could either make or break a boy – odd, yet with likeable traits. An Oxford Rowing Blue, he trained the school crews – harangued them from the riverbank with phrases like,

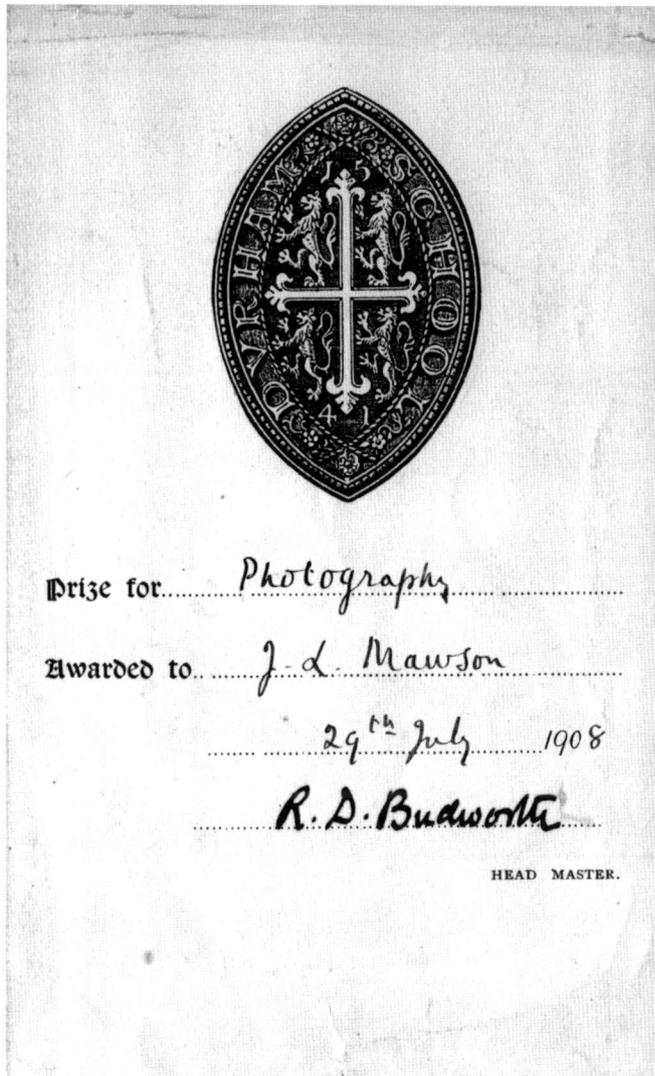

Prize for *Photography*

Awarded to *J. d. Mawson*

29th July 1908

R. D. Budworth

HEAD MASTER.

Landt's photography prize certificate, 1908.

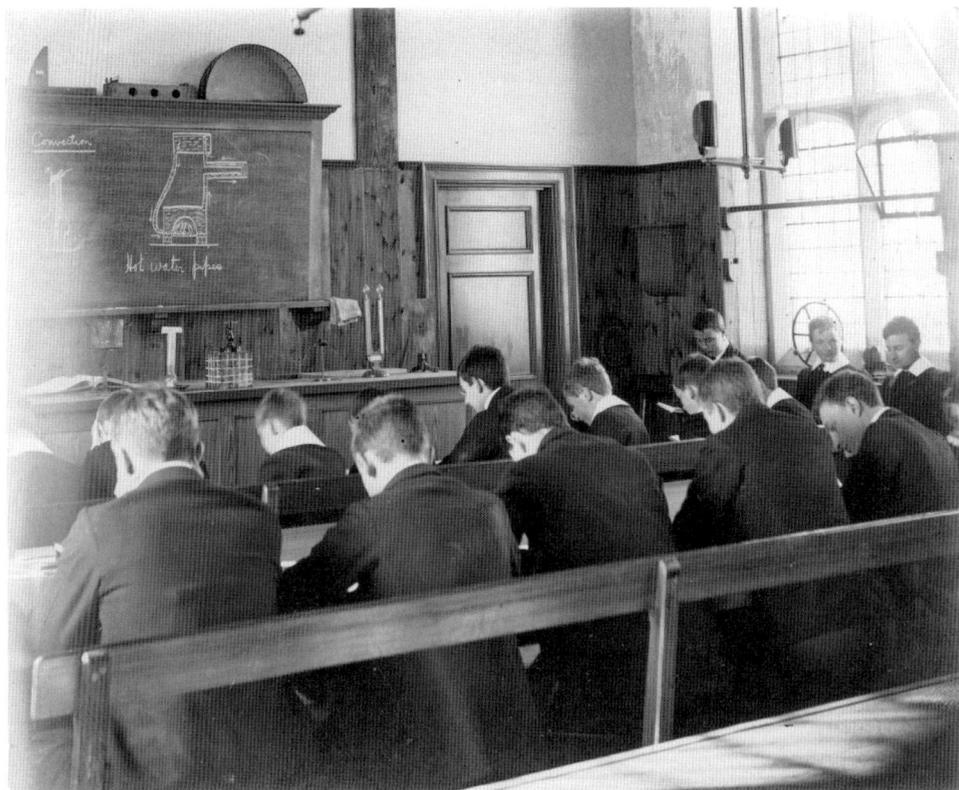

A science class at Durham School, about 1906 – photo by Science Master 'Jock' Beith. (Landt is in the front row, near the right-hand door jamb – sixth from left/third from right.)

'Oh my God, I never saw such a lot of bloody fools. I could row better myself with a damn teaspoon!' – an entertainment to hear, so long as you weren't the victim!

Another occasion shows how he nevertheless understood boys. The school tuck shop was round behind Pimlico in a little house run by a 'Ma' Rakes – a real Victorian, with a face like a horse; grey hair parted down the middle, and with a black net; *pince-nez* on her nose; and a shawl over her shoulders. Among other things, you could get large mint balls or black bullets, about the size of a penny or halfpenny, at two or four a penny. Real gobstoppers. Suck 'em a bit, then put them in your hanky till you wanted them again!

Well, at this time I was in Poole's form – the 'Remove' – and after games, I started on a mint ball. The bell went at 3.55 p.m., and school began at 4 p.m. At 3.55 or thereabouts, I got my mint ball stuck between my cheek and my teeth, and could shift it no-how! So when Poole came in, I hid under my desk – hoping.

Presently,

'You boy, Mawson – take your head out of your desk.'

I didn't, and the next thing, he came over, got hold of the lid, and banged it on my head. I was exposed! Was my face red, and didn't it just hurt my cheek! All he said was,

Above: 'Black
Bullets' are still
available in 2010.

Right: Old
pennies and
ha'pennies
(shown actual
size).

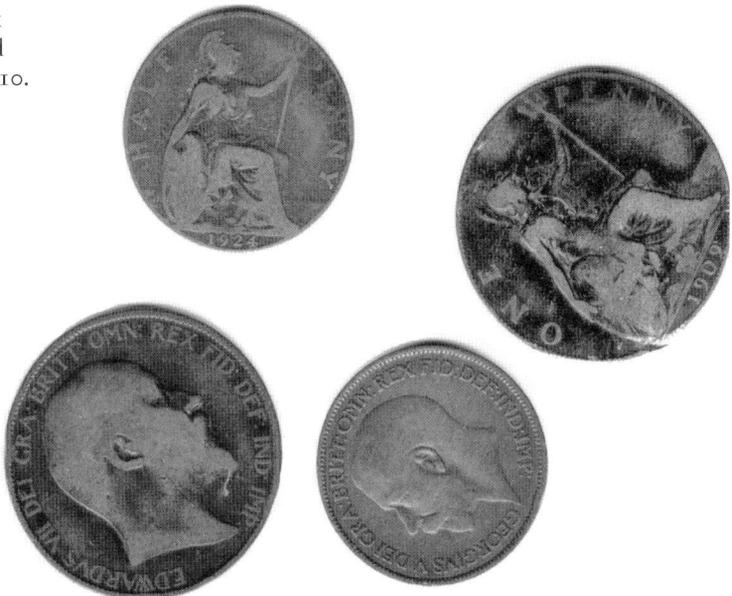

'Get out and finish it!'

I went, and thought I might as well be hung for a sheep as a lamb, so stayed out longer than I needed after I'd got it melted and free. Strange thing was, Poole (or 'The Rajah' as he was nicknamed) never referred to it nor mentioned it when I returned.

Funny how this seems to have gone on. Got a bit mixed somehow trying to record the old places and customs, and turned into a sort of autobiography. Often there is quite a long interval between one session of writing and another, and thus some incidents and events get out of place.

Hillard was Headmaster when I went to Durham School, and was also Housemaster of School House – alias 'the Bungites' – so called after a former Head *[nick]*named 'Bung'. Incidentally, Hillard was nicknamed 'The Egg' from the shape of his head. H. W. McKenzie was Housemaster in the Caffinites, and Poole in the overflow house 'The Grove' (which took eight boys).

I remember two points most about 'The Grove'. First, Miss Harwood was Matron, and we all fed in the room at the north-west corner of the house. It was most embarrassing at first, because Poole sat at the head of the table and Miss Harwood at the other end. What was also embarrassing at first, till we got used to it, was the fact that two solemn-looking maids stood against the wall at either side of the table to 'wait' (very tempting to try and make them laugh!), very austere and proper they were, with typical Victorian pinafores over long black dresses, and also the usual maids' white caps!

The other memory that sticks out was the day there was a big rugger match, and Poole had kept us in for bad work in his form – we were all champing and calling him a bad sport and what else, when he suddenly appeared at the door with a cane, and with his leg-pulling smirk said,

'Last boy out gets three!'

Was there a scramble in the rush past him, which nearly bowled him over. We saw the whole match!

After a term or two in 'The Grove', I was transferred to the Caffinites under McKenzie and 'Jock' Beith ('hereuntofore referred to', to use the language with which I later became all too familiar). One thing there I hated, and that was 'Hall singing'. In the 'lower study' were two tables in a very long room – one long table the full length of the study, and the other somewhat shorter, leaving an open square area in front of the fireplace. Lockers all round, and sports groups covering the walls. When the Head of House sent round via Hall Monitors the announcement at tea time that there would be 'Hall singing' that night – first time it didn't bother me, because I didn't know what I was in for, being then just a kid junior and a 'fag'. *['Fagging' was a system where the younger boys acted as servants to the older ones.]* What happened was, we had to put forms on the table opposite the fireplace, and the seniors came in from their studies and sat on them. Rest of House sat all round the tables on forms. When all set – a Senior Monitor or Hall Monitor would announce, 'So-and-so will now give us a song.' Being the latest newcomer, I was the first called, and

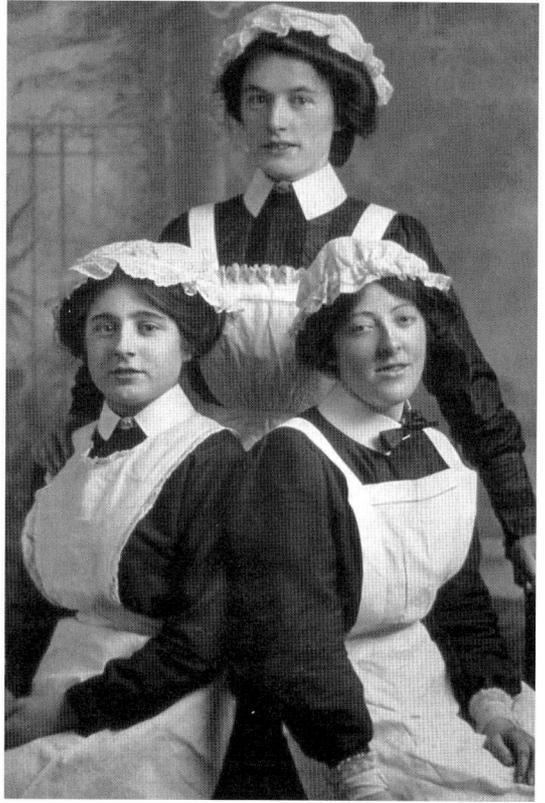

Right: Maids, about 1915. (Back, Minnie Marshall; front left, unknown; front right, Alice ?. They worked for Canon Robertson at St Margaret's Vicarage at the top of South Street.) *[MR]*

Below: 'The Sausages', with Durham School beyond, seen from Pimlico in the early 1900s – 'The Grove' is on the far right. *[MR]*

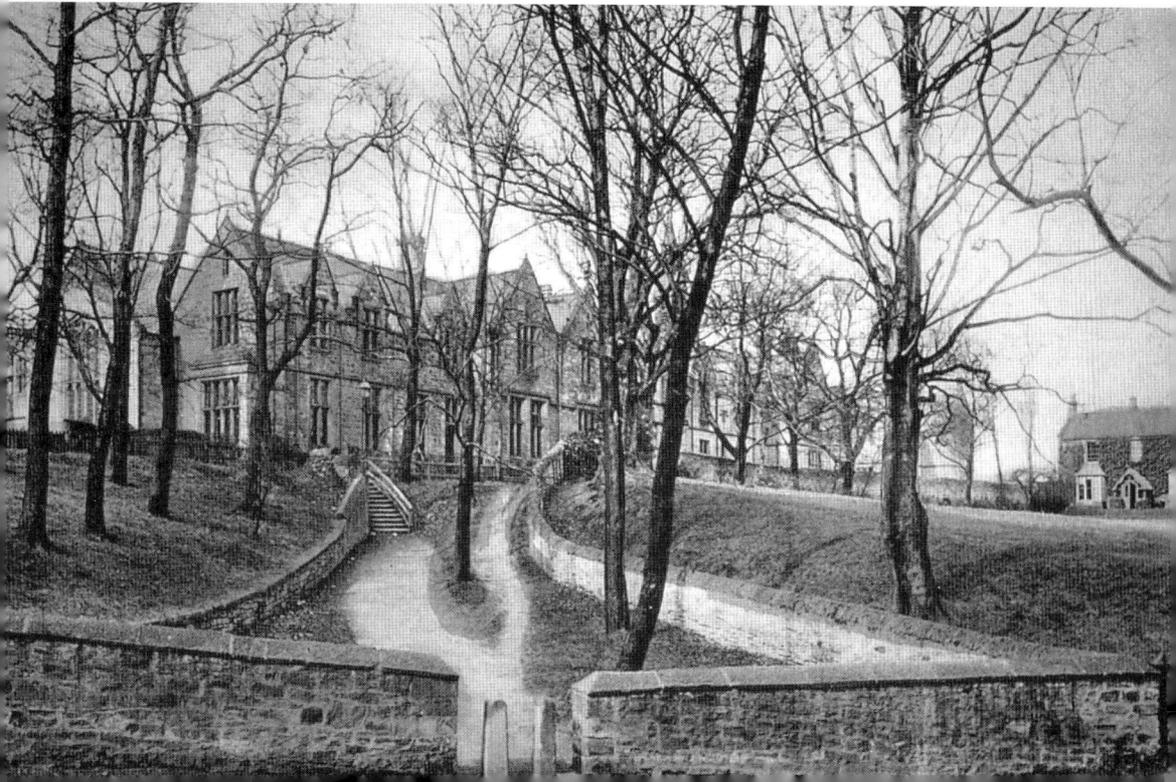

unceremoniously stood up at the end of the short table near the 'arena'. Scared as I was, I started to sing, 'God save the Queen', *[sic]* and had hardly got going when a fusillade of books hit me on the back of the head and shoulders and literally knocked me off my perch. Roars of laughter from all but me. That was that, but worse was to come. After several other songs from juniors came boxing, and the bouts were announced. I had no experience, and was matched against another lad about my age. Gloves were ceremoniously put on; no 'seconds' but announcement went,
'Round one – Go.'

All I could do was just plain non-stop pummelling, so fast and continuous that my opponent hardly got a shot in. Great applause from 'the gods'. One round only.

On another occasion when the Head of House was also the Head of the 'Babies' Dormitory' (in which there were eight of us juniors, the Head of House and another senior. None of us liked the Head of House – too cocky, and made fun of the weak), he had matched me at 'Hall singing' with a much bigger boy, and though I put up a good scrap and got some applause, I ended up with a lovely black eye. I managed to hide it during prep, but when we went to bed, the Head of House was obviously scared, and cautioned me to keep my head turned away from the light – obviously to avoid 'Jock' Beith noticing it when he came round the dormitories for his nightly chat, as he might have asked questions about who-done-it, and why I was matched against a much bigger boy.

After a year or two, I ceased being a boarder and turned day-boy. It seemed stupid to be limited to 'bounds' in my home town and environment as a boarder. Friends and I frequently 'broke bounds' along the riverside and up Tinkler's Lane, and over the wall in Ravensworth Terrace where we lived, and later returned armed with 'tuck'.

I'm off again. 'Tuck' reminds me of 'the little shop' up an alley opposite St Margaret's School in Margery Lane.

On Sundays the seniors used to bribe us juniors to go to 'Little Shop,' which meant breaking bounds from the bottom of 'Teep' Lane *[once known as 'Colly Rippon's,' and now called 'Blind Lane']* ('Teep' meant where seniors went for a surreptitious smoke)/Clarty Lonnen *[local dialect meaning 'muddy lane;' now called 'Clay Lane']*. On Sundays we had to wear top silk hats and Eton jackets (otherwise known as 'bum freezers') – result made it difficult to conceal contraband if caught. Obvious place – in your 'topper'. Being trained to raise our hat when meeting our elders and betters, male or female – one Sunday afternoon another boy and I were returning with a load of contraband in our hats when (just not quite in bounds) who should appear on the narrow path on the blind bend in the road but Mrs Hillard, the Headmaster's wife! Were our faces red, but we managed to slide past by only touching our hats just as we got level with her. We saw her look round, but heard no more about it – sport she was!

We had to attend Abbey *[the School's traditional name for the cathedral]* Service twice on Sundays, and filled the South Transept – eating jelly babies from Little Shop. If there wasn't a sermon in the afternoon service, we had to suffer a school sermon in the Galilee chapel before evensong.

Above: Winter on the riverbanks near Prebends'
Bridge, 1900s.

Right: The riverside: looking towards Framwellgate
Bridge from near Durham School boathouse, 1890s. *[MR]*

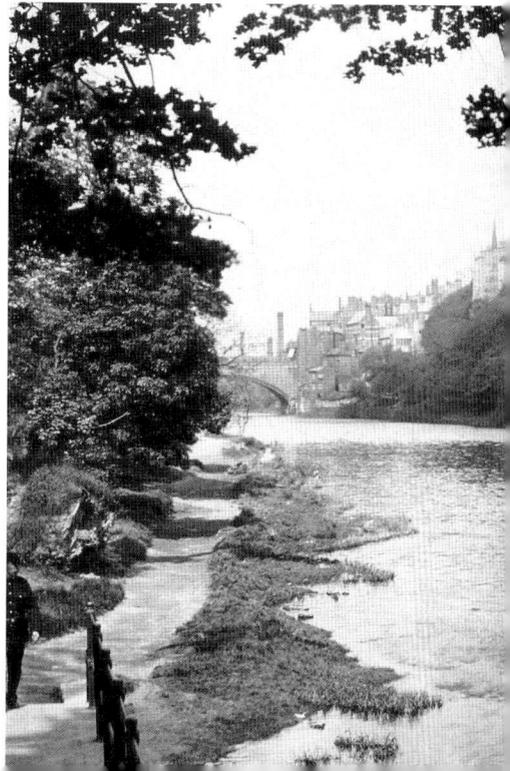

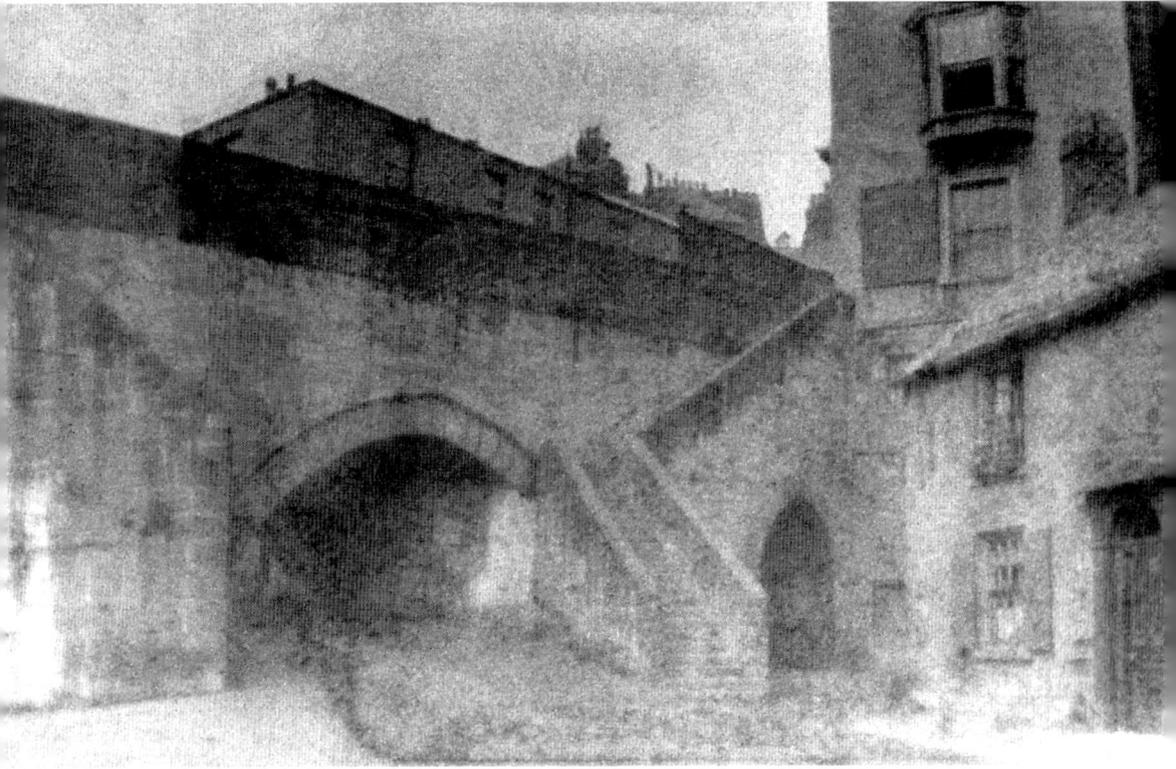

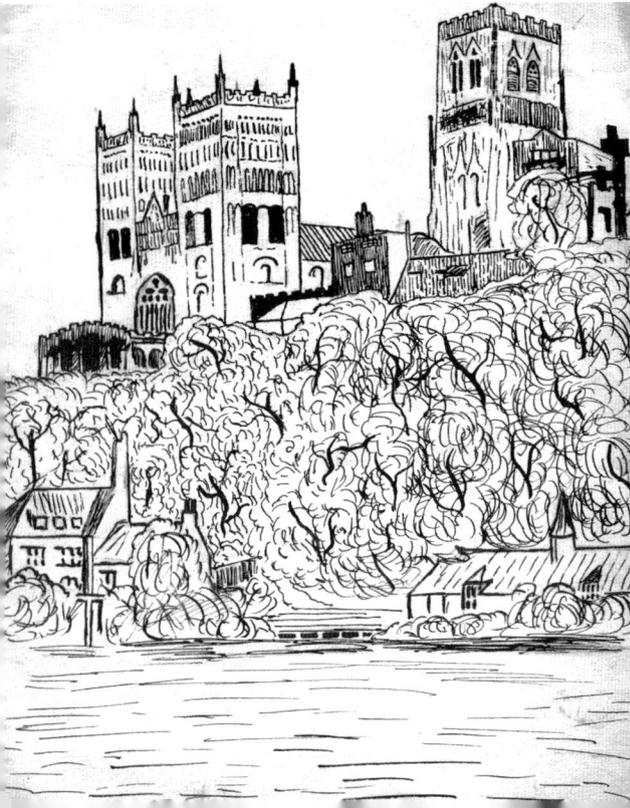

Above: Along the riverside: the steps up to Elvet Bridge, seen from the end of Brown's boathouse, 1900s. (The archway to the right of the steps was one of the old gaols. The small house on the right stood where the corner of the 'Prince Bishops' car park is now.)

Left: The cathedral from the riverbanks (pen-and-ink drawing by J. Landt Mawson, aged fourteen).

Talking about breaking bounds again – somewhere about 1903 *[1904]* 'Buffalo Bill's' Wild West Show came to Durham – a huge concern run by the famous Col. Cody – and was to give a show on the Saturday afternoon. My father asked McKenzie, the Caffinite Master whose house I was in, if I could have the afternoon out for him to take me to see the show; but permission was refused, and the whole school made to play cricket on school playground to prevent any boy going to the show, for some reason best known to the master. How aggravating it was playing cricket that afternoon and hearing the shots, war-whoops of the Indians and general noise of the show!

The show was held on the field below Little High Wood, behind Elvet Pit, opposite the New Inn and Bow School. Elvet Pit – the pit-head was still there next to the road, with its ovens, steam boilers and the rest – was the open field upon which now stands the university's science laboratory (no wonder it's cracking: it's over the old pit workings!).

Another boy and I were so keen to see something of the show that I had found out the time and place of arrival – Gilesgate Goods Station – so he (another Caffinite) got up with me at about 3 a.m. We went down to the Caffinite stoke hole and escaped through the coal-chute, and so got free and went to the show field. We got there in time to see the whole concern arrive – Indians, cowboys, lovely horses, and wagons, and all the rest – coming in column from Hallgarth Street and entering the corner gate on this lovely sunny summer morning. We watched them pitch their tents and wigwams, light fires and generally fix the awnings round a huge area, leaving the inside open to the heavens.

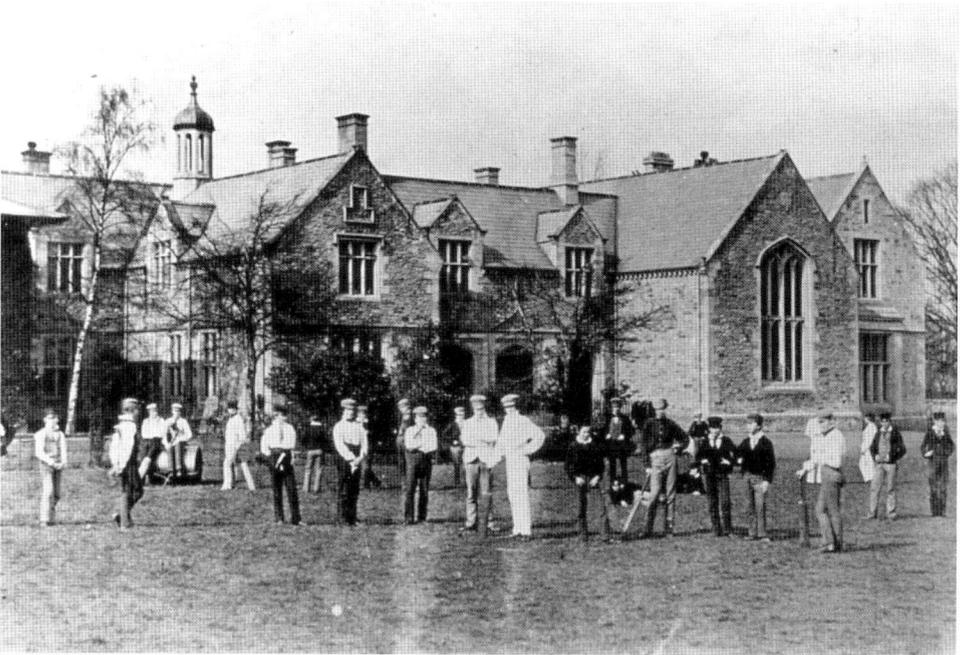

Cricket at Durham School, about 1855 (photograph by Revd Henry Holden, Headmaster from 1853 to 1881). *[MR]*

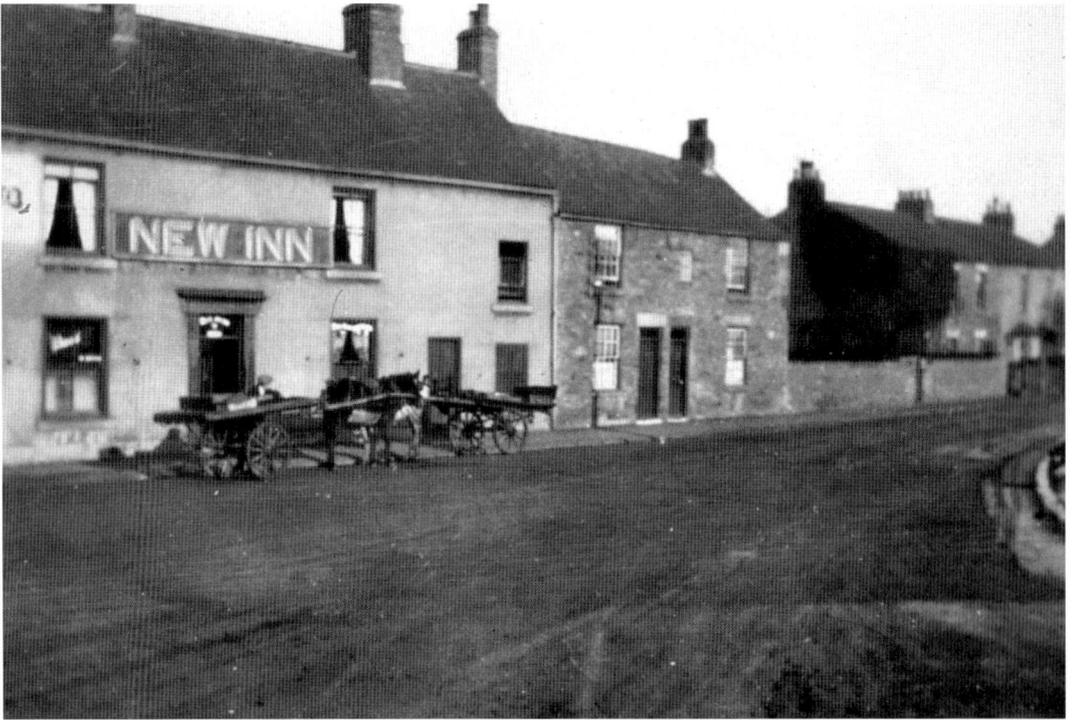

Above: The New Inn, 1920s (opposite Elvet Pit). *[MR]*

Below: Elvet Pit from Mountjoy, about 1904 (now the site of many university buidings). *[MR]*

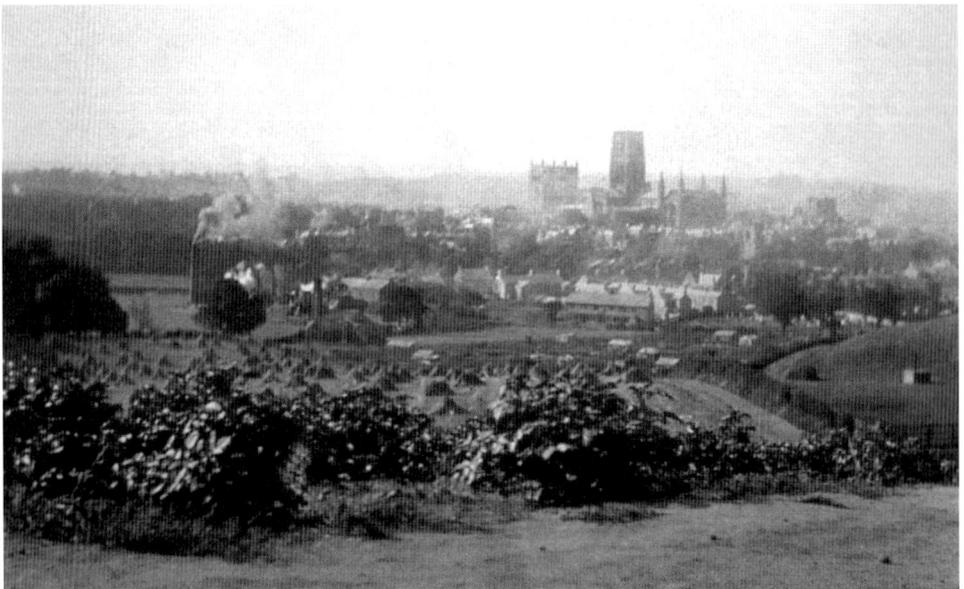

Then as they settled, some of the cowboys started practising with their lassos, and actually trussed up my friend and then yanked him off his feet onto the grass; and when they got him up again, completely unroped him the same way.

We got back to school by 7.30 a.m., with no one in authority being any the wiser!

And then came the time I turned day-boy and travelled on foot from Ravensworth Terrace to School for 8.10 a.m. by school bell. How I remember the daily trek, meeting the same people going to work every morning, right on time. So prompt, in fact, that I remember meeting two women who worked at the Co-op Stores in Claypath one morning on Framwellgate Bridge instead of the wide flagged path in front of St Nicholas' church, and hearing one say to the other

'We must be late, meeting that boy here instead of by the church!'

And so those carefree schooldays gradually passed.

A poster advertising the show, 1904. (A contemporary local newspaper report confirms that the show was in fact held on the engine field behind Elvet Pit, and not on the Sands.) *[MR]*

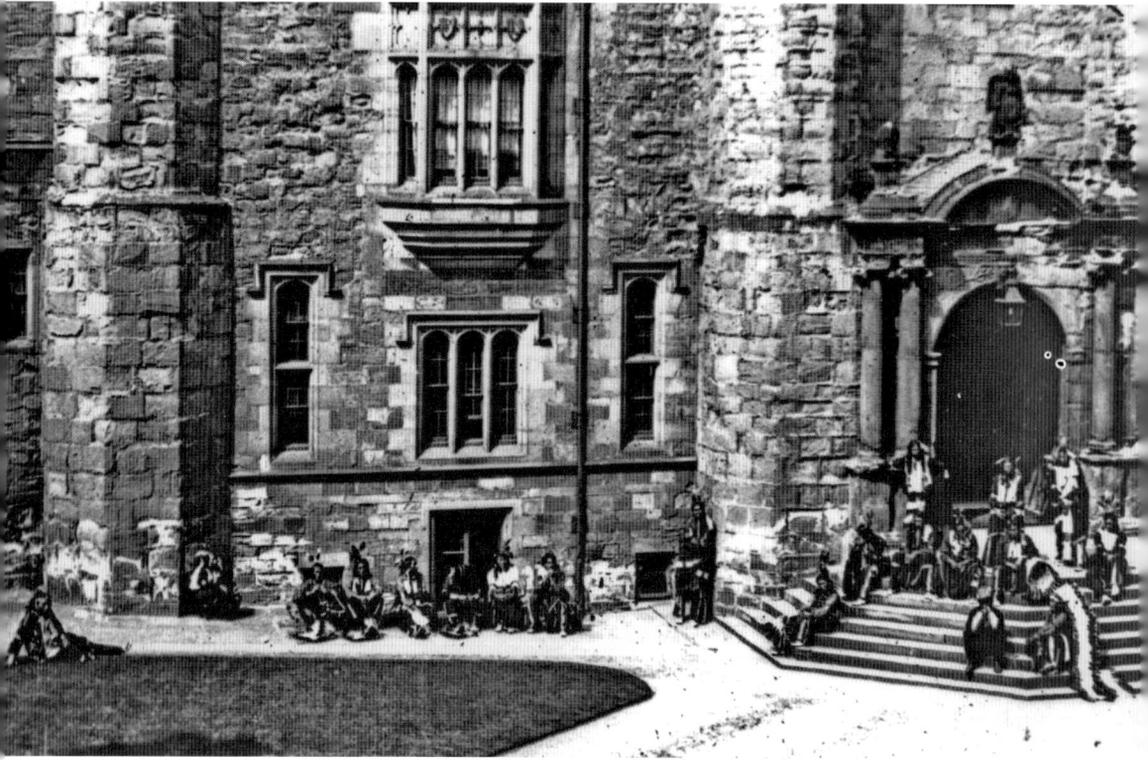

The Red Indians in the courtyard at Durham Castle, 1904. *[MR]*

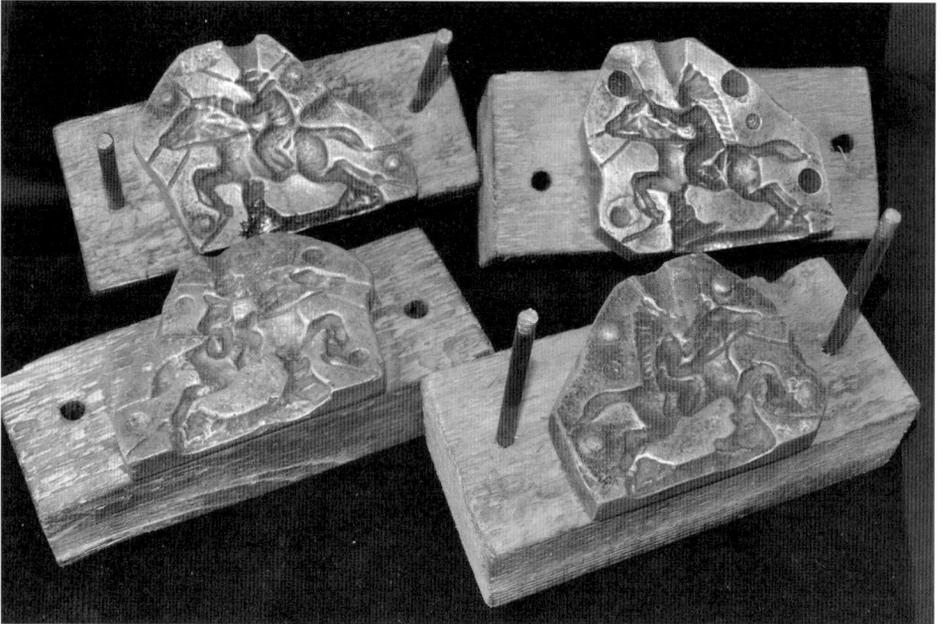

Moulds, sold at the show, to cast your own lead cowboys and Indians. *[MR]*

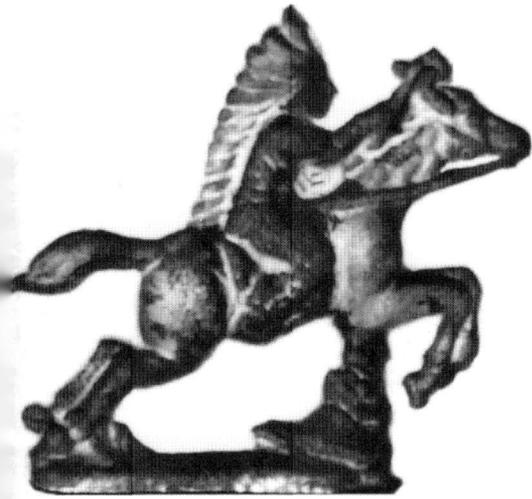

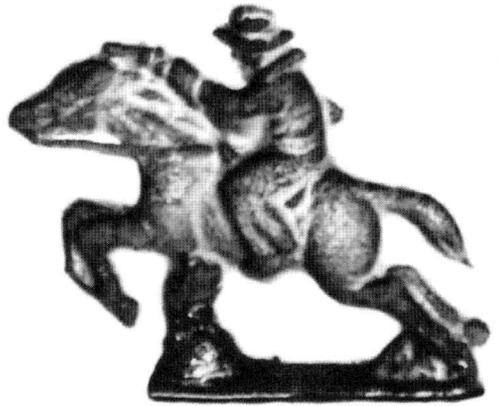

Above: An Indian and cowboy from the moulds.

Right: An Indian from the show. *[MR]*

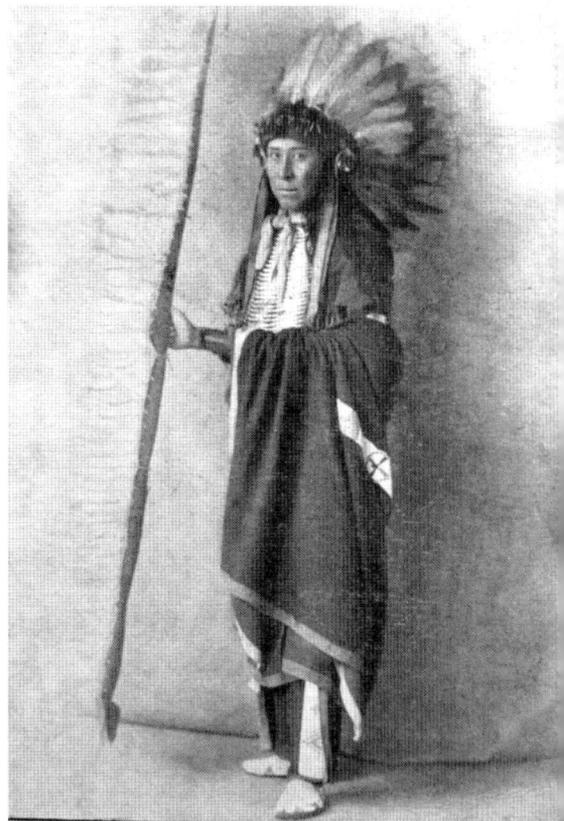

CHIEF LONE BEAR.
WITH BUFFALO BILL'S WILD WEST.

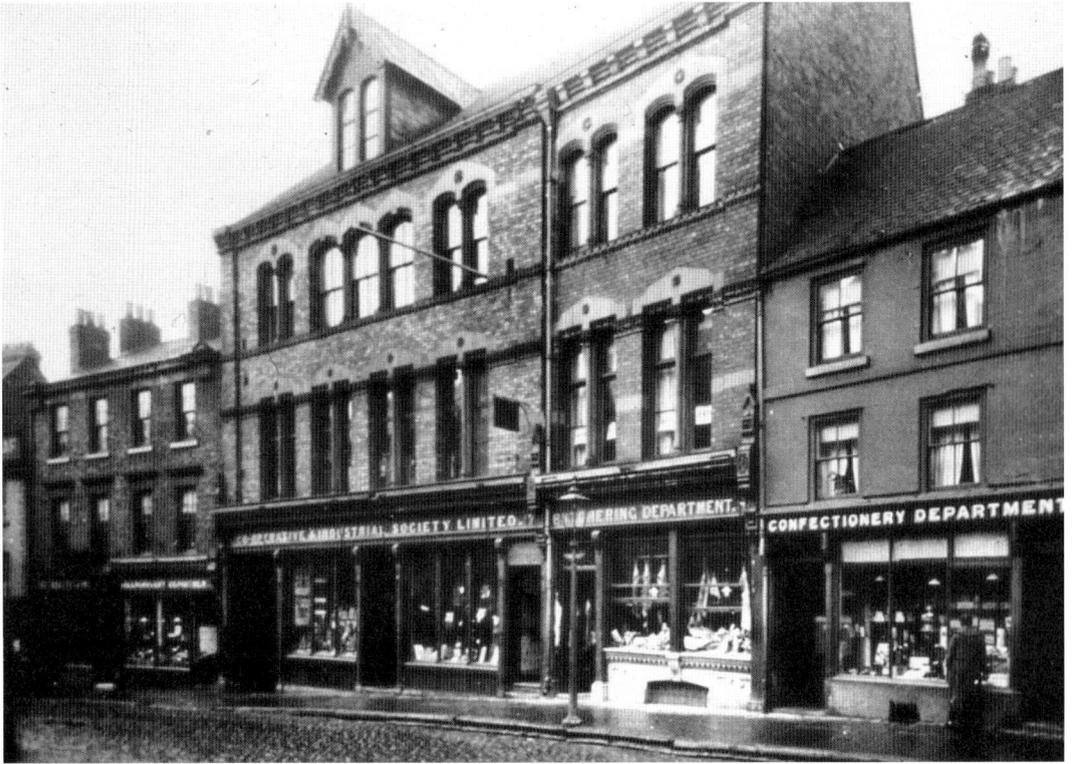

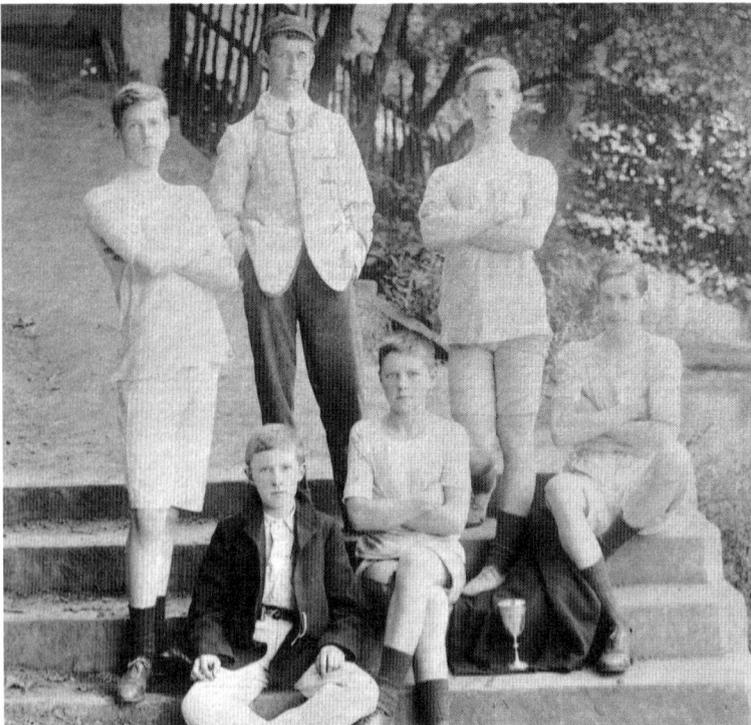

Above: The Co-op stores in Claypath, 1900s. *[MR]*

Left: Day-boys rowing crew, 1905. Standing, left to right: A. A. Guest-Williams, T. Rushworth, [J. K. J.] Haworth. Seated, left to right: J. L. Mawson, D. [S.] Cumberledge, W. A. Guest-Williams. (The initials in square brackets were not legible on the photo surround, but I was able to find them in the Durham School Register for that time. The photograph was taken by John R. Edis.)

Along the River Wear

On our way to school we went up South Street and had to run the gauntlet of the girls who worked at the stocking factory, who deliberately bunged up the footpath and caused a bumping match as we barged through. They started work at 8 a.m. This factory was just below the then technical school [*the Johnston School, which later incorporated the old factory premises*], which has now been taken over by the Revenue (Tax Office). [*All have since been demolished and replaced by modern 'town houses'.*]

Strange how I remember those cheery, happy factory lasses in their shawls and pinnies, and how later I came into contact with them when deputising for my father as Magistrate's Clerk, and then as Clerk myself. What I call real carefree, genuine good 'bad lasses' – who never bore anyone ill-will, just got one too many over the eight and made a nuisance of themselves in the streets on Saturday nights. Typical names – dare I mention – Mary Ann Carroll, Mary Ann Finan, Maggie Melia, and their pals Pat Murphy, Denham Ringwood, Eric Vasey and the rest. Nearly all living in those fine old houses in Milburngate and Framwellgate – once the houses of the aristocracy, but by then slum property, and now demolished. I had reason from time to time to visit these fine old houses – say on King's Proctor, divorce business – interviewing witnesses and the like. Lodging-houses, and huge rooms with several families to a room behind curtain partitions. Lovely oak-panelled rooms up once-magnificent staircases, almost equal to the black staircase in the castle. Mrs Carroll's lodging-house, where tramps could lodge for 4*d* a night. All gone long since. As also the smell of drinks, methylated spirits and general insanitary conditions.

Further down the river (beyond Martin's flour mill and Henderson's carpet factory), at the bottom of Sidegate, there lived a bloke with a boat who'd turn out and row you across the river to the Sands side for ½*d* (and vice versa, if you could get him to hear you whistle or shout). This trip could save some time and some walking from Claypath to Framwellgate.

During my time at Durham School, a friend was Walter Laidler, whose father and uncles ran a brass foundry and plumbers and gas fitters business where McIntyres Garage now is [*1968 – now replaced by modern university buildings*], next to the City Hotel and past the Half Moon Hotel in New Elvet. Together we got up to sundry pranks.

Laidler's made the miners' safety lamps, and as a result, threw out considerable numbers of metal discs cut out from sheet metal. These discs were about 3 to 4 inches [*8–10 cm*] in diameter, and were apparently useless. The high bankside on the opposite side of the river must have been littered with these discs, because we spent many a half-

Looking down South Street from the top (pencil sketch by Amanda Stobbs, 2010).

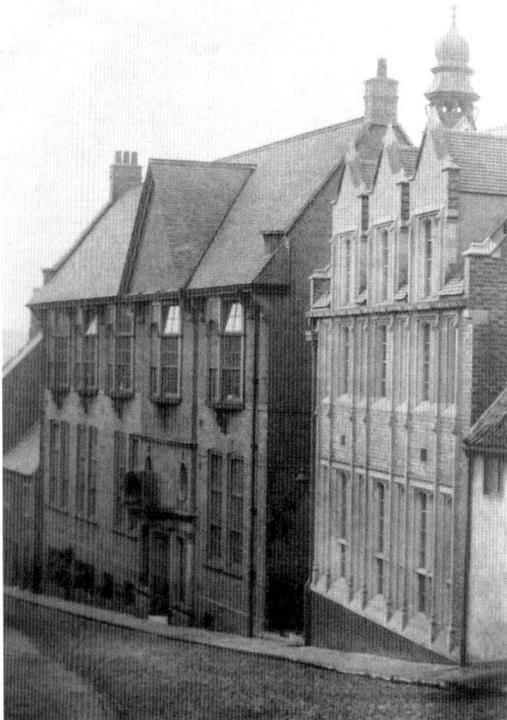

The Johnston School at the bottom of South Street, about 1912. *[MR]*

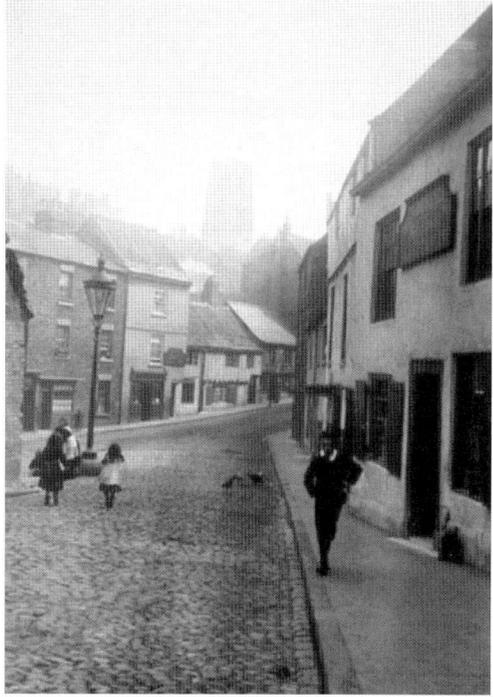

Looking from the bottom of Framwellgate down into Milburngate in the 1890s. *[MR]*

A seventeenth-century oak staircase in Lyon's Café (at the top of Silver Street, next to Lloyd's Bank), 1920s. *[MR]*

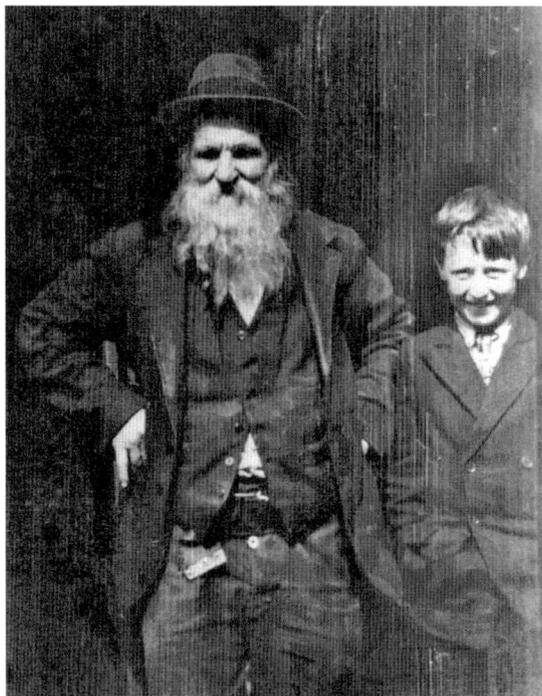

'Old Beaver' – a permanent lodger
at Mrs Carroll's lodging-house
– with Jack Adamson, Mrs Carroll's
grandson, about 1929. *[MR]*

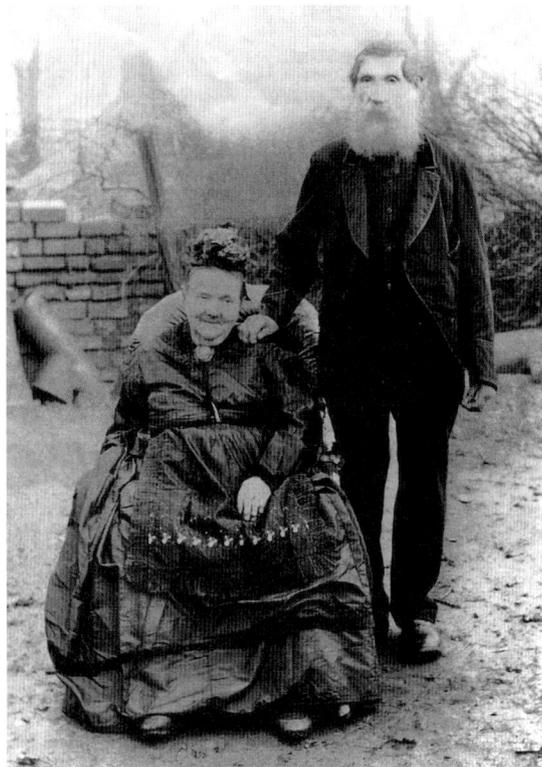

The Sidegate boatman, Robert
Lovegreen, and his wife Margaret,
about 1896 *[E. Shaw] [See page 186].*

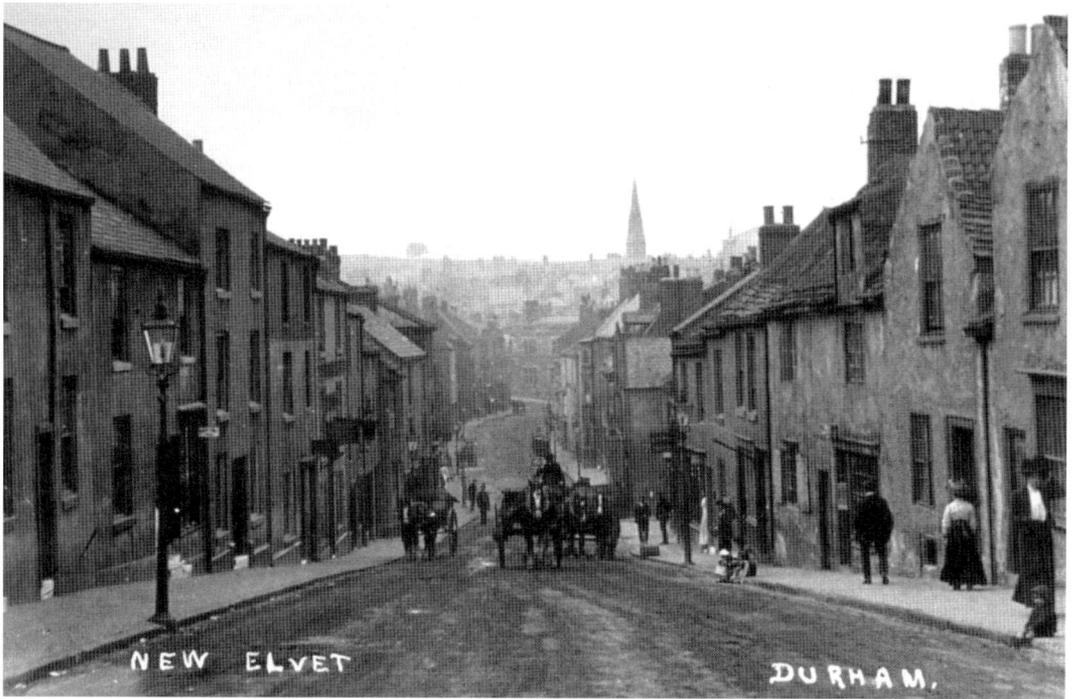

NEW ELVET DURHAM.

Above: Looking down New Elvet, around 1900. (The City and Half Moon Hotels are on the left at the far end of the road; almost all the other buildings in this picture have since been demolished.) *[MR]*

Right: Joseph Stobbs' miner's safety lamp.

hour throwing them from Laidler's Yard, from the low wall, to see who could get one to land highest up the opposite bank. The flight of these discs was really beautiful to watch, as they wove (weaved?) so gracefully across the river.

In those days, the land between St Hild's College and the river was divided into many small sections and let off as allotment gardens, one of which my father rented, and spent many happy hours there – before breakfast, and other spare time. He had a beautiful little summerhouse there with a seat, the lid of which lifted up to disclose garden tools, and a little cupboard for a small 'Beatrice' oil stove and general picnic necessaries. Also attached, a tremendous rain tub, about 5 or 6 feet *[roughly 1½ –2 m]* deep.

At the entrance to Pelaw Wood was a little stone bridge over a beck, which came down a deep ravine extending from somewhere behind St Giles' church and beyond, past the Barracks and Pelaw House. I don't remember tracking it to its source, but there was often a pretty substantial flow of water.

On holidays, we used to go to the allotment and get tools, and then go to the beck, well up, till we found a suitable spot with plenty of sods and clay available from the very high, bare bankside on the church side of the beck, and plenty of wood, branches etc on the wooded side. We'd skilfully pack these across the ravine with a big 'key' tree-trunk to dam the beck. Sometimes we took days over the job, and more than once must have had 8 feet *[2½ metres]* or more depth of water banked up against the dam. Our object was to get a head of water dammed up so big that, when we let the dam away, it would come down with such a 'whoosh' that it would flow over the low wall of the bridge at the bottom, and into the river. We never succeeded that I can remember, but we did get it just above the top of the arch. Then we'd watch the discharge of dirty brown, muddy water with leaves, twigs, branches and lumps of wood, gush into the river – you could follow it as far as Elvet Bridge or further before it got lost in the general river water! The wonder is that we never got caught by the 'whoosh' – but it was quite a sight; and when all was over, there was quite a delta of gravel, clay and debris extending quite a way into the river at the bottom of the beck.

What energy we must have had, and what daft things we did for our fun – all innocent stuff, though, which harmed nobody – never any kind of destructive, deliberate damage. Perhaps we broke things accidentally, but owned up and made good at once. For instance –

One lovely day in the holidays, Walter and I decided we'd use our boat (my father used to pay Brown the boat-builder at Elvet Bridge – son still there *[1970s – the business has since closed]* – an annual fee for use of a boat at almost any time) to see how far up the river was navigable. Our parents packed up our 'eats' for the afternoon – Walter's, I remember, was in one of those rectangular baskets with a lid which folded over and had a handle – in fact the type then used generally by railway signalmen, engine drivers and such for their 'bait' *[packed lunches]*.

We decided we'd take a Canadian canoe – in which the stern man sat on a little raised board as a seat, and the other sat in the bottom of the boat – and away we paddled. First 'obstacle' was the 'rapids' just above Shincliffe Bridge, but we didn't have much difficulty in negotiating this, as we found a rather narrow channel of swift-flowing water deep

Durham. St. Hild's College.

The allotments between St Hild's College and the River Wear, about 1900. *[Postcard]*

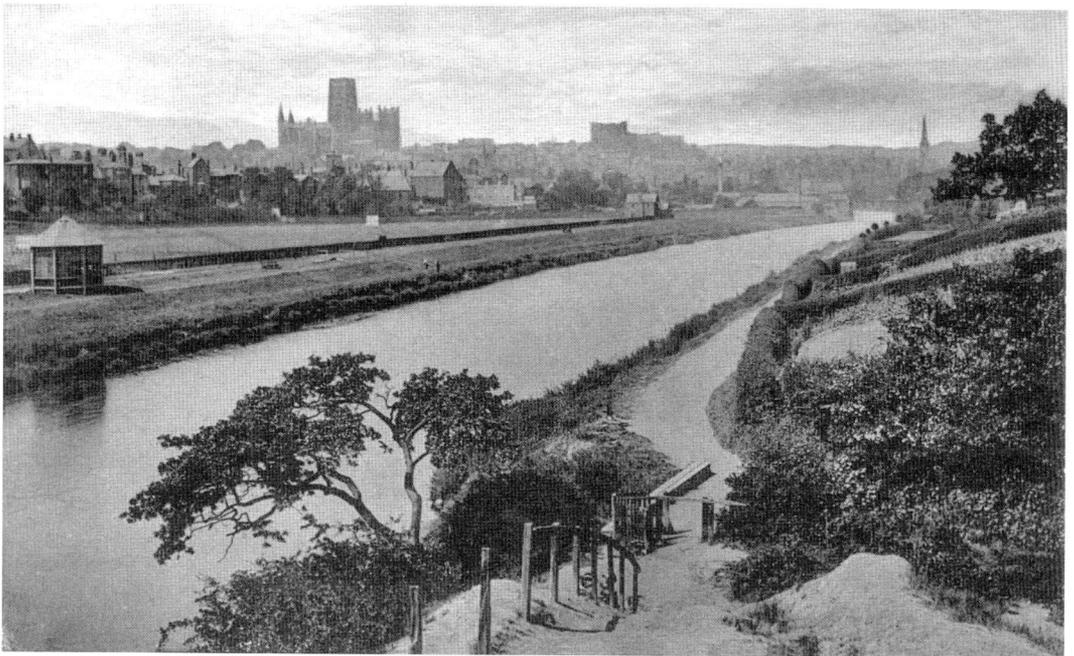

Durham from Pelaw Wood, about 1900. (The 'little stone bridge' can just be seen at the foot of the path. The bandstand and racecourse are on the opposite bank.) *[Postcard]*

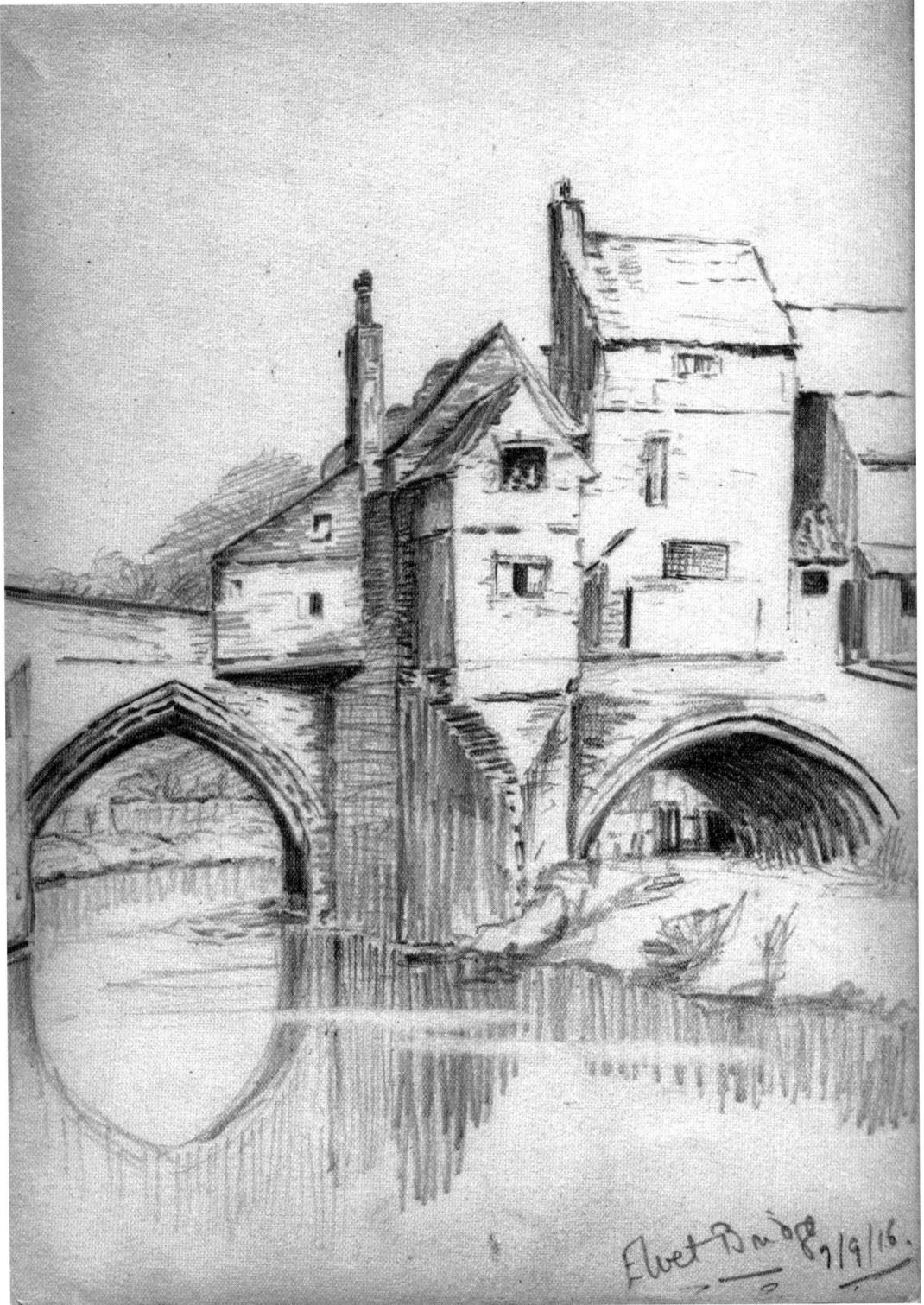

Elvet Bridge 7/9/16.

Above: Landt and friends on the river below Shincliffe (the tip of the church spire is just visible above the horizon). Photo taken by Frieda Mawson, 25 May 1915.

Opposite: Elvet Bridge, 1915 (drawing by Flora Mawson).

'Above Shincliffe Bridge', 25 May 1915.
(Frieda Mawson is seated at the rear.)

enough for us to 'rush' after being spun round and driven back once or twice. After that we negotiated several other rapids – in some cases scrubbing the bottom of the canoe and 'punting' ourselves over the river bottom, and presently the ends of the paddles became decidedly frayed and chewed up – but we pressed on until nemesis overtook us well round the bend beyond the 'flats' beyond Shincliffe Hall.

We had reached a particularly vicious and fast-flowing set of rapids, and after several tries, got stuck on the river-bottom in quite a powerful flow of water. I was sternman and Walter on the bottom. We stuck our paddles like punt-poles on the river bed, one at each side, and then heaved and pushed. Unfortunately, Walter had a better purchase than I, with the result that the canoe spun round on a stone as pivot, and the River Wear rushed into the boat and tipped us into the river out of the boat, which sailed away on its own with cushions, bottom boards and the rest floating beside it. I think we saved everything and got all together on a gravel bank further down. There, we upturned the canoe to empty it, and saw the damage – a main board stove in towards one end, with its jagged edges sticking in, obviously done by the stone or boulder on which we had pivoted.

Shincliffe Hall, mid-twentieth century. *[SLHS]*

We tried to press it back and 'stopped' it with clay from the bankside, but it proved completely useless when we launched the boat. What to do next? Knowing the district well, I walked back to Shincliffe Hall, where lived Harry Peele, the vet (whose son *[John]* is still in practice in Durham *[1970s – he retired in 1986]*). He listened with considerable amusement to my account of our escapade. Best he could do was supply me with some putty. So back I went, and we tried putty instead of clay, but it was little better.

We thought things out, and discerned that with only one aboard, and a big boulder under him at the stern of the canoe, the front of the boat came sufficiently high out of the water to keep the 'breach' above the water too, albeit making the handling pretty tricky, but manageable. And so – one boating, and the other on foot carrying cushions, etc., in turn – we ultimately got back to Brown's boathouse, to be 'told off', dismissed our ship, and we'd be told what it would cost us in due course. But what a day! In spite of it all, we'd enjoyed it, and often discussed it later. 15s *[75p]* it cost us: seven and sixpence each, paid by 6d *[2½p]* a week out of pocket money. Such was our fun in those happy, carefree days!

Gas and Electricity

I wonder how many people can remember the times before cinemas? They first came to my notice when quite a small boy. Long before cars took possession of the Market Place, and when it was paved with the old-style round cobblestones, sundry side-shows used to set up in the Market Place for spells of a few days to a week or two: circuses and boxing booths and cinemas!

One immaculate gentleman – and I mean both immaculate and 'gentleman' – named Randall Williams, would be the first to bring the silent movie film shows to Durham (the nearest date I can put to it now would be around 1900 or thereabouts). *[In fact, Randall Williams himself had died in 1898, but his son-in-law, Richard Monte, took over both the show and his father-in-law's name.]* He set up his big tent in the Market Place with a truly magnificent organ at the front, which even in those days must have cost thousands, the like of which I have never seen since. It had almost life-size figures which beat drums and clashed cymbals, and masses of organ pipes with ornate decoration all about them – all beautifully painted and really artistically designed and coloured – the organ driven by a steam engine out of sight at the side and providing adequate lighting with the old type of electric bulbs – lots of them. Street lights had the old type batswing burners – dim things; and incandescent would be just coming in then. But the organ front at night did put them in the shade.

This organ was a great attraction, apart from the novelty of the 'motion pictures', and many of the local aristocracy used to come and stand and watch, and listen to well-rendered good music. Such as I remember: 'Daughter of the Regiment', 'Zampa', 'William Tell' and the like – all within the range of Harrington's fish and chip van (more about that presently) parked by St Nicholas' church. Best seats in this show were threepence – a penny minimum – and the film that struck me most was my first glimpse of a Canadian river with water rapids (in black and white, of course – long before colour photography), and some sort of slapstick comedy with bowler-hatted fat men pulling over bookshelves on top of themselves. All very 'jumpy' and a strain on the eyes; and all quite silent, with captions now and then. When the film was running, only the sound of the whirring bioscope *[an early type of film projector]* could be heard!

It would be about that time that Charlie Chaplin would be at the Palace Theatre as one of a troupe of acrobats and dancers called 'The Eight Lancashire Lads' – or was that perhaps a little later?

And so back to Harrington's fish and chips van – 'two and one' meant a big lump of fish for twopence and lots of chips for a penny. The van was a sort of caravan with open

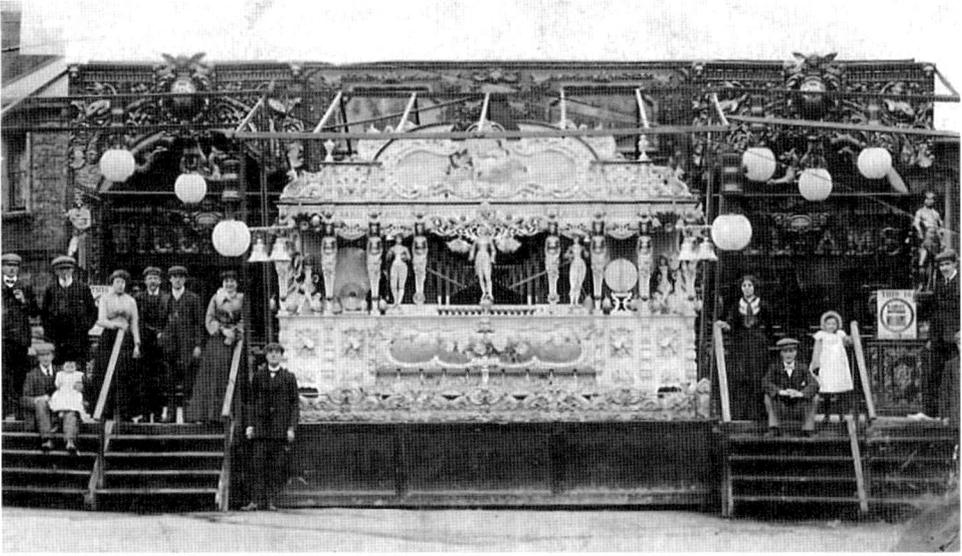

Randall Williams' bioscope (with eighty-nine-key Gavioli organ) at Hull Fair, around 1903.
[*D. Williams*]

Model of an early 1900s Showman's Steam Traction Engine – 'Randall Williams' used such engines, both to generate the power to run his shows and (instead of horses) to tow his trailers from venue to venue.

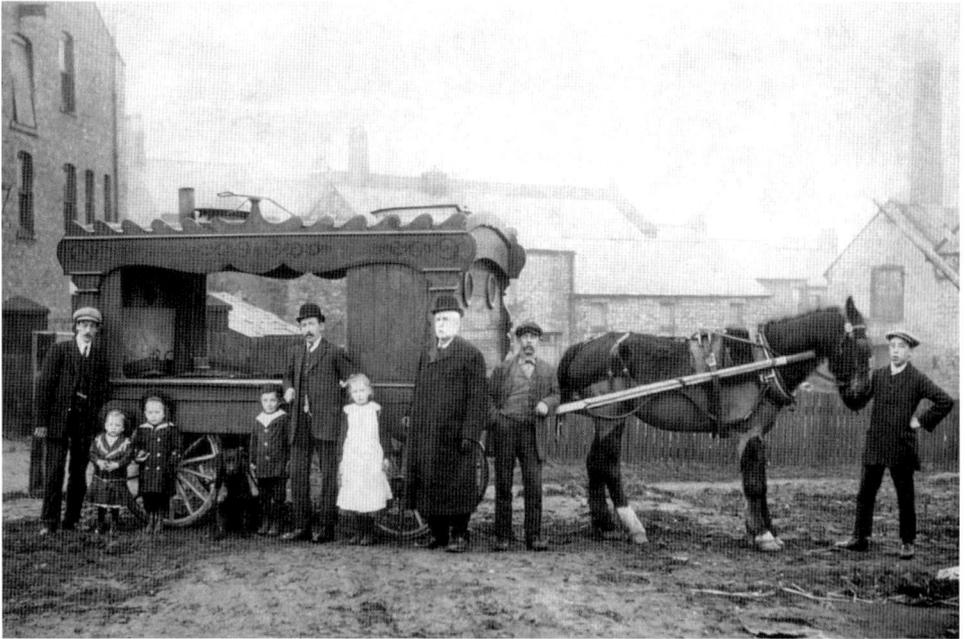

Harrington's van with Mr Joseph Harrington (centre, wearing the greatcoat) and his family, 1890s (at the top of Station Lane, Gilesgate). *[MR]*

sides, with a counter on which stood chipped enamel tin cans which were perforated at the top and contained help-yourself pepper, salt and vinegar. You got the lot in a sheet of newspaper, which went all 'soggy' before you finished your meal, but fish and chips never tasted better anywhere. A tip: if you want real potato chips – fry 'em in plenty of fat to a nice brown – then tip them onto a nice clean sheet of newspaper and fold over and scuffle them about for the newspaper to absorb excess fat; from time to time add salt and pepper to taste. Lovely! And eat them outside – out of newspaper!

At night these vans were indeed attractive – smell and taste – and lit by hanging paraffin lamps, which hooked onto a catch. Paraffin in a tin tank, tapering at the base to a feed-pipe to the ring-burner where the pipe curved to it, and giving a good smelly light from its numerous jets, and fizzing like a good siphon.

Funny how one memory brings back another. Gas, for instance, and light. The old batswing burners with a big round globe and the chandeliers which you could pull down or raise – with counter-weights hung over pulleys. If you pulled the chandelier too far down, the water seal started bubbling and the place stunk of gas. Then came the incandescent burner – then the inverted incandescent, as all along gas tried to imitate electric appliances. Often, gas pressure failed, and as kids we got scared stiff when the batswing burner gradually all but petered out on us. And what gas! None of your high-speed gas – just plain stinking gas, produced at Framwellgate waterside from huge retorts and furnaces – all hand-fed by men stripped to the waist and grimy with the coal. We used to watch them – with permission, as our father was a director

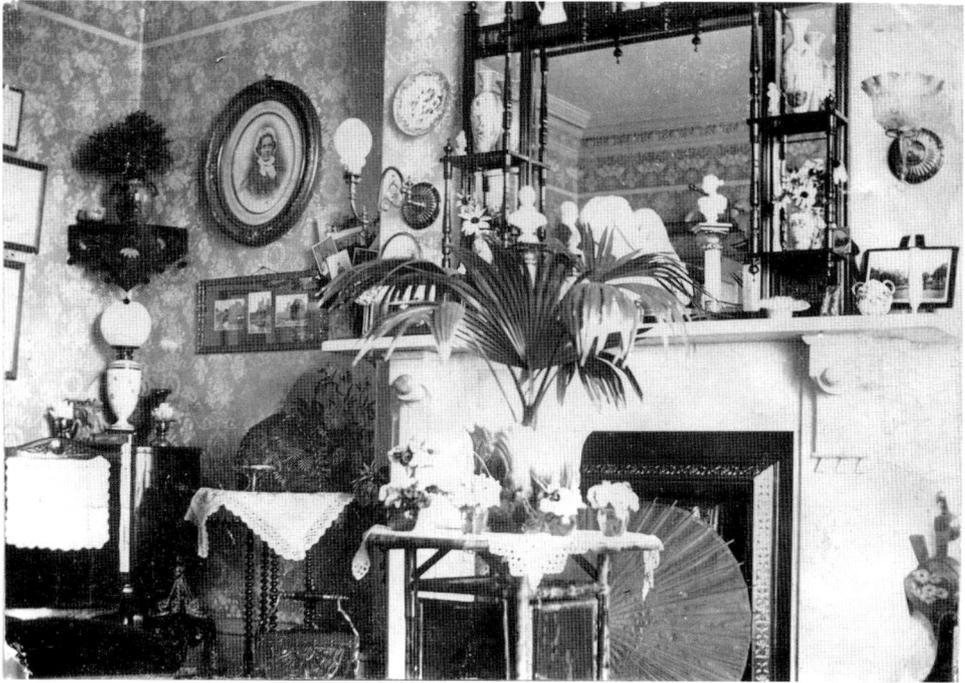

The drawing room at 10 Ravensworth Terrace, about 1903, with gas wall lights to either side of the mirror above the fireplace.

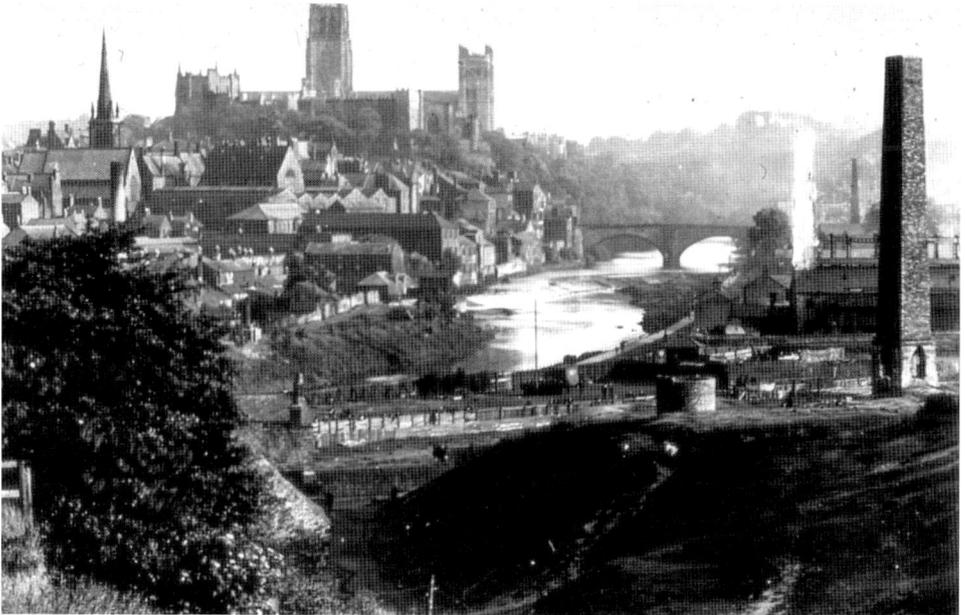

Shaft and chimney at Sidegate Colliery with the gasworks beyond, seen from Crook Hall (Martin's flour mill and 'The Islands' are to the left of the river) in the 1920s. *[MR]*

[30 & 37 Vict.] *Durham Gas Act, 1873.* [Ch. cxxvi.]

CHAPTER cxxvi.

An Act for incorporating and conferring Powers on the City A.D. 1873.
of Durham Gas Company. [7th July 1873.]

WHEREAS in the year 1846 certain persons formed themselves
into a gas company under the

*Durham Gas Act,
1873.*

49. All gas supplied by the Company to any consumer of gas Pressure of shall be supplied at such pressure as to balance a column of water gas. from midnight to sunset of not less than seven tenths of an inch, and from sunset to midnight of not less than one inch in height, at the main as near as may be to the junction therewith of the service pipe supplying such consumer ; and any gas examiner appointed under the Gasworks Clauses Act, 1871, may, subject to the terms of his appointment, from time to time test the pressure at which the gas is supplied, and may for that purpose open any street, road, passage, or place vested in or under the control of any local or road authority, and the provisions of the Gasworks Clauses Act, 1871, with reference to testing of gas and to penalties, shall, mutatis mutandis, apply to such testing of pressure : Provided that on each occasion of such testing, sufficient notice in writing shall be given to the Company of the time and place at which the same shall be conducted, to enable them to be represented.

Extract from the Durham Gas Act of 1873.

– and when we were kids, with I think it was whooping-cough, our mother's help used to take us to the gasworks to dig in the sulphur heap – which was supposed to help cure us. Did it? I wonder!

The gasworks produced sundry by-products – among them, tar. This was carted in a huge black barrel-shaped tank on a four-wheeler rolley all the way from Framwellgate via Silver Street and Claypath to the goods station *[at Gilesgate]*. It took two lusty horses in tandem to pull it, and sometimes three.

Coke also did the same trip in the old-type coal cart, usually managed by one horse. The coke was still hot, and clouds and wisps of steam floated above the load. Cheap stuff in those days, before the coke-burning stoves and fires such as the Aga cooker were invented.

Cooking in those days was mainly done on the huge old black kitchen ranges, which also heated the water in larger houses; and in the miners' houses were smaller ranges; and all were kept black-leaded, and polished where steel showed or brass knobs; and they were the pride of the housewife; also those steel fenders with flat tops, on

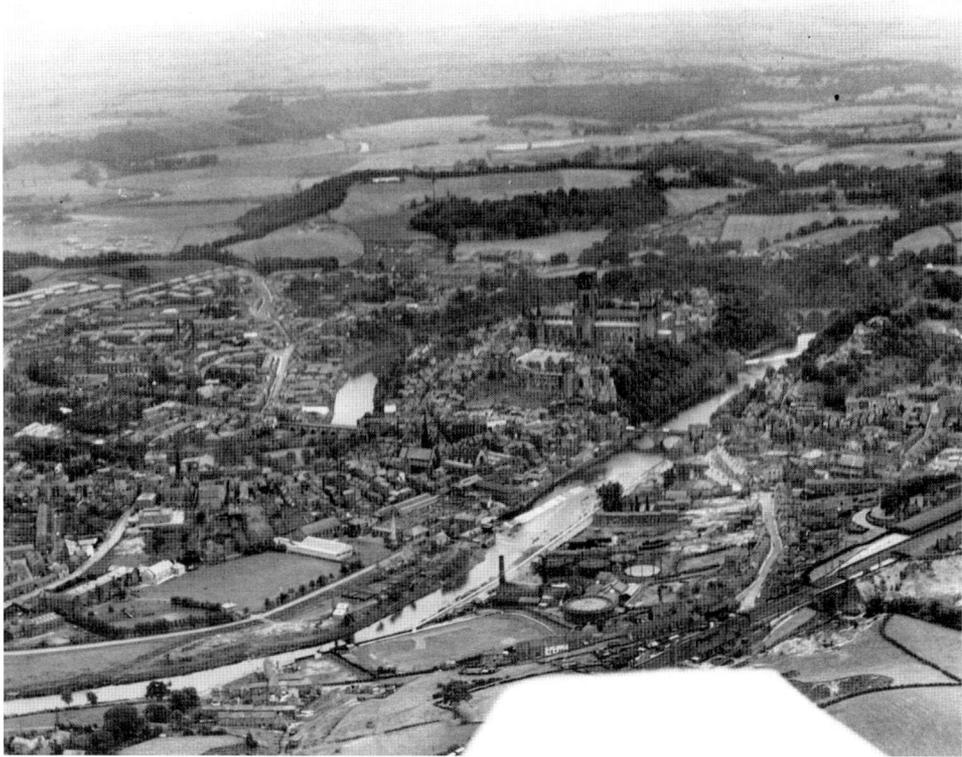

Durham from the air, 12 July 1938. North Road Station is mid-foreground, right; Sidegate Gasworks are visible just above the plane's wing-tip; the flour mill and the carpet factory are opposite them, at the end of the weir. Elvet Bridge crosses the further loop of the river; 1920s houses now line Whinney Hill, middle-distance, left; and Shincliffe is beyond them, just off the left of the photograph. *[Photograph by Roland Park, Newcastle]*

which pots were kept warm; also hobs at the sides. All real coal-eaters – but then coal was cheap. Then came these clumsy gas-cookers – devils to keep clean – and black gas-stoves for room heating; none of your fancy fronts and the convector types now available.

For all that, I don't think I've ever tasted bread and tea-cakes like those baked in those old ranges at home. There weren't any 'bakeries' as we know them now, with their leathery, tasteless stuff. If you did buy bread, it was mostly baked at the back of the little shop where you bought it. I can only remember one what I would describe as 'whole time baker' and that was Rickerby's – father and son – whose bakehouse was at the bottom of a passage in Claypath, nearly opposite the Gas Office. Occasionally we went there and watched them all covered in flour and looking so clean, putting in the loaves on those long-handled plates right along what looked like an endless tunnel, and drawing them out a beautiful shade of brown, and appetising.

A domestic gas wall light, still in use in 2011: with a faint hissing sound, it casts a soft light.

The Seaside

This takes me 'off the rails' again, and reminds me of the preparations when we went on our summer holidays – mainly to Redcar – then a simple, quiet little seaside place, with miles of golden sands.

We were a family of seven, and usually had a maid and Mother's help to provide for too. Thus there was a tremendous baking before we went away, and all the bread was packed into one of the big rectangular basket-type trunks (around moist towels), with handles at each end. Laundry had to be done too. And what a washing-day: all done with the old poss-tub and hand-turned mangle.

Then all the trunks, boxes and bags were called for by a carter (Dobbin) with horse and four-wheeled flat-cart, and taken to the North Road Station, where they were taken over by our old friendly porter – Bartle by name. All porters were clean, polite, strong and respectful, and dressed in the old North Eastern Railway green corduroy trousers and sleeved waistcoats with badged, peaked cap. What a contrast with the 1970s! And the station was clean and tidy too. But the star turns were the trains. All clean and polished, and only beaten by those beautiful creatures, the engines. The second they stopped at the station, out came fireman or engine-driver (or both) with their clouts *[cloths]* and cotton waste: cleaning up the paintwork and polishing up the brass and windows and steel – which shone like mirrors. They weren't hampered and hamstrung by rigid modern rules – and weren't they happy and proud of their machines!

But back to Bartle, who took over from the carter – transferred onto trolleys all the luggage, and pulled one and pushed the other onto the platform and put them into the luggage van – here it was my job to count the items as they were placed aboard – usually thirteen or fourteen pieces, and two, then three, bicycles! Bartle then saw us all safely aboard the train.

At Redcar, the procedure was reversed, and all carted to our lodgings on the sea front. The promenade wasn't very wide in those days, and it was very convenient for Mother to sit in the window of our lodgings where she could see us children as we played in the sand, and keep an eye on us.

Amusements were comparatively few: donkey rides; or hiring tricycles from 'Cook's' on the prom – 3*d* an hour; no cars then, but horse landaus – penny a ride 'round Redcar' (which consisted of along the front to just beyond Redcar Pier, where the prom ended; back along the High Street and up on to the prom again opposite Coatham Pier; and back to where you started). There wasn't much beyond Redcar Pier except

From left: a hand-turned mangle (to squeeze water out of the laundry), a flat iron (placed on the range to heat up while another was in use) and wooden and copper possers (to twist and agitate the laundry) – dolls' house versions.

Staff at Durham North Road Station, 1890s. *[MR]*

Joseph and Amalie on the beach, about 1908.

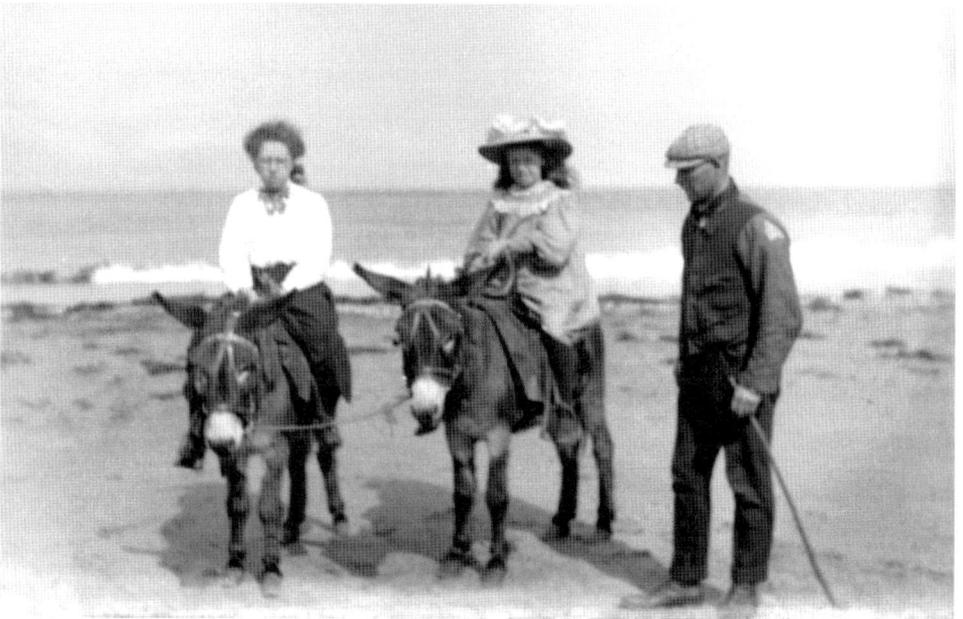

Dottie and Frieda on beach donkeys, around 1906.

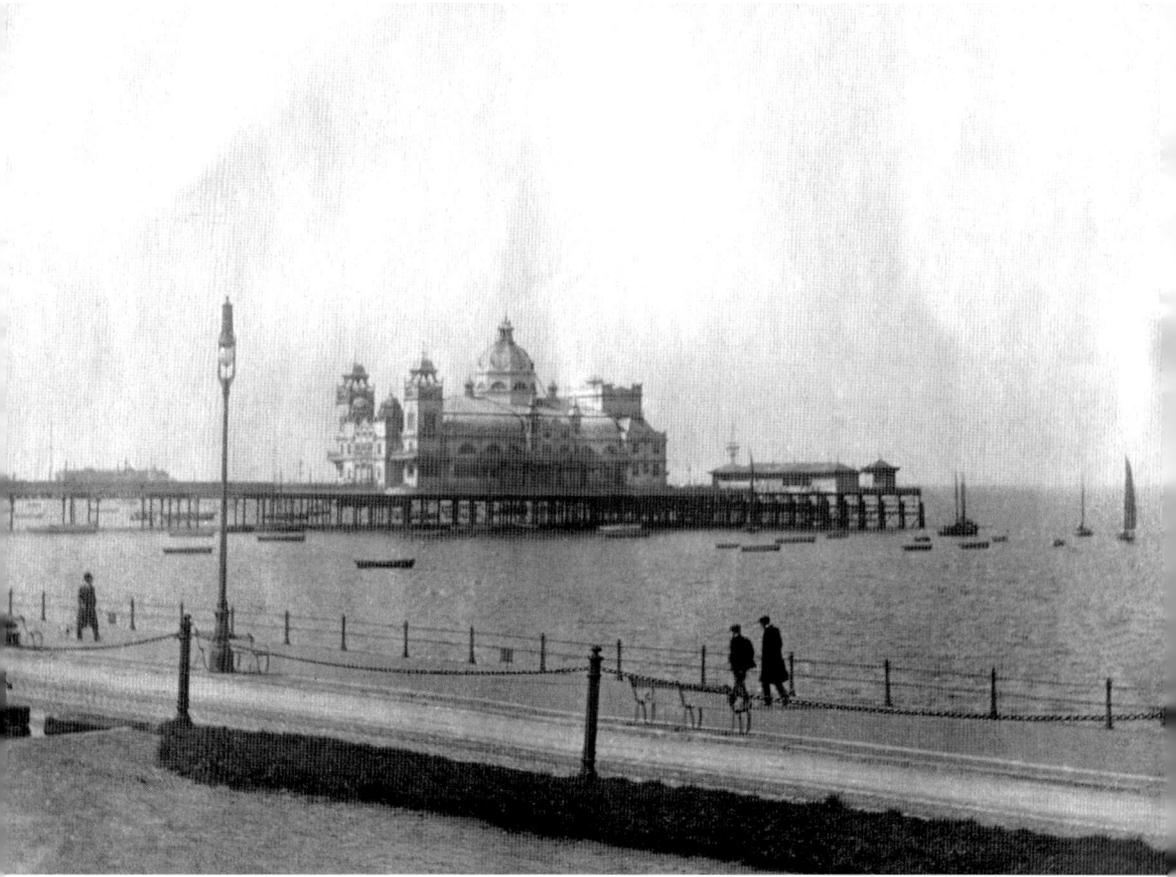

'The Pier' (location unknown – possibly Redcar), about 1906.

two or three fishermen's cottages and sandbanks; and the same beyond Coatham Pier at the other end.

One of the 'things to do' was to hire a landau and drive to Kirkleatham Gardens (and walk round eating fruit grown there) – open country all the way; peaceful: no motors then. Happy days!

Father used to come down at weekends, when we might bicycle 'round by Kirkleatham' – down Redcar Lane, and back by Coatham end. How long and dusty Redcar Lane seemed if we came back that way, usually tired and hungry. Remember, roads were rough going in those days, and bicycles were quite hard work – no speed-gears or free-wheel in those days, and the old 'tyre' brakes, before rim-brakes were invented; and a puncture was a real business with the old wired-on tyres, and all too frequent.

Holidays didn't cost much in those days – you made your own amusements: walking; playing games on the sands; fishing from the pier; or watching the fishing boats – cobles [*small, single-masted, flat-bottomed fishing boats*] – going out, and coming in after

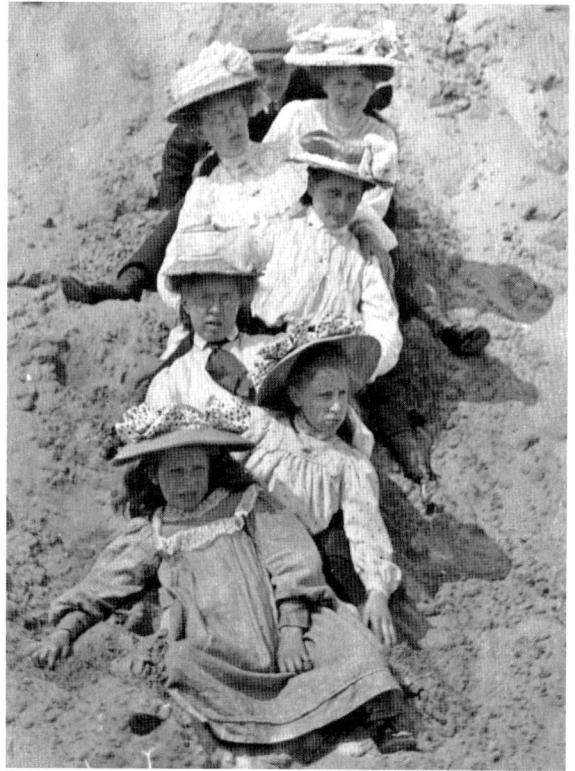

Right: Mawson girls and friends. From the rear: possibly Landt; unknown; Flora; unknown; Dottie; Anna; Frieda, around 1906.

Below: Anna, Flora, Landt, Dottie and Frieda – warmly dressed – about 1905.

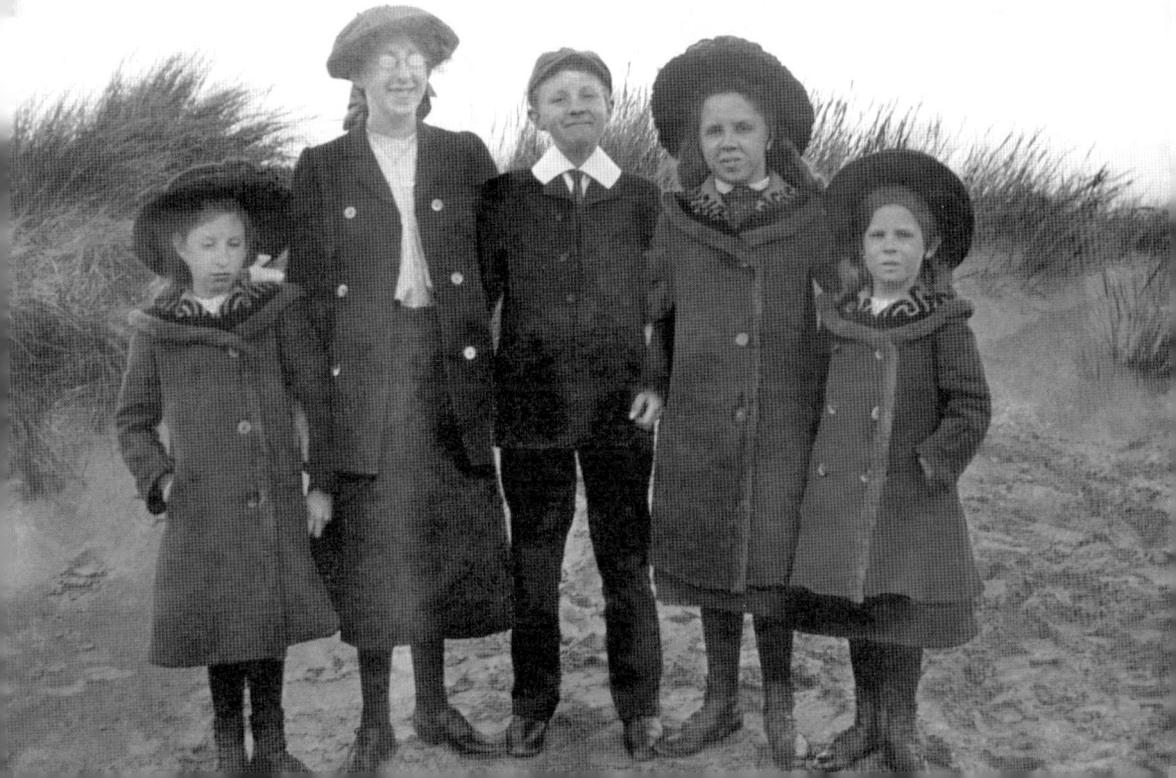

fishing; picnics along the sand banks. But there were also what we knew as 'the Bell Ringers', who played tunes on handbells; and there were pierrots. The most popular pierrot was an ugly big 'funny man' who obviously loved kids – we called him 'Weary Willy,' and he turned up year after year.

Another entertainment was the old barrel organ parading the prom with the then modern tunes. The owner went round with the hat *[to collect the money he was given]*. Sometimes they had a monkey with them, which sat on top of the organ – which was worked by turning the handle of a piano-like instrument mounted on a two-wheeled barrow – which sometimes served to carry a tub of ice-cream.

Another type of organ existed then – usually an Italian owned it. A smaller contraption, mainly a rectangular box which could be strapped over the shoulders to carry from place to place, and when being played it was supported on one single 'leg' which looked like a broom-handle. These were the men most likely to be wearing Tyrolean hats and to be accompanied by dressed-up monkeys.

Another entertainment, but much less frequent, was the blokes dressed up like a Russian, who handled a full-grown bear – which clumped about on its hind legs, 'danced' (*sic*), caught things thrown to it, and generally capered about. These gipsy types roamed the country, and somehow always looked fit and well, albeit somewhat dirty and maybe 'lousy' with 'sleeping out' in the hedgebacks or hayricks or barns.

While at Redcar or Saltburn, don't let us forget the old bathing facilities – though as I remember them, I would hardly call them 'facilities' – the old bathing machines – and bathing costumes! You didn't really enjoy them, I'm sure. The machines were hut-like contraptions mounted on four heavy wheels almost 6 feet *[2 m]* in diameter, all painted with thick tar. These machines had a door at each end with steps down outside. Inside were wood screens at each end, to prevent anyone outside seeing you changing your clothes if the door was open, and round the end of which you got in or out. Behind the screens was a wood plank seat along the sides. The only light came from a small fixed pane of glass – about 10 inches by 6 or 8 inches *[25½ cm by 15 or 20 cm]* – high up near the roof at each end. The whole inside was painted a dingy green as I remember it. Doors never fitted, and gaps between the boards all over made them the chilliest of places to change, only made worse because the floor was usually sopping wet and sandy. Oh yes, and there was a small mirror about 6 inches *[15 cm]* square with some advert on it and half the silvering on the back gone! Below it was a tiny little shelf for your collar, studs, etc.

For this bathing exercise you bought your ticket and went into the landward door and perhaps began to undress and waited till presently you'd hear clanking whilst the horse was hitched to the machine, then:

'Hold tight!' while you were dragged 'out to sea' and left to it. You then, all 'costumed,' emerged from the seaward end, properly chilled down to start with, and enjoyed your bathe. The men were usually in oversize 'costumes', the women – oh dear! – sort of blouses and skirts with baggy kind of bloomers, and a sort of tam-o-shanter bathing cap. Real sketches if and when they got wet – with shocks

of stray hair sticking out of the caps – or when their costumes 'ballooned' when air got into them! How far out to sea you were dragged depended on whether the tide was coming in or going out. Having splashed about and maybe swum a little, you returned to your machine to dry and dress – and in spite of a good rub-down with a rough towel, a damn chilly, sandy business that was, particularly if you had to wait long to be pulled ashore. At busy times, there were rows of these machines almost wheel to wheel. Most embarrassing to some! Yet folks kidded themselves they'd enjoyed it all! I much preferred going along the sand banks, changing in the open where no-one else was about, and running down to the sea; and after the bathe, drying off by running alone in the open sand, often with nothing on at all. The feel of the fresh sea breeze was most invigorating, tho' sometimes the wind blew dry sand along the beach – wonderful, but could sting like the devil.

Later, we got better bicycles, and used to venture further away – say to Roseberry Topping at Ayton. Country all the way – no motors – what a thrill when I got my first free-wheel! A bit different from father's old mount, on which he sat like a begging poodle in his knickerbocker cycling suit and flat cap. The front wheel was bigger than the back one, but it had a wonderful spring fork and bar frame, and weighed half a ton, so had a very low gear; and at quite slow speeds he pedalled like lightning, and it was fun watching the little cloud of dust behind the back wheel – no tarmac in those days. You got off and walked up hills. No easy gradients then.

Presently, as we got a little bigger and were let loose on our own, we ventured further afield and did journeys that would scare modern 'wheelers' stiff. Rough, bumpy roads, and dusty. One of our favourite runs from Durham on a Saturday was to Redcar or Saltburn. It was 37 miles *[about 60 km]* each way – all on 1s *[5p]*. Before free wheels we 'rushed' our hills, and put our feet up on the footrests on the front forks. How we stuck on was a mystery! We left home at Ravensworth Terrace (a schoolfriend and I) at about 8.45 a.m. Practically all country except a little, peaceful Sedgefield, and Stockton. First stop was Marton Bungalow *[an inn open through the summer]* – right out on its own in the country then – where we got a pint of real country milk with two raw eggs in it for 3d and sat on the verandah of this wooden shanty (closed in winter) and drank it. Then on to Redcar or Saltburn, where one of the landladies where we stayed on holidays gave us a good feed for 6d *[2½p]*. We bathed or played in the sands, and then at about 5 or so, off back for home by 8 p.m. or so, with another pint of milk and raw eggs at Marton Bungalow for our final 3d. If we got caught after dark, we just had little oil lamps which bumps in the road kept knocking out, and which were no good for illuminating the road, but just a sort of will-o'the-wisp that let on-coming traps or such know there was something on the road. How we enjoyed those trips – home tired, dirty but happy – all for a bob! *[A 'bob' was slang for a shilling (written 1s), equivalent to 5p in decimal money.]*

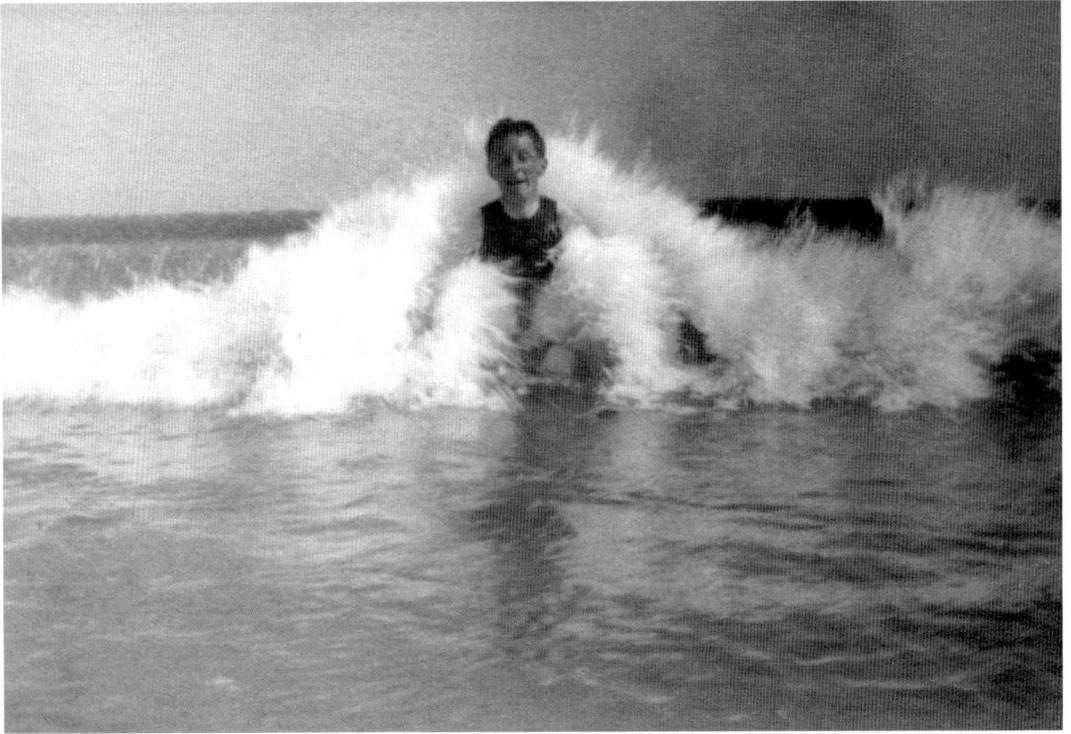

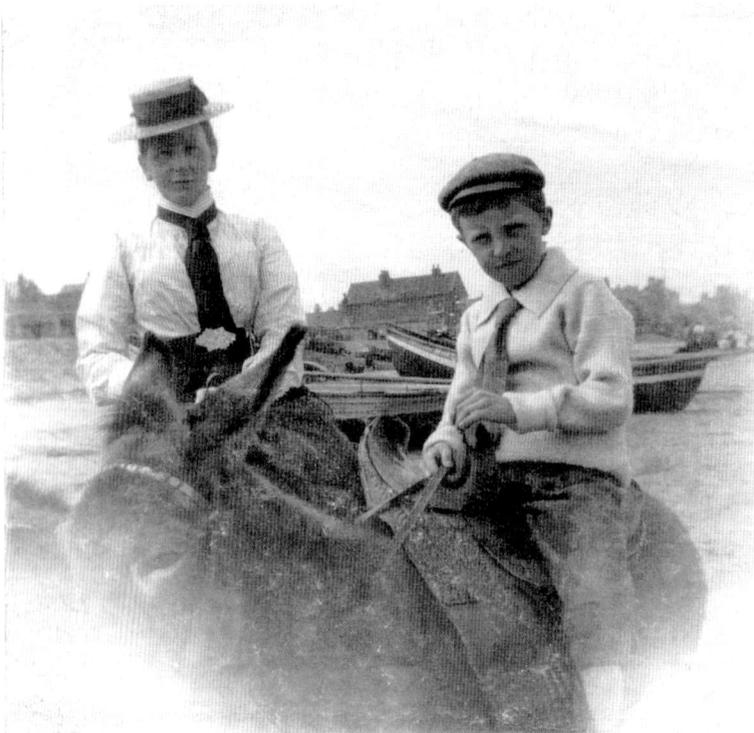

Above: Landt enjoying a bathe at Saltburn, August 1919.

Left: Landt on a beach donkey, around 1900. (The curved shape at the front of the saddle is to allow ladies to ride side-saddle, as the 'mother's help' is doing.)

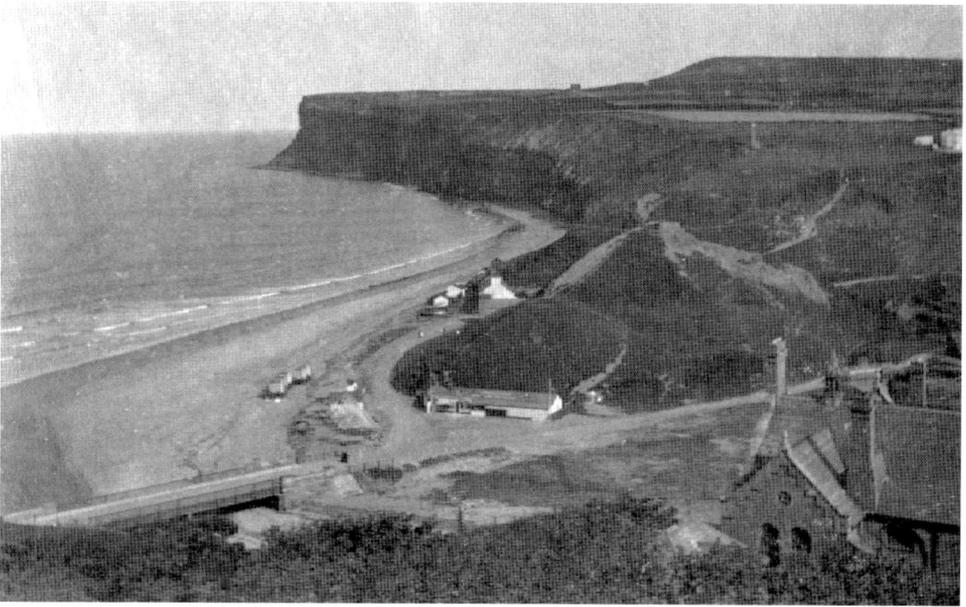

Old Saltburn and Hunt Cliff, 1909 (some bathing machines are just visible on the beach).

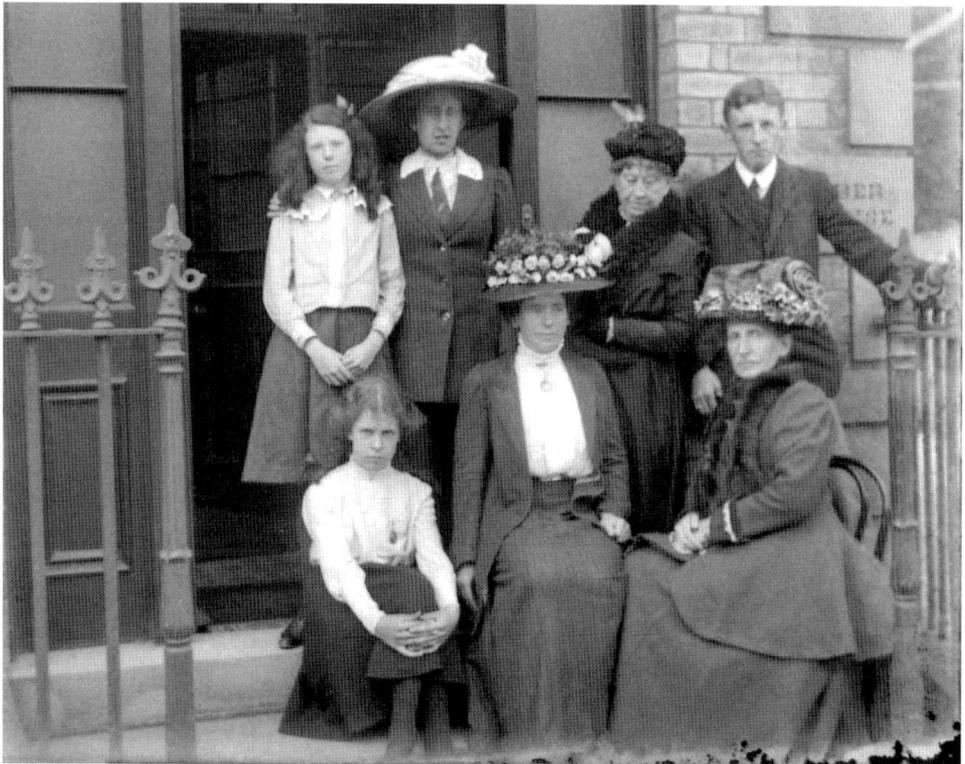

With friends outside 'Amber House' (where they stayed in Saltburn), about 1908. Back row: unknown, Flora, unknown, Landt; front row: Frieda, unknown, Amalie.

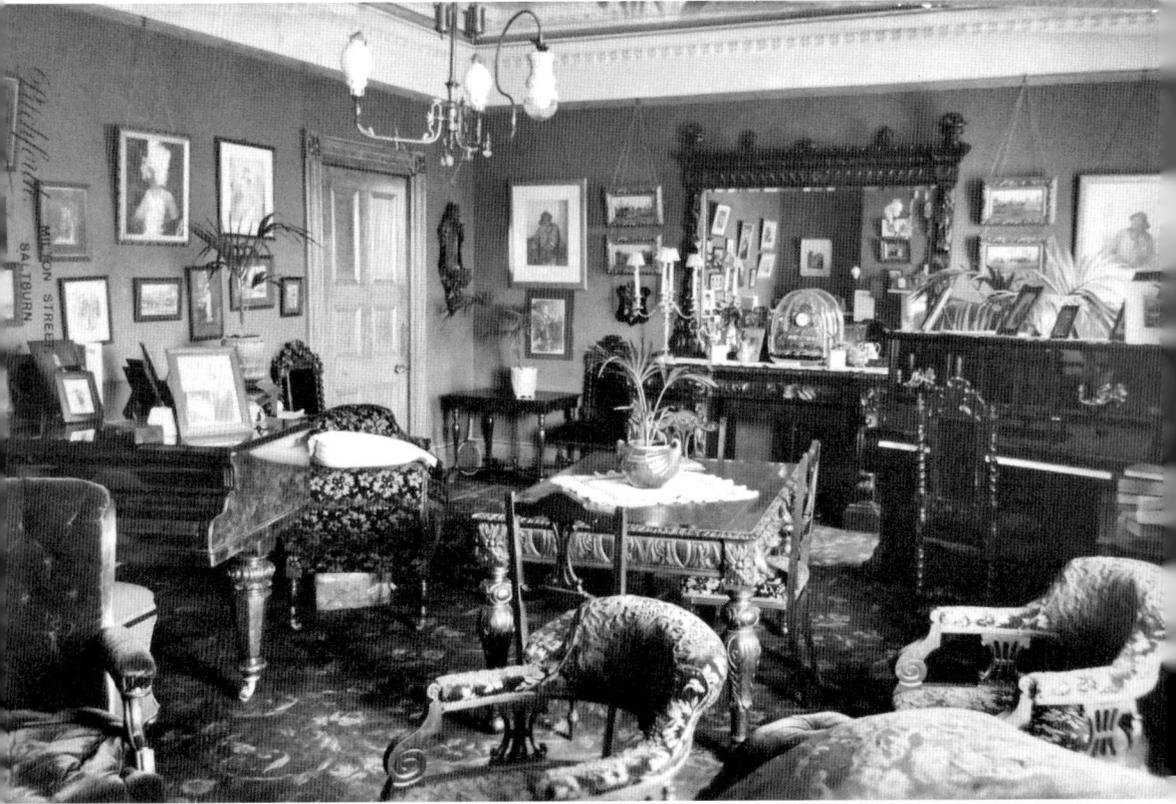

Above: The interior of 4 Britannia Terrace (where they also stayed in Saltburn), around 1912. *[Postcard]*

Left: Young Landt with his bicycle, around 1900 (taken from one of the earliest surviving negatives in the Mawson collection).

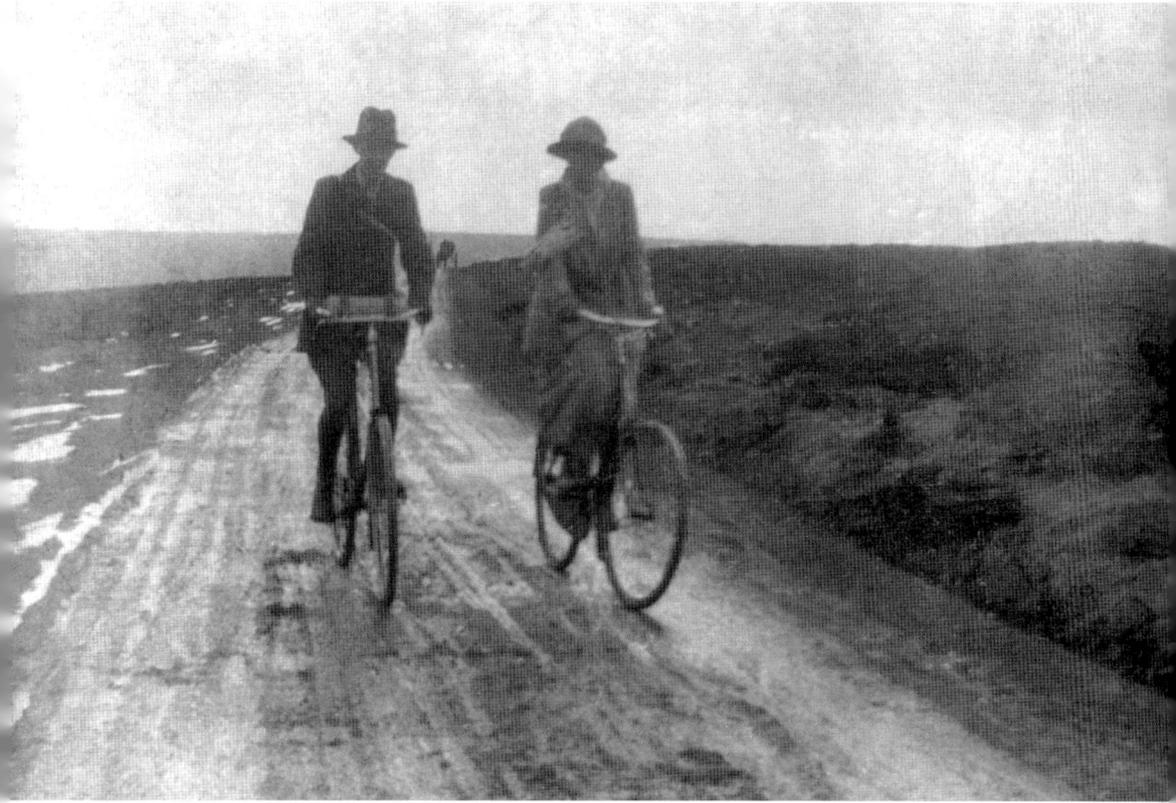

Above: 'The road from Blanchland to Stanhope', 27 April 1919.

Right: Walking the bikes up 'the hill from Shotley Bridge', 27 April 1919 (a few weeks after Landt was discharged from hospital in London after the end of the First World War. His cycling companions were the Mackay family – of Durham Carpet Factory fame – who lived in Shincliffe).

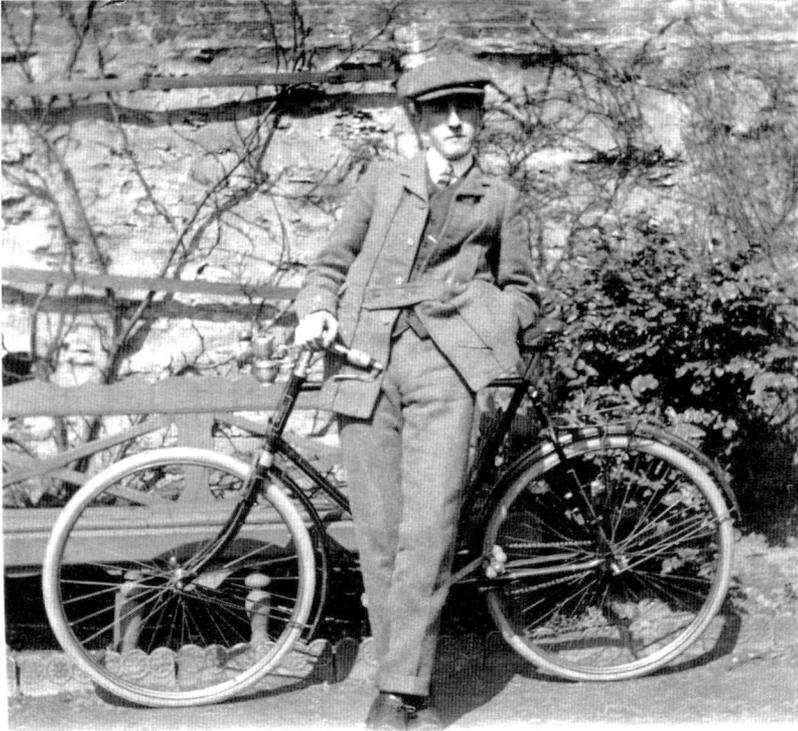

Above: Landt and his 'modern' bicycle, about 1907.

Left: 'Boats on the Mersey' around 1919.

Trades and Crafts

And now let us try and dig up a bit more 'old' Durham, and some of the old trades and crafts, many now completely 'out' by machinery and mass production.

Take saddlery, leatherwork – quite a few, to cope with all the harness and leather goods needed for the many horses on farms, and pit ponies, goods wagons and what have you. Real craftsman stuff, beautifully finished with brasses and what not. Huge horse-collars with steel horns – all hand-made and polished to the limit. Nelson's in the Market Place where Hepworth's now is; Willoughby, Foley and who else. Blagdon's leather works in Framwellgate. Real leather, properly tanned and dressed. Mohun in Claypath.

The old tallow candle factory; and Aynsley's mustard works – up behind the goods station in Gilesgate. Then watch-making the real old style: bearded old toiler at his bench – like Hume on Elvet Bridge, with his wire spectacles; and the two-faced clock over the door where Bramwell optician now is (and since moved to the other Bramwell, the jeweller's on the other side of the road).

Pastry cooks like Earl's and Adamson's. Real meaty pies for 2*d*. Adamson's had two shops, one on Elvet Bridge with a big bulging window of small panes about 8 inches by 6 inches *[20 cm by 15 cm]*; higher at one end than the other; and a way through the back to their other shop in Saddler Street. Earl's where they still are now *[opposite the top of Magdalene Steps – hence older residents still refer to 'Earls' Steps', though Earl's closed many years ago]*, but producing nothing like they did in the old days – too many additives and preservatives now to get the old flavour that Henry and Charlie Earl could turn out!

Then there was Hutton's the sports outfitters, who supplied all the sports gear for school and university. Hutton a big, stout man who always wore the Durham City Cricket Club blue cap with its crest on the front. A hand like a leg of mutton, and did all repairs to bats, balls and restringing rackets etc. on the premises – and did them well.

Further up the bridge was Miss Jeckell's baccy *[tobacco]* shop – a tall, handsome woman who, even when I was a kid, I think dyed her hair. Always very elegantly dressed, with frilly blouses and the like – attracted all the 'gentlemen' of the town, but I don't think ever 'got off'. Her only commercial opposition then, I think, was Donkin's in the Market Place, run by the husband. A little, dapper man, with a spiky, waxed moustache, and a huge, handsome wife – also elaborately dressed: pulled-in waist, busty, with sequins – very impressive! They only sold baccy, cigars and snuff. Don't see many taking snuff nowadays; quite the thing then, though, with fancy snuff boxes

Left: William
Wasey's – saddler
and leatherworker
at 28 Claypath,
photographed in the
1900s. *[MR]*

Below: Samuel
Hume the jeweller
at 17 Elvet Bridge,
around 1890. *[MR]*

Above and below: The two-faced clock (still there) outside Bramwell's, at 24 Elvet Bridge, 1904. *[MR]*

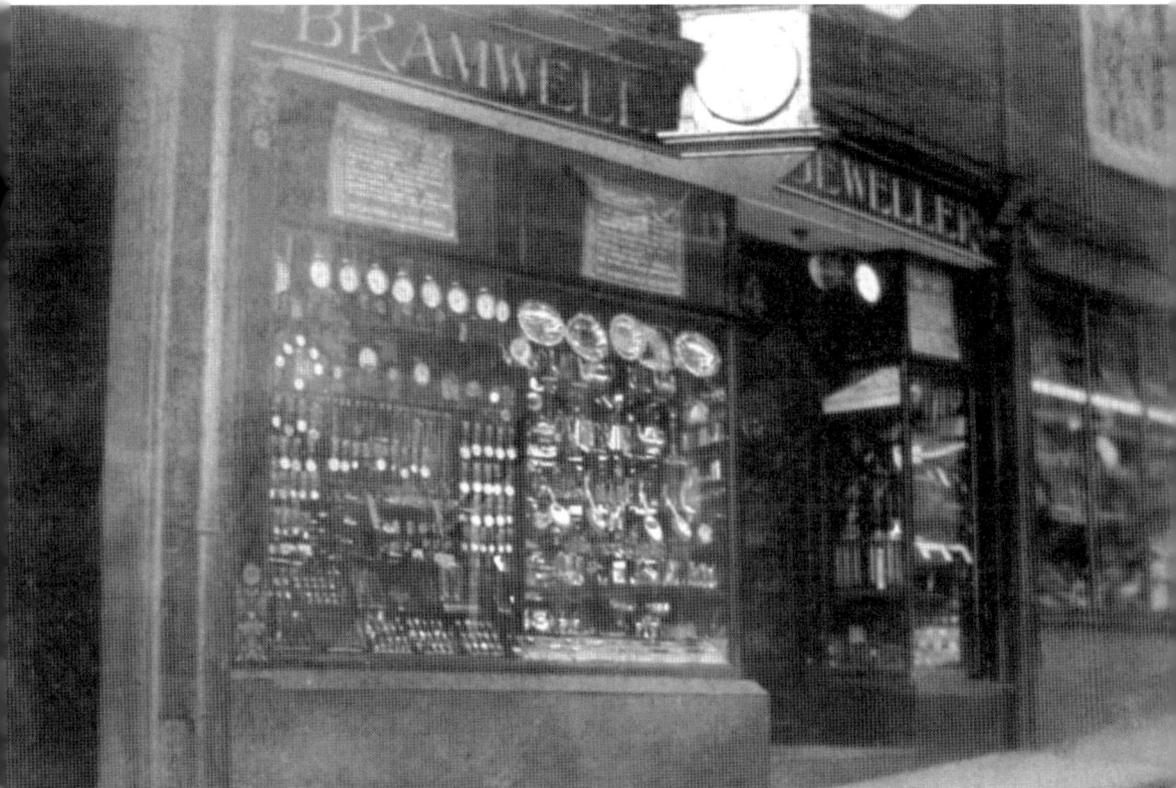

which were tapped first and then opened very ceremoniously with the invitation, 'Have a pinch!'

Yet another craft which seems to be moribund if not already dead as an individual and personal skill – 'coopers', who made barrels and water butts, poss-tubs and baskets, and cane seats for chairs – like the Wright brothers, who operated at the bottom of Silver Street. Where can you get a cane chair mended now?

'Cutler and smith' like Peacock (or was it Pearson?) *[it was Pearson]* down the steps in his little dungeon under the shop next to the old Castle Hotel. Sharpened your knives, scissors, chisels, saws and what not. Big, dark man with a stoop, and his great leather apron – quite a presence, particularly when rigged up with his trumpet with banner attached, billy-cock hat, knee breeches, buckled, polished shoes, and gaudy costume as one of the judge's entourage when he was here for the Assizes. (A very impressive show, with ornate carriage – with powdered and bewigged driver with three-point cap, on a box draped with tassels all round – two grooms standing on a small platform between the big back wheels; outriders, heralds and all the rest that went with the pomp and circumstance of the 'good old days'. Now the judge is whisked down in a glorified taxi, with two 'cops' on motorbikes, and a police car. And because the taxi once ran out of petrol, they now fill the tank so full that when they go round the police box in the Market Place, petrol overflows and surges out of the filler cap all over the road. One day, it'll light up!)

Funny how my mind jumps about. Now it's chemists. I wonder how many remember those old shops like Lamedy's *[see page 187]* at the bottom of Elvet Bridge, with the forecourt enclosed by iron railings (taken during the Second World War to make shells and bombs); Sarsfield's in the Market Place, with an iron grill across the window; and others? They nearly all had great big jars lined up in the window, some beautifully shaped, with long necks; and all filled with coloured liquid – blue, red, green and so; and at night lit up from behind by little batswing gas burners (no incandescent then). Precious few 'pills' in those days – now it seems to be all pills! Mason's was another (still there *[1970]* in Saddler Street) – managed by the real 'card', Jimmy Griskell, a little lively man who couldn't keep his false teeth in – they shot out at you when he talked, and went back all sudden-like, with a hell of a click. He played – or tried to play – golf, but beyond being a damn nuisance on the course at Pinkerknowle, never got anywhere. Cheery little soul, with a long handkerchief always flapping out of his pocket.

Gosh, now my mind jumps about again – interval – apparently my hand jumps about too, because I've just had to mop up my drink which I've knocked over – you see, I write all this sitting in an easy chair, which is not the most convenient set-up! Now where were we? Crafts, trades and professions …

Believe it or not, there were nearly forty solicitors in Durham at the turn of the century, and all seemed to make a reasonable living – accountants were very few; but now … – direct result of taxes! Pawnbrokers with the three balls outside – find one now! But as to pubs and beerhouses, there were dozens of them. Claypath had about eight or nine within 100 yards, and The Grapes and Wearmouth Bridge next door to each other!

Doing the laundry in a poss-tub, about 1932 (coalminer's wife Mrs Elizabeth Eltringham of the Queen's Head Yard, Back Silver Street). *[MR]*

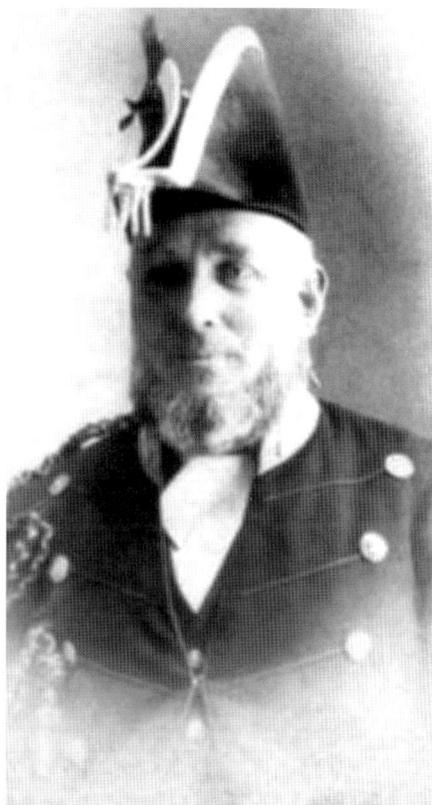

One of the judge's entourage in his official regalia, 1890s. *[MR]*

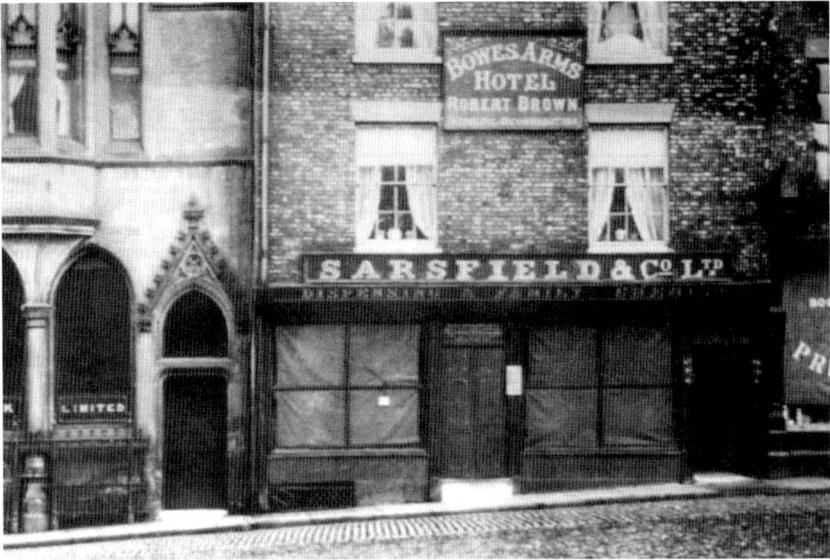

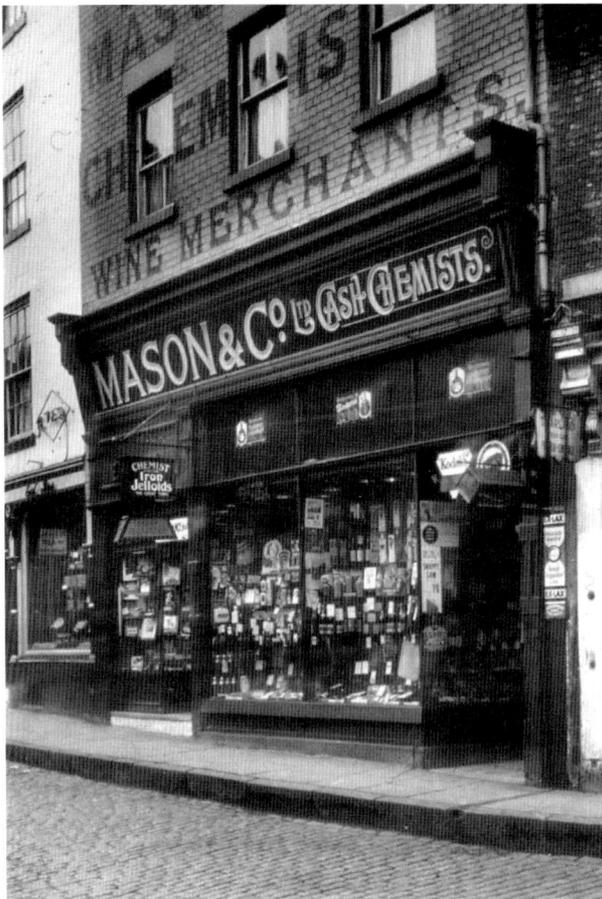

Above: Sarsfield's dispensing chemist's at 7 Market Place, 1890s. (The Bowes Arms Hotel was above the chemist's shop.) *[MR]*

Left: Mason's cash chemist's at 69 Sadler Street, 1938 (Earl's pie shop is on the left). *[MR]*

Where now do you hear of whitesmiths and bell-hangers – and what bells! Rows of them in the kitchen, all hitched up to 'pulls' by wires from each room and front doors – real clangers – but they worked. And you had maids then – you got them from 'Servants Registries' run mainly as a side-line by little old women who had little shops to sell wool, baby linen and such to eke out a living. And how contented most of the maids seemed. They learned cooking and how to run a household and such, and then married and made real good wives – and would come back to show their offspring to their old mistresses and express appreciation of the training they got in 'service'.

Now let's take another look at Saddler Street as it used to be: the old post office – then the Labour Exchange, and since then the County Court Offices – and next below, the old *Durham Chronicle* office with its little square bay windows sticking out. All defunct. Then Martin's Bank built their branch across the passage which led up to Thwaites printing works – now all taken over by the *Durham Advertiser [since moved away]*. The Shakespeare Tavern (still there); then Rushworth's Art Gallery, which extended well back and behind the little sweet shop and the Shakespeare. The proprietor, old 'Tucker' Rushworth, on fine mornings sat on a stool on the footpath, with his square top felt hat. He chatted with anybody and knew all the landed gentry in the kingdom. His man Haswell was quite a character himself, who used to be sent to all the aristocracy to clean and renovate their pictures and art treasures, and was full of the most interesting stories. An artist himself, who turned out some fine pictures. But what a character – very thin and lanky, always smartly dressed with a little waxed moustache. A face and eyes that missed nothing – full of fun, made all the more amusing because he had a really bad stutter, and used to explode like a syphon! If it wasn't that he was naturally funny, it was most difficult to keep a straight face when listening to his tales of when, say, he was renovating Lord Somebody's pictures and the question of accommodation came up. He said he'd 'sleep on the b-b-b-billiard table!' His face was always a sort of brick colour and looked almost as though he used make-up (but that was practically unknown in those days).

Looking down Sadler Street, towards the market place with the Shakespeare Tavern on the left, 1900s. *[MR]* (Despite the caption on the postcard, not Drury Lane – which is a vennel on the right, leading down to the river.)

Rushworth's Art Gallery, at 61 Sadler Street, 1900s. *[MR]*

A Trip to Newcastle

(Another evening) Strange how little incidents seem to revive old memories as old age cramps your style and you've got to take things quietly. Sometimes you've just got to sit quietly and think; and when you've had as full a life as I, and tried your hand at most things, there's a lot to think about. Particularly if you recall some of the pleasanter incidents that happened in the 'good old days', when little things gave so much pleasure, and we didn't have to depend on our amusements being created for us by other people.

I'm a bit off the rails again, as I set out to describe a happy little afternoon when I was a very small boy, and a trip to Newcastle was indeed an 'event'! On this particular day, my father decided to take us there to see the sights, and we trudged our way up to the North Road Station. I think my two youngest sisters were tiny at the time, and I seem to remember father taking only my two older sisters and me. We had our best clothes on. I in a Norfolk suit (with belt and knickerbockers), a waistcoat *[Landt always used the Victorian pronunciation, 'wesskit']* which buttoned right up to the top, and rounded off with an Eton collar, thick, black, new woollen stockings, and black boots which had tags to pull them on and had to be continually pushed in. On this day we stopped at Imrie's (hatter and hosier) and I was rigged out with a new straw hat.

At the station, the train came in all smart and clean, with the usual North Eastern Railway engine in the front in the company's pretty green paint, and polished up to the last brass stud and rail. We all packed in and gazed out of the windows as we sped to Newcastle Central Station. A real thriller – so vast, with trains chuffing about, and clouds of clean white steam hissing out of the brass safety valves; and all the porters and guards in their smart green corduroys.

First call was to visit the High Level Bridge over the Tyne. When we got there (walking, of course) we found charabancs drawn by pairs of horses which took people over the bridge – ½d per person per trip – waiting to load up. You climbed up steps at the back, and sat in a row on seats facing one another so you could see through the open sides, up and down the river. Pretty high up you were, because these vehicles had pretty big wheels. Father at once decided to let us do this trip, and we all piled in. Off we set, with the cloppety-clop of the horses' hoofs on the road, and a really healthy wind blowing down the river.

We hadn't got very far – not halfway over – when Father spotted that the Swing Bridge was about opening, and decided it was a sight we mustn't miss. Without stopping the bus, he got off down the steps and grabbed us one by one as he ran behind, dumped us on the road, and told us to look over and see the bridge. (Traffic then was negligible, so

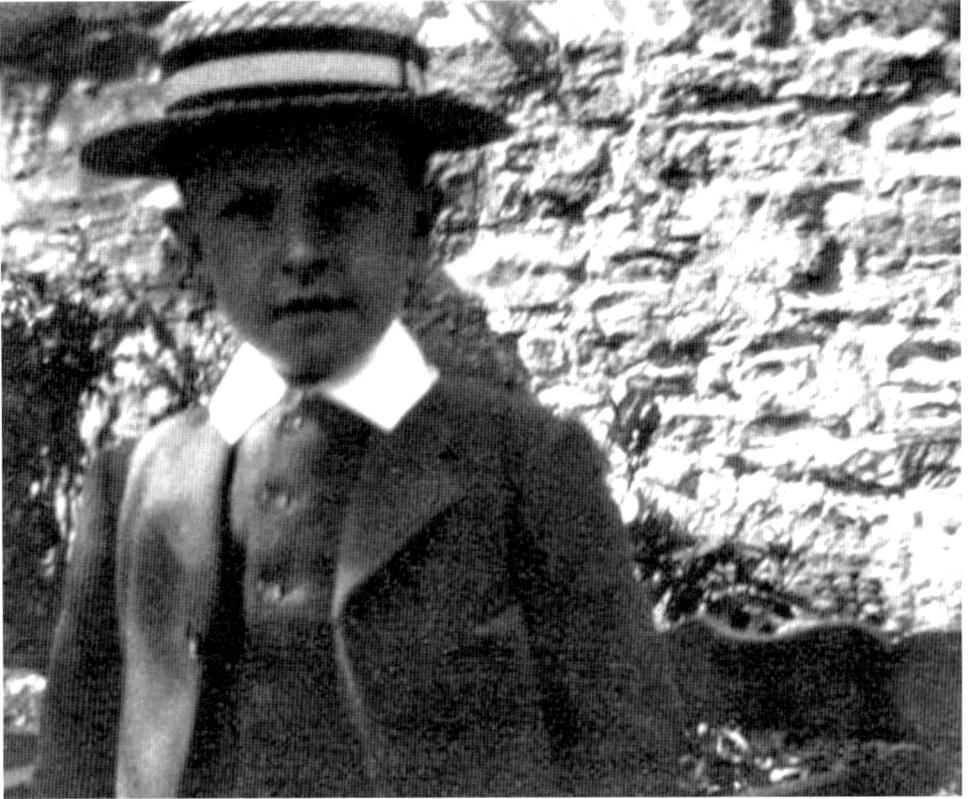

Landt dressed for the outing, 1900.

Bridges over the Tyne between Newcastle (to the left) and Gateshead, about 1907: the High Level Bridge of 1849 and (beyond it) the Swing Bridge of 1876. *[Postcard]*

*High Level Bridge, Newcastle on Tyne: Length of
viaduct 1337 feet; length of water way 572 feet; height
from high water mark to the line of railway 112 feet; and
to the carriage way 85 feet: Total cost £491,153.*

Notes on the High Level Bridge (built in 1849) – extract from Joseph Mawson's notebook of
October 1877.

The Swing Bridge open to allow a ship through, seen from the High Level Bridge – early 1900s.
[Beamish Museum Archives]

there was little or no danger in the manoeuvre.) I rushed to the rail and saw the bridge
half open, turned to tell Father, and at that moment a gust of wind caught my new straw
benger [*now more commonly called a boater – a flat straw hat with a wide brim*], and
away it floated over the rail, and gracefully sailed down into the Tyne, after bouncing
off the edge of the Swing Bridge central pier. There it was, floating down the river! We
watched for a bit, and then saw a man at the quayside waving up and pointing, and he
went to a boat, obviously to rescue the hat. I cannot remember just how we got down
to the quayside, but I do remember getting my hat back all soggy and sticky, and Father
giving the man something. Never mind, we'd had a real thriller, and seen the bridge!

I cannot remember much more of that trip, except the number of cabs (horse-drawn)
in the forecourt of the station; and the trams.

13

Photography

It must have been about this time that I took up photography. Father took me to Mason's, and we got a 'Brownie' Box Camera *[introduced in 1900]* costing 5s *[25p]*. It was a small square box *[later models were rectangular]*, with a little viewfinder, and a lever to expose the film. Six exposures to one roll, which cost 7d *[3p]*. You had to develop and print your own photos in those days, so we got a developing outfit – trays, chemicals in powder form and hypocrystals. I think that cost 6s or 7s *[30p or 35p]* the lot, including – most important – a darkroom lamp: a paper contraption coloured red, illuminated by a night-light candle.

We 'shot' a roll, and then tried to develop it. It was all set out on the pantry shelf one evening. Out came the exposed film all in one piece, but we had the utmost difficulty in preventing it curling and rolling itself up again. At about half-time – when the image was just appearing – it beat us, and one end got free and flicked the lamp which promptly took fire, and that was that.

Still, we persevered, and presently got some quite interesting 'snaps' for their day, and that started me on photography – a hobby which gave me a lifetime's pleasure and records.

Next *[about 1902]* I got a 'KLITO' quarter plate camera costing 21s *[£1.05]*. It had to be loaded in the darkroom, the glass plates fitting in black tin slides, all stacked neatly at the back of the camera. After each exposure, you pulled a catch sideways and heard the exposed plate fall forward flat on the bottom of the camera with a rare clonk – how it didn't break the plate was a mystery!

By then, we'd got a tin lamp with a red glass window, and passed the 'curling' hazard and difficulty. Nevertheless, development was a messy business, mixing chemicals and getting your fingers all stained brownish yellow.

Printing, too, was a lengthy process. In frames, up against a window, before gas light paper came in. I still have quite a few prints taken over seventy years ago (in the early 1900s), and still in quite good condition.

Then followed enlarging – all still in the experimental stage, but what fun it was finding out, and getting better and better results, and what a grand hobby it has been!

Now it's all so easy, like handling and driving a car – you just point a camera at something and shoot and all the rest is done for you; you get in a car and it goes – you had to 'drive' it in the old days. Somehow I think that the present generation miss out on so many of the joys of finding out how to do things yourself, experimenting, and always doing better next time. Really contriving, striving and 'working' for results gives so much pleasure and satisfaction!

A 1916 Kodak Box Brownie Camera.

A box of old glass negative plates from the mid-1900s (from which some of the illustrations for this book have been taken, directly or via original prints).

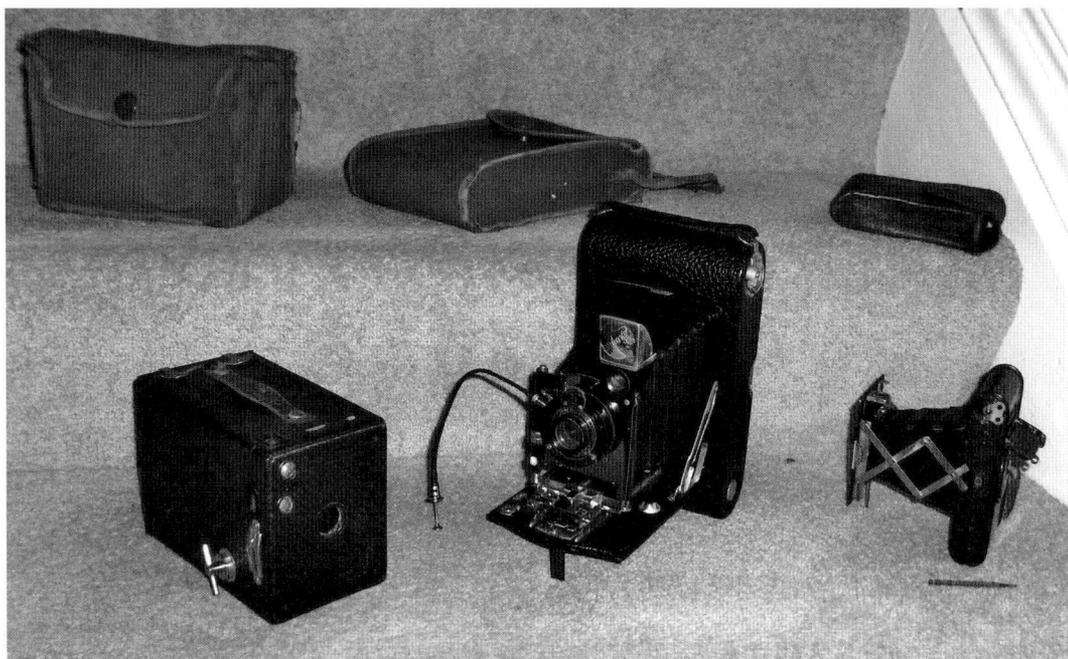

Some of Landt's cameras from left to right: Box Brownie – 1916; Kodak No. 3 Autographic Model H – 1913; Vest Pocket Kodak *[Autographic Model]* – 1913.

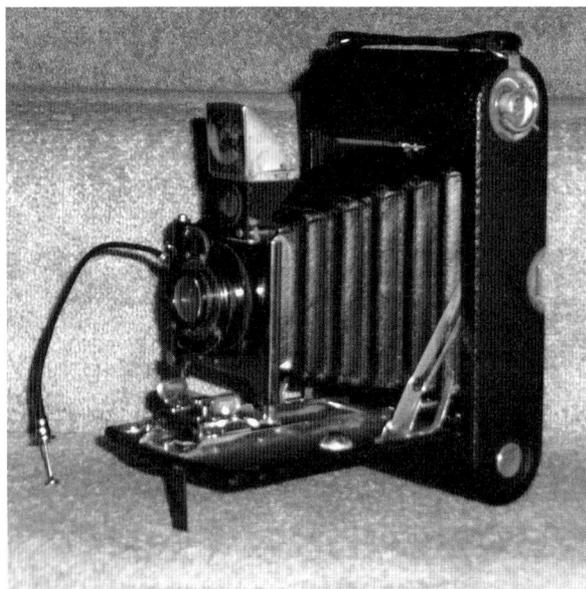

Left: Kodak No. 3 Autographic Model H (1913).

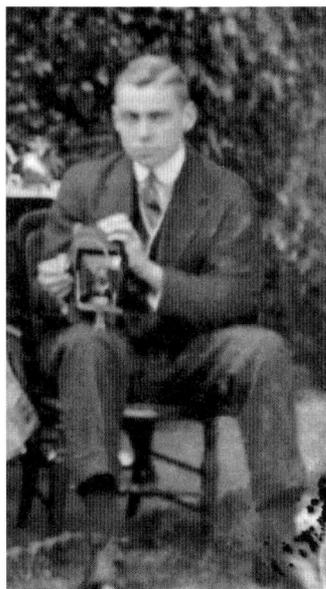

Right: Photographing the photographer, 1913. Taken in the Mawsons' back garden at 10 Ravensworth Terrace.

14

Golf

It's some time since I wrote these preceding memories, so I must be forgiven if there's some repetition and slight variation in my recollections!

When Ravensworth Terrace was built, Number 5 was the end house, and my father gardened the area above it, but gave up as the upper five houses were built.

Opposite was an uncultivated field, behind Pelaw Terrace (four fine houses, solidly built, but now demolished for the new road – Leazes Road). This field had pigeon crees at the top where Arthur Pattison (of 3 Ravensworth Terrace) tended his birds. The lower part of the field was kept as a drying ground for washing for the occupiers of Pelaw Terrace.

The whole field was a bit rough and untidy until my father persuaded the Blagdon family to let him rent the top half, which he terraced and cultivated. But before this, I got my introduction to golf – all through measles!

I caught measles, and when I got better my sisters got them, so my parents' friends at No. 1 Pelaw Terrace offered to look after me till the girls recovered. John McCartan (another solicitor) and Mrs; and whilst I was there he – being a keen golfer – cut down the shaft of a 'cleek' to fit me, and gave me it and a well-used 'gutty' ball *[an old-style golf-ball made of gutta percha, a type of white rubber]* to knock about the field. That 'gutty' ball was just like hitting a brick, but it set me off for golf, and until I was old enough to join the Durham Golf Club, provided me with hours of fun and practice, particularly at the seaside on the sands.

In due course I was admitted to the golf club as a school-boy member. The club was at Pinkerknowle (also called Pinnock Hill) – and was a really tough nine-hole course over ravines, with blind holes. The hazards would have scared the lights out of present-day golfers! At the top of the hill, the line crossed you, and balls came over from all directions!

Golf really *was* golf in those days – a real sporting, tough game; none of your easy, well-kept courses and masses of fancy clubs which have to be carted about in trolleys. (You couldn't have got them round the old Pinkerknowle course.) We had about five clubs each, yet could use them and put up scores that were every bit as good as now. Playing at Pinkerknowle, you just *had* to keep straight, or you were out of bounds or lost your ball.

The caddies employed by the older men used to go down to the woods round the course and cut themselves sticks and branches from which they fashioned clubs for themselves – and they could teach 'the players' quite a bit! My friends and I used to

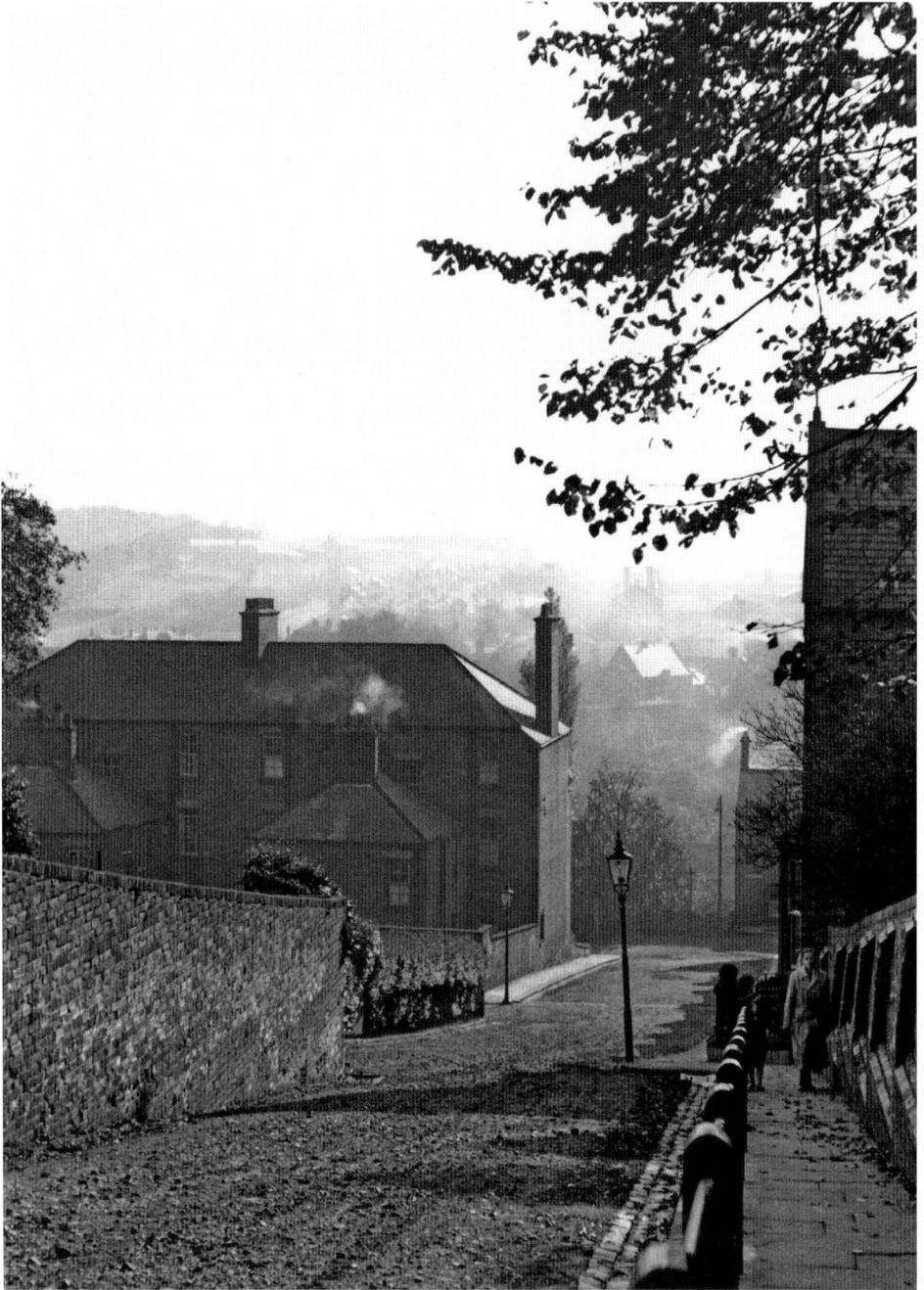

Looking down Ravensworth Terrace to Pelaw Terrace on the left, around 1946. (The end of 10 Ravensworth Terrace is on the right, and beyond it the end of the Pelaw Leazes is just visible at the bottom of the road on the right. Pelaw Terrace, Pelaw Leazes, and the two lowest houses of Ravensworth Terrace were demolished in the mid-1960s to make way for the new Leazes Road through road.) *[MR]*

John McCartan (Durham City Cricket team, 1902). *[MR]*

Landt in action at Pinkerknowle, about 1907.

Part of Pinkerknowle Golf Course (home of Durham City Golf Club from 1887 until 1927) – pencil sketch by Amanda Stobbs, 2010 (from a photograph).

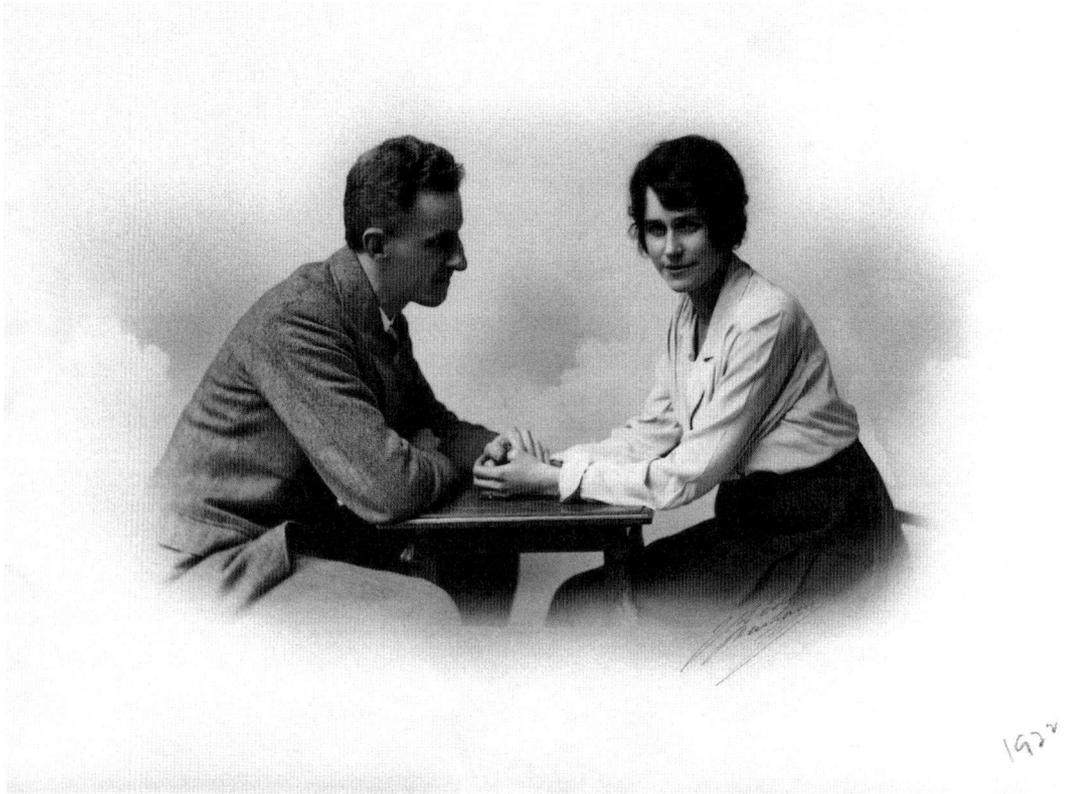

Landt and future wife Helen, 1922, photographed by John R. Edis (probably an engagement photograph).

practise with the caddies, who could play real good golf with their single home-made club. Two I remember well are Newton and Baker, though there were others.

Believe it or not, we used to *walk* the 2 miles or so *[about 3¼ km]* from Ravensworth Terrace to the links at Pinkerknowle, play 36 holes in a day (or 18 holes in the longer evenings), and then walk back home – and thought nothing of it. Can you imagine a modern golfer doing that? But the days seemed longer then …

All this gave me good training, and in due course I left my name on the club's major cups. But my golf fizzled out when I spent my spare time 'courting' my wife. And golf started that. (Briefly, I was invited – when convalescing after World War One – by a golfing friend, to Saltburn – for golf. But he 'got off' with his girlfriends, so I took up 'fishing' from the pier, and there I 'caught' my wife! But that's another story …)

Transport

I seem to be getting ahead of myself again, so back to some of the older memories.

Comes to mind the old horse parades we used to see, when owners and drivers paraded their beautifully cared-for and groomed animals, all decorated, and with carts and rolleys polished and painted by real craftsmen, with much brass about the harness, wheel hubs or axles and elsewhere, and all those chains – polished steel. It was interesting to see how they got those steel or iron chains so beautifully polished. It was done like this. The chains were put into deep sacks with sand, then the sacks were tied to the spokes of the cart-wheels, some of which were 5 feet *[150 cm]* or more in diameter. And when the carts or wagons were driven about the streets on their daily job, the chains and sand were thrown from one end of the sack to the other at each wheel turn. Ingenious indeed. But how they shone! Alas, all that has gone now, with the coming of the petrol engine.

Now that takes me back to my earliest memories of motoring! But first –

Talking of horses brings back memories of the old blacksmith's shop at the foot of Elvet Bridge, where we used to watch them shoeing Mr Peel's horses.

My father was a keen horseman, and when we were kids, he quite often used to hire a horse and phaeton *[a four-wheeled open carriage with two crosswise seats]* or wagonette *[a four-wheeled open carriage with two lengthwise seats facing each other behind a crosswise driver's seat]* from Peel's. We met it at the Waterside, next to Baths Bridge, where Father took over from the groom who delivered it. In the phaeton Father, Mother and one child sat facing forward; the rest of us sat backwards, facing them. The reins went over our heads through a sort of metal wishbone. The favourite run was to Merrington (we had to get out and walk up places like Croxdale Bank – the old road, over the old stone bridge) to see Father's friends the Crowthers, who had moved there from Shincliffe. They lived next to a farm. Here we spent the holiday – bank or otherwise – and the farmer stabled and fed the horse till evening for the return journey. I still, in 1968, have the old thick carriage rug we then used. Black outside with brown stripes inside – wonderful! Getting a bit dilapidated now – a little worn and holey – but still quite sound after years of service in cars, before heaters were invented.

It would be about those horsey days that Vincents used to meet trains at Croxdale with a pair-horse brake – quite a vehicle, with a row of benches either side where you sat facing one another after climbing up steps at the back end. It had open sides, but

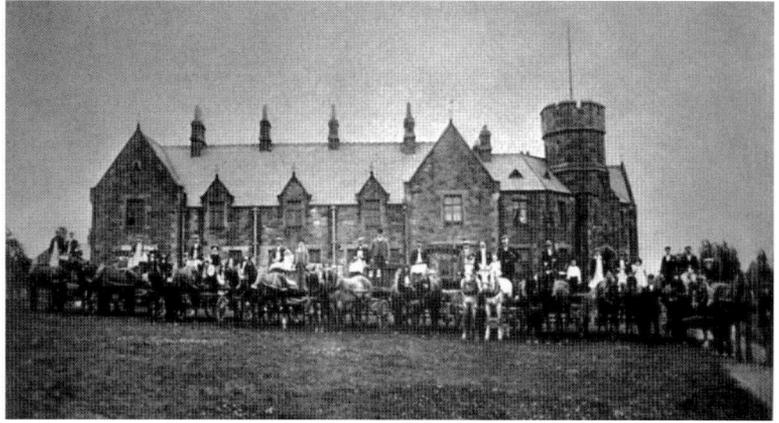

Durham City Horse Parade, Barracks Field, Whit Monday, 20 May 1907. *[MR]*

Wood & Watson's entry for the Horse Parade, 1920s. (The second man from the left is possibly Landt's old school friend Joe Wood.) *[MR]*

Durham Regatta in the 1900s – Peel's premises at Elvet Waterside can be seen on the right. *[MR]*

The old carriage rug (even more faded and frayed, but still with us in 2011).

thin metal rods holding up a canvas canopy. It was then the only means of getting from Croxdale to Spennymoor, unless you 'hoofed it' *[walked]* – and don't forget, roads weren't like they are now!

Vincents farmed at Hett, and I suppose they were a go-ahead family, because they were about the first – if not the first – in the district to tackle motor transport, by substituting a motor bus for the brake. It was a great lumbering vehicle, with large wheels with solid tyres, great big sprockets and a huge chain drive. Unfortunately it was not a success, and was forever breaking down! They were a jump ahead of their time, and it was some years before that type of transport became a commercial proposition.

Another early motoring memory would be about 1901 or 1902. My mother's old school friend, Margaret Wright (formerly Constantine) was married to Roger Wright. She was his second wife, and he had two sons rather older than I. At any rate, the older one – Oswald – was capable of driving a car, so Mr Wright had an 'Argyll' open tourer typical of the age.

Knowing my interest in motors even then, the Wrights used to invite me to their home on a Sunday to go for a day's outing in the car. This involved getting an early train to Newcastle, walking out to their home in Scotswood, and starting motoring from there.

That old car was a 'smasher' in its day, with great brass acetylene headlamps, oil-burning side lamps, brass radiator, brass furnishings, numerous glass oil-feed drip tubes on the dash, a hand pressure pumper, and what else. You sat bolt upright in the front bench seat, but you climbed up steps at the rear to get to the two back seats, where you sat facing each other after closing the little back door. Most uncomfortable, because the back of the front seat stopped you sitting up straight. Result: you leaned slightly to the rear, and when Oswald let the somewhat jumpy clutch in, or the engine began chuntering, you had to hold on to avoid being shot off the back and left behind!

Much time was spent stopping to tinker up when it stuck, and we'd had a real good day if we got as far as Matfen and back. But what fun it was in those days – no other motors about. Nor petrol stations. You had to get out and home under your own steam. Punctures repaired in the road – plenty of them, and 'do-it-yourself'.

Then walk back to Newcastle Central. And home tired but happy. Those were the days!

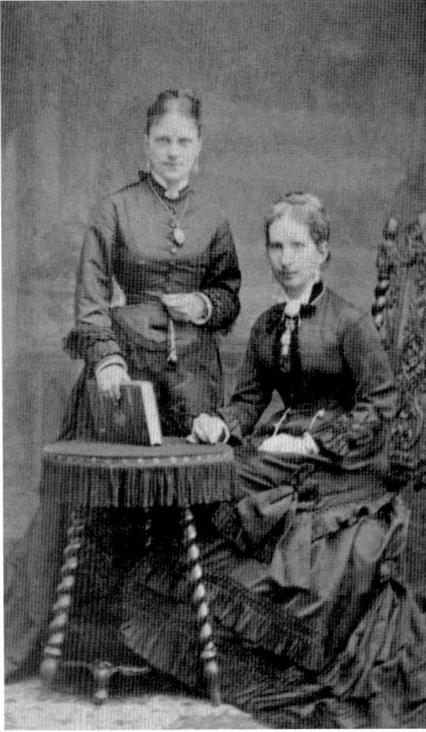

Left: This photo was taken when Margaret Constantine – later Wright – (standing), and Amalie Landt – later Mawson – (seated) visited Durham – and London – for an extended holiday from their homes in Flensburg, May 1877 to June 1878.

Below: A 1900 Argyll – drawing by Amanda Stobbs, February 2010 (from a photograph).

Detail from a print of 'a County Map of Northumberland, 1830'. (Matfen and Newcastle are underlined.)

One of a series of tiny motoring cartoons (actual size) drawn in pen-and-ink by fourteen-year-old Landt in 1905. This one possibly depicts an Argyll bodywork design introduced shortly after the one illustrated on page 144 (the small front wheels he has drawn owe more to the horse-drawn vehicles of the day than to the real vehicle, however!), so the cartoon may be based on Landt's outings with the Wrights. (One can only hope that the car did not normally produce quite such prodigious quantities of steam from the radiator!)

Miners' Day

Miners' Day when I was a boy was a vastly different affair from what it has now become, with miners – 'pitmen' as we knew them – now so much better-off, well dressed, and with their own cars or coaches to bring them to Durham Racecourse. Not so many as there used to be, but just the same average miner.

Back to Miners' Day in my boyhood days. During the week, all the shows and roundabouts came and set up their stands on the racecourse; and on the Friday night, my father used to take us kids to see the shows which were all trying themselves out for Miners' Day. Many local people too visited on the Friday eve. How different were the shows then. In fact, the whole set-up has changed. Aunt Sallys – where do you see them now? Rows of 'faces' painted on sort of bags stuffed with straw or sawdust. Three balls a penny, and the prize depended on how many you knocked down. After each 'shy' the showman pulled a rope and set them all up again. Hobby horse roundabouts – wonderful craftsmanship put into them. Coconut shies – three shots a penny! What else?

Rifle ranges: you shot along a long tube with a target set up at the end, and if you got a bullseye, a bell rang and you got a prize or 2*d* back. Then they had coloured ping-pong balls bobbing up and down on the top of jets of water – good fun potting at them. Boxing booths, where the pitmen with more confidence than wit took on some real 'toughs', to the amusement of watchers. Menageries with freak animals. The infancy of 'moving pictures' of the silent films, with a piano tinkling out appropriate improvised music.

Then there were the swings – 'shuggy-boats' – where two people sat facing one another and pulled ropes attached to the opposite side of the top centre bar, and often got the swings so high as to look positively dangerous, as if they might go over the top and complete the circle with disastrous consequences!

There were 'try your strength' stands with a high sort of thermometer-like mast thing with a scale of pounds marked on it, and a big gong at the top. You got a big 'mell' or mallet – a lump of hard wood shaped like a barrel with iron bands round it to stop it splitting. The barrel might be 6 or 8 inches *[15–20 cm]* in diameter; heavy in itself, with a shaft 3 feet *[90 cm]* or so long. And lusty lads wielded it to hit a sort of 'plunger' at the foot of the column, which shot a metal pointer up a guide-rail to stop on the dial and show your pounds, or ring the bell.

Not least among the whole business were the fish and chip vans – smelled most inviting! A penn'orth *[one penny's worth – less than ½p]* of fish and a penn'orth of chips in newspaper; you flavoured it with salt and vinegar out of enamel containers on

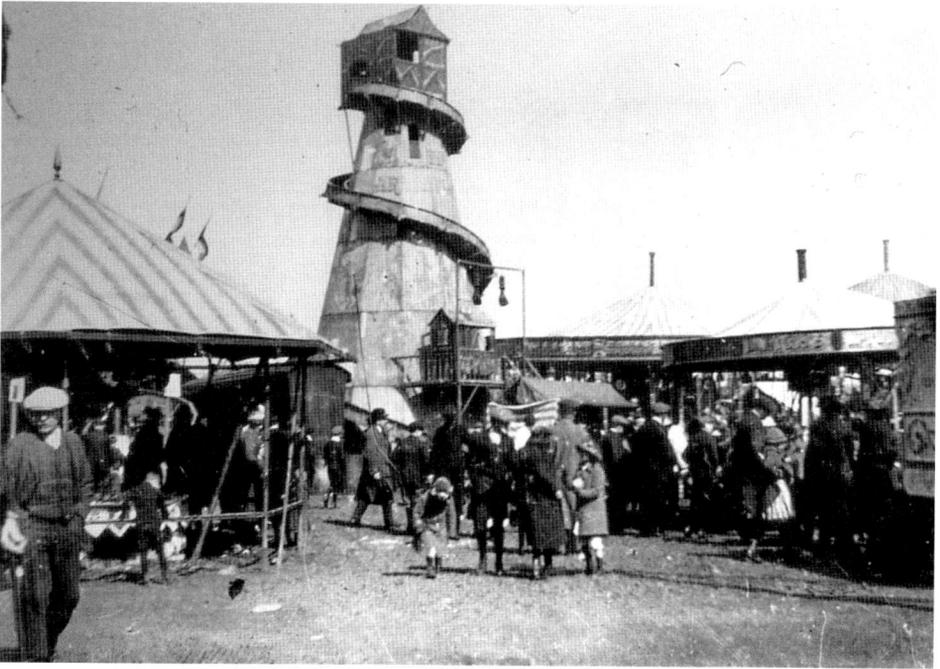

Above:
Fairground on
the sands, 1920s.
[MR]

Right: Shuggy
boats at the Sands,
Durham, 1904.
[MR]

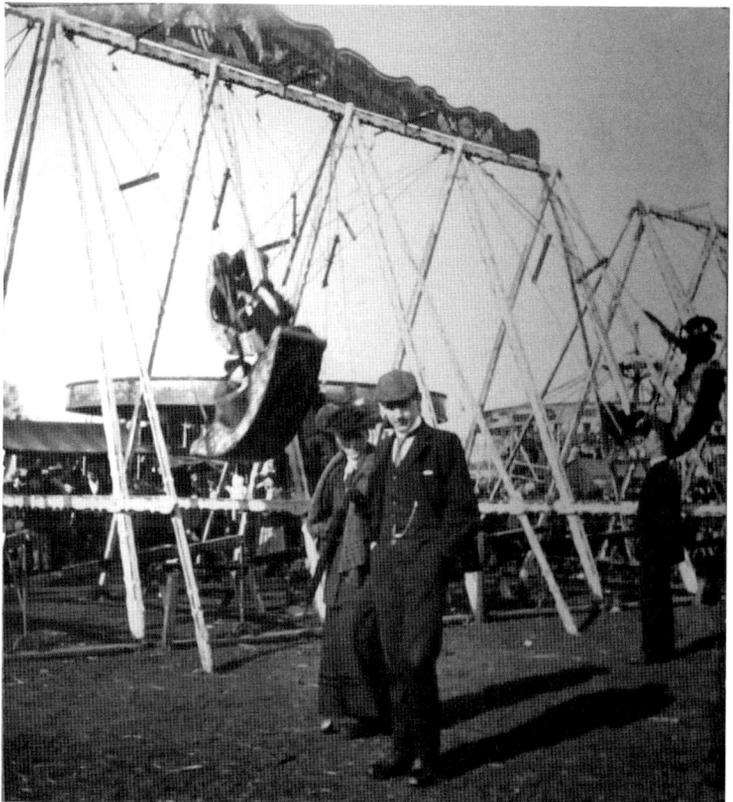

the counter, which at night was lit up with those wonderful fizzing paraffin lamps like a gas ring, fed down a pipe from a tin can hung on a hook on the roof. Harrington's of Durham, and others. Wonderful times!

Then on the Saturday morning from 6 a.m. or so, you heard the brass or silver bands marching in from the pits, leading the Lodge Banners – big, beautiful silk things carried by two men between two poles resting on sockets on their leather belts. Then silken cords with tassels from the top of each pole, one fore and the other aft, held by sort of 'outriders'; all followed by men, women and children from the district till the banners reached the racecourse, where they were fixed to the railings, one might say 'wheel to wheel' these days.

Many of these people walked very long distances, and arrived tired, hot and bothered to rest on the racecourse. But pubs were open all day, and beer cheap. Then, all the churches and chapels in the town provided refreshments for the more sober-minded.

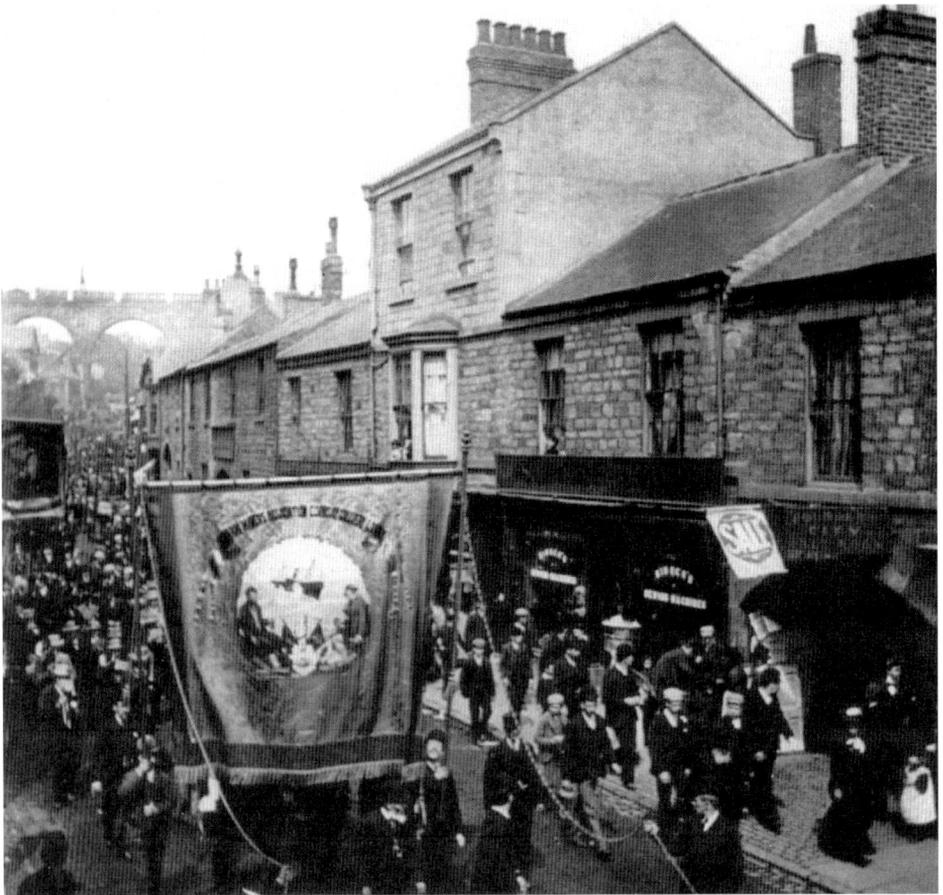

Miners' Gala Day Procession [*'Gala' here is pronounced 'Gay-luh' not 'gar-luh'*] marching down the North Road, 1890s. (This is the only known photo of this particular banner from Consay Colliery.) [*MR*]

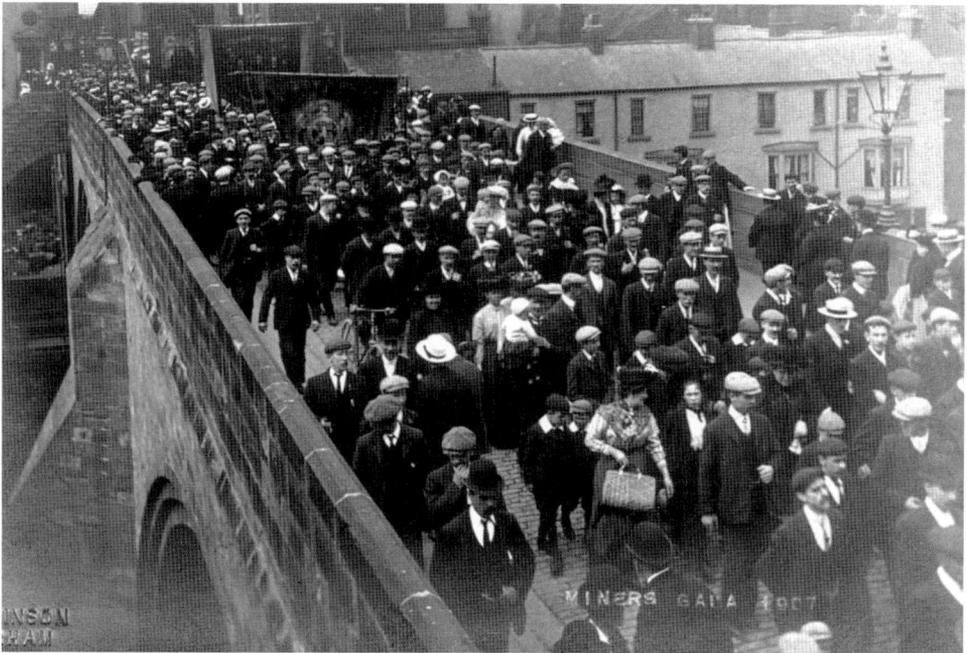

Miners' Gala Day 1907 – the procession crossing Framwellgate Bridge. *[MR]*

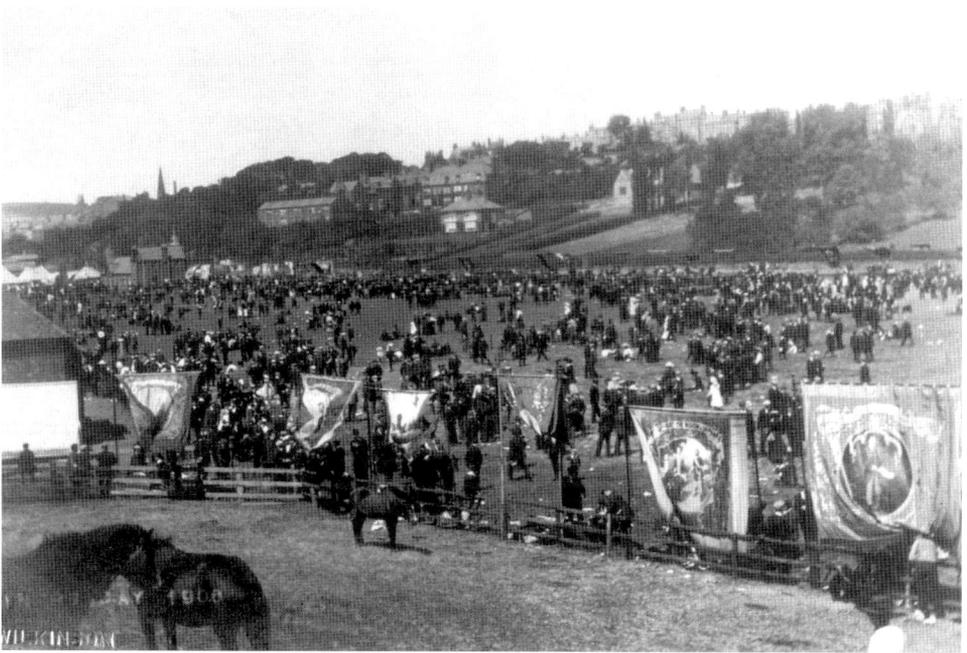

Miners' Gala Day 1908 – crowds on the racecourse. (The ponies in the fenced area in the foreground are pit ponies brought in by the marchers.) *[MR]*

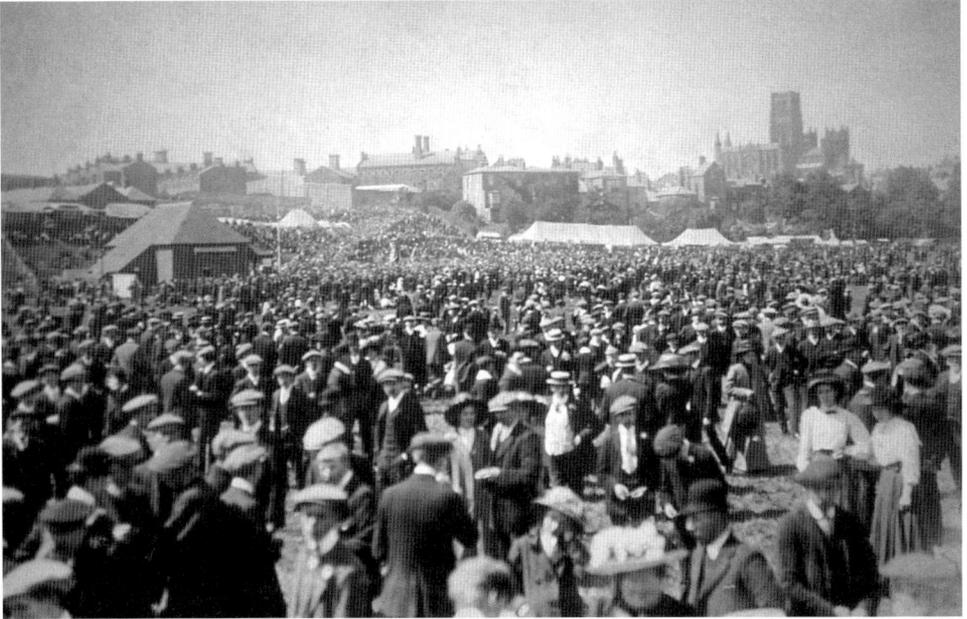

Crowds packed on the racecourse for the 'Big Meeting' (as the Gala is often known), 1900s. *[MR]*

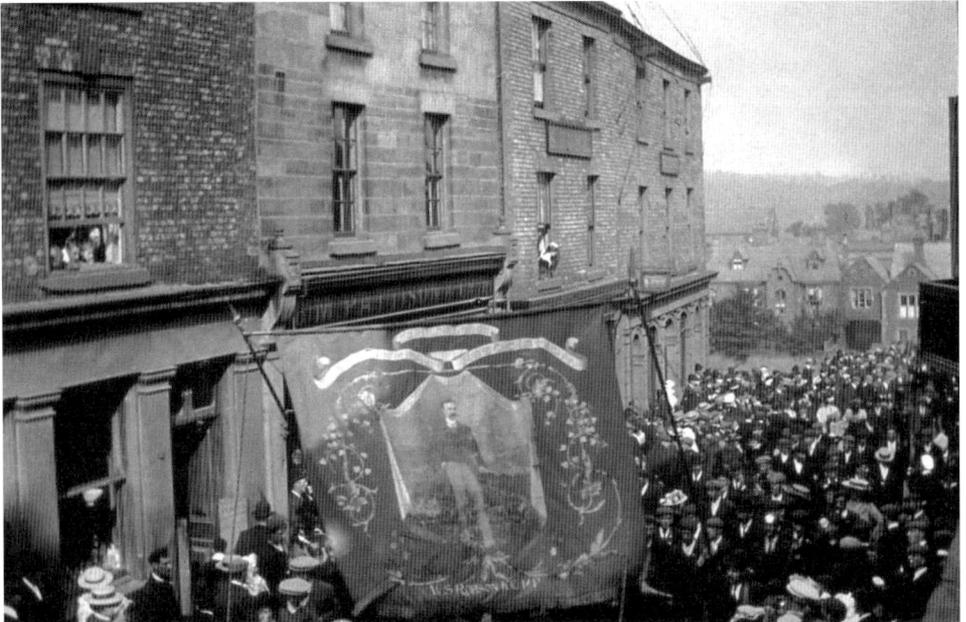

Miners' Gala Day, early 1900s – the procession heading home across Elvet Bridge. *[MR]*

Some of the banners didn't reach Durham until pretty late in the morning, and had to leave in the early afternoon to get home in decent time – no motors in those days, just tubby-traps run by the thrifty pitmen on Saturdays to get an extra bob or two *[a 'bob' was slang for a shilling – 5p today]* – quite inadequate for Miners' Day! Normally, these little tubby-traps used to stand in rows on Saturdays outside the County Hospital, Crossgate, Gilesgate and wherever else – and run half-tight, or 'merry', pitmen home. Littletown, Langley Moor, 3*d* a time *[just over 1p]*, and say 6*d* a bit further like Rainton or Lanchester, Crook, etc. Many a night when I stayed at Shincliffe Croft with Uncle John, I'd hear the 'cloppety clop' of the ponies, the mouth-organs and singing of the merry, half-squiffy, pitmen going to Bowburn, Coxhoe, etc. – no Shincliffe bypass then!

How simple and happy folks seemed then compared with today! People made the most of their spare time then, and enjoyed it – few admitted they were 'bored' in the good old days!

Durham Regatta

And so to the other big event of Durham as it was in the old days, the Regatta – a really popular two-day event. Somehow, the weather seemed so much better then, because it was also a sort of social event and fashion show. All the local clubs put in crews for the events, and in addition there were 'professional' crews in clinker fours, as opposed to the mostly amateur entries. These professionals had little skill, but drove their boats along with sheer brute-force – interesting and amusing to watch, with their cox urging them on, rocking forward with each stroke, shouting,

'Howway, yer boogers!' and sometimes cursing them. Big, lusty pitmen or buck navvies, brickies and what-have-you, in short sleeved sweaters – blowing and perspiring like anything, and taking it very seriously – there was money in it!

The riverbanks were lined with spectators, and the amateur crews competed for trophies still evident: the Wharton, the Grand, Lady Herschell and others. Durham School usually in their neat green-and-white; University in Palatinate *[purple]*; and Tyne and Tees crews. All the crews were very smart in their 'Fine' boats – juniors in 'Cutters'.

The judges' box was a canopy-covered, open-sided box built on a platform on top of the old Baths' Bridge. That big, clumsy-looking steel-girder structure was built in my time to replace the previous arched wooden one (on the steps of which I had fallen and split my forehead open).

The Racecourse riverbank was the 'payment' end, and the 'enclosure' the posh end, with a Band in the old wooden bandstand. The band was often from the boys of the Earls House Industrial School, who marched to it playing, and did extremely well.

Then there was the refreshment tent, to me in those days expensive – *6d* for a big dish of strawberries and cream. But the enclosure was where everyone put on their best clothes – long skirts, sashes, big fancy hats, parasols – in fact, as good a fashion show as you could see anywhere. Durham School boys and university students brought their 'people', all in their best – a colourful show indeed, with all the flags flying along the waterside; bunting and what else.

In the evening, ropes between poles were all hung with Chinese paper lanterns, or little coloured glass jars lit with the old-fashioned night-light candles *[now usually called 'tea lights']*. There was dancing in the Wharton Park, and a concert in the Town Hall on the first evening; and on the second night was a display of fireworks on the Pelaw Wood bank of the river – and Pelaw Wood lit up with coloured matches – rockets – big bangers – and coloured showers of stars, bringing cries of 'Ooh!' 'Ahh, ahh!' from the crowd of workers on the Racecourse bank. Set pieces with 'the King'

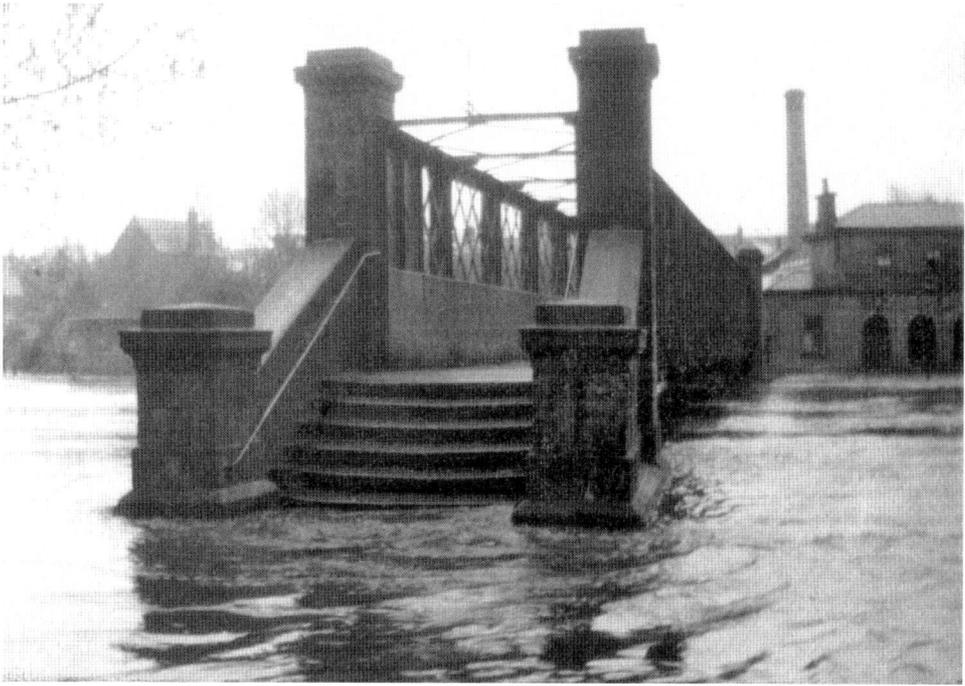

The second (steel) Baths' Bridge during floods, 1 June 1924.

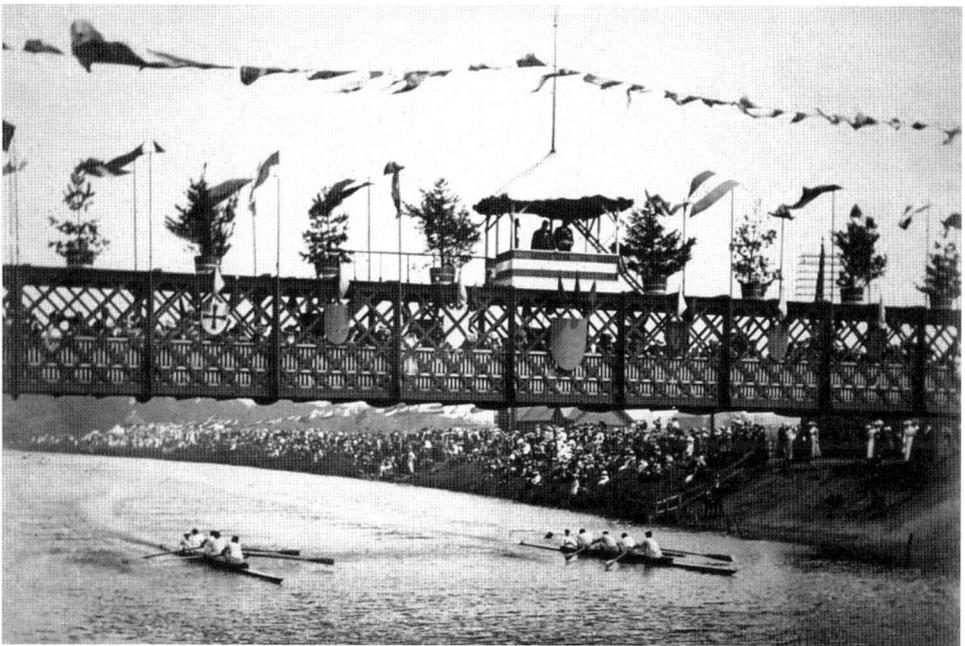

The judges' box on Baths' Bridge, about 1904 – crowds fill the bridge and line the banks. *[MR]*

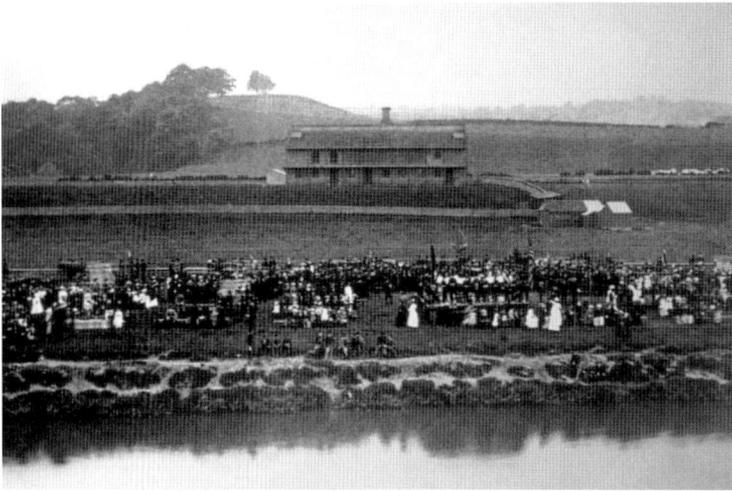

Crowds at the racecourse watching the Regatta, 1890s. *[MR]* (The 'roof' of the old Grandstand is actually tiered seating. Beyond it is Nine Tree Hill; the houses on Whinney Hill have not yet been built.)

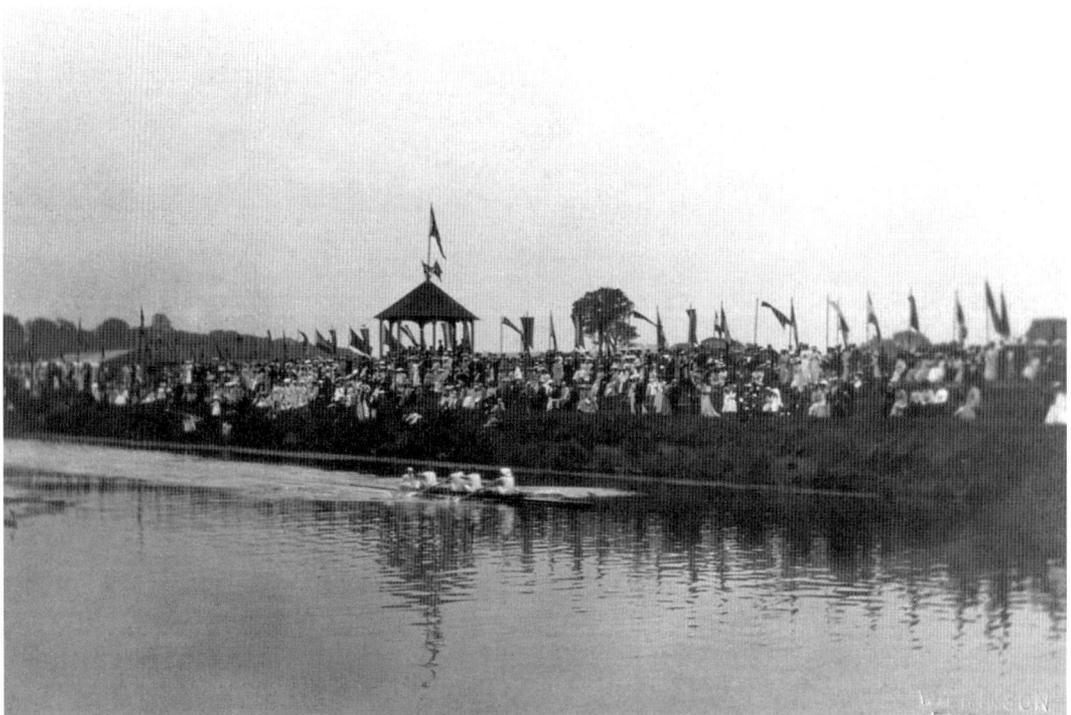

The Regatta, about 1904, showing the original bandstand. *[MR]*

(or 'Queen') *[i.e. the National Anthem]*, and 'Success to our Regatta'. People watched too from Parsons Field, Nine Tree Hill, and the Scar Head, before any of Whinney Hill was built up.

Durham School boys were allowed out late to see the fireworks, and at the end of the show all formed up and marched back to the school, singing at the top of their voices the school song, 'Floreat Dunelmia', till they were hoarse as crows the next day.

Prizes were distributed in the Town Hall during the evening, before the firework display. A real 'event' was the whole show!

On other occasions there used to be boat parades – people hired the boats, and dolled them up in fancy dress, with Chinese lanterns hung about them and round a sort of frame, with coloured canopy, just above the heads of the occupants. After dusk or dark, they paraded up the river, all lit up with night-lights in little coloured jars; and there was music – concertinas, fiddles, etc.; singing – cathedral choir singers like Duncanson, Peacock, and Cradock; Nuttin who played the double bass and wore a wig; and later Joc Lisle. The singing was mostly done without music – just voices in perfect harmony, sounding wonderful over the water.

Then there was the annual swimming gala opposite the racecourse – quite a 'do'. The only outstanding name I can remember was Weavers. Then there was the 'clown' – a wonderful man, a great big fellow with a large nose and black hair, who used to disappear underwater and come up in the most unexpected places – under the bushes or a boat-landing – and make the most weird seal-like bellows or belches to let you know where he was. Pity I cannot remember his name (was it Webster?) – but he was a real character!

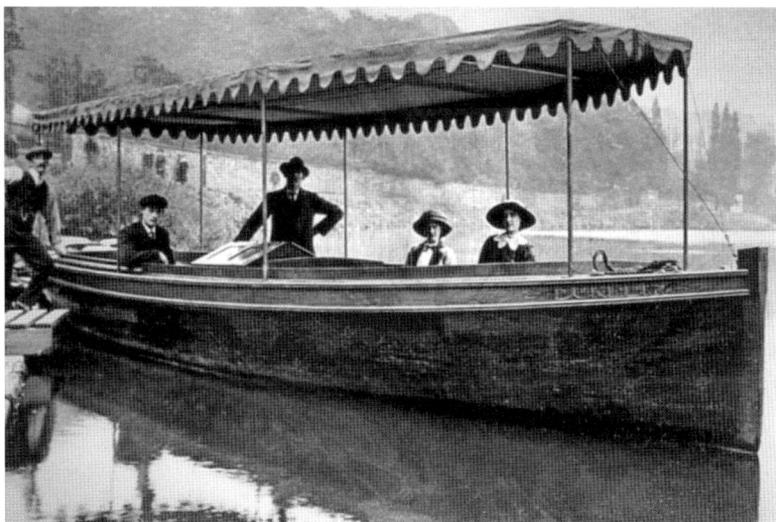

Pleasure boat *The Dunelm* on the River Wear at Brown's Boathouse, about 1914. (She was built by Joseph Brown of Brown's Boathouse and launched in 1911.) *[MR]*

'Characters'

Talking about 'characters', I'll try to dig up a few of the good old days of 'gentlemen', when an Englishman had self-respect. It's a bit difficult, when I only dig up these old memories after comparatively long intervals, to remember whether or not I've written about them before in these 'memories'; if I have, there may be slight differences in the recollections – after all, most of it happened a long time ago!

For instance, we'll pick old Tom Jones the solicitor and notary public, whose office stood back from the road in Queen Street *[now called Owengate]*, nearly opposite my father's office (which was on the corner of North Bailey, with windows onto Queen Street). The old man lived in the top house on the right of Queen Street; the entrance steps were (and perhaps still are) recessed into the building. Old Tom Jones was one of those real gentlemen, and dressed like one. He had sort of aquiline features with white hair wisps coming forward above his ears, a grey topper on his head, quite a stoop, but still very tall. He wore a tailcoat, black-and-white check well-fitted trousers, probably white spats, and patent leather shoes; the inevitable silk handkerchief hanging from his cuff, and an ebony stick. He lived with his spinster daughter – a big, handsome woman with white hair, and always beautifully turned-out.

They were friends of my father, and in my early days in the office, a maid in white apron, cap, etc., would gently and discreetly knock at the outer office door where I was, and say when I opened it,

'Mr Jones' compliments, and he would be pleased if Mr Mawson would come over at about four o'clock and take tea with him and Miss Jones.'

Of course my father was delighted to come!

The old man never really practised in my time – just 'looked in' at his office now and then to keep an eye on his junior partner, John Burrell.

Now who else? Say E. G. Marshall – another solicitor, who lived along the Bailey (all the aristocrats lived along there then), and walked down to his office (which was above the National Provincial Bank in the Market Place) most mornings. He was mostly solicitor to – was it Lord Londonderry? – no, I think Lord Durham. He had a typically Victorian staff of three deferential minions, all properly dressed with choker collars, black tailcoats and stripy trousers.

'E. G.' himself was a tall, well-built and erect person, always immaculately dressed in tailcoat, choker, probably a white stock, and stripy trousers; crowned by one of those black felt toppers, he carried an ebony stick with silver top, and gloves. He smoked a fat cigar on his way to the office, held in his right hand.

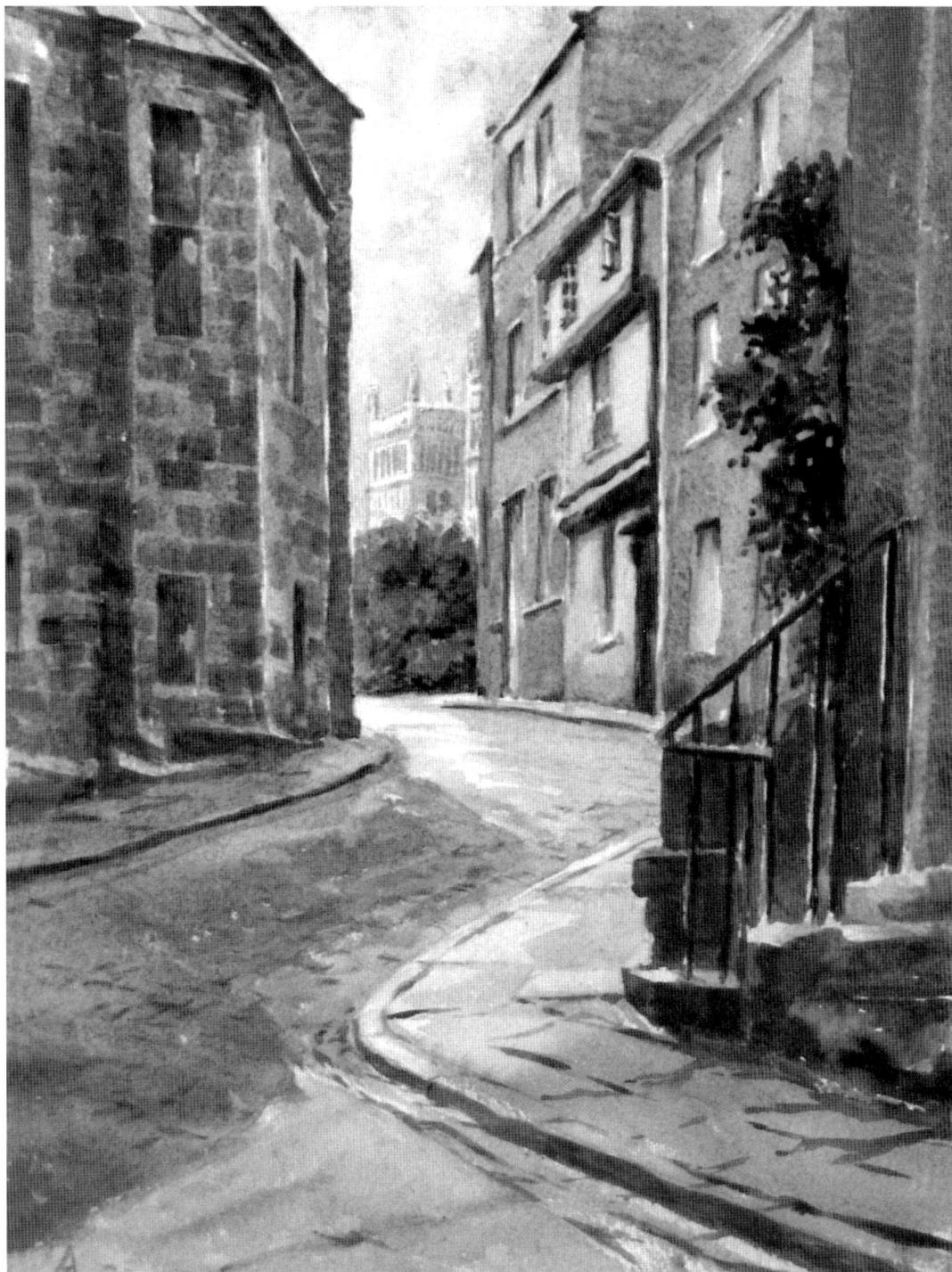

Looking from the Bailey up Queen Street to the cathedral. (Joseph Mawson's office windows are on the left.) [M. Heron]

Mr Thomas Jones of 6 Queen Street – about 1905. *[MR]*

He was a bit awe inspiring until I got to know him, but one typical incident sticks in my memory. I was coming up Saddler Street one morning and saw 'E. G.' coming along past Earl's shop. As he got to what is now 'Book's Fashions' *[1969]* but was then Hiller's Piano and Music shop *[today it is 'The Edinburgh Woollen Mill' shop]*, he found the footpath – which is very narrow at that point – obstructed by two women with a pram, who were looking into Hiller's window. Instead of stepping into the road – there wasn't much traffic then, and few motors – he walked right up to the pram, stopped dead and stood there puffing his cigar till the women looked up, so embarrassed that they moved out of the way and let him go by on the inside of the pavement. 'E. G.' didn't bat and eyelid, just moved on without a word! I was decidedly amused, but just took off my hat and said,

'Good morning, sir!'

Those were the days!

Somehow, all these 'characters' were big, fine-looking people, who had a sort of 'presence' – a kind of 'breeding' which you rarely, if ever, meet nowadays. It wasn't just a question of money or wealth, but their very poise and manner, courtesy and politeness which made one respect them. Now what do you get? Would anybody say 'Good morning, sir,' to a senior? I nearly fell flat when the first kid office-boy from another firm came into my office, calmly sat in the client's chair and then – after a lesson in manners – as he went out, coolly shouted 'Cheerio!' and left the door open! I had to teach him some more manners, and I think some of it had sunk in by the next

time I saw him – but lack of manners seems to be 'normal' in the 1960s ... or was it the '50s?

I'm tired now, but wonder where my memory will take me next? What a happy and contented generation we seemed in the old days. We worked hard and earned our leisure, didn't have too much of it, and never had to complain of being 'bored'. We didn't want to be entertained – we made our own amusement.

When I got to bed after writing that last bit, my mind still recalled some of the old characters, and took me back to Patrick McCartan, who was one of the old-style Irish linen drapers. He had his shop at 1 and 2 Gilesgate *[where the Chains council flats now stand]* – a single-storey building with pantile roof. The dwelling house was behind the shops, with a back entrance to Kepier Terrace at the end of a yard and garden. You went down two steps into the sales shop at Number 2, which was usually run by Mrs McCartan: a big, fine personality with a rather mannish voice – Irish! Number 1 shop was usually bung-full of bedding, with linen piled up to the ceiling and up against the multi-paned window – the sort of warehouse portion.

These Irish drapers travelled the countryside with their wares, and old 'Paddy' – a big, stout, burly man, with white hair and red face, strong as a horse and tough – passed our house in Ravensworth Terrace with a great big stack of linen in a huge sheet pack, with a stick over his shoulder through the knot at the top of the pack, on his way to his 'rounds' – often from Elvet Station. In the evenings, he'd just have the wrapping sheet (folded under his arm) and the stick left.

'Diggers' in the garden at 10 Ravensworth Terrace, Spring 1919.

In the spring of 1915, before I enlisted *[a motorcycle accident in 1913 left Landt with injuries which meant he repeatedly failed the medical in the early years of the war]*, my father decided to 'dig for victory' and got me to plant potatoes in the lawn opposite Number 10. Old Paddy spotted me almost the first morning, and told me,

'That's no way to plant tatties – come and I'll show you!'

He then duly introduced me to the 'Irish Lazy Bed' method *[see page 187]* – good for breaking virgin ground. For sheer energy and strength, I was amazed – he handled the spade as easily as if it were a teaspoon!

Another of the linen traders was Peter McCartan, who also had a shop, but further down Claypath, almost opposite the end of Leazes Place. He too went off on his travels with his 'pack' of linen on a stick over his shoulder.

Advertisement for Peter McCartan, around 1909. *[MR]*

Funny how old times and customs keep cropping up from time to time. I went to the old firm of stockbrokers today – Adamson's – on business, but went first to the little baccy shop (next to Mason's the chemist's) lately run by Connie Earl, who was the daughter of Charlie Earl – who, with his brother Harry, ran the bakery and the confectionery shop next door to it when I was a boy …

Charlie Earl – a caricature from the Durham City
Bowling Club, July 1933. *[MR]*

As a Durham schoolboy, in our 'down town' leave during lunch-hour, I used to call at
Earl's and eat fresh custard 'straws', all warm from the bakehouse behind, at a penny
a time. Nobody has ever made straws like that since! Old Harry was a wonderful
pastrycook, with his tuppenny meat pies and four or sixpenny veal and ham pies for
a home meal (special). He also had a special recipe for sausage – the recipe died with
him, but it was famous. When the judges came for Assizes and lodged in the Castle,
it was always on their menu, and those judges used to give a standing order for the
sausages to be sent to their homes in various parts of the country. When the brothers
Earl died, their son Charles and daughter Connie carried on, but the sausages and
cakes were never the same. Then young Charlie died, and Connie carried on. Now she
has retired and the old business is closed down (1969).

*But in the tobacco shop, I talked to Connie's friend, who's still running the 'baccy
shop', and we dug up old memories of the old days when Earl's had a serious rival,
Adamson's, who had a shop across the road in Saddler Street – later run by Mrs Walton,
but now offices.*

Adamson's also had a shop on Elvet Bridge – now *[1969]* Finlay's. In those days,
the Elvet Bridge shop had a bulging window made up of small panes of glass with
bubbles in the glass, and a grill in the brick-work below from which the savoury smell
of 'cookies' used to emanate! There was a rear communication way between the two
shops.

The interior of Earl's Shop at 68 Sadler Street, October 1935. *[MR]*

Next door to Earl's was a little old house with a rectangular bay window, which in my time was the old *Durham Chronicle* office, run by Salkeld's, and later by Welsh's. But the *Chronicle* died a natural death years ago, and only the *Durham Advertiser* – the local weekly – survives.

Above that was the head post office – now taken over by the County Court offices. Over the alley-way adjoining were the reconstructed Martin's Bank premises – manager 'Ikey' Jackson – and at the top end of the alley was Thwaites Printing Works – later taken over by the *Advertiser*.

But to 'come back on the rails' again – after buying my baccy, I went over to the stockbrokers formerly run by John Adamson, another Durham character. A fine figure of a man – dead years ago now – who walked slowly but firmly, and was always smoking a fat cigar. After John Adamson died, the old name was carried on by Jack Hay, who came to him as an office boy, but is now himself retiring, and the business is taken over by a firm from Sunderland, of which his son is a partner.

Hay is a big, bluff fellow now, with a wonderful interest in wildlife and nature, not to mention archaeology and old Durham history. He seems to have absorbed a great deal of local history from his former employer, and is a veritable fund of information!

Adamson's office was a little room in a semi-tumbled-down premise, with a window looking onto Elvet Bridge, at the end of a passage from Sadler Street. When I went there the other day, a notice said, 'Removed to 35 Saddler Street', so there I went, to a neat, tidy office with a 'Mind your head!' notice over the little passage joining the

Jack Hay (left) and T. Wright, with 'Pop' the dog, at Brasside Ponds, Summer 1950. *[M. Hay]*

clerks' office to the boss's office behind – where Hay junior is now installed. But Jack was there, with his usual rose buttonhole *[flower]*.

Of course, we got talking of what those reconstructed premises were in the old days, and I asked him if he remembered when the little, scruffy, second-hand bookshop was there, run by old Smith – yet another 'character'. He wore old clothes and a misshapen trilby hat. You had to go down two steps into the lockup shop, and books were just lumped together anyhow. How the old man ever found what was wanted, heaven knows; but as schoolboys we used to go for 'cribs' – i.e. translations of our Greek and Latin prose: Ovid, Virgil, Plato etc. (strictly on the quiet, because we weren't supposed to use them!) He had two pretty daughters – Maisie and Madge, we called them – who were years ahead of their time. They used to dress '*à la*' in what were near mini-skirts even when I was a schoolboy in 1902–8! – kilts and the like; with high, leg-fitting boots to just below the knee, and fair hair frizzed and sticking out round their shoulders from under natty little hats, berets or the like. They were often seen round the school, parading Pimlico to Margery Lane, giving and getting the glad eye to and from the senior schoolboys!

I happened to tell Jack Hay this, and to my surprise, he said that they're still alive, and until recently ran a little sweetie shop in the corner of the Market Place, near the entrance to St Nicholas' church. Well, well, after all these years it tied up, because from leaving school in 1908, I never heard squeak of them; and when going there for my sisters' lollies in the 1950s, there were the two Miss Smiths, but it never occurred to me that they were the same 'girls'! They've packed up now, and must be about my age, and I haven't seen either of them for quite a while – if I do see them again, I'll ask if they are one and the same of the old days!

Times have changed in my lifetime – I'm eighty now, and dig up memories of long, long ago. Thinking of Jack Hay brings to mind another bit of old history.

As an articled clerk to my father and later, I must have handled thousands of golden coins. It's astonishing to me (or is it?) how many people nowadays have never seen, much less handled or owned, a golden sovereign. They were once common currency, and clients saved them and brought them into the office to pay for their houses. Thrifty miners, who saved and bought houses to provide the rents when they were too old to work in the pits. Many owned quite a few houses, and occupied their time keeping them in repair, or generally tinkering them up or improving them, sometimes re-selling at a nice little profit! They brought their golden sovereigns into the office in little bags, and when they spilled them onto the desk, the sovereigns looked and felt solid and substantial, and seemed to mean something.

The sovereigns all went through the bank – come and go – and our business account was at the National Provincial Bank in the Market Place – which is still there, under a changed name . How well I remember the dignity and 'presence' about a bank in those days – particularly the then cashier, whose name was Pike. He was always polite and well turned-out, with a buttonhole in his lapel – he was a keen rose-grower, and had a garden by Durham School, in an elevated position on the corner between 'Teep

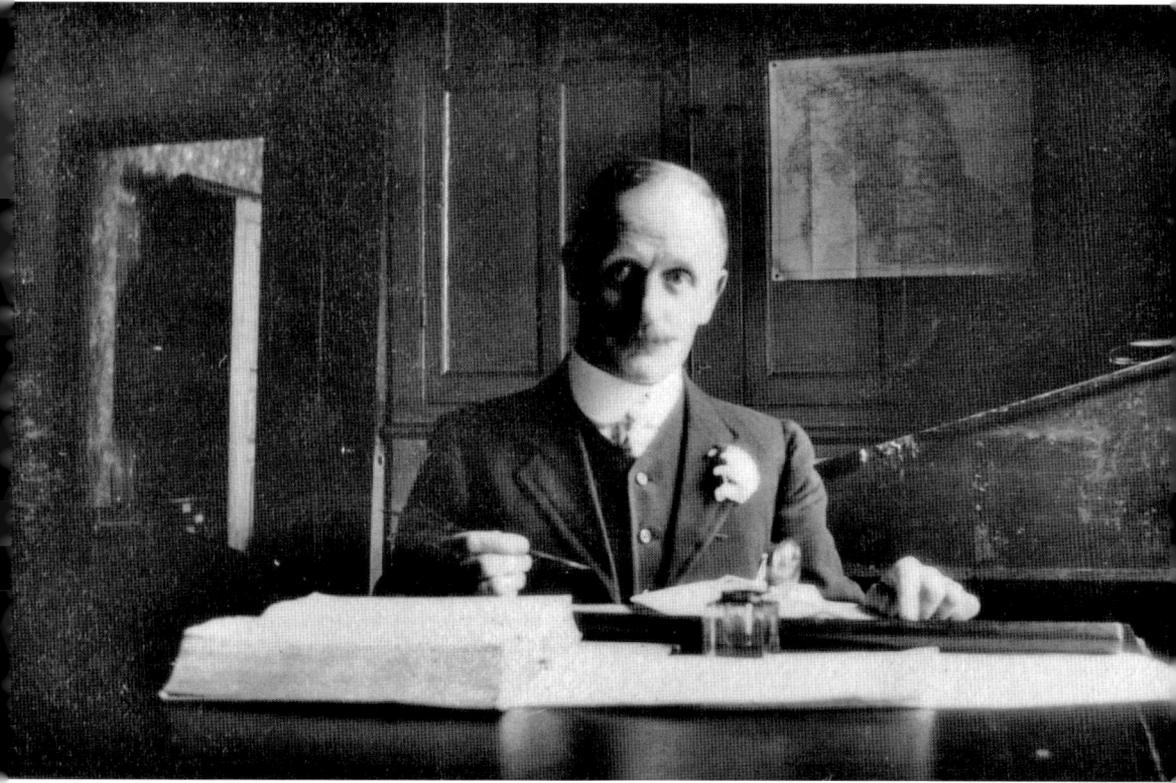

Above: 'In the office', about 1912. (An employee of Joseph Mawson, solicitor.)

Right: The National Provincial Bank, on the corner of Saddler Street and the Market Place, 1880s. (Neptune is just visible on the 1863 pant in the bottom left corner of the picture.) *[MR]*

A gold sovereign from 1890 (the year of Landt's birth), and a gold half-sovereign from 1914, with a canvas bank bag.

Lane' *[probably a Durham School corruption of 'Steep Lane', usually called 'Colly Rippon's', now known as 'Blind Lane']* and 'Clarty Lonnen' *[now called 'Clay Lane'].* He had rather fat, podgy hands, but immaculately clean and manicured, with a gold ring on one finger. A pair of brass scales stood on the counter, with weights labelled and stamped '500 sovs' and so on. When the scales were loaded, Pike pressed a lever to lift both bowls of the scales clear of the counter to balance. Then (or maybe before weighing?) he'd tip the sovereigns onto the counter to count, and though he held his receiving hand an appreciable distance from the counter, with his other hand he could flick those sovereigns into it with amazing accuracy – I never saw him miss! Then he'd put a handful on the counter till all were counted. Next, he'd open the counter drawer, pick up a well-polished copper shovel, scoop up the counted coins into it, and tip them into the drawer. Finally, he'd complete the paper slip, and that was it! What an experience, which I cannot see ever being repeated! Those sovereigns looked and felt as though they meant something – and they surely did! Nearly all coins in those days had a 'ring' if you dropped them. Compare present coins, which drop with a dull thud like blobs of lead; or treasury notes, like soap coupons! Ah well …

Riverside Businesses

The old flour mill seems to have come into the news again recently – apparently because of probable demolition. In my boyhood days, most big families baked their own bread, tea cakes and what-have-you – in the old big black kitchen ranges, with the steel-work polished, and the steel fender in front of it, on which the bread in tins was put to 'rise'. Opposite our range was the flour bin – a big, rectangular, wooden affair, with two separate compartments – one for white flour, the other for brown, and with little receptacles at the back for yeast or the like – all covered with a lift-up lid.

Periodically, flour was delivered in what I think would have been 5 or 6 stone sacks [around 32–38 kg], by horse wagon, the driver with flour-covered clothes. It all came from the old flour mill at the lower end of Framwellgate Stakes. The flour was ground out by the great big wooden mill wheel, which was driven by water power from the river. Water was channelled under the building by a water duct from above the stakes [weir], and discharged below them after it had done its job.

When we went there, the mill was run by Mr Martin, who lived at the top of Ravensworth Terrace, and was an old friend of my father. His little office faced upriver over the duct, and was below a flight of steps which went into the mill proper and had flour bags – everything was always white with flour, including the mill hands coming up and down, to say nothing of the many cats which seemed to overrun the place (an obvious necessity to keep down the rats and mice). When the mill wheel was working and grinding, the whole building used to rattle, shake and vibrate in what to us children was a most alarming way! Happy days! And now, after being used for other purposes for many years, the old mill landmark is to go.

Across the road from the mill was what was then Henderson's carpet factory, but later taken over and expanded as the Mackay works. Incidentally, Hendersons then lived in Leazes House, the big house at the end of Leazes Place and across Tinkler's Lane from Ravensworth Terrace. (The high school moved there in 1912 from their previous premises in the Bailey, just south of the college gates.)

Some time before World War One, the old carpet factory became a roller-skating rink, and what fun we had there! At some sessions they had a brass band in a sort of circus box, to which we tried to dance. They also had sort of carnivals, with lots of fairy lights. Now there's the proper ice rink across the road (not a beautiful erection!) built on what we used to call 'The Islands', because a waterway ran between it and what I might call the 'mainland'. Apparently now the ice rink is a flourishing concern. [It later ceased to flourish, and closed in the 1990s.]

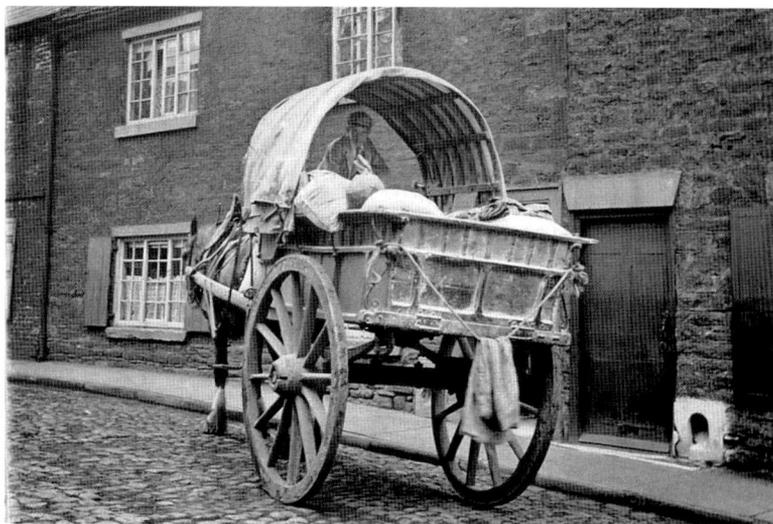

Above: Martin's flour mill in the mid-1960s, shortly before demolition. (The ice rink can be seen back left. The little old building with pantile roof at the end of the weir had been the medieval Bishop's Mill, and can still be seen today.) *[MR]*

Right: A flour cart delivering sacks of flour in the city, 1880s. *[MR]*

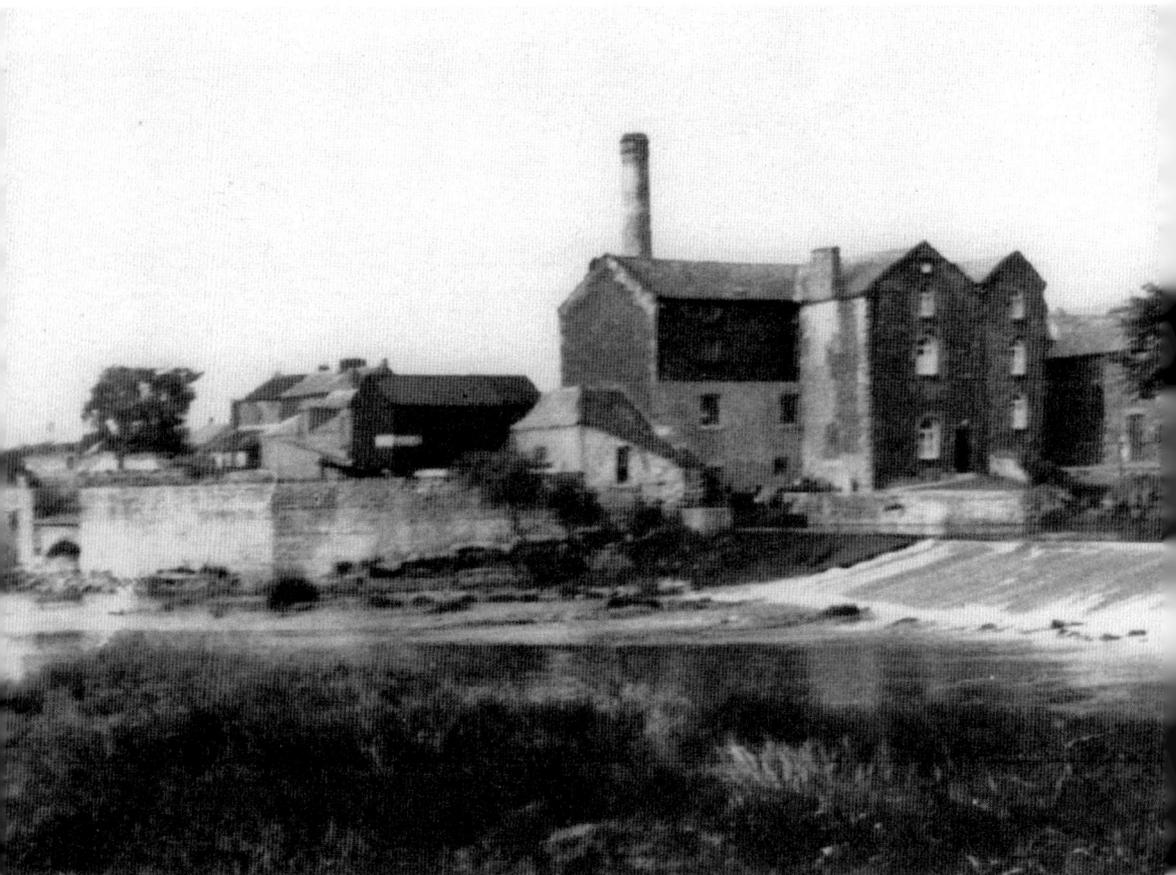

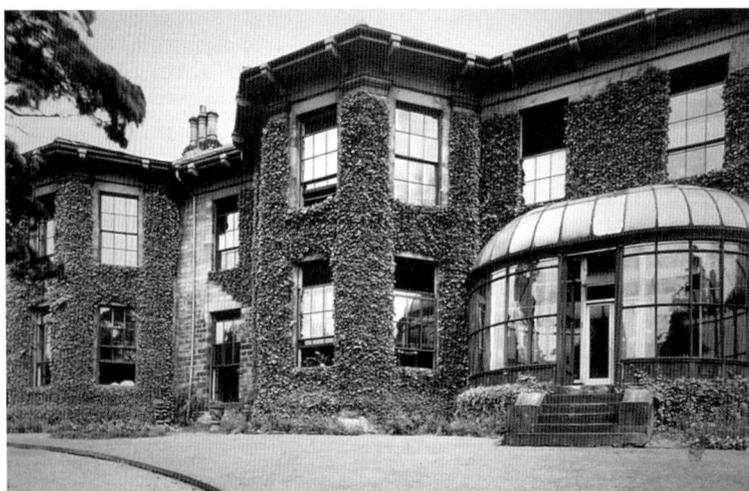

Above: Martin's flour mill in the 1930s (taken from the opposite bank, approximately where the 1960s Millburngate Bridge now spans the river.) *[MR]*

Left: Leazes House, at the end of Leazes Lane, off Claypath, 1910s. *[MR]*

School girls, 1900s. (Anna Mawson is sitting in the front row, on the left.)

The Olympia roller-skating rink at Freeman's Place, about 1910. It was officially opened on 27 December 1909 by the Mayor and Mayoress of Durham, Mr and Mrs W. H. Wood. *[MR]*

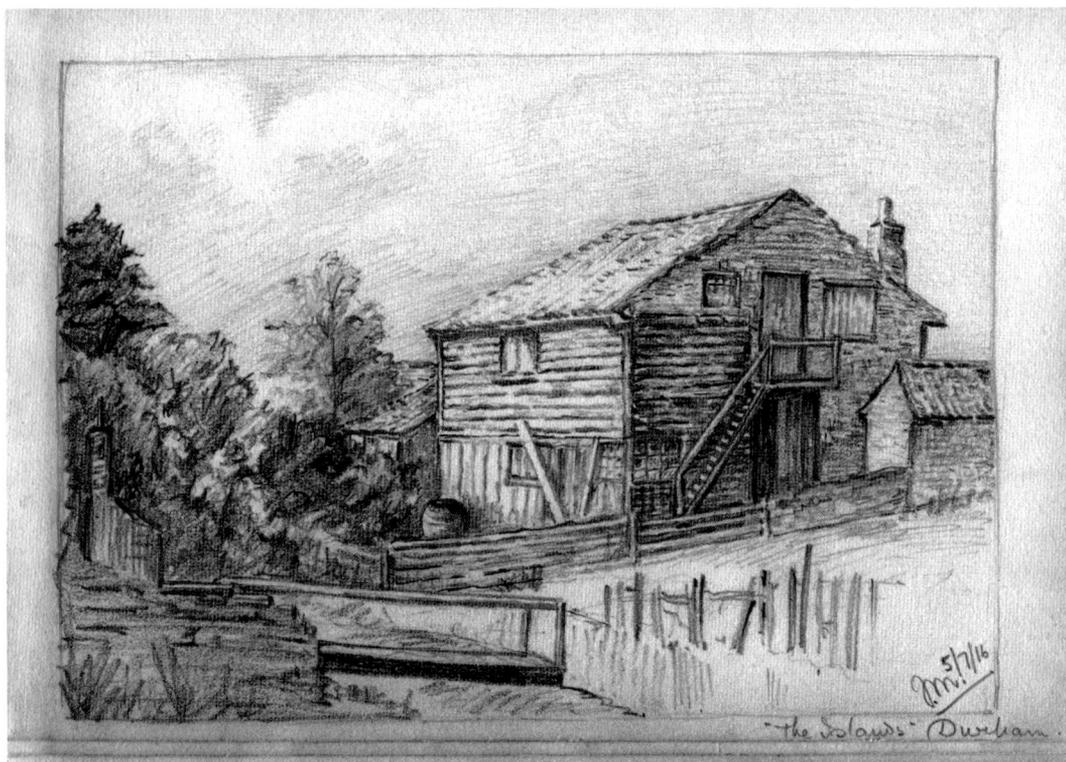

'The Islands, Durham' – pencil sketch by Flora Mawson, 5 July 1916.

Coming up from the old mill, opposite the entrance to the carpet factory, was the old blacksmith's shop – run by old Brown, whose descendants now have their workshops at Dragonville. Then adjoining round the corner was the old Palace Music Hall – a wonderful old place, where many 'turns' made their first appearance – not least, Charlie Chaplin, who in those early days was a member of a troupe of acrobats and dancers who called themselves 'The Eight Lancashire Lads'. *[See page 187]*

Occasionally the Palace put on plays with some quite good little travelling companies, and played things like *When Knights were Bold*, a James Welsh production; *The Private Secretary* about a dumb curate; *Charlie's Aunt*, and the like. Now all that has gone, and left nothing but happy memories, where now is the new road from North Road to Gilesgate, Leazes Road.

Poor old Durham – so much of its identity and originality seems to have been lost. Pretty well only the cathedral and castle left, or so it feels. The city seems cluttered up with 1960s buildings and busy modern roads and car parks! Once-pleasant family homes are increasingly being turned into student 'digs'. And as the university expands, so it buys up ever more of the old city – even the much-maligned Shire Hall in Old Elvet. The students, and even the professors, look so casual nowadays: no longer do they dress formally in their academic gowns as we did in my day (and later)!

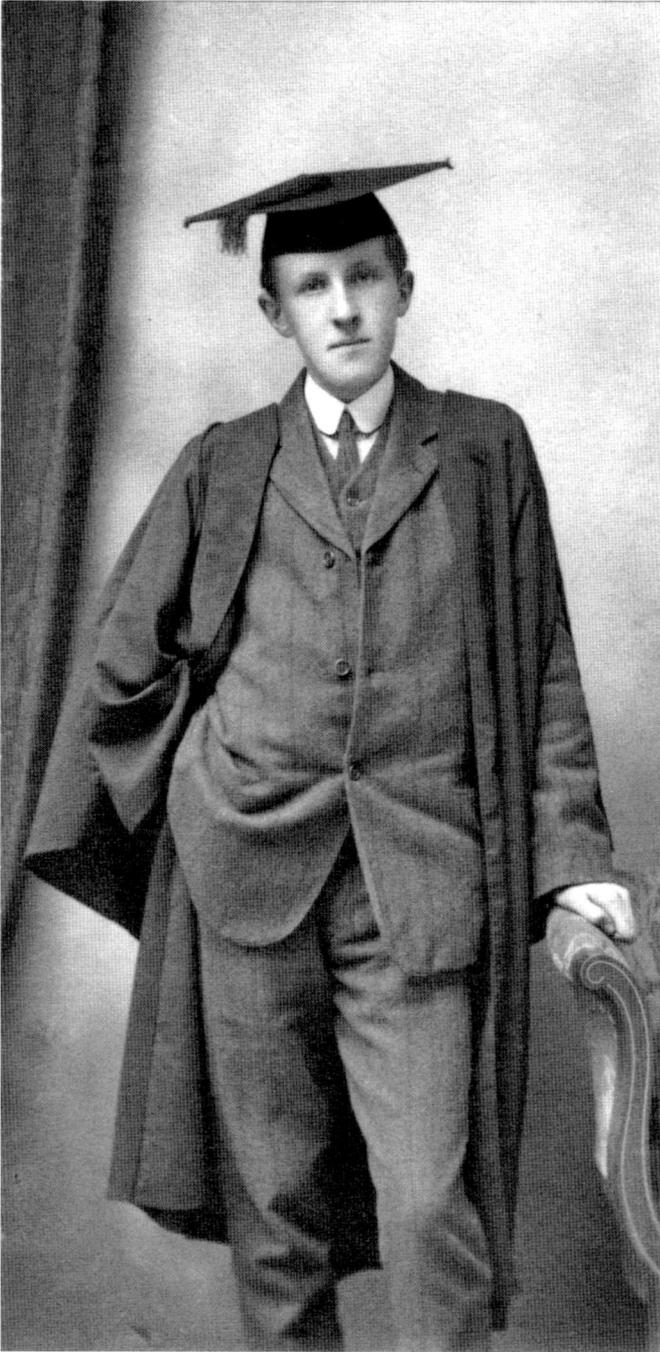

Landt in academic robes, about 1909. (A formal portrait by John R. Edis.)

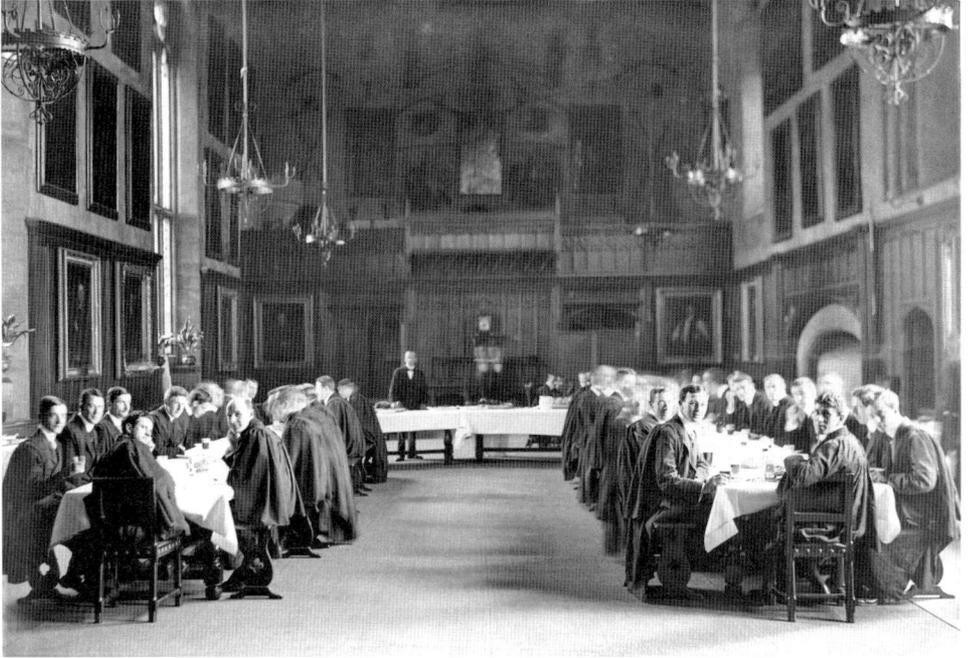

Students dining in the castle (Durham University) about 1909. (Landt is on the left-hand side of the left table, fourth along, leaning forwards.)

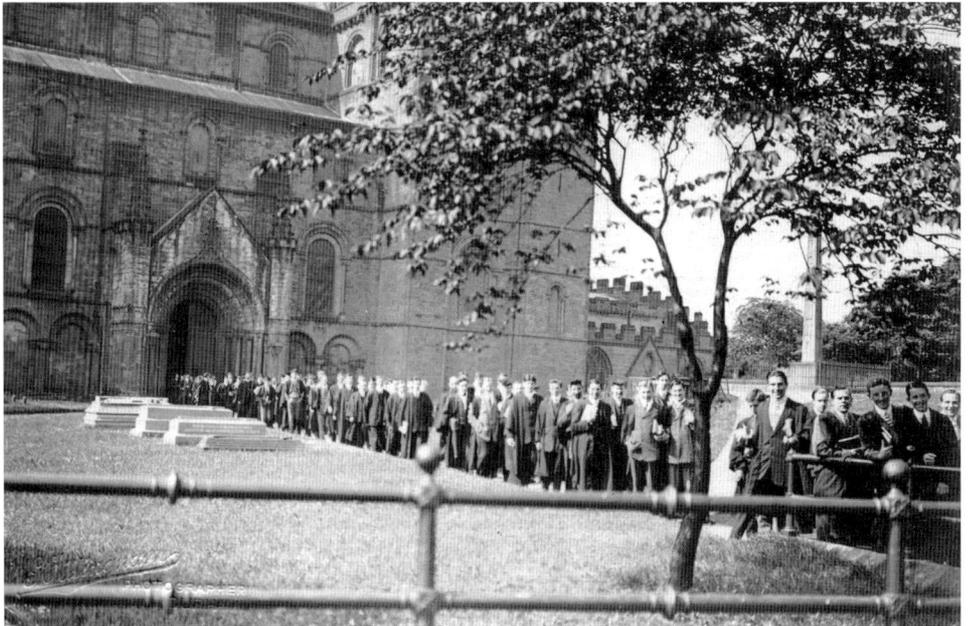

Students leaving the cathedral, about 1909 (Landt is third from the right). *[Photograph by G. Fillingham]*

Market Day

(1974) Sometimes there's quite a gap in these bits of memories, so there may from time to time occur a certain amount of repetition – possibly with some discrepancies, just as my memory recalls particular incidents. For instance, I've just given someone what I called a 'Mawson's Medal', – an old golden sovereign I still had – which brings back more memories.

When we were kids, Durham Market Place really *was* a market, where all kinds of produce was handled. Saturday was market day. Farmers and others brought in their produce from the country to sell, and apparently housewives got their 'housekeeping' *[money from their husband's wages, for household expenses]*.

We used to go with Mother to the covered markets, where there were mostly not proper stalls, but forms (or sometimes trestle tables) to display the produce – for instance, spotless baskets covered with clean napkins, and containing say butter, eggs, cheese, cream – all fresh from the country.

In those days, women wore long skirts and 'bodices', small hats or bonnets, and veils. Here's where the sovereigns come in again, because long before money depreciated to become bits of paper for currency, ladies got their 'housekeeping' in golden sovereigns, and used to spend them in the market. How well I remember Mother turning back her glove, taking a golden sovereign from her purse, lifting her veil over her nose, then scraping off a little piece of butter with the sovereign, to taste and see if it was too salty or otherwise. There was a sense of dignity about the whole performance.

Then on other benches there would be chickens, ducks, hares or rabbits – all spotless and ready to cook; and livestock such as guinea pigs, rabbits, etc. I used to make a bob or two now and then, because I kept rabbits. A friendly old soul from Meadowfield, whom I called 'Old Huntley', would bring in live rabbits, and sell them to me at sixpence apiece at six weeks old, and I'd sell them for a shilling when full-grown. Or I'd take them to my hutch where I had a good Belgian hare to breed from. When a nest of baby rabbits came along, I'd go back to Old Huntley, and sell 'em at say *6d* apiece for him to sell on to someone else.

In the Market Place, in front of St Nicholas' church, hurdles were put up as 'pens' where pigs, lambs and such livestock were offered for sale. We had much fun with the pigs, particularly the little ones!

When the farmers came to Durham, the custom was to unharness their horses and take them down Rickerby's passage, or up the Rose & Crown yard to stable them

for the day. Their traps all had the shafts sticking up and pushed against the next one – parking! Meantime, there were plenty of pubs handy – many long-since done away with – 'referred for compensation,' as they called it. Sometimes several were next door to one another, like The Grapes, Wearmouth Bridge, Taylors' Arms, Wheatsheaf, Hat and Feather, Angel, Maltman and many others.

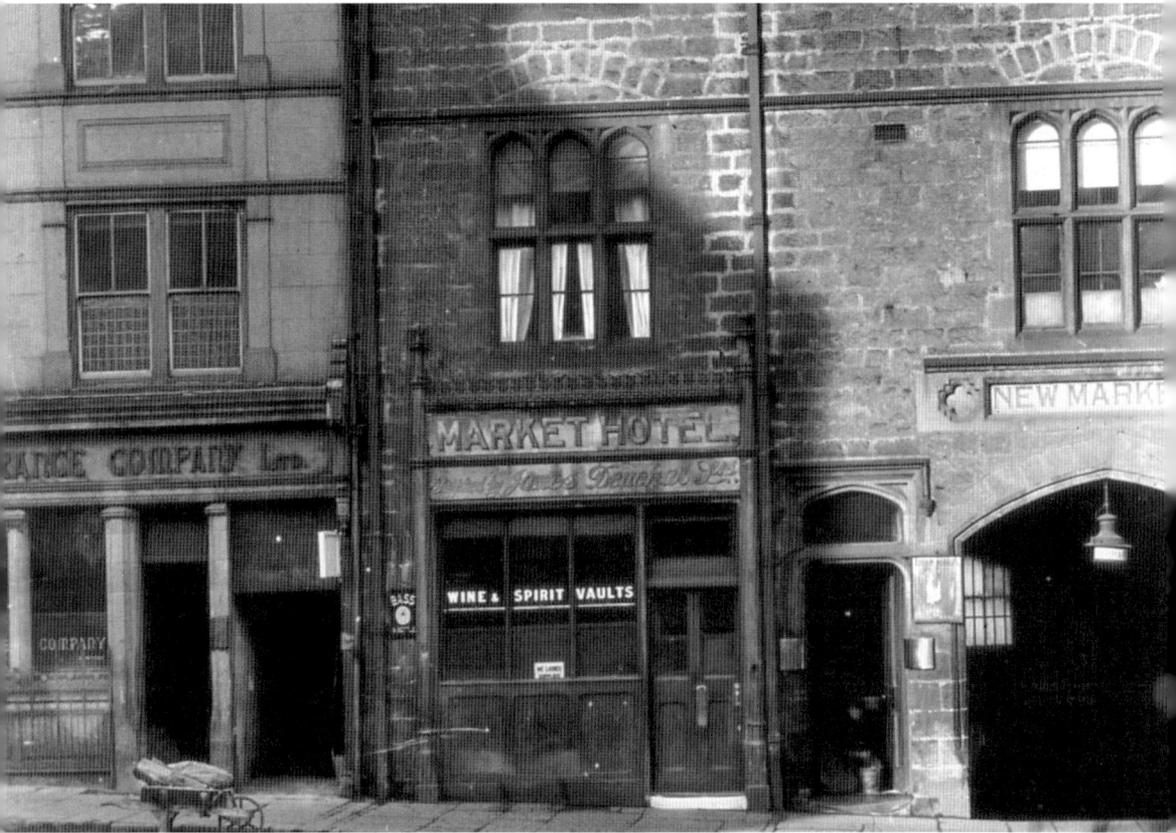

The Market Hotel, centre (a small notice in the window reads, 'No Ladies Supplied') and the entrance to the covered markets, right – about 1919. *[MR]*

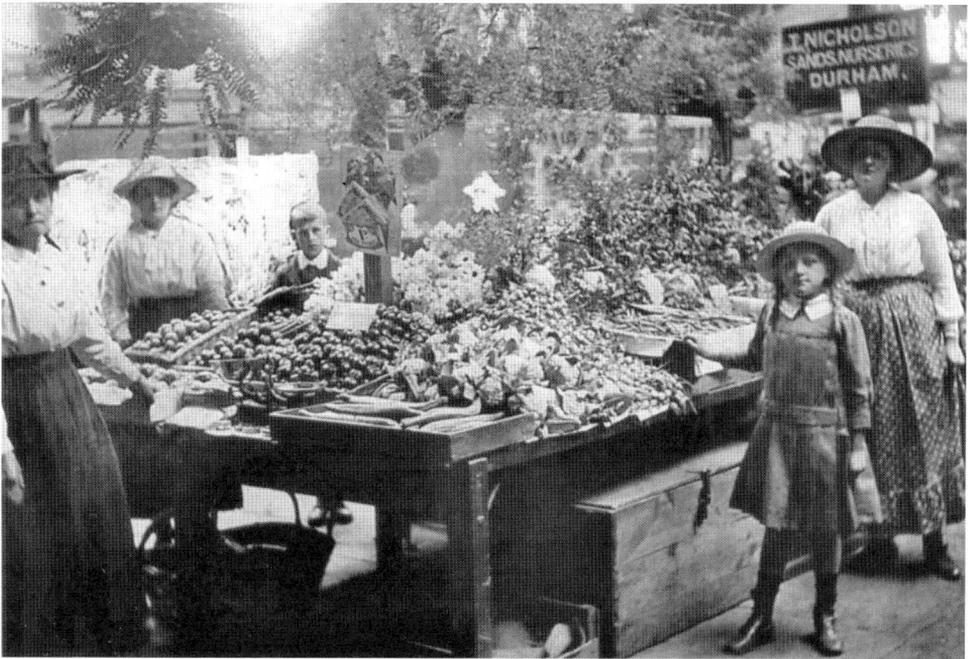

Nicholson's nurseries' stall in the covered market, 1900s. (The small boy, centre, is Jack Raybole.) *[MR]*

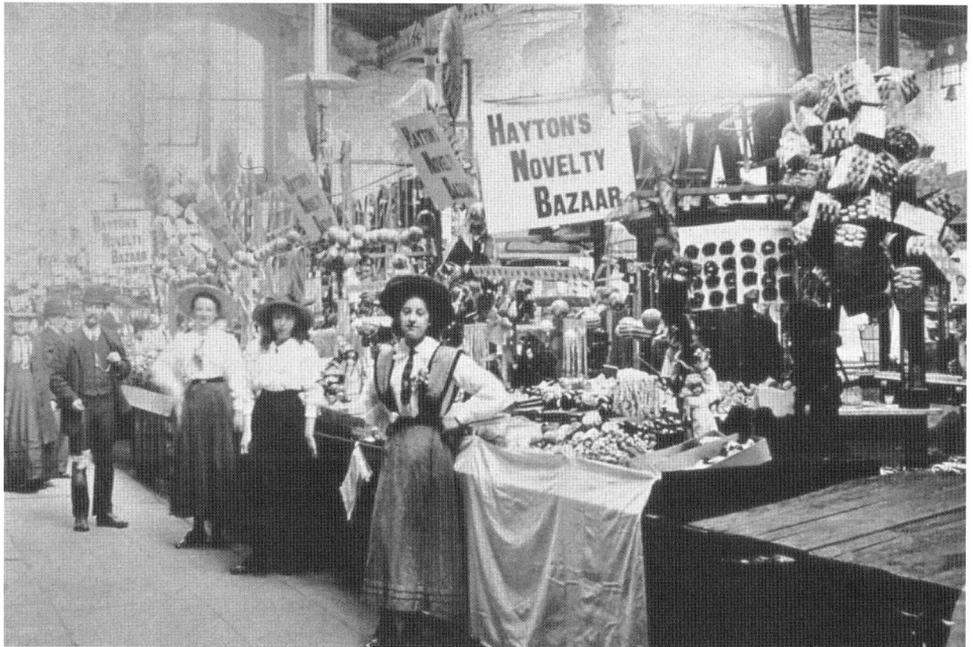

'Hayton's Novelty Bazaar', the covered market, 1900s. *[MR]*

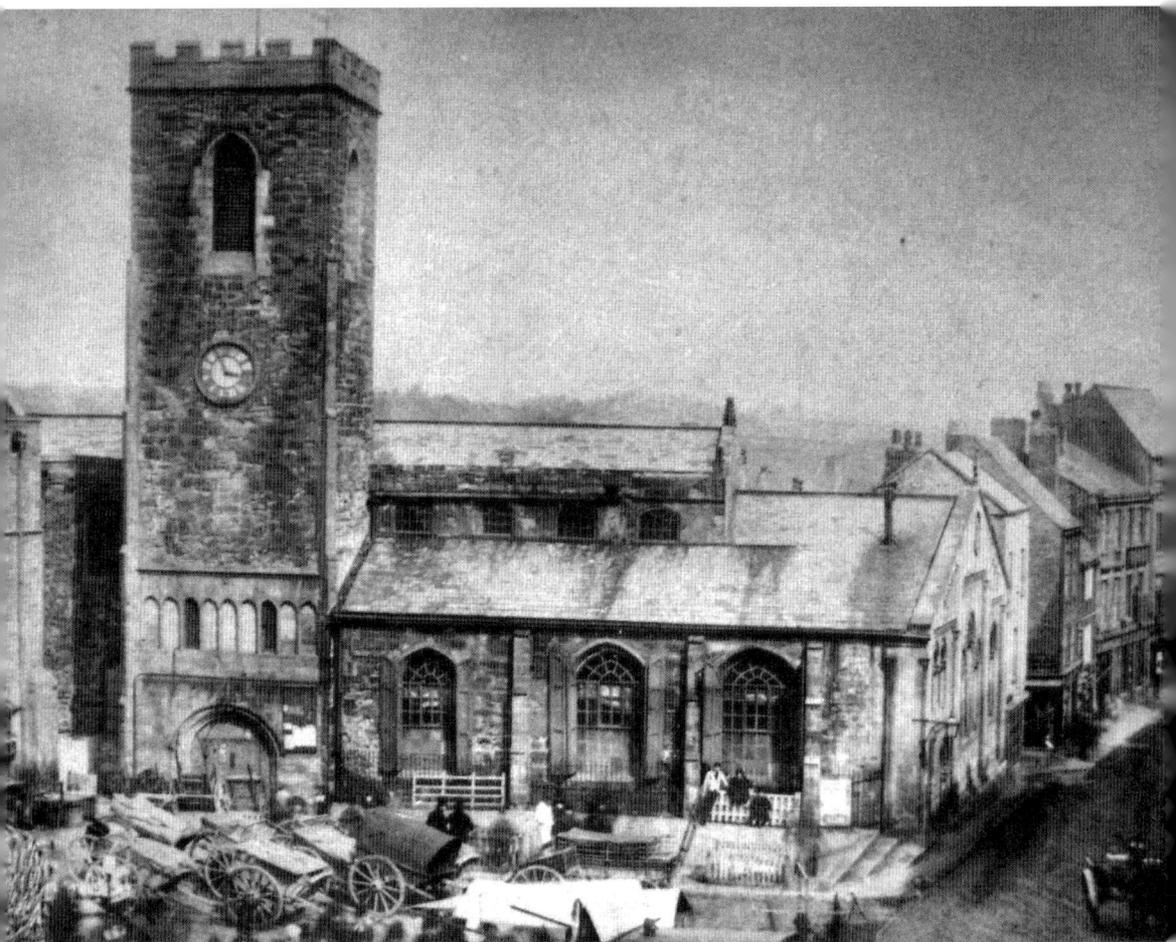

Above: St Nicholas' church and Durham Market, about 1855. (One of the earliest photographs of Durham, taken by Revd Henry Holden, Headmaster of Durham School.) *[This photo was left to Landt by Mrs Fish, the widow of Landt's father's old schoolmaster. See page 42.]*

Left: The Maltman, 29 Claypath (to the left of the Palladium Cinema), pictured in the 1960s. *[MR]*

The Wearmouth Bridge, 17 Claypath, pictured in the 1960s. (The site is now occupied by the lane leading to the stage door of the Gala Theatre.) *[MR]*

The Wheatsheaf, 3 Claypath, pictured in 1910. [MR]

Afterword: Guisers

The memoirs end here, although there are pencilled headings at the back of the manuscript which indicate that Landt, had he lived longer, intended to write about several more topics – including 'Guisers'. Traditionally, Guisers were small groups of boys who dressed up ('in disguise'), and went around at Christmas performing short plays to earn themselves 'a bob or two'. By the middle of the twentieth century, the tradition had largely died out.

Although there is no information in the memoirs themselves about the Guisers, and we will never know exactly what Landt intended to say, an extract from a newspaper cutting of January 1963 (which refers back to a television programme – shown a few days earlier – about Guisers in County Durham) gives us a hint. And tucked in the back of an old scrapbook still in a drawer in Landt's desk is a manuscript (labelled *Tot's Copy of 'The Guisers'*) which had been passed down to Landt's uncle 'Tot' (Thomas) and then to Landt himself. The play is very similar to other versions found in County Durham *[see page 187]*. A pencilled note on the back suggests that it was copied out sometime around 1860 or 1870.

> In the possession of the late Mr Tot Mawson of Durham there was found a handwritten copy of a programme which the guisers presented at each house they visited.
>
> In most of the villages of our county, these curious bands of players were in action about Christmas time, in those more leisurely days when customs of this description were popular features of village life.

So to the Guisers' themselves goes the last word:

'The Guisers'

(7 or 8 boys disguised)

1st boy: Open the door, I enter in,
I hope the 'game' will soon begin:
Stir up the fire & make a light,
For in this house there shall be a fight.
If you don't believe the words I say,
Step in Bold Wallace & clear the way.

2nd boy: In steps Bold Wallace.
 Bold Wallace is my name.
 A sword and pistol by my side,
 I hope to win the 'game.'

1st boy: The 'game,' Sir,
 It's not within thy power:
 I'll cut thee into mincemeat
 In less than half-an-hour.

2nd boy: What! You, Sir.

1st boy: Yes! Me, Sir.

2nd boy: Then take your sword & try, Sir.

(They fight, & 1st boy is killed.)

2nd boy (after tearing off the dead boy's disguise):
 Heavens! What is this I've gone & done?
 Killed my father's eldest son.
 Is there not a doctor to be found?

3rd boy: Yes! In steps old Doctor Brown.
 The best old Doctor in the Town.

2nd boy: What made you the best old Doctor in the Town?

3rd boy: My travels.

2nd boy: Where have you travelled?

3rd boy: England, Scotland, Ireland & Wales,
 And up my grandmother's stairs and down again.

2nd boy: What can you cure?

3rd boy: Anything!

2nd boy: Can you cure a dead man?

3rd boy: Yes! I have a little bottle in my pocket which says,
 'Tick, Tack,
 Rise up, Jack.'

(1st boy Rises up, & comes to life again.)

Then they all sing:

> My brother's come alive again.
> We'll never fight no more!
> We'll be as kind a brothers
> As ever we were before.
>
> With your pockets full of money
> And your cellars full of beer,
> We wish you a Merry Christmas,
> And a Happy New Year.

(Some of the boys also sing songs.)

Then the 4th boy steps in, saying:

> I'm Johnny Funny,
> The man who carries the money.

Then he goes round with the cap.

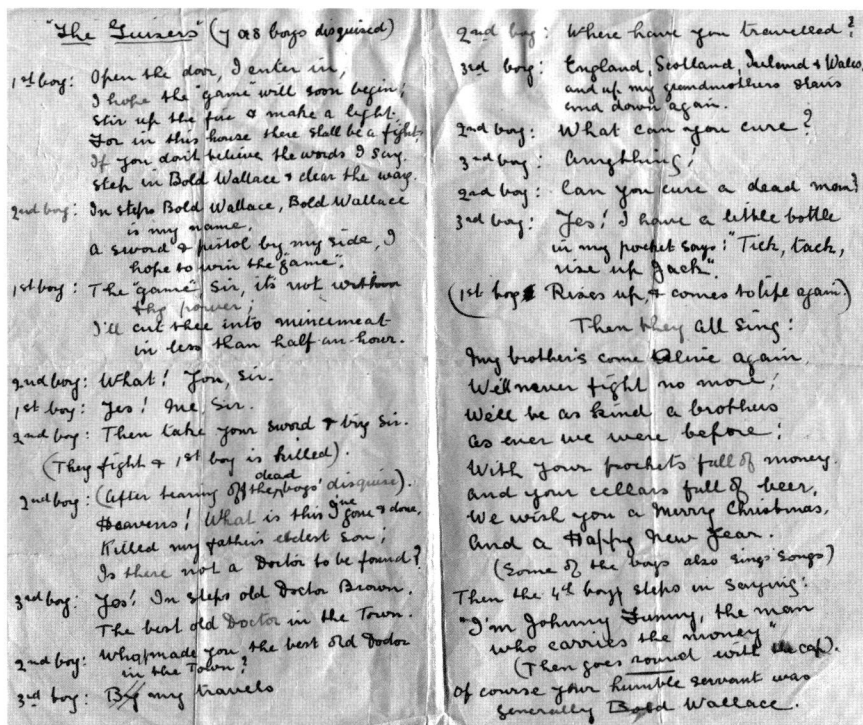

'Tot's copy of "The Guisers".'

Addenda and Corrigenda

The Duck Pond *[Page 13]*

Local people continue to use the name to refer to the grassy area between Sherburn Road Ends and Gilesgate Bank – to the bemusement of newcomers and visitors, as the pond itself was filled in (for health reasons!) in the 1850s.

Neighbours *[Page 20]*

In Chapter 2, Landt talks about the people living in Ravensworth Terrace. Just as I associate certain people with certain houses in the street where I grew up, even though families came and went over time – so Landt has chosen to write about certain residents in his neighbourhood, although a check of the census or the Durham Directory shows that they did not all live there concurrently.

Neptune *[Page 26]*

I have found only two apparent mistakes in Landt's memoirs – remarkable, considering that he was writing sixty or seventy years afterwards! Here, Landt wrote that Neptune was moved onto the Battery in Wharton Park. Although Neptune was certainly in Wharton Park itself, I have found no evidence that he was ever on the Battery.

Sadler Street/Saddler Street *[Page 35]*

This is not a spelling mistake, nor a typing error. Until around the time of the Great War, the usual spelling was 'Sadler Street' with a single 'd' (although there were exceptions). The double 'd' became increasingly common in the inter-war years, and by the middle of the twentieth century had almost completely taken over, even on the street signs – though there are still many people alive even today, at the beginning of the twenty-first century, who consider the double 'd' to be incorrect! Landt consistently uses the single 'd' when talking about his earlier memories, but when remembering later events he often uses the double 'd' – which is a fair indication of the prevailing confusion!

 (The same uncertainty still seems to exist today between Millburngate or Milburngate.)

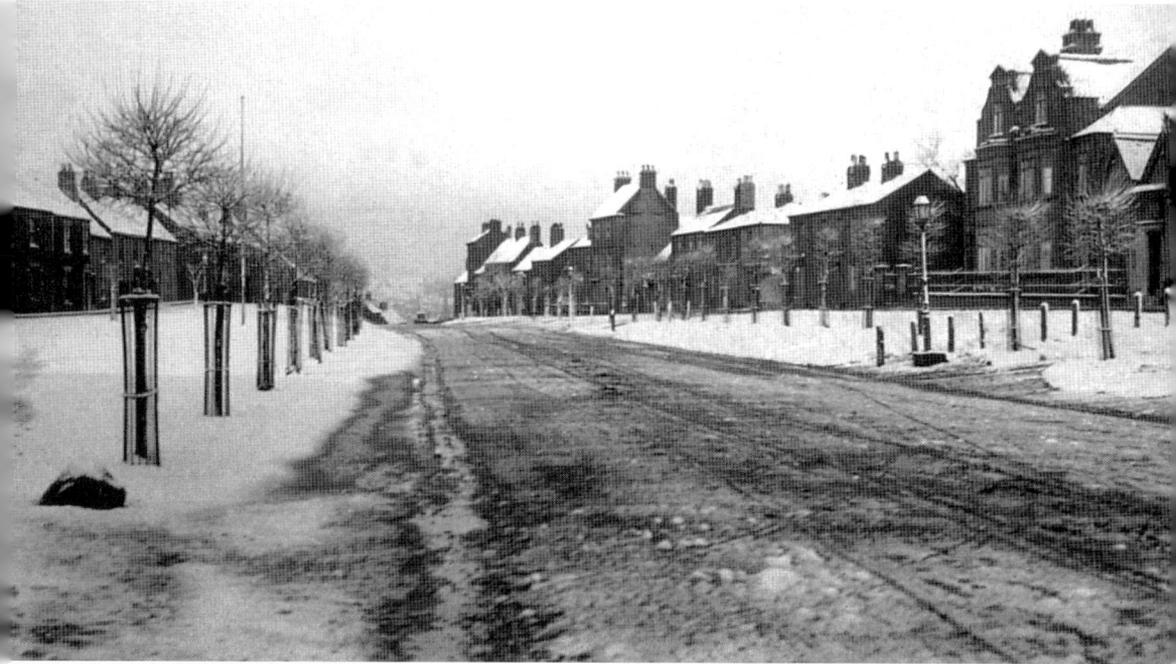

Above: Gilesgate Duck Pond area in the snow, about 1900 (photograph by John Edis). (The duck pond was originally on the left, foreground.) *[MR]*

Right: 10 Ravensworth Terrace, about 1910. (Flora and Amalie are in the doorway.)

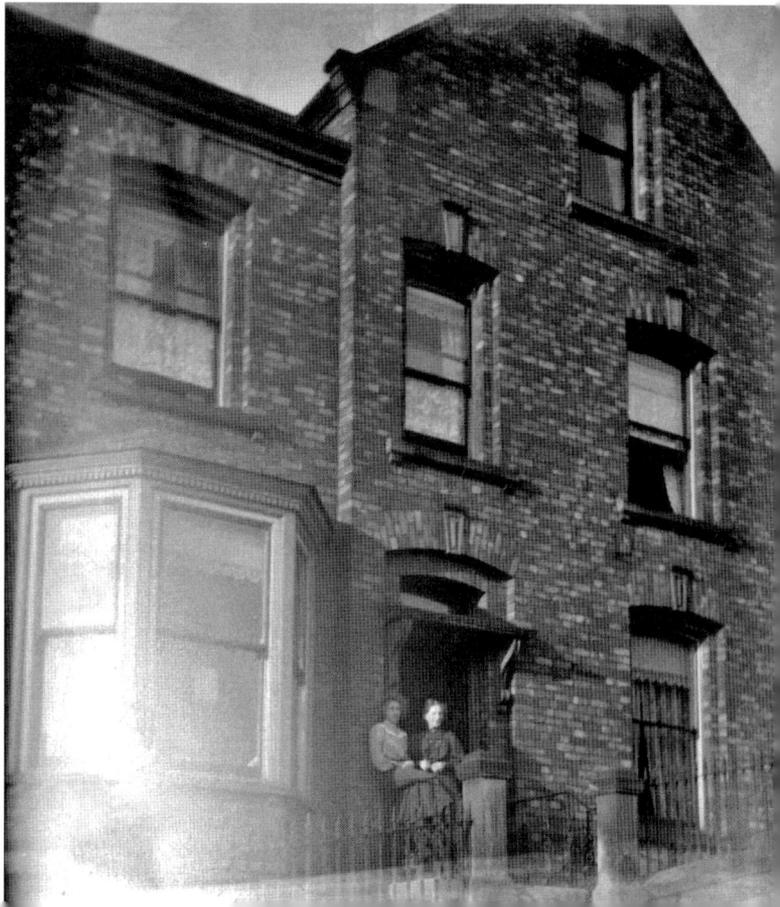

Pelaw House *[Page 44]*

Mr W. H. Wood, of Wood and Watson's 'Pop Factory' in Gilesgate (father of Landt's schoolfriend Joe, and later Mayor of Durham), subsequently bought Pelaw House and re-named it 'The Laurels'. The house still exists today. (The current 'Pelaw House', part of the university, is however a different building and in an entirely different location – at the opposite end of Pelaw Wood, just off the Gilesgate roundabout.)

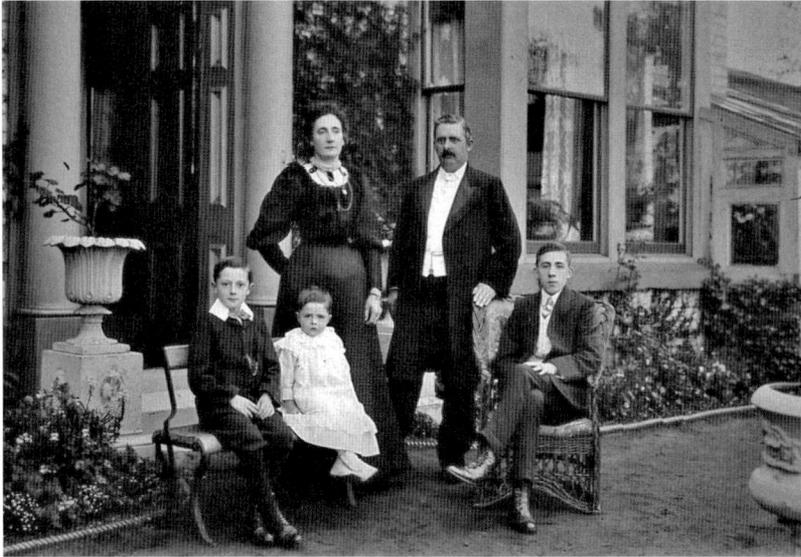

Mr and Mrs W. H. Wood with sons Joe, William and Sydney, about 1907, outside 'The Laurels' (formerly 'Pelaw House' – compare the photo on page 46). *[MR]*

Oswald House *[Page 62]*

Although Landt wrote 'Oswald House', it is clear from his description that he was actually talking about Mount Oswald (Oswald House being on the other side of South Road – the same side as Howlands Farm and Hollingside Lane). However, when it was first built, Mount Oswald was originally called 'Oswald House', and it is probable that Landt, whose ancestors had lived in Durham for some 300 years, was preserving the older name. After all, his aunts – the last of whom died in December 1958 – continued throughout their lives to use the ancient name 'Gillygate' (pronounced '**Jilly**-gut') rather than 'Gilesgate'. The 'lane below Oswald House' still exists today as a public footpath. Mount Oswald itself is now a private golf club.

Sidegate Ferry *[Page 94]*

Several generations of the same family operated the ferry. Despite the name of the modern footbridge which currently crosses the river at this point – the 'Pennyferry Bridge' – the ha'penny fare which Landt mentions is confirmed by Mr Lovegreen's granddaughter, Elsie Shaw.

Lamedy's Chemist's Shop *[Page 124]*

This is the second apparent mistake. Although Landt gives the name of the chemist's shop as 'Lamedy's', a thorough search of all the old Durham Directories from 1890 to 1914 suggests that that was a coiffeur/hairdresser, and that the chemist's shop in this location was actually called 'Lambert's'.

'Irish Lazy Bed Method' for Planting Potatoes *[Page 161]*

Dig long, shallow, parallel trenches; drop the potatoes in; fill the trenches with manure or compost; then heap the soil back over the trenches in long, low ridges. (Apparently this method was common in Ireland, Scotland and parts of northern England.) So now you know!

Charlie Chaplin *[Page 172]*

Although residents of Landt's generation generally believed that Charlie Chaplin performed in Durham early in his career, Chaplin himself in later years denied ever having been to Durham before. Maybe he was listed on the programme as one of the 'Eight Lancashire Lads', but – perhaps due to ill health or some such? – was not actually present when they performed here; and people didn't notice at the time as he was not well known in those days …

Guisers *[Page 180]*

Another version from County Durham (found on the internet), dating from about 1900, is much the same as this, except:

• The character called Bold Wallace is instead called King George.

• After the fight, the boy exclaims the nonsensical:

'Oh dear, oh dear, look what I've done –
I've killed me father's only son!'

(Surely his father's *only* son would be himself?)

• Dr Brown's travels are the rather more elegant:

'England, Scotland, France and Spain,
I've come to cure that man that's slain!'

Landt cultivating potatoes in the 'front lawn' at 10 Ravensworth Terrace, 1919.

The porch at St Giles' church, Durham – unfinished watercolour by Flora Mawson, *c.* 1914; completed in coloured pencils by her great-niece Amanda Stobbs, 2011.

DURHAM
circa 1900
(Sketch map, not to scale)

REFERENCE SOURCES: Durham Directory, 1906
Durham A-Z, 2005 Durham area map, 1861
Ordnance Survey, 1923 Durham Street Plan, 1820

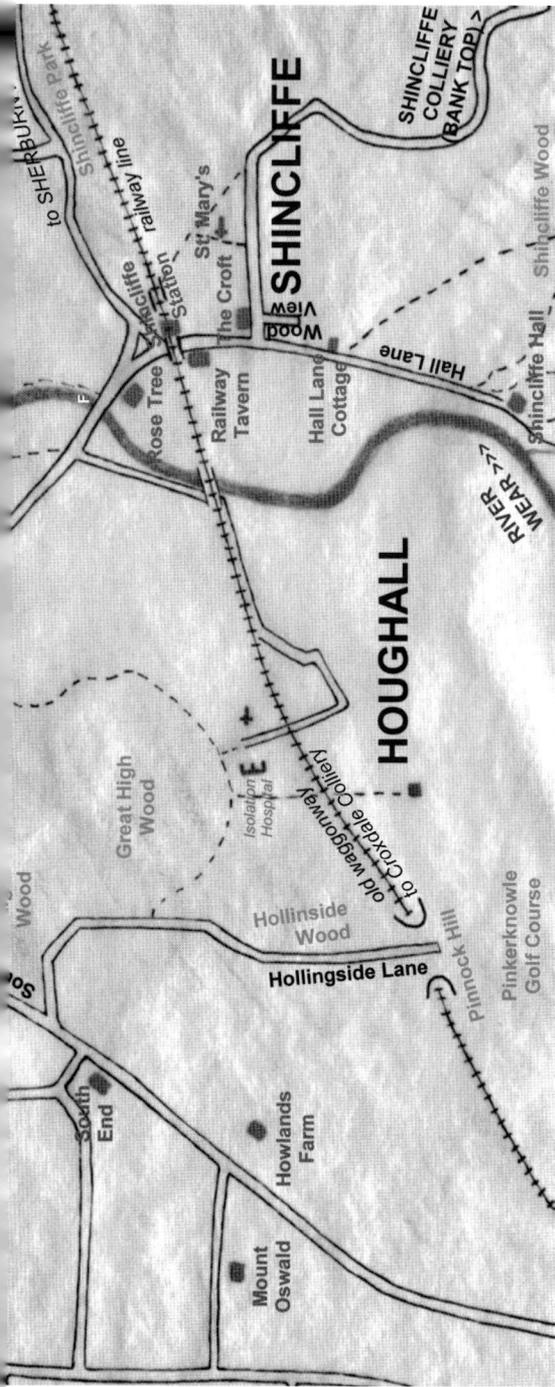

Sketch map of Durham City (centre and south-east) as it was in about 1900 showing the main places Landt talks about (not to scale). (A. Stobbs, 2010)

KEY TO NUMBERS AND LETTERS

A	Framwellgate Bridge	5	The Grove
B	Prebends Bridge	6	Silver Street
C	Elvet Bridge	7	Market Place
D	Baths Bridge	8	Sadler Street
E	Pelaw Wood Beck Bridge	9	Queen Street
F	Shincliffe Bridge	10	Joseph Mawson's office
1	Framwellgate	11	Leazes House
2	Milburngate	12	Tinkler's Lane
3	St Margaret's	13	Ravensworth Terrrace
4	St Margaret's School		

Amanda Stobbs is the granddaughter of Landt Mawson. She is currently researching her family history, and has traced one branch back some 350 years living in the centre of Durham City.

This book is born from that genealogical research, the manuscript having been found amongst Landt's photos and memorabilia.

Many of the illustrations are from Landt's own albums and collections, and some have been taken directly from his old glass negatives.